Tree of Life, Mythical Archetype

Tree of Life, Mythical Archetype

Revelations from the Symbols of Ancient Troy

Gregory Haynes

With a Foreword by Michael Witzel, PhD
Wales Chair of Sanskrit, Harvard University
Fellow, American Academy of Arts and Sciences

Symbolon Press San Francisco

Symbolon Press, San Francisco

Printed in the United States of America
18 17 16 15 14 13 12 11 10 09 1 2 3 4 5 6 7 8 9 10

ISBN: 978-0-9824034-5-7 (paperback)

Library of Congress Control Number: 2009902539

Published 2009

⊖ The paper used in this publication meets the minimum requirements of the American National Standard for Information Sciences—Permanence of Paper for Printed Library Materials, ANSI Z39.48-1992.

www.SymbolonPress.com

We make trifles of terrors, ensconcing ourselves into seeming knowledge, when we should submit ourselves to an unknown fear.

William Shakespeare

Contents

Foreword

By Michael Witzel, PhD

Wales Chair of Sanskrit, Harvard University
Fellow, American Academy of Arts and Sciences

The Tree of Life is one of the oldest sacred stories known to us from antiquity. It is found in ancient traditions throughout Eurasia, North Africa, and America with characteristics so similar as to be inconceivable that they originated independently. The theme also occurs prominently in most major religions: It is a massive tree located at the center of the world, bearing fruits of immortality, and guarded by a serpent. How this story spread so widely, and indeed, what it ultimately signifies, has been a subject of intense debate for centuries.

In recent years psychological explanations have gained ground, postulating a collective unconscious mind, mentally or spiritually accessible to all human beings. But such theories have never been able to account for the absence, in isolated areas like Australia and sub-Saharan Africa, of many myths common to Eurasia and America. If the collective mind were truly universal, as proponents claim, then one would expect to find similar myths everywhere. Equally problematic is the immense complexity implied by such an amorphous mental structure, including its location and the details of its communication network. Even if there were answers to these questions, they would be impossible to verify by ordinary scientific methods.

In contrast, Gregory Haynes offers explanations that are simple and straightforward. In his view, the Tree of Life reflects a tangible, physical phenomenon, observable everywhere, which corresponds in minute detail to the sacred traditions preserved from the past. He is guided in this inquiry by a reinterpretation of archaeological artifacts, mythological texts, and artistic representations from a multitude of cultures. The arguments he proposes are as fascinating and intriguing as they are cogent and persuasive.

But the results of Haynes' investigations are far wider than an analysis of the Tree of Life theme. He convincingly demonstrates that many cultures represented the same natural phenomenon using

widely varying anthropomorphic or zoomorphic images. These variations gave rise to many of the innumerable gods and goddesses, composite animals, and highly imaginative episodes described in the myths. Consequently, a detailed understanding of this natural phenomenon, and of the many guises in which it appears throughout the world, provides for the first time, a simple and powerful key to world mythology.

Scientific theories can be judged by two basic factors: their power and their elegance. Their power consists in how much of the world they make comprehensible, and their elegance consists in their simplicity. By this standard, *Tree of Life, Mythical Archetype* is a major contribution to the study of mythology. Building solidly on the work of previous scholars, it creates a synthesis that organizes the otherwise chaotic world of myth into a coherent picture. But Haynes makes no claim to completeness. He is a generalist whose wide perspective provides an organizing principle, challenging future scholars to fill in the many details. Much work remains to be done in each field of specialization to verify his findings, to amplify the scope of available evidence, and to further investigate mythological themes not addressed here.

Of special interest is his treatment of symbols, especially those found on artifacts at ancient Troy. These have eluded any comprehensive interpretation since their discovery by Schliemann nearly one hundred forty years ago. The suggestion, offered here, is that these represent essential elements of the Tree of Life cult, which is generally known to have been worshipped during the millennia proceeding our present era. His remarkable discovery of the Tree of Life's identity in the natural world actually proceeds from this interpretation of the Trojan symbols.

Of these, the most enigmatic is the swastika. It appears in the archaeological record as early as eight thousand years ago, but its meaning is still not understood well. Haynes presents a new interpretation of the swastika symbol that, if correct, is shocking in its implications. He suggests that the swastika is a geographical symbol that presupposes detailed knowledge of the Atlantic Ocean in antiquity. Notwithstanding the elegance of this theory, it implies very early knowledge of American geography, a knowledge which, so far, is not supported by sufficient archaeological finds. Therefore, this derivation of the swastika should be considered an intriguing suggestion for further study. Without doubt, it merits serious consideration by scholars since, if it proves correct, this would radically change the way we look at ancient history.

In conclusion, *Tree of Life, Mythical Archetype* provides the most plausible explanation yet offered of that ancient religious conception known as the World Tree, or Tree of Life. Presupposing nothing that cannot be comprehended with an intelligent mind and observant eye, it breaks new ground in our understanding of mythology and comparative religion. Above all else, it achieves this with true elegance and a simplicity that is persuasive.

Part I

The Identity of the Tree of Life

Yggdrasil's ash great evil suffers,
Far more than men do know;
The hart bites its top, its trunk is rotting,
And Nithhogg gnaws beneath.

Grímnismál

Chapter 1

Overview

The oldest scriptures at the heart of every major religion make reference to a mysterious tree at the center of the world. Its fruits, guarded by an evil serpent, confer immortality. A nearby stream of water divides into four rivers flowing into the four cardinal directions. The vicinity of this tree is said to be the birthplace of the first human ancestors. Despite differences in doctrine among the world's many religions, the Tree of Life is a common element so old that its source is lost in antiquity. The story is taken literally by billions of believers throughout the world, and while skeptics and scholars tend to view the legend symbolically, none has ever succeeded in identifying what the concept represents. It is the oldest, most widely dispersed, and most mysterious religious idea known to mankind.

In variants of the legend, the tree was pictured as a tall mountain that reached up to heaven. It could also be conceived as a massive god, like Atlas, who held up the sky. The place where this great tree, mountain, or god was believed to stand was at the axis—or navel—of the earth, the center point around which all the heavenly bodies appear to revolve. Scholars have searched for this lost Paradise without success. Various theories have placed it in Palestine, Africa, Arabia, or even at the North Pole, but none of these is convincing. No one has yet located four rivers that diverge from a single point or that match the other common characteristics of the story. In its many local variants, details were changed to reflect familiar geography. The names of the four rivers, for example, invariably correspond to those well-known in the surrounding region. But the basic structure

of the original legend has shown a remarkable consistency for at least five thousand years.

Archaeologists excavating ruins throughout the Middle East have found innumerable artifacts bearing images of the Tree of Life. When Heinrich Schliemann discovered the lost city of Troy in the 1870's he identified the many treelike decorations on ceramic objects as further examples of this ancient icon. But because scholars have never succeeded in decoding the Trojan symbols, no one knows if Schliemann was correct in this belief. Along with trees, he found other recurring symbols: human-like figures with upraised arms, ladders, stags, and swastikas. Unlike Egyptian hieroglyphics, the Trojan symbols do not form an alphabet that can be translated into a sequential text. Scholars tend to regard them as religious symbols representing unknown objects of devotion. The most enigmatic of all these is the swastika. Despite many attempts to explain its meaning, no convincing interpretation has yet been offered. It has been called a symbol of the sun, the earth, fertility, water, or the motion of the stars. Lord Baden-Powell ventured the theory that the swastika represented the four primordial rivers of Paradise. They flowed from a mountain on the lost island of Atlantis, he said, and the swastika is merely a map of those rivers with Atlantis at the center.

Such theories have been dismissed as fanciful. Atlantis was supposedly an island in the Atlantic Ocean somewhere west of Gibraltar. Its name means "of Atlas," and this refers to a legend, told by Plato, where Atlas and his children were kings of the island. This follows a long tradition of older myths that describe other islands in the same location, also ruled by Atlas or his offspring. His daughters, together with a serpent, guard trees bearing golden apples of the gods. But if four rivers shared a common source at that location, neither they, nor the island itself, have ever been found. The meaning and location of the Tree of Life remain an unsolved mystery.

Symbols from Troy

The city of Troy guarded the entrance to the Black Sea from the Eastern Mediterranean. Its location at this strategic point made it powerful and wealthy, but these qualities also made it a target for attack by jealous rivals. The Trojan War of Homer's *Iliad* describes one of the many battles fought there. In all, nine cities were built one on top of the other, each beginning again after destruction of the old by war, earthquake, or fire.

The books of Homer were held sacred in antiquity, much as the Old Testament is to Christians, or the Vedas are to modern Hindus. Like the Old Testament, Homer's books combine theology, standards of ethical conduct, and episodes in the early

history of the race. By the classical periods of Greece and Rome, Homer was considered an authority on all aspects of religious and social life.

But by the nineteenth century, Homer's bright light had dimmed. Scholars began to doubt the historical basis of the events portrayed in the *Iliad*; many insisted that Troy had never even existed outside of Homer's mind. After all, no site had been clearly identified as the former location of that great city, nor were the events celebrated by Homer corroborated by other historical or archaeological accounts.

All this changed in the early 1870's after Heinrich Schliemann began excavations on the hill of Hissarlik in Northwest Turkey. A German businessman who had made his fortune in the indigo trade of Venezuela and in the California gold rush, Schliemann was determined to find the lost city of Troy. Sifting and evaluating conflicting evidence, he made trial excavations at various sites. Upon his determination that Hissarlik was the most likely location of the ancient city, he committed a considerable part of his personal fortune to the project.[1]

Schliemann proved that Troy was more than a literary fiction. The golden treasure he found there dazzled the world and proved that an advanced civilization had flourished in the Mediterranean at a time previously thought to be crude and primitive. Homer's poem was finally recognized as an accurate portrayal of the life and customs of an authentic culture that we now call the Bronze Age.

Unlike later discoveries on Crete and on mainland Greece, no clay tablets with written records were found at Troy. Regrettably, we know very little about the history, language, or religious beliefs of these people who figured so prominently in the ancient world. Although the city was inhabited almost continuously for five thousand years, strategically placed at the juncture of Europe and Asia, we are woefully ignorant of the rich culture that must have existed there during its periods of ascendancy.

Schliemann did find, however, a large number of ceramic objects bearing mysterious signs and symbols. They appear mainly on spindle whorls used for spinning raw wool into thread for weaving (Figure 1.1). Most are flattened disks with a hole at the center for a wooden distaff. Animals, trees, human forms, curved line-segments, swastikas, ladders, zigzag meandering lines, and curious comb-like figures are among the many decorative elements repeatedly inscribed in the clay. What these symbols mean individually, how they relate to each

Figure 1.1 Navajo woman with spindle. Rotating the spindle twists the wool into yarn, which is then wound around the distaff. The spindle whorl acts as a flywheel, increasing circular momentum. This technology has been found in cultures all over the world.

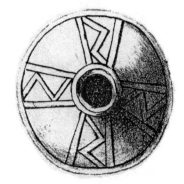

Figure 1.2 A Trojan spindle whorl. Four rivers flow into the cardinal directions.

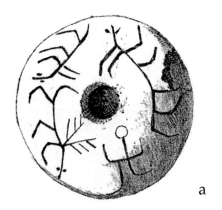

a

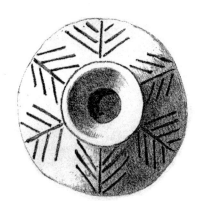

b

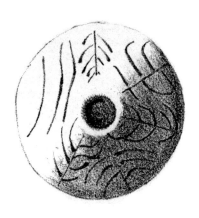

c

Figure 1.3 Trojan spindle whorls: (a) Stags and figure with upraised arms; (b, c) Trees of Life.

other collectively, or why they were used so often on spindle whorls, no one knows (Figures 1.2 – 1.6 and Appendix 2).

Similar designs appear on spindle whorls and pottery in a nearby but much older civilization that was centered in the Balkans and Romania.[2] Artifacts found there provide evidence that the origin of these symbols is highly archaic; some have been dated to the fifth and sixth millennia BC. Strikingly similar patterns can also be seen on the oldest examples of Greek pottery dating from the geometric style of the tenth to seventh centuries BC. The swastika symbol in particular, while often found at Troy and in Southeast Europe, is abundantly seen on the Greek artifacts of this period. But, not surprisingly, the meaning of these symbols in their Greek context is no more understood than those found on the objects at Troy.[3]

Attempts by scholars to unravel the secrets of the Trojan spindle whorls have been disappointing. Schliemann's beliefs about the various symbols, while plausible on an individual basis, lack any unifying coherence.[4] Attempts by later scholars fail on similar grounds, with theories varying widely. In 1995, a comprehensive investigation and reevaluation of the spindle whorls and their decorative symbols proved inconclusive. With regard to the swastika in particular, this study stated that research up to the present time does not allow for any definite interpretation. It calls for wider detailed investigations of bronze age artifacts and further discussions among scholars.[5]

No other ancient symbol has been the object of so much speculation, some of it reasoned, some not. Because none of the countless theories about the origin of the swastika has gained acceptance, even after centuries of attempts, researchers tend to shy away from the subject. This tendency is compounded by the modern use of the symbol as an emblem of Nazi Germany, and its association with the innumerable evils committed by that regime. But the extensive use of the swastika in pre-Columbian America, primarily in the regions of the Mississippi and Amazon rivers, has amazed and puzzled commentators, who concede that the symbol is too complex to have arisen independently in both hemispheres. But how it got from Eurasia—or Africa—to America in prehistoric times is a complete mystery.[6]

The wide range of scholarly opinions about the meaning of the swastika in antiquity parallels the lack of agreement about the other Trojan symbols. The following excerpts illustrate the diversity of these viewpoints:

SWASTIKA, a decorative and symbolic ornament…The swastika is one of the most ancient and widespread of all ornamental forms, appearing in both hemispheres. It is generally interpreted as a sun symbol.

Encyclopedia Britannica

Tree of Life, Mythical Archetype

But, while from these indications we are justified in supposing that among the Aryan nations the Svastika may have been an old emblem of the sun, there are other indications to show that in other parts of the world the same or a similar emblem was used to indicate the earth.

Müller, in Illios

[These] various writers … all agree that it is a mystic symbol, peculiar to some deity or other, bearing a special signification, and generally believed to have some connection with one of the elements—water.

Waring, Ceramic Art in Remote Ages

It represents the two pieces of wood … the violent rotation of which, by whipping (after the fashion of top-whipping), produced fire, as did Prometheus.

Burnouf, Des Sciences et Religion

Dr. H. Colley March, in his learned paper on "The Fylfot and the Futhorc Tir," thinks the swastika had no relation to fire or fire making or the fire god. His theory is that it represented the celestial pole, the axis of the heavens around which revolve the stars of the firmament.

*Wilson, Swastika, the Earliest Known
Symbol and Its Migrations*

The fact that [the swastika] is drawn within the vulva of the leaden image of the Asiatic goddess seems to show that it was the symbol of generation.

Sayce, in Illios

Used everywhere as an auspicious sign, the svastika is meant to remind man that the Supreme Reality is not within the reach of the human mind, nor within man's control.

Danielou, The Myths and Gods of India

American Indians of the pre-Columbian period used this cross … as a symbol of the four directions, which were important in Indian ritual.

*Funk and Wagnall's Standard Dictionary
of Folklore, Mythology and Legend*

Some people … affirm that there was once a great continent where now there is the Atlantic Ocean, but it went under the sea in an earthquake. This continent was called Atlantis,

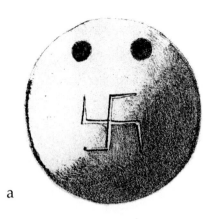

a

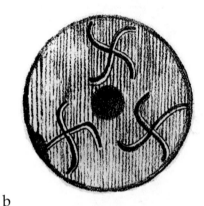

b

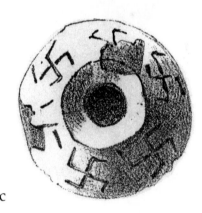

c

Figure 1.4 (a) Trojan loom weight with vertex of swastika centered on axis; (b, c) spindle whorls with swastikas.

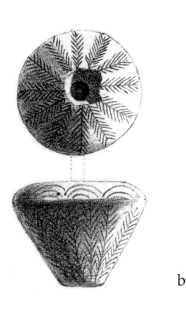

Figure 1.5 Trojan spindle whorls: (a) Ogee (curved) swastika; (b) Trees of Life on a volcano-shaped whorl.

a

b

and joined up Europe with America. It was supposed to have four vast rivers running from a central mountain in different directions—North, East, South, and West—and the Swastika is merely a map of Atlantis showing those four rivers rising from the same center.

Baden-Powell, What Scouts Can Do

What seems to have been at all times an attribute of the Swastika is its character as a charm or amulet, as a sign of benediction, blessing, long life, good fortune, good luck.

Wilson, Swastika, the Earliest Known Symbol and Its Migrations [7]

Schliemann accepted the opinion of Émile Burnouf, quoted above, that the swastika was a symbol representing the instrument used by ancient Aryans to kindle fire.[8] But if this view is correct, it is not at all clear how such a concept functions in context with the other symbols.

Another of Schliemann's suggestions is of more particular interest. He believed that the frequent occurrence of tree symbols on the Trojan spindle whorls was intended to represented the archaic Tree of Life so commonly found on artifacts in the Near East. The concept of a World Tree was central to Sumerian, Babylonian, and Assyrian religion and was inherited from them by the Hebrews, who preserved a variant of the story in the book of Genesis (Figures 1.7 – 1.21).

Schliemann's belief about the Tree of Life and its occurrence on the Trojan spindle whorls has not received the consideration it deserves, but this is not surprising. A mere conjecture about one symbol out of many found at Troy, lacking any verification from internal evidence, was bound to be seen as speculative. But what Schliemann appears to have overlooked is that many of the other symbols found on the Trojan spindle whorls point back to the same ancient story about the Tree of Life. This observation gains credibility once the details of that story are fully investigated. The Tree of Life played a pervasive role in ancient religion, and although anthropologists have documented its occurrence in widely divergent locations, its symbolic significance is still not understood.

The Tree of Life in the Ancient World

The sacred Tree of Life is best known from the account of Paradise given in the Hebrew Bible. There the tree is planted in the middle of the garden, bearing fruits of immortality. Nearby one great river divides into four streams. The first human progenitors live in this garden, where the woman is born from the side of the man. These two encounter and converse with God

in Eden, but the garden is also the dwelling-place of an evil serpent.

The story finds parallels in Babylonian and Assyrian legends of the hero Gilgamesh who travels to the source of all rivers where he sees a tree bearing fruits which are alluring to the eye. He is given a plant of immortality for his trouble, but this is later stolen from him by a serpent.

In Greek myth, the hero Hercules steals golden apples from the trees of the gods, killing a guardian serpent in the process. In his travels he visits a number of rivers, among which are the Nile and the mythical Eridanus. Jason and the Argonauts enact a similar theme. Against divine orders, Jason and Medea steal a golden object from a tree guarded by a serpent. Nearby four streams run in different directions. In their escape, they also visit the Nile and the Eridanus rivers.

In the legends of ancient Scandinavia, the Tree of Life is called Yggdrasill. It stands at the center of the world and connects the earth with heaven and the underworld. At its heights grow the apples of immortality, guarded by the goddess Idunn. At its base lives a serpent so huge that its body completely surrounds the world, with its tail reaching back again to its head. Five stags live in the branches of Yggdrasill. From the antlers of one of them, dew drops fall down the tree in such quantity that they fill all the rivers of the world.

In Hindu myths, the tree is sometimes replaced by a pillar or by a great mountain. A celestial river flows down from heaven, and at the mountain, parts into four earthly streams, each flowing into one of the four cardinal directions. When the mountain was spun, using an enormous serpent as a bow, a drink of immortality was created.

In many cases this tree, pillar, or mountain takes on anthropomorphic attributes. Instead of a tree with branches reaching up into heaven, the legends describe a god or goddess (often depicted with upraised arms) supporting the heavenly spheres. The Greek titan Atlas is an example of this motif, and here he is also associated with the Tree of Life, for he stands on the same island where the trees of the gods bear their golden apples.

Examples without end could be listed, and many of them will be described in much greater detail in the following chapters. Here it is sufficient to say that the Tree of Life, in each of its several forms, can be identified by a series of unmistakable characteristics. These tell-tale markers are like the fingerprints or genetic code of the myth. They serve to identify it, even when its main elements have become lost or transformed. Sometimes the story has metamorphosed so completely that, on the surface, it bears little resemblance to the original, but these markers provide the clues necessary to trace the later myths back to their source.

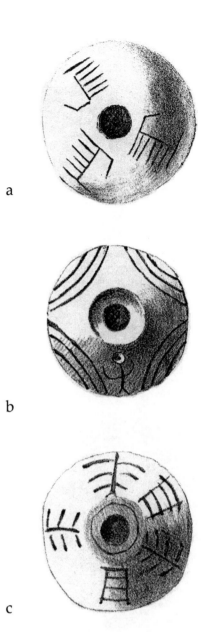

a

b

c

Figure 1.6 Trojan spindle whorls: (a) comb-like figures believed by Schliemann to represent flaming altars; (b) parallel semicircles believed by Schliemann to represent rising suns. A figure with upraised arms stands near the center; (c) Trees of Life with ladders.

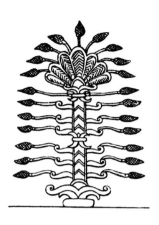

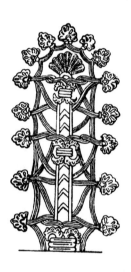

Because the legends often place the Tree of Life at the center (or navel) of the world, some commentators have favored a psychological interpretation. According to this line of thought, the myth expresses the primitive need to see the individual ego at the center of his universe near a bridge to heaven, and in proximity to the gods. This explanation has been used to account for the otherwise unexplainable occurrence of the myth in widely divergent areas of the world. From Siberia to Malaysia, from Alaska to Guatemala, in Northern Europe and Central Asia, the same story occurs. A magic tree or mountain stands at the navel of the world and provides a passageway from earth to heaven, or down into the underworld. The psychologist Jung and his followers have suggested that the myth was transmitted through the agency of a collective unconscious mind shared by all human beings.[9]

While such ideas undoubtedly appeal to a frame of mind attuned to mysticism and the occult, many researchers prefer to base their conclusions on rational chains of causality. But lacking viable alternative explanations, rationalist investigators must either adjust their thinking, or else find a plausible model that would account for the wide distribution of the myth in the remotest periods of prehistory.

But so far all attempts to find a geographical location for the ancient Tree of Life have failed. The Bible describes it as located at the source of four rivers; but the rivers named there do not share a common source and never have. Hindu legends likewise name four rivers in India, and in Chinese legends, the rivers named are all located in China. Obviously, local names cannot be trusted in a search for the original source of the legend. The Bible provides an additional clue. One of the rivers was said to encompass the land of Havilah, but scholars have never been able to locate Havilah, and many consider it to be a purely mythical place.

Figure 1.7 Trees of Life from Assyrian Bas Reliefs.

Background and Methodology

The significance of the Tree of Life myth remains mysterious and elusive. Part of the reason for this may be because modern commentators have tended to look for it in the fuzzy territory of psychological space. But in most human experience, ideas require a physical transmission, either oral or written, in order to reappear at times and locations remote from their source. Normally an advance in technology occurs at one place and then spreads by diffusion to the rest of the world. The same process typically occurs in the case of songs, stories, scientific discoveries, and other intangible products of a psychic rather than material substance. One would expect myth to follow similar channels.[10]

Tree of Life, Mythical Archetype

It may be that our failure to understand how the myth spread so widely in antiquity is merely the result of a lack of evidence for the process of diffusion. Schliemann's discoveries at Troy required serious revisions of the previously accepted model of early Mediterranean history, and it may be that further revision is called for in our historical conceptions of the millennia preceding the Bronze Age.

This book will take the point of view that the original referent for the Tree of Life can be found outwardly in the physical world. It will propose a fairly simple model for the ancient conception of a tree at the navel of the world located at the confluence of four great rivers. This model was developed out of the author's insight about the significance of the swastika as a decorative symbol on the Trojan spindle whorls. When investigations into the meaning of the swastika led him back to the Tree of Life mythology, Schliemann's conjecture about the tree symbols on the spindle whorls took on a more serious significance.

This correspondence suggested a methodology that was subsequently followed with respect to the other Trojan symbols. The ladder, for example, which appears on a number of the whorls, was found to appear in contexts remarkably congruent with other aspects of the mythology, where the Tree of Life was often described as a ladder leading from the earth up to heaven. The stag, often pictured on the Trojan spindle whorls in close proximity to clusters of dots, suggested the stags in Norse myth which live at the top of Yggdrasill. From their antlers fall dew drops which fill all the rivers of the world. Following this thread, it was further discovered that the stag plays a prominent role in world myth, frequently appearing in contexts associated with the Tree of Life or the swastika. The anthropomorphic figure with upraised arms, also found on the Trojan artifacts, corresponds to a genre of Atlas-like representations. These occur in many parts of the world in association with other symbols that together form the core of the Tree of Life myth.

Pursuing this method leads to three consequences. The first is that the definition of the myth itself becomes sharper in its outlines. The Tree of Life legend is a composite formed from many individual elements: tree, rivers, serpent, flaming sword, progenitor who gives birth from his side, fruits of immortality, and so on. The recurrence of these elements together in the creation stories of widely separated cultures allows for a reconstruction of what must have been the original prototype of the story. Based on key elements which the many variants share, it is possible to separate the essence of the myth from the numerous extraneous features that have crept into it over millennia in each locality.

The second result follows from the first. Those features of the myth that do not vary in the numerous retellings—from Siberia to Europe to America—reveal enough detail to identify

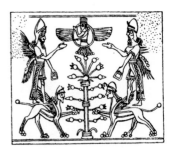

Figure 1.8 Trees of Life from Assyrian Bas Reliefs. The winged disk, in axial alignment with the tree, is typical.

Figure 1.9 Trojan spindle whorl depicting Trees of Life.

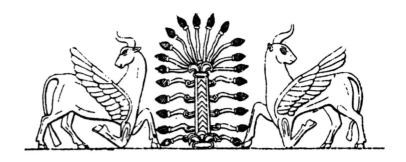

Figure 1.10 Tree of Life with winged griffins on a Bas Relief from Nineveh.

what the Tree of Life signified to ancient people. Familiarity with these essential elements leads to the observation that the myth refers to a real and tangible natural phenomenon that was observable and held sacred throughout the world. This identification is confirmed by the close agreement between the common attributes described in the myths and the characteristics of the physical object to which they refer.

The third consequence results from the first two. Once the natural referent of the Tree of Life is identified, the interpretation of a large number of formerly obscure myths then becomes possible. Narrative details that at first seem merely incidental can be understood as attributes of this natural referent. This makes it possible to identify those myths as stemming from the same archaic original. Clarity about the common mythical characteristics of the Tree of Life on the one hand, and recognition of its natural referent on the other, leads to a generalization of fifteen recurring patterns that together constitute the unique signature of the myth.

Tree of Life at the Confluence of Four Rivers

The insight concerning the meaning of the swastika is the simple observation that the four largest rivers, on the four continents bordering the Atlantic Ocean, stand in relation to each other as do the outer arms of a giant swastika. These four

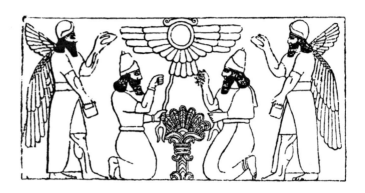

Figure 1.11 Tree of Life on Assyrian Bas Relief from Nineveh.

rivers, the Amazon, the Mississippi, the Baltic, and the Nile—with their extensions along the connecting river Ocean, as the ancients called it—form a perfect swastika. The vertex of this swastika falls at the classical location of an island, said in Greek myth to belong to the titan Atlas and his daughters. This island was sometimes described as being located at the "navel of the sea." These facts suggest that ancient navigators had discovered the orientation of the Atlantic rivers and derived the swastika symbol from them.

This theory about the origin of the swastika finds confirmation in the legends of Tibet. There the great mountain, which stands next to the sacred tree at the center of the world, is called the Nine-Story Swastika Mountain. That image also conforms to the Atlas legend of Greece where Perseus, out of anger, is said to have transformed Atlas into a mountain which supports the heavens and the stars. Thus the Tree of Life, or its alternate form as a cosmic mountain, is related to the swastika symbol, and both symbols occur together on the spindle whorls of Troy.

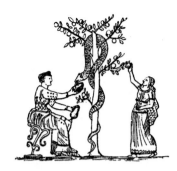

Figure 1.12 Tree of Life, the serpent Ladon, and the Hesperides; from the Hellenistic period.

Identification of the natural referent for the Tree of Life was equally simple. A cloud of interstellar dust creates a dark schism—called the "Great Rift" by astronomers—that separates a portion of the Milky Way galaxy into two long branches, giving it the appearance of a radiant tree in the night sky. Star constellations oriented along the length of the galaxy mirror many of the characteristics described in the mythology. The serpent constellation Hydra, for example, reflects the position of the serpent so often described in proximity to the Tree of Life.

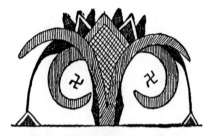

Figure 1.13 Detail of a Cyprian vase depicting the lotus as Tree of Life, with swastikas. Metropolitan Museum of Art, New York

Because the Milky Way appears to pass near both celestial poles, ancient people could believe that this great celestial tree served as the axle of stellar rotation, that it was located at the very hub or nave of the universe, the center-point around which the sun, moon, and all the stars appear to revolve. The galaxy also appears to intersect the earth at the horizon, but the exact point of this intersection is ambiguous. It moves in relation to the observer rather like the end of a rainbow, always receding. We can conclude from the evidence presented in the following chapters that early observers believed that this elusive point of intersection occurred at the center of the known world, where the four principal rivers, tributary to the Atlantic Ocean, could be said to intersect. Thus the axis point of the four rivers corresponded to the axis of the greater universe. Together they formed one great earthly and cosmic alignment.

Figure 1.14 Trees of Life from Chaldaea, ca. 4000 BC.

Mayan legends explicitly associate the galaxy with a cosmic tree located at the center of the world. It provided a path for the souls of the dead to follow in order to reach heaven. This is one of the few traditions where the galaxy is openly acknowledged as the Tree of Life; in most, the identity of the sacred tree is a carefully guarded religious secret, not to be divulged to anyone outside the priesthood. But a cosmology, similar in this respect

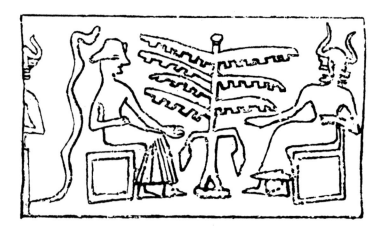

Figure 1.15 Tree of Life, serpent, and two figures; from a Chaldean cylinder.

Figure 1.16 Eagle-headed divinity sprinkling water on the Tree of Life; from Nimroud, Louvre, Paris.

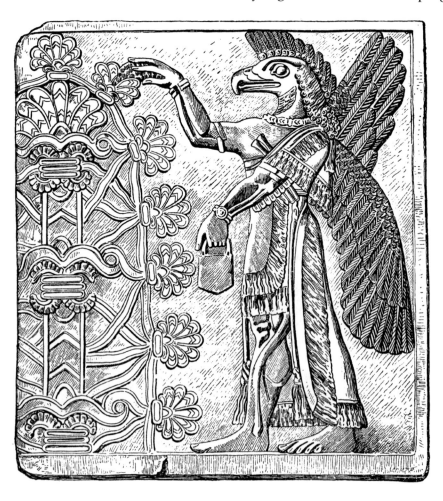

to the one held by the Maya, was prevalent all over the world in antiquity. The evidence will demonstrate that both the Eurasian and the pre-Columbian American versions were ultimately derived from a single common source.

A large number of derivative myths reflect the underlying structure of the Tree of Life motif, where the tree is replaced by a goddess, a titan, or a progenitor god. Therefore, knowledge about the location and the identity of the Tree of Life provides a powerful key for the understanding of world mythology. Numerous myths will be examined in detail in the following chapters, illustrating their conformance to this archetype. The patterns that emerge from this investigation can then be used to decode the symbols in a wide variety of other contexts.

On this basis, we will be able to confirm that the symbols on the Trojan spindle whorls reflect the primary elements of the Tree of Life myth, thus providing—for the first time—a coherent interpretation of their meaning. The evidence suggests that these symbols shared a cohesive objective as votive representations. An ancient cult that venerated the Tree of Life, well-known to have

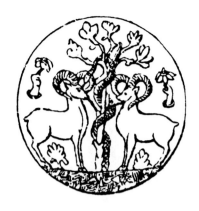

Figure 1.17 Tree of Life, serpent, and two rams; from a Sassanian bowl.

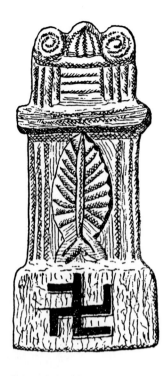

Figure 1.18 Stone altar with swastika and Tree of Life on pedestal; France, Museum of Toulouse.

existed in antiquity, must also have existed at Troy. The use of these symbols on spindle whorls can be seen as consistent with the ancient conception of the Tree of Life located at the central axis of the rotating cosmos—a conception paralleled in miniature by the rotating spindles.

Finally, these patterns will be applied to two mythical traditions that persisted right through the middle ages and into the seventeenth and eighteenth centuries. Because the basic archetypes in these traditions have been so thoroughly transformed—out of a desire for secrecy—the symbols employed there have eluded any successful attempt at interpretation. But, using the tools developed here, it will be seen that these later quest legends are merely variants of the ancient quest for the Tree of Life.

The following chapter provides a first-person account of the discovery that revealed the identification of the four Atlantic rivers with the four rivers of Paradise. The orientation of these rivers in the form of a swastika matches ancient representations of the swastika on artifacts found in the Mediterranean and Baltic regions. This evidence, derived from archaeology, strengthens the case for the interpretation of the swastika as a river symbol, and for its later use as a symbol of the tree believed to stand at the axis of the world.

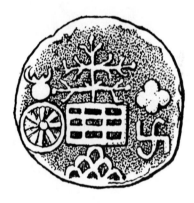

Figure 1.19 Tree of Life with swastika. From an Indian coin, ca. 330 BC. The beehive shaped mountain at the base is a typical representation of the omphalos.

Figure 1.20 Tree of Life; from the palace at Sennacherib.

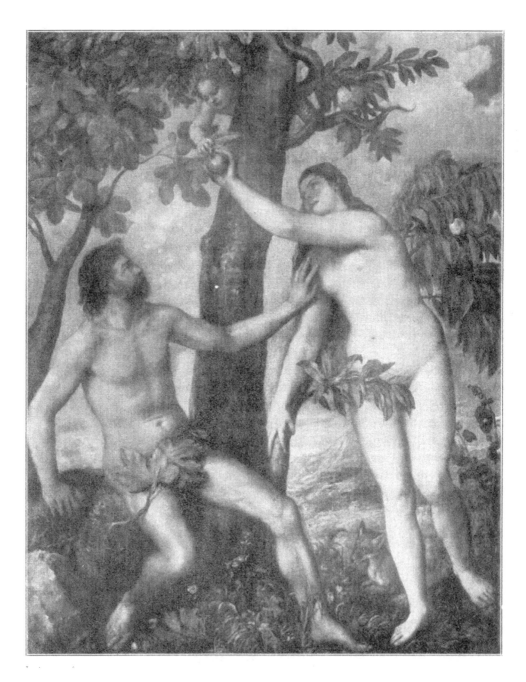

Figure 1.21 Adam and Eve in Paradise; Titian, Prado Museum

Tree of Life, Mythical Archetype

Chapter 2

Prologue: The Rivers of Paradise

In the legends of the Hopi Indians, Másaw, their guardian spirit, instructed them to embark upon a series of migrations, following their emergence in the wake of a great flood. They were to journey to the edge of the American continents in each of the four cardinal directions: north, east, south and west. When they reached the sea (or the ice pack in the northern Arctic), they were to turn right and continue traveling for a certain distance. Then they were to retrace their steps back to the center and start all over again in another direction, until they had traversed the length and breadth of the Americas in the form of a great swastika (Figure 2.1). Only after completing this migration in all four directions were they allowed to settle into their permanent home at what they considered to be the center of the universe—their ancestral homeland in the Southwestern United States. The Hopis had carved the swastika, among other symbols, on rocks along the path of these migrations, and remnants of these petroglyphs can still be found throughout North America.[1]

I first encountered this Hopi migration myth many years ago. I remember brooding over the question of the swastika, of its use by the Hopis as an enormous geographical symbol, laid out upon a surface of the earth as large as two continents, of their use of the swastika as the path of sacred pilgrimage. And then I remember wondering vaguely if the swastika could have

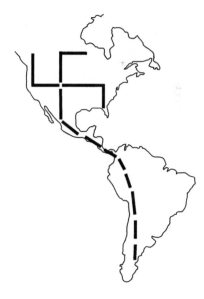

Figure 2.1 Ancient migration route of the Hopi Indians in swastika form, as commanded by their guardian spirit Másaw. (Illustration adapted from Waters, 1963.)

some mythological connection to the four rivers that are said in the Bible to have issued from the one stream flowing out of Paradise:

> And a river went out of Eden to water the garden; and from thence it was parted, and became into four heads. The name of the first is Pison: that is it which compasseth the whole land of Havilah, where there is gold; And the gold of that land is good: there is bdellium and the onyx stone. And the name of the second river is Gihon: the same is it that compasseth the whole land of Ethiopia. And the name of the third river is Hiddekel: that is it which goeth toward the east of Assyria. And the fourth river is Euphrates.[2]

This was a far-fetched idea. The Hiddekel (an ancient name for the Tigris) and Euphrates do not conform in any way to the orientation of a swastika. The Gihon, described as encompassing the land of Ethiopia, was presumably an old name for the Nile, but the Nile has its source in central Africa, far from the source of the Tigris and Euphrates. Consulting an atlas, I scanned the area of eastern Turkey where both of the Mesopotamian rivers originate, looking for other rivers that might form one branch of a swastika, but I found none.

Myth has a way of localizing itself to changed circumstances. Migrating peoples will cling to their ancient stories and find referents for the old mythical features in their new locations. In ancient Greece there were at least fifteen mountains called Mount Olympus, ranging from Asia Minor through Thrace and down into the Peloponnese.[3] Perhaps one or more of the rivers mentioned in Genesis had been similarly localized.

The Nile runs north. If my theory about the swastika were correct, and if the Nile was original to the myth, then I would need to find other major rivers running south, east, and west from the source of the Nile. But I found no such rivers on the map of Africa. Reflecting that the Nile itself has no prominent right angle that would give it a swastika-like shape, I was on the point of abandoning my theory.

It occurred to me then that perhaps I had misunderstood the biblical story. What if the point of confluence of the four rivers was not at the source, but rather at the downstream end, in the great River Ocean, as it was called in ancient times?[4] This would make infinitely more sense anyway, for how could one river split into four? But this possibility raised still other questions. How could Paradise be located in the middle of the ocean? And which ocean was meant—the Mediterranean, the Persian Gulf, the Atlantic...? And what about the fourth river in the Genesis account? Pison it is called there, and it is said to encompass the whole land of Havilah. There is gold, and the gold of the land is good. And there is bdellium and the onyx stone. Where was Havilah, and what in the world was bdellium? As to Havilah,

I found that scholars remain doubtful about its location, with some even questioning its existence:

> As regards the locality of Eden its situation has long been a matter of debate ranging from the Far East to Armenia, Somaliland, Arabia, the Persian Gulf, and even the North Pole! . . . The Hiddekel has frequently been equated with the Tigris, and Perath with the Euphrates, but all attempts to locate the other two have completely failed. The Pishon is said to have encircled the land of Havilah . . . and the Gihon to have encompassed the land of Cush, probably Ethiopia.

> If, however, the Hiddekel and the Perath represent the Tigris and Euphrates these two rivers never had a common source, and Havilah . . . is described as being both in southwest and north-east Arabia. Pison and Gihon have had a variety of identifications none of which has proved to be convincing. Josephus and the Christian Fathers . . . regarded the Pison as the Ganges while Gihon was identified with the Nile by Josephus, and most of the Fathers . . . This, however, presupposed that the Nile and the Euphrates came from the same source. The "land of Havilah" is equally an enigma in spite of repeated attempts to locate it in various parts of Arabia and the Nubian desert.[5]

As I pondered these questions, I began to think about the southward-flowing Mississippi River. It occurred to me that if you were to draw an east-west line from the mouth of the Nile to the mouth of the Mississippi, that line and the two rivers at each end would form one-half of a perfect swastika. Two rivers, each running in a cardinal direction, joined by one great river, which was the Atlantic Ocean—it seemed to fit the description in the Bible as far as it went, and as long as you considered the ocean to be a river, as ancient people did.

As for bdellium, it is a type of myrrh. It was used as incense in ancient times, and it is derived from the sap of trees of the genus Commiphora. Remember the three wise men who followed the star to Bethlehem? Their very costly gifts were gold, frankincense, and myrrh.

One species of Commiphora grows primarily in dry locations of Africa, where much of the local economy is based upon the extraction and export of its sap. Other species are found in parts of western India and Arabia. A similar tree, of the genus Bursera, is found in great abundance in the arid regions of central Brazil. For many years this genus was considered distinct from the African Commiphora, but recent research has demonstrated by DNA testing that the two genera are genetically identical.[6]

And in the land of Havilah, there was onyx stone. Onyx is a translucent agate striped in alternating layers of black and

white. It has been used since ancient times for making cameos (Figure 2.2). The Bible says that God commanded Moses to make special robes for the priests of his temple to wear on holy occasions. Over the shoulders of these robes were to be set onyx stones engraved with the names of the tribes of Israel.[7]

Onyx is found primarily in India and South America.[8] The state of Minas Gerais in central Brazil is the South American source for onyx, which is interesting, since the Commiphora tree is also found in that area. Brazil is also rich in gold. It was discovered at Minas Gerais in 1698, and for the next century Brazil was one of the world's major sources of gold.[9]

I went back to the atlas and bisected the line between the mouths of the Mississippi and the Nile in order to find the midpoint. From there I drew a line running north and south, the two segments together being approximately equal in length to the first bisected line. If my hunch was correct, there would be a major river running west from the southern end of this new line, and another running east from the northern end. I found that the Amazon River fit the pattern exactly (Figure 2.3). Could the river Pison be the Amazon, and could the land of Havilah be Brazil?

Havilah is a Hebrew word derived from a root meaning "whirling."[11] Its use in the Bible as the name for a region of uncertain location—or for conflicting locations—has led some authorities to suggest that its origins may be purely mythical. In searching for the fourth river of the swastika, I found that the Greeks also used the adjective whirling to describe certain mythical rivers of uncertain location. Hesiod, writing in the middle of the ninth century BC, says:

> And then she [Earth] lay with Heaven, and bore deep-whirling Oceanus.[12]

Hesiod goes on to describe how Oceanus (the river Ocean) married Tethys, his sister. Referring to this marriage in his Dionysiaca, the fifth-century writer Nonnos also mentions a mysterious turning (whirling) point:

> Loud-booming Okeanos, girdled with the circle of the sky, who leads his water earth-encompassing round the turning point which he bathes, was joined in primeval wedlock with Tethys.[13]

We encounter the notion of whirling rivers once again in Hesiod when he describes the children of Oceanus and Tethys:

> Tethys bore whirling Rivers to her mate
> Ocean: the Nile, Alpheios and the deep
> Eddying Eridanus, Strymon ...[14]

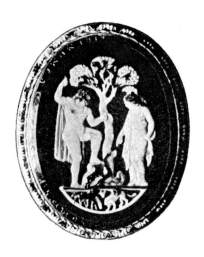

Figure 2.2 An onyx cameo showing Athena and Poseidon at the sacred olive tree. A serpent rises up from below, and the tree bears a cleft in its side; from the National Library, Paris.

Tree of Life, Mythical Archetype

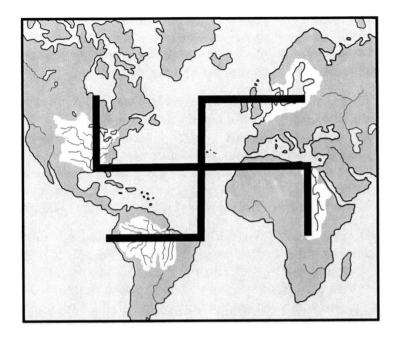

Figure 2.3 Swastika orientation of the four largest rivers of the four continents bordering the Atlantic Ocean. Outer arms correspond with the Nile, Amazon, Mississippi, and Baltic. The Azores Islands lie just north of the swastika's vertex.

These lines occur within a longer passage describing the many river children of the gods Tethys and Oceanus. A long list of other rivers follows, but I treat these first four as a distinct group because they figure more prominently than any others in Greek myth.

The river Eridanus is particularly interesting. The myth tells us that Phaethon begged his father, the sun god Helios, for a chance to drive the chariot of the sun across the sky. But he was unable to control the spirited horses, and the blazing sun was brought too near the surface of the earth, threatening to burn up all living things. In a desperate attempt to save the earth, Zeus blasted Phaethon with a bolt of lightning, and he fell down into the river Eridanus. His sisters, daughters of the sun, were turned into poplar trees along its banks, and they wept tears of amber over their lost brother.[15]

Notice in the passage from Ovid, cited below, how the Eridanus is described. Its waters are "wide," and it is located "half a world away":

Phaethon, flames ravaging his auburn hair, falls headlong down, a streaming trail of light, as sometimes through the cloudless vault of night a star, though never falling, seems to fall. Eridanus receives him, far from home, in his wide waters half a world away and bathes his burning face. The Naides Hesperiae bury his smoldering body in a tomb and on a stone engrave his epitaph: "Here Phaethon lies, his father's charioteer; great was his fall, yet did he greatly dare."[16]

In the following passage from Hesiod's Catalogues of Women, note that the Eridanus is "deep-flowing" and "of amber," and that it is associated with the realm of the Hyperboreans, inhabitants of the northernmost part of Europe:

> Round about all these [the Sons of Boreas] sped in darting flight . . . of the well-horsed Hyperboreans—whom Earth the all-nourishing bare far off by the tumbling streams of deep-flowing Eridanus . . . of amber, feeding her wide-scattered offspring—and about the steep Fawn mountain and rugged Etna to the isle Ortygia and the people sprung from Laestrygon who was the son of wide-reigning Poseidon.[17]

Despite the confused addition of Etna, Hesiod's mention of Laestrygon offers further proof that the Eridanus is located in the northernmost part of Europe. We know this from Homer; after drifting for six days and nights, Odysseus and his men finally arrive at the "Laistrygonian height." In the high northern latitudes the sun never completely sets in summer. Based on Homer's description, it appears that Odysseus moored for the night inside a Scandinavian fjord (Figure 2.4):

> He drove me from the place, groan as I would, and comfortless we went again to sea ... six indistinguishable nights and days before we raised the Laistrygonian height and far stronghold of Lamos. In that land the daybreak follows dusk, and so the shepherd homing calls to the cowherd setting out; and he who never slept could earn two wages, tending oxen, pasturing silvery flocks, where the low night path of the sun is near the sun's path by day. Here, then, we found a curious bay with mountain walls of stone to left and right, and reaching far inland, a narrow entrance opening from the sea where cliffs converged as though to touch and close. All of my squadron sheltered here, inside the cavern of this bay.[18]

The Roman historian Tacitus, writing at the end of the first century AD, says that Odysseus was believed to have found his way into the Northern Ocean (the Baltic) and to have founded a town on the banks of the river Rhine:

> They even say that an altar dedicated to Ulysses [Odysseus], with the addition of the name of his father, Laertes, was formerly discovered on this same spot, and that certain monuments and tombs, with Greek inscriptions, still exist on the borders of Germany and Rhaetia.[19]

The Greek mythographer Pausanias spent several decades in the second century AD traveling around Greece, documenting its many religious sites and the legends concerning them.

He described the Eridanus as being located in the "remotest" (that is, the most northerly) part of Europe:

> These Gauls inhabit the most remote portion of Europe, near a great sea which is not navigable to its extremities, and possesses ebb and flow, and creatures quite unlike those of other seas. Through their country flows the river Eridanus, on the bank of which the daughters of Helius (Sun) are supposed to lament the fate that befell their brother Phaethon. It was late that the name "Gauls" came into vogue; for anciently they were called Celts, both amongst themselves and by others.[20]

Legend held that the Eridanus had islands at its mouth from which amber was gathered, but Strabo called this a myth, claiming that the Eridanus existed nowhere on earth. Herodotus, while acknowledging that amber comes from the ends of the earth, says:

Figure 2.4 A Scandinavian fjord.

> For I do not allow that there is any river, to which the barbarians give the name of Eridanus, emptying itself into the northern sea, whence (as the tale goes) amber is procured. [21]

Later authors believed that the Eridanus was identical with the river Po in northern Italy, but since no islands exist at the mouth of the Po, they found other alternatives near the Adriatic Sea. But even today, the most productive amber district in the world is the region around the Baltic Sea. The Baltic is the world's only source of "true amber," an extremely valuable commodity in ancient times.[22] There were overland routes by which the amber was carried south across Europe and sold in the cities of the Black Sea and the Mediterranean. Tacitus tells us that the Germans are "the only people who gather amber."[23]

These references should be enough to establish that the river Eridanus of antiquity can be nothing other than the modern Baltic. Its associations by various ancient authors with amber, Hyperboreans,

the midnight sun, the land of the Celts, and the characteristics of being both wide and deep with islands at its mouth, taken together leave very little doubt. The later identification of the river Eridanus with the Po is an example of the localization process that I referred to earlier. Ovid's description of the Eridanus as "half a world away" can hardly be applied to the Italian River Po.[24]

The passages from ancient authors cited above show that detailed geographical information about the Baltic-Eridanus must once have been widespread, but that this information had been lost by the time of the classical period. Old references to the river Eridanus had become unintelligible, assumptions had been made about its identity in the legends, and gradually substitutions became standardized. A similar process may have occurred with respect to the Tigris and Euphrates rivers in the Genesis account.

Just as the river Eridanus was localized to the Po, so two other river names of the first four mentioned by Hesiod have been applied to familiar Greek topography. But the fact that each of these rivers seems to be a magnet for additional legendary treatment is a strong indication that the localizing process may have been operative there as well.

The Alpheios, for example, was said to travel uncontaminated through the sea from mainland Greece to the fountain of Arethusa near Syracuse in Sicily, where it spouted fresh and pure.[25] The link between Arethusa and the river Alpheus is significant because Arethusa is also the name of one of the Hesperides, the daughters of Atlas who guard the trees that bear the golden apples, said to be located on an island somewhere in the Atlantic Ocean. As we have seen, the garden of the Hesperides, with its trees, alluring fruits, and guardian serpent, is a variant of the Tree of Life legend closely paralleling the biblical account. The Sicilian fountain near Syracuse appears to be a localization of the original fountain of Arethusa. Pausanias records an oracle from Apollo at Delphi that is believed by scholars to date from the time of Homer and Hesiod:

> Somewhere in the misty field of the sea
> Where Ortygia lies by Thrinakia
> Alpheios' bubbling mouth intermingles
> With Arethousa's streaming water-springs.[26]

The Greek word thrinax actually means "trident," so Thrinakia would be the "land of the trident." Because of its resemblance to the word trinakria, which means "three cornered," used by the Greeks as an old name for the triangular-shaped island of Sicily, the spring of Arethusa was in later times identified with the one near Syracuse. But we know from Homer that Thrinakia was the land where the sun god pastured his cattle,[27] and we know from Apollodorus that it was identical

with Erythea,[28] which, Hesiod tells us, was located "out beyond glorious Ocean":

> Three-headed Geryones . . . mighty Heracles slew in sea-girt Erythea by his shambling oxen on that day when he drove the wide-browed oxen to holy Tiryns, and had crossed the ford of Ocean and killed Orthus and Eurytion the herdsman in the dim stead out beyond glorious Ocean.[29]

The fourth river mentioned by Hesiod, the Strymon, also figures in this legend. It hinders Hercules in his passing with the cattle that he steals from the sun god (or some say the giant Geryon) in the land of Erythea. Hesiod's first four whirling rivers, children of Oceanus and Tethys, seem to form a mythic unit: the Nile, the Baltic, and two other rivers localized to Greece, but with mysterious ties to the Atlantic Ocean.

As illustrated in Figure 2.3, four continents border the Atlantic Ocean, and the largest river of each continent stands in relation to the others as do the outer arms of an immense swastika. Each is linked by the waters of the great River Ocean, as it was called in ancient times. The fourth arm of this great swastika aligns squarely with the Baltic Sea, the ancient river Eridanus "wide and deep."

Archaeological Evidence

In addition to these mythological accounts, archaeological evidence links the swastika symbol with rivers. A bronze pin from Bavaria, for example, makes the connection explicit (Figure 2.5). Parallel to each outer arm of the swastika is the unmistakable depiction of a meandering river.

A circular ornament of silver and gold, taken from a grave mound in Norway, dates from the fifth century BC. It bears a curving, or ogee, swastika formed by two parallel lines of connected semicircles (Figure 2.6). Like the pin from Bavaria, this ornament suggests the underlying meaning of the swastika: A river symbol runs down the center of each arm.

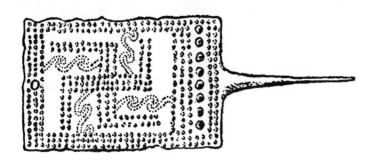

Figure 2.5 Bronze pin from Bavaria with rivers paralleling outer arms of swastika.

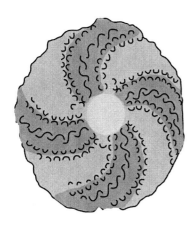

Figure 2.6 Ornament of gold and silver from a grave mound in Norway, fifth century BC. River meanders run through each arm of the curving (ogee) swastika. After an artifact in the collection of the Universitets Oldsaksamling, Oslo.

A fragment of a bronze ceinture from the Caucasus is decorated with three swastikas (Figure 2.7). In two of these, meandering rivers are depicted running through each of the swastika's four arms, and crossing at the center.

Additional objects that explicitly associate the swastika with rivers have been found in Greece. Figure 2.8 illustrates decorations on three bow fibulae from Thisbe in the Peloponnese dating from the eighth century BC. In Figure 2.8a, wave patterns are aligned parallel to each arm of the swastika as in the pin from Bavaria. To emphasize this meaning, fish and water bird symbols are placed immediately outside the swastika form. In Figure 2.8b, a zigzag meander pattern runs down the center of each arm of the swastika, with a water bird and a snake as borders. In Figure 2.8c, wave patterns again parallel each arm of the swastika with fish and water birds on all sides.

These artifacts linking the swastika to rivers, coupled with the mysterious parallel between the swastika and the rivers tributary to the Atlantic Ocean, form a consistent pattern. The explicit association of the swastika symbol with the great migration path of the Hopi Indians documents its use in antiquity as a geographical symbol. Hesiod's poem closely associates the Nile and the Eridanus among the "whirling rivers," and this is consistent with the nature of the swastika symbol, which clearly depicts whirling or axial motion. Finally, the parallels between the Biblical land of Havilah and the geography of Brazil suggest that the river Pison may have been an ancient name for the Amazon. The swastika, then, is no arbitrary symbol; it appears to preserve geographical information gathered at some remote period of prehistory and later forgotten.

Figure 2.7 Bronze Ceinture from the Caucasus with three swastikas. River meanders flow through the arms of the swastikas and cross at the center.

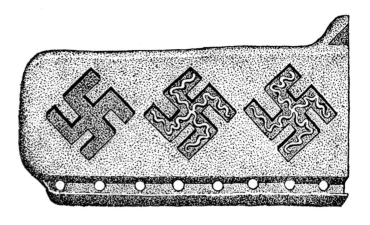

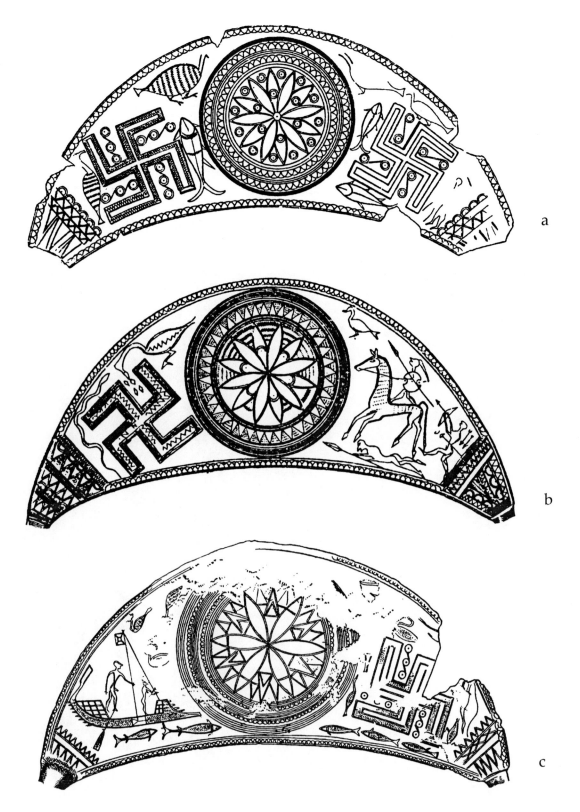

Figure 2.8 Three bow fibulae from Thisbe; probably Central Peloponesian, eighth century BC. Swastikas with wave symbols paralleling outer arms; waterbirds, snakes, and river meanders indicate river and water symbolism. (a, b, Staatliche Museen, Berlin; c, British Museum, London).

Chapter 3

The Heroic Quest I: The Greeks

Though too premature to draw definite conclusions, the evidence was adequate to justify a deeper investigation into this novel hypothesis—specifically, that the swastika symbol preserved ancient knowledge of geographical facts. The living oral tradition of the Hopi Indians, coupled with the archaic biblical records, provided the starting point, but even with the archeological evidence linking the swastika to rivers, these were hardly conclusive.

The next step unfolded gradually. Since the four rivers in Genesis pertain to the creation story of the ancient Hebrews, it seemed logical to investigate the creation stories and related myths of other traditions.

The Greek material, in particular, provided interesting similarities to the Hopi migration myth. Remember that the Hopis were required by Másaw to travel over the American continents in the geographical form of great swastika; only after they had completed this journey in all four directions could they return to their homeland. In Greek mythology, we find a similar motif: The hero must complete a long and arduous journey before he can return to his home and family. In the case of the Greeks, however, this journey usually involves an element of sea travel. In some cases, the hero journeys over land and water; in others, he makes the entire journey by ship.

The protracted homecoming of Odysseus, which takes ten years to complete, exemplifies this motif. Similarly, Jason and his Argonauts traverse the wide world on their homeward journey after capturing the golden fleece. Theseus (Figure 3.1) and Hercules (Figures 3.4, 3.5, and 3.6) also suffer ordeals of this classical type.

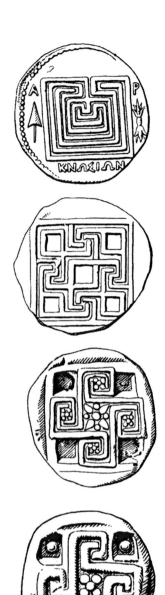

Figure 3.1 Four coins from Knossos depicting the labyrinth, at the center of which Theseus is said to have killed the Minotaur. The oldest forms of the labyrinth are shown in the form of a swastika; from ca. 500 BC. British Museum Catalogue of Coins.

Hercules

The story of Hercules is paradigmatic. In a fit of madness inflicted on him by the angry goddess Hera, Hercules kills his own children and those of his brother Iphicles. In order to expiate his guilt, he is required by the gods to perform a series of difficult labors for Eurystheus, a cruel taskmaster. In all, there are twelve labors, but the fifth, tenth, eleventh, and twelfth most clearly exemplify this migration theme. The passages from Apollodorus, quoted below, illustrate these migrations of Hercules. Note how the four whirling rivers, described by Hesiod, figure in these passages. Note also that in order to accomplish his labors, Hercules must cross the Atlantic Ocean twice, once from Europe (Spain) and once from North Africa (or Libya, as it was called then):

> The fifth labour he laid on him was to carry out the dung of the cattle of Augeas in a single day . . . Hercules accosted [Augeas}, and without revealing the command of Eurystheus, said that he would carry out the dung in one day if Augeas would give him the tithe of the cattle. Augeas was incredulous, but promised. Having taken Augeas's son Phyleus to witness, Hercules made a breach in the foundations of the cattle-yard, *and then diverting the courses of the Alpheus* and Peneus, which flowed near each other, he turned them into the yard, having first made an outlet for the water through another opening.[1]

> As a tenth labour he was ordered to fetch the kine of Geryon from Erythia (Figure 3.2). Now Erythia was an island near the ocean; it is now called Gadira. This island was inhabited by Geryon, son of Chrysaor by Callirrhoe, daughter of Ocean…He owned red kine, of which Eurytion was the herdsman and Orthus, the two-headed hound … was the watch-dog. So journeying through Europe to fetch the kine of Geryon he destroyed many wild beasts and set foot in Libya, and proceeding to Tartessus he erected as tokens of his journey two pillars over against each other at the boundaries of Europe and Libya. But being heated by the Sun on his journey, he bent his bow at the god, who in admiration of his hardihood, gave him a golden goblet in which he crossed the ocean. And having reached Erythia he lodged at Mount Abas. However the dog, perceiving him, rushed at him; but he smote it with his club, and when the herdsman Eurytion came to the help of the dog, Hercules killed him also …and [Geryon], coming up with Hercules beside the river Anthemus, as he was driving away the kine, joined battle with him and was shot dead. And Hercules, embarking the kine in the goblet and sailing across to Tartessus, gave back the goblet to the Sun …

Tree of Life, Mythical Archetype

Hera afflicted the cows with a gadfly, and they dispersed among the skirts of the mountains of Thrace . . . Having with difficulty collected the cows, Hercules blamed the river Strymon, and whereas it had been navigable before, he made it unnavigable by filling it with rocks …

When the labours had been performed in eight years and a month, Eurystheus ordered Hercules, as an eleventh labour, to fetch golden apples from the Hesperides … These apples were not, as some have said, in Libya, but on Atlas among the Hyperboreans. They were . . . guarded by an immortal dragon with a hundred heads, offspring of Typhon and Echidna, which spoke with many and divers sorts of voices. With it the Hesperides also were on guard, to wit, Aegle, Erythia, Hesperia, and Arethusa …

And going on foot through Illyria and hastening to the river Eridanus he came to the nymphs, the daughters of Zeus and Themis. They revealed Nereus to him, and Hercules seized him while he slept, and though the god turned himself into all kinds of shapes, the hero bound him and did not release him till he had learned from him where were the apples and the Hesperides. Being informed, he traversed Libya. That country was then ruled by Antaeus, son of Poseidon, who used to kill strangers by forcing them to wrestle. Being forced to wrestle with him, Hercules hugged him, lifted him aloft, broke and killed him …

After Libya he traversed Egypt. That country was then ruled by Busiris; a son of Poseidon by Lysianassa, daughter of Epaphus. This Busiris used to sacrifice strangers on an altar of Zeus in accordance with a certain oracle … So Hercules also

Figure 3.2 The Cattle of the Sun (or of Geryon) at the base of a conspicuous tree. Detail from an illustrated Greek kylix, red ground around central medallion; from Vulci, ca. 428 BC.

was seized and haled to the altars, but he burst his bonds and slew both Busiris and his son Amphidamas.

And traversing Asia he put in to Thermydrae, the harbor of the Lindians ... And passing by Arabia he slew Emathion, son of Tithonus, and journeying through Libya to the outer sea he received the goblet from the Sun.

And having crossed to the opposite mainland he shot on the Caucasus the eagle, offspring of Echidna and Typhon, that was devouring the liver of Prometheus, and he released Prometheus ...

Now Prometheus had told Hercules not to go himself after the apples but to send Atlas, first relieving him of the burden of the sphere; so when he was come to Atlas in the land of the Hyperboreans, he took the advice and relieved Atlas. But when *Atlas had received three apples from the Hesperides*, he came to Hercules, and not wishing to support the sphere he said that he would himself carry the apples to Eurystheus, and bade Hercules hold up the sky in his stead. Hercules promised to do so, but succeeded by craft in putting it on Atlas instead ...

And so Hercules picked up the apples and departed. But some say that he did not get them from Atlas, but that he plucked the apples himself after killing the guardian snake. And having brought the apples he gave them to Eurystheus.

A twelfth labour imposed on Hercules was to bring Cerberus from Hades (Figure 3.3).[2]

*　*　*

It is important to point out that, in these passages from Apollodorus, amid a welter of mythological episodes and confused geography, an important sequence of events is concealed:

- Hercules diverts the Alpheus River.

- At the coast of Spain (Gadira is Gades, modern Cadiz) the sun gives him a golden goblet in which he crosses the ocean.

- Hercules steals the cattle and then recrosses the ocean to Spain with them.

- Hercules blames the river Strymon for hindering his progress with the cattle and fills it with rocks.

- Hercules is ordered to steal the golden apples of the Hesperides from Atlas.

- At the River Eridanus, Hercules learns the secret location of the apples.

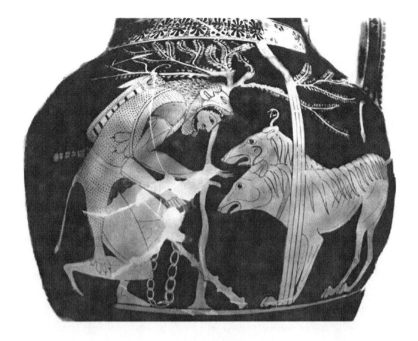

Figure 3.3 Hercules capturing Cerberus, the two-headed hound of hell, from the threshhold of the underworld at the base of a conspicuous tree. An Attic bilingual amphora by Andokides, now in the Louvre, Durand Collection, Paris.

• Hercules traverses Egypt. (In ancient times, Egypt was the Nile; all of North Africa west of the Nile to the Atlantic Ocean was called Libya.)

• Hercules travels across Libya to the ocean.

• Again, he receives the golden goblet from the sun and crosses the ocean to the opposite mainland.

• He steals the golden apples from Atlas, killing a serpent in the process.

• He descends to Hades and fetches Cerberus, the hound of Hell.

In this narrative there are strong parallels not only to the Hopi migration myth, but also to the Genesis account. Sacred trees in a garden produce a kind of magical fruit, guarded by a serpent who can speak human language. Before reaching the garden, Hercules visits the four "whirling rivers" of Hesiod— Alpheus, Strymon, Eridanus, and the Nile (represented by Egypt).

Like the Hopi Indians, Hercules embarks on a vast intercontinental migration at the insistence of the gods. He visits two known rivers located in Europe and Africa, which lie in the form of a partial swastika. The other two rivers that would complete the swastika are located on the other side of the Atlantic Ocean. Hercules crosses the Atlantic twice during the course of these labors.

In addition to the fact that he crosses the Atlantic Ocean from Spain in order to steal the cattle of Geryon (also said to

Figure 3.4 Hercules at the tree of the Hesperides. Statuette from Byblos, British Museum.

belong to Helios, the sun god), there is another factor that suggests the North American continent as the location of Hercules' tenth labor. The land where these cattle graze is called variously Erythia, the island of Geryon, the land of Helios (the sun), or simply Thrinakia. The cattle are described as "shambling" and "wide-browed," and there are vast numbers of them. The Roman poet Ovid tells how they roam free, unhampered by the limiting fences of neighbors:

Descending from the sky, he [Perseus] reached Hesperia, the land of Atlas … This Atlas, son of Iapetus, was massive; no man could match his stature. And no land lay farther west than his domain—earth's edge and sea span that received the panting steeds and weary chariot of the Sun that set. He had a thousand flocks, and he could claim as many herds; they grazed on his green plain at will: no neighbors bordered his domain. And he had trees with gleaming golden leaves that covered golden boughs and golden fruit—the apples of the three Hesperides.[3]

Statements such as "no land lay farther west than his domain" led some later commentators to speculate that the land of Geryon was Spain, since they knew of no land farther west. According to Hesiod, however, the land of the sun's cattle is located "beyond glorious Ocean."[4] Homer's *Odyssey* also places Thrinakia where the sun both sets into it and rises from it— that is to say, on the other side of the earth.[5]

The Greek word *Erytheia* is derived from a root meaning "red"; hence it means "the red land."[6] Geryon himself is described as a giant, the biggest man who ever lived.[7] He has three heads and bodies, but is joined at the hips and legs. This is an unusual form even for a giant, but it conforms to the alternative name of his land, Thrinakia. For Geryon is a giant in the shape of a huge trident.

As a matter of fact, there *was* a land on the other side of the Atlantic, and its inhabitants were red complexioned. This land was also home to vast herds of shambling broad-faced cattle, which roamed free on the limitless prairies and which drank from a great river that formed the third arm of a swastika with the Eridanus and the Nile. Do the "cattle of the sun" represent a vague historical memory of the American bison? Any civilization advanced enough to collect the geographical information necessary to derive the swastika from rivers tributary to the Atlantic Ocean would certainly have known about these animals.

Tree of Life, Mythical Archetype

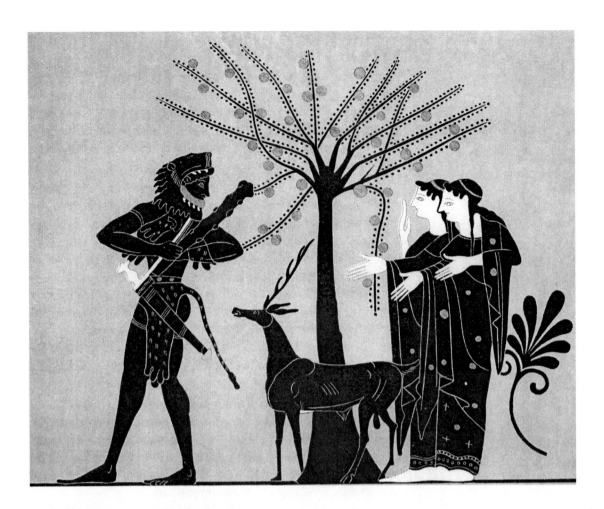

Jason and the Argonauts

The Hercules account preserves the most complete remnants of the swastika migration motif, but this also survives more or less intact in several other legends. Jason and the Argonauts visit the Eridanus, Thrinakia, Circe's island, Calypso's island, the Garden of the Hesperides, and finally the Nile (called the Triton) on their homeward journey, and in this case there is also an element of divine compulsion.

Jason must bring home the golden fleece in order to regain his rightful title to the throne. He assembles a band of famous warriors as his crew, and they set out for the land of Aeaea, where the fleece is kept hanging on an oak tree, guarded by a serpent.[8] Resolving to try diplomacy first, they enter the grounds of the royal palace, where they behold four fountains:

> Silently they crossed the threshold. And close-by garden vines covered with green foliage were in full bloom, lifted high in air. And beneath them ran four fountains, ever-flowing, which Hephaestus had delved out. One was gushing with milk, one with wine, while the third flowed with fragrant oil; and the fourth ran with water, which grew warm

Figure 3.5 Hercules capturing the Ceryneian Hind at the base of a conspicuous tree. A stag is often placed in association with the Tree of Life in world mythology.

at the setting of the Pleiads, and in turn at their rising bubbled forth from the hollow rock, cold as crystal.[9]

Aietes, the king of Aeaea, is the son of the sun god, Helios. He refuses to hand over the fleece, so the Argonauts must resort to stealth and force. Prompted by the god Eros, the king's daughter, Medea, falls in love with Jason and promises to help him by using her magic to charm the guardian serpent to sleep:

> And they two by the pathway came to the sacred grove, seeking the huge oak tree on which was hung the fleece, like to a cloud that blushes red with the fiery beams of the rising sun. But right in front the serpent with his keen sleepless eyes saw them coming, and stretched out his long neck and hissed in awful wise; and all round the long banks of the river echoed and the boundless grove ... he raised aloft his grisly head, eager to enclose them both in his murderous jaws. But she with a newly cut spray of juniper, dipping and drawing untempered charms from her mystic brew, sprinkled his eyes, while she chanted her song ... Hereupon Jason snatched the golden fleece from the oak, at the maiden's bidding.[10]

In striking parallel to the Genesis account, a man and a woman (Jason and Medea) take a forbidden object from a special tree in the presence of a serpent. The tree is located in a sacred grove near a river, close to which four fountains flow. The authority who has forbidden the act is himself partly divine. The man takes the object at the woman's bidding.

After stealing the golden fleece and eloping with Medea, Jason flees with the Argonauts from King Aietes' soldiers. In order to slow them down, Medea kills her brother, Apsyrtus, and hacks him to pieces. One by one, she drops the parts of his body overboard, and the pursuers must stop each time in order to retrieve them:

> But ... when the Argonauts were already sailing past the *Eridanus River*, Zeus sent a furious storm upon them, and drove them out of their course, because he was angry at the murder of Apsyrtus.[11]

The fullest account of the Argonauts' voyage is contained in the *Argonautica*, written by Apollonius Rhodius in the third century BC. Apollonius localizes much of the geography of the legend to known Mediterranean sites, but the general structure of the route is still recognizable, and it conforms to the swastika pattern in the main. Despite his tendency to localize the myth, Apollonius preserves key indicators of the original migration. For example, he does not merely state that the Argonauts enter the Eridanus, but adds that their pursuers are willing to follow them "through all the Cronian Sea," an ancient name for the Baltic or the Gulf of Finland.[12]

Tree of Life, Mythical Archetype

Apollonius Rhodius places Aeaea at Colchis, near the east end of the Black Sea, but more than five hundred years earlier Homer had placed it in the middle of the Western Ocean. Attempts to put it near the Black Sea create awkward problems, including the need to add an episode in which the Argonauts carry their ship overland from the Mediterranean to the Baltic. Adding to the confusion, Apollonius later names a harbor in Italy "Aeaea"—another late localization.[12]

On the way back toward the Eridanus, the Argonauts pass by the island of Calypso, daughter of Atlas, the king of Atlantis (the Greek text calls her Calypso Atlantis[13]). In the *Odyssey*, Homer describes her island as being located "where is the navel of the sea," somewhere in the middle of the Atlantic Ocean.[14]

Figure 3.6 Hercules slaying the Stymphalian Birds. Dürer, Nürnberg.

After the Argonauts pass Calypso's island, the goddess Hera contrives a wind that blows them to the "rocky isle of Electra."[15] In Greek, the word *electra* means "amber." Note that the Eridanus is described as "that deep lake":

> And far on sped Argo under sail, and entered deep into the stream of Eridanus; where once, smitten on the breast by the blazing bolt, Phaethon half-consumed fell from the chariot of Helios into the opening of that deep lake…And all around the maidens, the daughters of Helios, enclosed in tall poplars, wretchedly wail a piteous plaint; and from their eyes they shed on the ground bright drops of amber.[16]

Like Hercules and the Hopi Indians, the Argonauts are prevented by the gods from returning home directly; they must first perform an arduous intercontinental migration. Zeus himself has ordained that:

> by the counsels of Aeaean Circe they should cleanse themselves from the terrible stain of blood and suffer countless woes before their return.[17]

After a variety of adventures involving Sirens, wandering icebergs, and encounters with the monsters Scylla and Charybdis, the Argonauts pass near Thrinakia where they observe the cattle feeding by a river:

> And as long as the space of a day is lengthened out in springtime, so long a time did they toil, heaving the ship between

the loud-echoing rocks; then again the heroes caught the wind and sped onward; and swiftly they passed the mead of Thrinacia, where the kine of Helios fed . . . *These kine the heroes saw feeding by the river's stream.*[18]

Next the Argo is blown by a storm upon the desert coast of Libya. Unable to reenter the ocean, the Argonauts carry their ship eastward across the desert until they come to Lake Triton, which has an outlet to the sea.[19] But earlier in the *Argonautica*, we are told that *Triton* is an old name for the river Nile:

> In the days when Egypt, mother of men of an older time, was called the fertile Morning-land, and the river fair-flowing Triton, by which all the Morning-land is watered; and never does the rain from Zeus moisten the earth; but from the flooding of the river abundant crops spring up.[20]

So the Argonauts are forced to traverse the leg of the swastika extending up the Nile before the gods will allow them to journey homeward. As they travel across the desert, they encounter the (here implausibly located) Hesperides, in the "garden of Atlas," where grow the trees that bear the golden apples guarded by the serpent Ladon.[21] In ancient Greek literature, the Garden of the Hesperides is typically located in the western Ocean.[22] Its location in the Libyan Desert is out of place; yet its placement here as one of the stations that the returning heroes must pass is absolutely consistent with the heroic migration pattern. One could also argue that placing the Garden of the Hesperides in Libya is not inconsistent with our observations about the Atlantic swastika. For the legendary garden containing the tree of life was said to be located at the confluence of four rivers, and the vertex of the great swastika lies in the Atlantic Ocean, just west and south of the Straits of Gibraltar, off the coast of North Africa.

Homer's *Odyssey*

This episode in the *Argonautica* is not unique by any means. In the *Odyssey*, Menelaus, attempting to return home after the Trojan War, is becalmed for twenty days on the Island of Pharos. The Old Man of the Sea tells Menelaus that he ought to have made offerings to the gods before embarking:

> "... you should have made good offerings on setting forth, if you would quickly reach your land, sailing the wine-dark sea; for now it is appointed you to see your friends no more nor reach your stately house and native land till you have gone again to Egypt's waters; to its heaven-descended stream, and offered sacred hecatombs to the immortal gods

who hold the open sky. Then shall the gods grant you the course which you desire."

As thus he spoke, my very soul was crushed within me because he bade me cross again the misty sea and go to Egypt's river, a long and weary way. Yet still I answered thus and said: "Old man, all that you bid me I will do."

So back again to Egypt's waters, to its heaven-descended stream, I brought my ships and made the offerings due. And after appeasing the anger of the gods that live forever, I raised a mound to Agamemnon, that his fame might never die. This done, I sailed away; the gods gave wind and brought me swiftly to my native land.[23]

Although Odysseus is not himself compelled to ascend the Nile, this episode involving Menelaus seems to represent the Nile leg of the great migration in the *Odyssey*.

We saw in chapter 1 that Odysseus and his crew visit the far north of Europe, and the Tacitus reference cited in that chapter supports the assumption that they enter the Eridanus at that time. For them as for Hercules, the encounter with the cattle of Helios in Thrinakia appears to stand for the North American leg of the migration. But what do we know about the final, southern leg? Are there indications that Odysseus travels south to visit the fourth of the "whirling rivers"?

After their adventure at the Laistrygonian height, Odysseus and his crew land on the island of Aeaea, the domain of the dread goddess Circe, the sister of Aietes. They find Circe weaving on her loom and singing an enchanting song. She is a witch who transforms half of the crew into swine before Odysseus is able to break her spell. Later she entertains them all with lavish feasts, and she takes Odysseus into her bed. Her four maids are nymphs, and they are associated with the sacred rivers that flow to the sea.

Children are they of the springs and groves, and of the sacred rivers that flow forth to the sea.[24]

The crew spends a year with Circe before they decide to return home. Circe is reluctant to part with Odysseus but declines to hold him against his will. She informs him, however, that fate has decreed that he may not go directly home:

"But first there is another journey you must accomplish and reach the house of Hades and of revered Persephone, there to consult with the soul of Teiresias the Theban, the blind prophet."

Odysseus asks her who will be their guide to Hades, and she answers:

Son of Laertes and seed of Zeus, resourceful Odysseus, let no need for a guide on your ship trouble you; only set up your mast pole and spread the white sails upon it, and sit still, and let the blast of the North Wind carry you. But when you have crossed with your ship the stream of the Ocean, you will find there a thickly wooded shore, and the groves of Persephone, and tall black poplars growing ...[25]

From the island of Circe they are to cross the ocean, running before the blast of the north wind. Now the north wind is a wind blowing *from* the north. Therefore, it will carry them south across the ocean to the land of Hades, growing thick with black poplars, which in Greek mythology are emblematic of the underworld. Another name for Hades is Plutus, and Plutus is the god of wealth.

The oldest conceptions of the earth saw it as a sort of flattened disk with a clearly defined top and underside. Already by the time of Aristotle, and probably much earlier in some circles, it was known to be spherical.[26] In either case, the concept of a gravitational force that would allow human beings to live on its underside was unknown and unthinkable. By the classical period of Greece, the conception of the underworld's location was believed to be in the dark interior of the earth. Modern scholars, while recognizing this belief, have noted its inconsistencies with older descriptions of Hades that include halcyon fields and gentle breezes.

These discrepancies are resolved, however, by the view suggested here, that the ancients saw the limits of the upper world as corresponding roughly with the northern hemisphere, the area of the earth's surface from which the pole star—considered the top of the world—was visible. The equator would then have been the line generally marking the absolute limit of the upper world. Beyond this lay the mysterious land of the dead. Hence any voyage south to the earth's equator or beyond would be termed a voyage to the underworld. Most people in the ancient world believed such a voyage impossible. Anyone rash enough to attempt it would simply fall off the edge.

Hence Odysseus' voyage south from Circe's island is just such a journey to the underworld. After leaving Circe's island, Odysseus travels so far south as to encounter the gloom which was believed to be characteristic of the underworld:

All day long her sail was stretched as she sped over the sea, and the sun set, and all the ways grew dark. She came to deep-flowing Oceanus, that bounds the earth, where is the land and city of the Cimmerians, wrapped in mist and cloud. Never does the bright sun look down on them with his rays either when he mounts the starry heaven or when he turns again to earth from heaven, but baneful night is spread over wretched mortals. Thither we came and beached our

ship, and took out the sheep, and ourselves went beside the stream of Oceanus until we came to the place of which Circe had told us.[26]

The story has become highly embellished with pitiful conversations between Odysseus and the souls of the dead, but those seem to be theatrical trappings.[27] Significantly, the shade of Hercules is made to ask Odysseus:

> Son of Laertes sprung from Zeus, Odysseus of many devices, ah, wretched man, dost thou too drag out an evil lot such as I once bore beneath the rays of the sun?[28]

In this way, Homer links the migration within the *Odyssey* to the earlier travels of Hercules, which, as we have seen, follow the same pattern. Just as Hercules stole the cattle of the sun, so also Odysseus and his crew, after leaving the underworld, encounter these animals on the island of Thrinakia. Although warned by Circe and also by Teiresias to leave these sacred cattle untouched, an unfavorable wind from the south and east prevents their departure, causing near starvation. While Odysseus sleeps, his men bring on their own doom by slaughtering and feasting on some of the herd. In retaliation, Zeus smashes the ship, drowning all but Odysseus. The wind from the south and east, which prevents their sailing homeward, is a clue to the location of Thrinakia. North America is at the northwest corner of the great Atlantic swastika, and so the route home would lie to the south and east, directly against the wind.[29]

But what do all these journeys signify? We know that Odysseus visits the realm of Hades, and that Hades is also the god Plutus, who:

> goes everywhere over land and the sea's wide back, and him who finds him and into whose hands he comes he makes rich, bestowing great wealth upon him.[30]

We also know that at the river Pison there is gold, and the gold of the land is good. This would seem to tally with our hypothesis: On the one hand, a source of wealth (Plutus) somewhere south of the equator is encoded within the *Odyssey*, conforming to, on the other hand, a location known to possess gold, bdellium, and the onyx stone as described in Genesis. Could this ancient source of gold, like the sea route to the amber islands, be one of the reasons why the legends are so cryptic?

This interpretation is made more likely through evidence provided by the Danish historian Saxo Grammaticus. Saxo wrote a Latin language history of the Danes in the first half of the thirteenth century AD, but much of his material is known to be legendary rather than historical. He describes an expedition to the underworld led by one Gormo, for the purpose of gaining treasure. The encounter with perpetual darkness, adverse weather, near starvation, rebellious sailors, slaughter of

forbidden cattle on an island, and divine retribution leave little doubt that both Saxo and Homer were working from the same original:

> Gormo, son of King Harold, led an expedition of three hundred men in three ships, with Thorkill as guide, in search of the land of Geruth, in the perpetual darkness which prevails beyond the limits of the ocean, a land said to be full of treasure. They met adverse weather, and their provisions ran out. They were not far from starvation when they sighted an island, where they disembarked.
>
> Now Thorkill forbade them to kill more of the cattle, of which great numbers were running about on the shore, than would suffice to appease their hunger just once; otherwise the gods who protected the place would prevent them from leaving. But the sailors were more inclined to consider the continued satisfying of their hunger than to listen to this prohibition; they paid less attention to their safety than to the temptation of their bellies, and they filled the empty spaces of their ships with slaughtered cattle. During the night they were attacked by giants, who surrounded their ships. One of them, bigger than the others and armed with a mighty cudgel, actually walked across the sea; and when he got closer, he began to shout that they would not escape until they had atoned for the wrong they had done by slaughtering the cattle; they must make good the damage they had done to the sacred animals, by giving up a man from each of the three ships. Thorkill yielded to these threats and gave up three men chosen by lot.[31]

The parallels here with the *Odyssey* are unmistakable. But while we can only deduce from Homer's account that the voyage to Hades has wealth as its object, Saxo's account makes this matter explicit.

For seven years, Odysseus is held a virtual prisoner on Ogygia, the island of Calypso.[32] The name *Ogygia* has ancient associations. The first of the three great world floods in Greek mythology is called the Ogygian flood.[33] As an adjective, the word means "primeval." Homer locates this island at "the navel of the sea," or so it is usually translated. But the Greek word *omphalos*, which means "navel," can also mean "hub," "nave," or "center point."[34] In that sense, Calypso's island corresponds with the vertex (or hub) of the great swastika formed by the four Atlantic rivers. Athena pleads with her father, Zeus, to release Odysseus from Calypso's clutches:

> But my heart is torn for wise Odysseus, ill-fated man, who far from his friends has long been suffering woes in a sea-girt isle, where is the navel of the sea. It is a wooded isle, and on it dwells a goddess, daughter of Atlas of baneful mind,

who knows the depths of every sea, and himself holds the tall pillars which keep earth and heaven apart. His daughter it is that keeps back that unfortunate, sorrowing man; and continually with soft and wheedling words she beguiles him that he may forget Ithaca.[35]

Calypso and Circe share so many characteristics that it is reasonable to regard them as originally one and the same person. They are both goddesses who live on islands in the middle of the ocean; both are introduced singing sweetly as they weave at their looms. Of Calypso, Homer says:

> She within was singing with a sweet voice as she went to and fro before the loom, weaving with a golden shuttle … And right there about the hollow cave ran trailing a garden vine, in pride of its prime, richly laden with clusters. And fountains four in a row were flowing with bright water hard by one another, turned one this way, one that.[36]

In the *Odyssey*, Circe's island is called Aeaea. The description of Aeaea—the location of the golden fleece—in Apollonius is strikingly similar. There again we find a vine in full bloom, under which four streams flow:

> And close by garden vines covered with green foliage were in full bloom, lifted high in air. And beneath them ran four fountains, ever-flowing, which Hephaestus had delved out.[37]

Both Calypso and Circe fall in love with Odysseus, and they attempt to entice him to stay forever on their respective islands. Each is said by Hesiod to have born two sons to him.[38] These many similarities cannot be coincidental; both names must have originally belonged to the same goddess. It would also appear that the golden fleece of the Argonauts was originally located on this island, being later localized to Colchis. This observation is supported by the following facts:

- Apollonius says that the fleece was located at Aeaea, the name of Circe's island in Homer.

Figure 3.7 Odysseus and his men blind the Cyclops by twirling a flaming olive tree trunk in his single eye. The concept of a glowing or flaming tree is common in depictions of the Tree of Life, as is the frequent associations with the axial motions of twirling, twisting, or rotating. The single eye is consistent with notions of a navel, center, omphalos, or other axis of rotation. From a wall-painting in an Etruscan tomb at Corneto.

• Homer says that Circe was the sister of King Aietes, Medea's father.

• The Aeaea of the golden fleece is located near four fountains flowing under a blooming vine. This matches the description of Calypso's island and suggests Circe's island.

• The Argonauts are blown off course from the Eridanus (Baltic) directly to Calypso's island. Later, sailing from the Eridanus, they soon reach Circe's island.[39]

Taking Ogygia (land of Calypso), Aeaea (land of Circe), and Aeaea (location of the golden fleece) as a single locality, we find that it has the following combined characteristics:

• It is an island at the navel, or hub, of the sea.

• It is associated with a great flood in ancient times.

• It has four streams that originate close together and flow toward the sea in different directions.

• There are prominent trees associated with this island: a huge oak in the Argonautica, the forest surrounding the house of Circe as described by Homer, and the dwelling of Calypso on a "wooded isle."

• On this island, a formidable serpent guards a tree.

• A man and a woman steal a forbidden object from the tree.

• The goddess of the island (Calypso) is a daughter of Atlas (rendered "Atlantis or Atlantos" in both the *Odyssey* and the *Argonautica*).[1]

• This island is centrally located. Odysseus arrives there directly from Thrinakia, and from there travels directly to the underworld. Jason arrives there directly from the Eridanus. Both travel directly from there to the land of the Phaeacians en route home to Greece.

• There is a goddess at each of these three places (Medea is an enchantress with magic powers) who falls in love with the hero protagonist.

These characteristics conform very closely to the descriptions of the Garden of Eden in Genesis and to many features of the Hercules myth. The association between the four rivers and the "navel" or "hub" of the sea conforms to Hesiod's image of the "whirling rivers" and supports the concept of four rivers lying in a swastika formation, the axis of which lies at a mythical

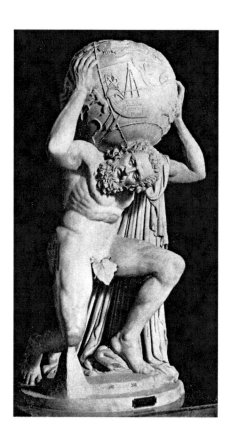

igure 3.8 Atlas supporting the heavenly spheres. In typical fashion, his head bows down below the level of his shoulders under the weight of his burden.

Tree of Life, Mythical Archetype

or formerly existing island—the island of Calypso at the "navel of the sea." This would also suggest an ancient, pre-Homeric belief in an island located outside the Straits of Gibraltar named "Atlantis," which means "daughter of Atlas."[42]

Plato's later reference to an island of Atlantis in precisely the same location would then be following an earlier literary precedent. His account (largely quoted in Appendix 1) raises many questions however—most specifically the question of its size:

> There was an island situated in front of the straits which you call the columns of Heracles [Straits of Gibraltar]: the island was larger than Libya and Asia put together, and was the way to other islands, and from the islands you might pass to the whole of the opposite continent which surrounded the true ocean; for this sea which is within the Straits of Heracles is only a harbor, having a narrow entrance, but that other is a real sea, and the surrounding land may be most truly called a continent. Now, in this island of Atlantis there was a great and wonderful empire, which had rule over the whole island and several others, as well as over parts of the continent … The islands of Atlantis, which, as I was saying, once had an extent greater than that of Libya and Asia … afterward sunk by an earthquake … [The king was] named Atlas, and from him the whole island and the ocean received the name of Atlantic.[43]

The sinking of Plato's Atlantis parallels the ancient flood associated with Ogygia, but both islands may well have been entirely mythical. Modern ocean research clearly demonstrates that no island anywhere near the size of Libya and Asia Minor

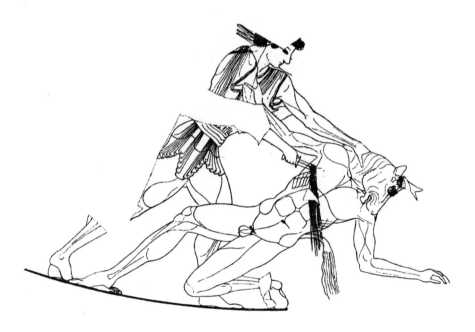

Figure 3.9 Theseus killing the Minotaur at the center of the labyrinth. The cosmic side or thigh-wound, here suffered by the Minotaur, is a frequent mythological motif. From a pelike in Florenz.

combined has existed in what is now the Atlantic Ocean for millions of years.[44] There is, however, a conspicuous underwater mountain range, the Mid-Atlantic Ridge, running north and south along the spine of the Atlantic, which rises high enough to form islands in a few areas. Nearest to the vertex of the great Atlantic swastika are the Azores, a group of nine small islands lying 900 miles west of Gibraltar.[45] These have been volcanically active in historical times so it is conceivable that they may have harbored some archaic civilization, long since destroyed by earthquake or volcanic eruption. Other nearby possibilities are Madeira or the Canaries, the latter of which were also known as the Fortunate Isles (or Islands of the Blessed) in ancient times. Therefore, Paradise, the Gardens of the Hesperides, Ogygia, Aeaea, and Atlantis may all be different names for a single mythically embellished place—an island believed to mark the axis of a swastika formed by the confluence of four great rivers.

In the next chapter we will consider a form of the heroic quest myth outside the Greek tradition. The Epic of Gilgamesh is perhaps the oldest story in human history to have survived from antiquity. We know of it because the clay tablets upon which it was inscribed were baked hard in fires that destroyed the ancient libraries. Although gaps in the accounts occur, the main lines of the story are still clear enough to reveal that the Tree of Life was the object of a quest by the hero-king Gilgamesh over five thousand years ago.

Tree of Life, Mythical Archetype

Chapter 4

The Heroic Quest II: Gilgamesh

The oldest artifacts bearing the swastika image are found in Iraq and date from the fifth and sixth millennia BC. In these images, the primary design element is the stag, often depicted in swastika-shaped formations or in close proximity to swastikas (Figure 4.2). Artifacts bearing similar decorations have also been discovered in nearby Iran (Figure 4.3). These artifacts date from the third and fourth millennia BC. Here again the stag motif is frequent, with swastikas in close association. The cultures that created these objects were precursors to the great civilization of ancient India known as Harappa, located on the Indus River.[1] There again, we find the swastika symbol as an important design motif (Figures 4.4 and 4.5), sometimes in association with trees:

> [At Mohenjo-daro] swastikas on or in association with aca-
> cia trees also occur on seals as a protection against demonic
> attacks on their beneficent properties, being always an aus-
> picious symbol.[2]

The Mesopotamian region is also the home to the oldest of all the quest myths that have come down to us from ancient times—the Sumerian *Epic of Gilgamesh*, dating from the third millennium BC. This mighty hero, after traversing all the seas of the world, visits the island home of Utnapishtim in the far west, at "the source of all rivers," where he finds a tree covered with alluring fruits. Gilgamesh acquires a plant of immortality there, which is later snatched from him by a serpent. Finally he makes a journey to the underworld, where he attempts to communicate with his dead friend, Enkidu. All the important elements of the hero quest are present here, except that specific rivers are not named as they are in the Greek versions.

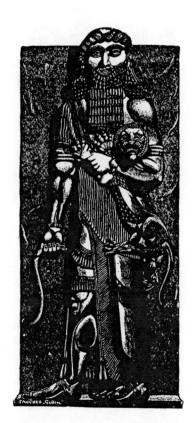

Figure 4.1 Assyrian low relief of Gilgamesh and the lion; Louvre, Paris.

a

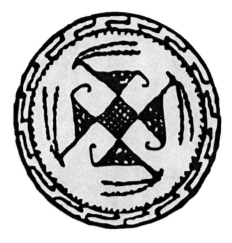

b

c

d

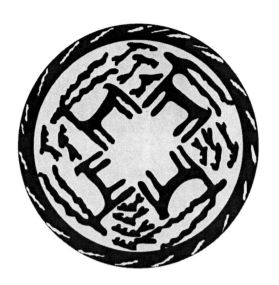

Figure 4.2 Pottery designs from Iraq showing stags in proximity to swastikas, or in swastika formation; late sixth to early fifth millennia BC: (a) From Tell Arpachiyayh; (b) From Choga Mami; (c) From Tell Hassuna; (d) From Karatepe

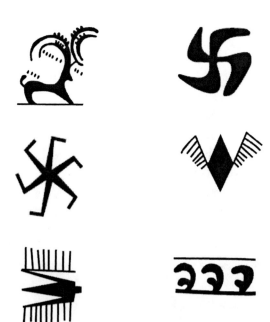

Figure 4.3 Pottery designs from Southeastern Iran, third millennium BC; stags and swastikas.

Figure 4.4 Seal with swastika from the ancient Indus city of Mohenjo-daro.

Figure 4.5 Artifacts from the ancient Indus Civilization: (a) Pottery fragment painted with swastika from Mohenjo-daro, fourth millennium BC; (b) Soul saucer with incribed swastika from Taxila.

a

b

Divine Cow

From the perspective of comparative mythology, the Gilgamesh story is important because it provides links to a number of related myths found in Europe, Asia, and Egypt—for example, that of the divine cow:

> Offspring of Lugalbanda, Gilgamesh is strong to perfection,
> Son of the august cow, Rimat-Ninsun…
> Gilgamesh is awesome to perfection.[3]

The theme of the divine cow also occurs, for example, in the myths of the Teutonic races of Scandinavia. There it is the cow

Figure 4.6 Streams of water flow from the Egyptian goddess Nut, who is also the sacred Tree of Life. Wall painting in the tomb of Sennedjem in Deir el Medineh, Thebes. ca. thirteenth century BC.

Audumla, who, along with the frost giant Ymir, are the first inhabitants of the newly emerging world. Four rivers of milk flow from the teats of her udder there in Ginnungagap, the temperate region midway between the torrid land of Muspell in the south and the frosty world of Niflheim in the north.[4] Thus in the Teutonic as the Greek and Hebrew myths, there are four rivers with a common source. The location of this source in the midnorthern latitudes is consistent with the hypothesis of the swastika vertex in the Atlantic, midway between the Baltic in the north and the Amazon in the south.

In Egypt, the goddess Hathor at one point assumes the form of a celestial cow. She shares this characteristic with several other Egyptian goddesses—namely, Nut and Isis. Ultimately, these appear to be multiple personifications of the same deity, a very common occurrence in Egyptian mythology.[5]

> The goddess Hathor of Denderah, who was originally symbolized by the head or skull of a cow nailed over the door of a temple, or on a pillar, was very early identified with the cow-shaped goddess of heaven; and many other female divinities identified with the sky—especially Isis—indicated their celestial nature in the pictures by wearing the horns or even the head of a cow.[6]

Hathor, besides taking the form of a celestial cow, also embodies the four cardinal directions through her heavenly tresses and through her associations with rivers and the ocean. At the principal temple of her cult in Denderah, her fourfold image was placed at the top of each column, facing toward each of the four directions. She was also the goddess whose dominion specifically included foreign lands.[7]

> As the mistress of heaven sitting amid green rays, Hathor can become seated in or can be identical with the celestial tree, from which she gives heavenly food and drink ... Her four blue-black tresses hang across the sky or form it, each tress marking a cardinal point ... (when a leopard skin forms the garment of the goddess she is assimilated to the goddess of fate) ... The idea of the sky as a cow is likewise combined with one which we have already noted, according to which the sky is the water of a river or a continuation of the ocean; so that the cow's body may be covered with lines representing water.[8]

In Egyptian art there are frequent representations of a goddess rising out of a sacred tree, of which she forms an integral part. From a pitcher in her hand, streams of water flow out and downward (Figure 4.6). In some cases, only the breast of the goddess is shown extending from the center of the tree, from which a king or god is drinking (Figure 4.7). Typically, the goddess is either Hathor, Isis, or Nut. This image parallels the

theme we saw earlier in the Greek and Hebrew myth where four rivers emerge from the location of a sacred tree. The association of Hathor with the cardinal directions: north, south, east, and west, supports this connection. The image of a god or hero drinking milk from the breast of the tree goddess parallels the Greek legend where Hercules drinks from the breast of the goddess Hera. From the milk that was spilt, the Milky Way galaxy was formed. Thus this early association with the divine cow in the Gilgamesh legend serves to link his journey with a mythological motif associated with the Tree of Life (Figure 4.9).

The Gilgamesh Legend

Very briefly stated, King Gilgamesh, one-third human and two-thirds god, is feeling lonely. Although he has innumerable wives and concubines, he lacks a true friend. Eventually, a wild man appears who runs with the wolves and lions, speaks their language, and avoids all things human. A beautiful woman is sent out to domesticate this character, Enkidu by name. Afterwards, she takes him into the city to meet the king. Following an initial disagreement and an evenly matched wrestling bout, the two heroes make a truce and pledge each other as eternal blood brothers.

They then set out on a series of adventures. They kill the giant Humbaba, who guards the cedars of Lebanon and then kill the menacing Bull of Heaven. This angers the fickle goddess Ishtar, and she accuses them before Shamash, the sun god:

> The brothers rested.
> But Ishtar rose up and mounted the great walls of Uruk;
> She sprang onto the tower and uttered a curse: 'Woe to Gilgamesh, for he has scorned me in killing the Bull of Heaven.'
>
> When Enkidu heard these words, he tore out the bull's right thigh and tossed it in her face.[9]

Enkidu's scornful act has disastrous consequences for the two blood brothers. In retaliation, Ishtar causes a fatal sickness to descend upon him. He eventually wastes away and crosses the threshold of death. Gilgamesh is devastated. He mourns his departed friend; he aches with sorrow. Disconsolate, he sets out on a quest to find his friend in the underworld. He travels the whole world over; like the Greek heroes, he travels all the seas. He seeks Utnapishtim, who, like Noah in the Hebrew story, has survived a great flood. Perhaps Utnapishtim can lead him to the gates of the underworld where Enkidu dwells:

> It is to see Utnapishtim, whom we call the Faraway that I have come on this journey.

Figure 4.7 King Thutmose III suckling the breast of Isis as a tree goddess. Painting on plaster from his tomb in the Valley of the Kings, 1425 BC.

Figure 4.8 Egyptian celestial cow-goddess, which can be Nut, Hathor, or Isis. The god Shu supports her with upraised arms in Atlas-like posture; stars along underbelly of cow indicate her celestial nature.

Figure 4.9 Outline of the northern-hemisphere portion of the Milky Way galaxy showing the two arms, divided by the Great Rift, which extends south from the zenith. The actual galaxy continues in both directions, and forms a circuit around the earth. Just beyond the "twin peaks" are the two constellations: Scorpius and Sagittarius. The north star, Polaris, is visible at center.

For this I have wandered over the world, I have crossed many difficult ranges, I have crossed the seas, I have wearied myself with traveling[10]

At last, Gilgamesh comes to a great mountain. This mountain resembles an archetype that appears frequently in world mythology. Its top reaches up into the highest heaven and its base descends down into the underworld. In many cultures, the mountain is replaced by a huge tree whose branches reach up to heaven and whose roots provide the connection to the underworld. It acts as a cosmic bridge or ladder linking the three realms—underworld, heaven, and earth. In this case it is guarded by the dreadful Scorpion-people, which provides a clue to its identity:

> [Gilgamesh] came to the mountains whose name is Mashu;
> approached the twin peaks
> which guard each day the coming and going of Shamash.
> Their tops reach the vault of heaven;
> below, their feet touch the underworld.
> Scorpion-people guard the gate,
> whose terror is awesome and whose glance is death:
> their grim aura is cast [up the slope of] the mountains.
> In the going of Shamash and in the coming of Shamash,
> they guard him.[11]

In the ancient Babylonian text, *The Epic of Creation*, Scorpion-man is the constellation Sagittarius,[12] and as we saw above, Shamash is the sun. When it is said that Scorpion-people guard the gate of the sun, this refers to the Milky Way galaxy where it crosses the ecliptic, the sun's celestial path. This point of intersection is located within the constellation Sagittarius, very near to its common boundary line with the adjacent constellation Scorpius—hence the designation of Sagittarius as the "gate."

Scorpius and Sagittarius are located at a point just beyond the two long branches of the galaxy. Caused by a band of dark interstellar matter, the Great Rift divides part of the Milky Way into two arms. The resulting form is like a tree with two vast branches extending across the heavens, or like the "twin peaks" of a great celestial mountain (Figure 4.9).

From the constellations Scorpius and Sagittarius, the Milky Way arcs up to the highest point of the night sky (the vault of heaven), and from there extends as a continuous band of diaphanous light in a circle around the earth. It also passes below the horizon, entering the underworld, the region below the earth as the ancients conceived it. Thus it forms a link or ladder between the earth, heaven, and the underworld of the dead.

Later, Gilgamesh arrives at the edge of the ocean and asks his way of a tavern-keeper there:

Tree of Life, Mythical Archetype

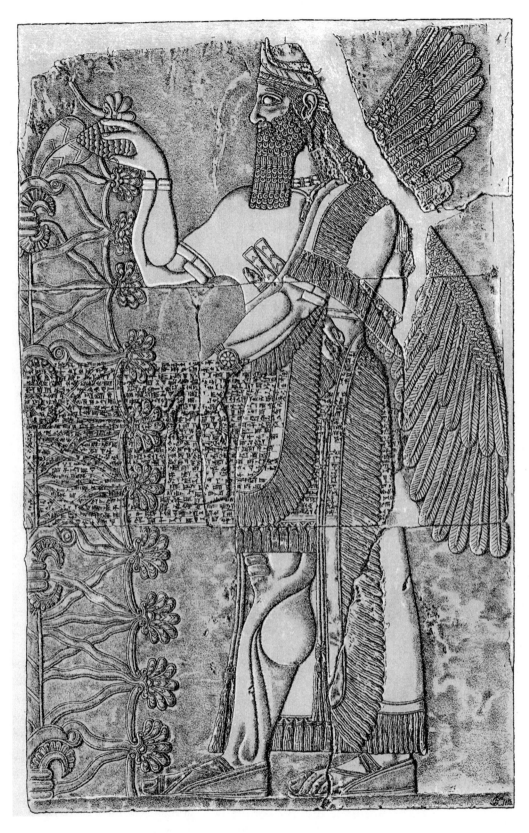

Figure 4.10 A winged genie sprinkling sacred water onto the Tree of Life. After a relief from Nimrud, from the Antiquarian Collection, Zurich.

Gilgamesh spoke to the tavern-keeper, saying:
"So now, tavern-keeper, what is the way to Utnapishtim?
What are its markers? Give them to me! Give me the markers!
If possible, I will cross the sea;
if not I will roam through the wilderness."
The tavern-keeper spoke to Gilgamesh saying:
"There has never been, Gilgamesh, any passage whatever,
there has never been anyone since the days of yore who
crossed the sea.
The only one who crosses the sea is valiant Shamash, except
for him who can cross?
The crossing is difficult, its ways are treacherous—and in
between are the Waters of Death that bar its approaches.[13]

Despite her warnings, Gilgamesh persuades the ferryman
to carry him to the far west, following the path of the sun "along
the road of Shamash," to the abode of Utnapishtim.[14] The voyage is eventful, dangerous, and dark. At last a tree is seen in the
distance, sparkling, jewel-like. The text is fragmentary, but the
meaning is clear enough:

At the nearing of eleven double-hours, light breaks out.
At the nearing of twelve double-hours, the light is steady.
He sees the grove of stones and heads for [it].
Carnelian it bears as its fruit,
[and] vines hang from it, good to see,
leaves formed of lapis lazuli,
the fruit it bears alluring to the eye.
. . .
. . . cedar tree . . .
. . . tree covered with precious stones
[sea-bright stones] . . .
carob . . .
Gilgamesh . . . when he was going . . .[15]

Here as in the Hebrew paradise legend and in the Greek
quest myths, there is a tree that bears alluring and precious
fruits. Here again, we find reference to a vine, like the ones described by Homer and Apollonius Rhodius. That this is actually
the Tree of Life is confirmed by the fact that it grows near the
home of Utnapishtim at the source of all rivers:

[The god Enlil] touched our foreheads, blessing us,
and said: "You were but human; now you are
admitted into the company of gods.
Your dwelling place shall be the Faraway,
the place which is the source of the outflowing
of all rivers of the world there are."

And so they led us to the Faraway,
the place we dwell in now, which is the source
of all the rivers flowing through the world.[16]

Additional confirmation that this is the Tree of Life is provided by the bestowal upon Gilgamesh of the plant of immortality. It is difficult to uproot, like the magic plant that Hermes gives to Odysseus on the island of Circe, but it confers eternal youth on him who possesses it. The most common attribute of the Tree of Life in world mythology is its association with a fruit or drink of immortality. As already mentioned, Yggdrasill, the great world tree of Teutonic mythology, extends its branches up into Asgard, the heavenly world of the gods, where Idunn tends the apples of immortality. As we are told in the *Prose Edda*:

> Idunn: she guards in her chest of ash those apples which the gods must taste whensoever they grow old; and then they all become young.[17]

In the Genesis account, the Tree of Life also bestows immortality. We know this because after Adam and Eve have broken God's commandment (Figure 4.11):

> The Lord God said, Behold, the man is become as one of us, to know good and evil: and now, lest he put forth his hand, and take also of the tree of life, and eat, and live for ever:

> Therefore the Lord God sent him forth from the garden of Eden, to till the ground from whence he was taken.

> So he drove out the man; and he placed at the east of the garden of Eden Cherubims, and a flaming sword which turned every way, to keep the way of the tree of life.[18]

Figure 4.11 Adam and Eve accepting a forbidden apple from the serpent in Paradise (at left), and then cast out by an angel with a flaming sword (at right); Michelangelo, Sistine Chapel, Rome.

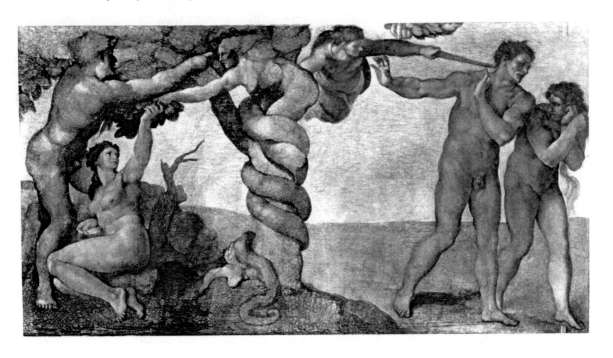

Note that the Cherubims and the flaming sword are placed by God at the east of the garden of Eden, presumably between the Tree of Life and the location where Adam and Eve are to live in the future. This would place the Tree of Life in the west—just where we find the trees with the golden apples that are guarded by the serpent in Greek mythology. In the Gilgamesh myth there is also a serpent. In this case it prevents the hero from retaining the magic plant of immortality:

> Gilgamesh, on hearing this, opened the conduit.
> He bound heavy stones to his feet;
> they dragged him down into the abyss, and he saw the plant.
> He seized the plant, though it cut into his hand;
> he cut the heavy stones from his feet;
> the sea cast him up onto its shore.
> Gilgamesh said to Urshanabi the Boatman:
> "Urshanabi, this is the plant of Openings,
> by which a man can get life within.
> I will carry it to Uruk of the Sheepfold; I will give it to the elders to eat; they will divide the plant among them.
> Its name is The-Old-Man-Will-Be-Made-Young.
> I too will eat it, and I will return to what I was in my youth."
> At twenty leagues they broke their fast.
> At thirty leagues they prepared for the night's rest.
> Gilgamesh saw a pool of cool water.
> He went down into it and bathed in the water.
> A snake smelled the fragrance of the plant.
> It came up through the water and carried the plant away.[19]

Finally, like Hercules and Odysseus, Gilgamesh makes a journey to the underworld, futile though it is. The dead are mere shadows; meaningful contact is impossible as Odysseus finds when he encounters the shade of his mother in the realm of Hades. The father god, Ea, allows Gilgamesh to contact Enkidu in the underworld:

> The hole in the floor of the upper world was open.
> The spirit of Enkidu, a puff of breath,
> came forth from the Nether Word into the Upper.
> Then Gilgamesh and Enkidu, companions,
> tried to embrace and kiss one another, companions.[20]

* * *

The Gilgamesh epic bears many points of similarity to the migration theme in the Greek myths. Points of commonality include the tree that bears alluring fruits located on an island in the western ocean at the source of all rivers; the tree or plant of immortality; the adversarial serpent; and the journey to the

underworld. The association of Gilgamesh with the source of the waters is particularly emphasized in ancient Sumerian images, where he is typically depicted holding overflowing jars of water (Figure 4.13).[21]

The Tree of Life motif was central to the religious life of the Sumerian and Babylonian cultures, and numerous accounts attest to its importance. In the mythical paradise of Eridu, there stands a sacred tree, a cedar covered with precious stones, bearing fruit alluring to the eye. Its top reached up to high heaven, the dwelling place of the gods, and its roots go down into the underworld.[22] Nearby is the mighty Apsu, a celestial river that surrounds the earth, and which is the source of happiness, abundance, wisdom, and knowledge. In the waters of the Apsu are the origins of all the rivers and springs of the earth, and though the celestial stream met the earthly sea at the time of creation, their currents do not mix. The sacred cedar tree must be constantly sprinkled with water from the Apsu, which flows near it in paradise.[23]

The tree of life appears frequently in Mesopotamian myth and on the archeological remains of Middle Eastern civilizations (Figures 4.12 and 4.15). Its appearance in the Gilgamesh legend in both of its archetypal forms—as tree and as cosmic mountain—is a development parallel to that seen in many other traditions. In ancient Sumerian ritual, the king had the responsibility of sprinkling an earthly tree with water to symbolize the sprinkling of the sacred world tree (Figures 4.10, 4.13, and 4.14). He carried a scepter that was deemed to have been made from a branch of the Tree of Life, just as Odin in the Norse myth carries a spear made from a branch of Yggdrasill.[24]

Another Mesopotamian legend describes the Tree of Life as a kiskana-tree. Like its counterparts, it stood at the navel of the world with its roots in the underworld and its branches in heaven:

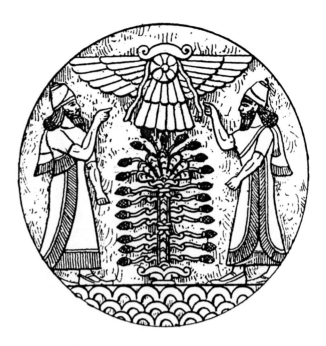

Figure 4.12 Mesopotamian kings and divine beings attend the sacred Tree of Life. A winged disk hovers above in axial alignment with tree. From embroidery upon a royal mantle.

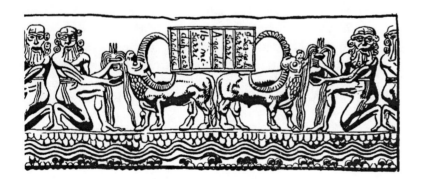

Figure 4.13 Gilgamesh holding jars of overflowing water. Cylinder seal. (Source: Langdon, 1964.)

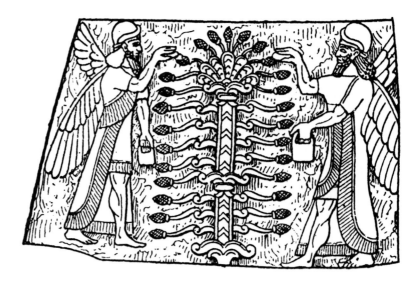

Figure 4.14 Mesopotamian kings and divine beings attend the sacred Tree of Life. From embroidery upon a royal mantle.

In its grove stood the sacred kiskana-tree, having the appearance it was said of lapis-lazuli and stretching towards the subterranean apsu where Enki had his abode. Being almost certainly the black pine of the Babylonian paradise it was believed to have derived its vitalizing power from the waters of life and made operative in the tree of life. The kiskana-tree, in fact, combined these life-bestowing characteristics with those of the cosmic tree rooted in the omphalos, or navel of the earth; Eridu being regarded as the center of the world, and the waters of the apsu as the substance out of which the universe was created and given its generative potentialities. Both trees embodied or symbolized the cosmos, often represented as a giant tree with its roots either in the nether regions or in the sky, and its branches spread over the whole earth.[25]

Gilgamesh appears in another Sumerian legend, *Inanna and the Huluppu Tree*, which dates from the third millennium BC. This legend shares many of the features that we have already encountered in the quest epic: the Tree of Life, the serpent at its base, a nearby river, and a hero who travels to it. The appearance of a bird in this version is significant since the bird is an element common to many other myths involving the Tree of Life.

[The *huluppu*-tree] was planted on the banks of the Euphrates; it was nurtured by the waters of the Euphrates. But the South Wind tore at it … while the Euphrates flooded it with its waters. Inanna, queen of heaven…took the tree in her hand … and planted it in her holy garden. There she tended it most carefully. For when the tree grew big, she planned to make of its wood a chair for herself and a couch.

Years passed … But Inanna found herself unable to cut down the tree. For at its base the snake "who knows no charm" had built its nest. In its crown, the Zu-bird … had placed

its young. In the middle Lilith, the maid of desolation, had built her house. And so poor Inanna, the light-hearted and ever joyful maid, shed bitter tears. And as the dawn broke and her brother, the sun-god Utu, arose from his sleeping chamber, she repeated to him tearfully all that had befallen her *huluppu*-tree.

Now Gilgamesh … overheard Inanna's weeping complaint and chivalrously came to her rescue. He donned his armor weighing fifty minas … and with his ax of the road, seven talents and seven minas in weight … he slew the snake "who knows no charm" at the base of the tree. Seeing which, the Zu-bird fled with his young to the mountain, and Lilith tore down her house and fled to the desolate places which she was accustomed to haunt. The men of Erech who had accompanied Gilgamesh now cut down the tree and presented it to Inanna for her chair and couch."[26]

From the Middle Babylonian period, Lilith (Figure 4.16) was identified with Lamia and Lamashtu, demons who seek to ensnare innocent men, seducing and murdering them. In the Talmud, Lilith is a night demon who can fly like a bird. According to Hebrew legend, she was Adam's first wife, who flew away from him after a quarrel. In ancient Persia, she was the daughter of the evil god Ahriman.[27] Her association with Adam in the Hebrew legend, with the serpent, and with the sacred tree growing near the Euphrates, suggests that the *huluppu*-tree was a variant of the Tree of Life.

The house built by Lilith in the side of the *huluppu*-tree has parallels in the legends of several other cultures. The trunk of the Norse tree of life, Yggdrasill, has a rotten place in its side; in the *Kalevala* epic of Finland, a worm devours the heart of a great aspen tree; in Greek legend, Adonis is born from the side of a myrrh tree. This cavity in the side of the tree is an alternative version of the wound in the side or thigh of the hero who

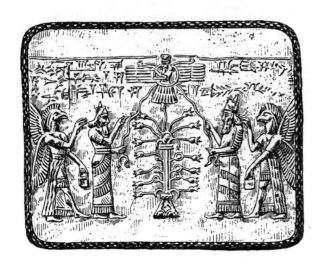

Figure 4.15 Tree of Life worshipped by kings and gods. Sargonid period; from an Assyrian cylinder, British Museum.

journeys to the Tree of Life—an image frequently encountered in mythology.

Two conclusions can be drawn from all that we have seen in these first chapters. First, the legends involving the Tree of Life seem to be composed largely of symbols. They do not bear the character of naturalistic narratives meant to record historical episodes. Second, these symbols are consistent across cultural boundaries. The tree, the serpent, and the river, for example, occur in Greek, Hebrew, Sumerian, Norse, Egyptian, Hindu, and many other traditions. For this reason, it is probable that the interpretation of these symbols will likewise be consistent.

In the next chapter, we will examine elements of the Tree of Life story as they appear in world myth and religion. From common features in the various accounts it will be possible to abstract what must have been its original attributes. From these we will be able to demonstrate the identity and significance of the Tree of Life in the ancient world.

Figure 4.16 Lilith with arms in upraised position; baked clay from Mesopotamia, ca. 2000 – 1600 BC. Louvre, Paris.

Tree of Life, Mythical Archetype

Chapter 5

Attributes of the Tree of Life

The quest myths considered in the previous chapters share several common features: a hero who travels to the four corners of the earth, a visit to—and return from—the underworld, compulsory voyages to certain rivers, an island said to be located at the source of all rivers or at the navel of the sea, and a sacred tree guarded by a serpent. This tree is familiar; we know it from the book of Genesis as the Tree of Life.

In each of these legends a goddess or demigoddess plays a significant role. It is she who intermediates between the tree and the hero. Directly or indirectly, she gives him the fruit, fleece, or magic plant. Eve offers the fruit to Adam; the wife of Utnapishtim prompts her husband to give Gilgamesh the plant of immortality; Medea, through her magic, secures the golden fleece for Jason. In variants of the story where the actual tree is not prominent, the goddess provides food, drink, or lovemaking to the hero—as do Circe and Calypso—often accompanied by offers of immortality.

Axis Mundi

Because this tree at the center, or navel, of the world occurs so frequently in world myth, scholars have given it a name that reflects its most characteristic feature; they call it the *axis mundi*. This "axle of the world" is often a very large tree, sometimes a pillar, and at other times a mountain. It is said to stand at the very center of the world because all the heavenly bodies appear to rotate around this central axis. It aligns with both the north and south celestial poles and often forms the mythical prop that holds up the sky.

In ancient times the earth was conceived as a large flattened disk, either spinning on its axis like a spindle whorl on its distaff, or else stationary with the stars moving around it. Both conceptions are archaic, and the ancients were divided in their opinions as to whether the earth or the stars were in motion. Aristotle, writing in the third century BC, argues that the earth is stationary:

> Let us first decide the question whether the earth moves or is at rest. For, as we said, there are some who make it one of the stars, and others who, setting it at the centre, suppose it to be "rolled" and in motion about the pole as axis. That both views are untenable will be clear if we take as our starting-point the fact that the earth's motion ... must needs be a constrained motion. It cannot be the movement of the earth itself.[1]

Aristotle may have been referring to Heraclides of Pontus, who in the fourth century BC declared that the earth rotated on its axis once every twenty-four hours, but there is no reason to believe that this view originated with Heraclides.[2]

In any case, this axle, imagined by the ancients to stand at the hub or nave of the observed whirling motion of the stars, was a deeply sacred feature of the universe. The tree or mountain, as it was variously conceived, was regarded with religious devotion. In Norse mythology it is the world tree Yggdrasill; in Hindu myth it is either Mount Meru or the giant stave, Skambha.

> This tree is the sustainer of the worlds and represents an organic *axis mundi*. Yggdrasill is the Norse representative of the abundantly attested and remotely archaic "tree of life" symbol. This symbol was taken seriously by many of the ancients and was frequently an innermost constituent of ancient and primitive religions. The primitive pan cultural Eurasian cosmology is unthinkable without the *axis mundi*, the tree of life, and the cosmic center, all of which freely combine in the ancient conceptions. Indo-European mythology is a pan cultural Eurasian phenomenon, and those studies that overlook the "tree of life," or dismiss it as marginal or incidental in importance, must fail to evaluate properly, or even approximately, many aspects of some Indo-European religions and mythologies.[3]

Frequently the axis mundi is said to stand at the confluence of four rivers that flow in the four cardinal directions. The environment of the tree and of these rivers is often regarded as an earthly paradise, and as such, may also be considered as the cultural homeland or the original place of emergence.

> Being essentially the source and giver of life in all its different forms and aspects it tended to have its roots in paradise,

whether this was located in some terrestrial or celestial abode, on isles of the blest, or far away in the west.[4]

This assemblage of mythical elements can be found in nearly every part of the world as a core feature of religious life. The Tree of Life was predominant throughout Asia, Europe, and North Africa. From the Kwakiutl Indians of the Pacific Northwest to the Mayas in Yucatan and Guatemala, the axis mundi was worshipped as the Tree of Life. One of its primary characteristics was its function as a bridge between the earth, heaven, and the underworld:[5]

> We meet with it, for instance, among the Semang pygmies of the Malay peninsula: at the center of their world there stands an enormous rock, Batu-Ribn, and beneath it is Hell. From the Batu-Ribn a tree-trunk formerly reached up towards the sky. Hell, the center of the earth and the "door" of heaven are all to be found, then, upon the same axis, and it is along this axis that the passage from one cosmic region to another is effected ... And even if we might suspect a remote Indian influence among these Semang pygmies, we should still have to explain the symbolism of the Center that is found upon the prehistoric monuments (cosmic mountains, the four rivers, the Tree, the spiral, etc.). Furthermore, it has been possible to show that the symbolism of a cosmic axis was already known in the archaic cultures ... especially among the Arctic and North American populations.[6]

In Babylon the island paradise was called Dilmun, where a sacred carob tree grew on the banks of the Euphrates, represented later by the garden at Eridu with its kiskanu tree, said to have its roots in the omphalos (navel) of the earth.[7] The name of the sanctuary at Nippur can be translated as "link between heaven and earth."[8]

> Thus Nippur as the navel of the world occupied much the same position as the Egyptian cities such as Heliopolis and Hermopolis which claimed to possess the Primordial Hill and erected their temples on it.[9]

Each culture typically came to regard its capital or primary temple complex as the true omphalos, the point where the sacred axis mundi intersected the surface of the earth disk at its center. This process of localization is nearly universal in world religion:

> The capital of the ideal Chinese sovereign was situated near to the miraculous Tree "shaped Wood" (Kien-mou) at the intersection of the three cosmic zones, Heaven, Earth and Hell. Examples could be multiplied without end. These cities, temples or palaces, regarded as Centers of the World, are all only replicas, repeating *ad libitum* the same archaic

image—the Cosmic Mountain, the World Tree or the central Pillar which sustains the planes of the Cosmos.

This symbol of a Mountain, a Tree or a Column situated at the Center of the World is extremely widely distributed. We may recall the Mount Meru of Indian tradition, Haraberezaiti of the Iranians, the Norse Himingbjör, the "Mount of the Lands" in the Mesopotamian tradition, Mount Tabor in Palestine (which may signify tabbur—that is, "navel" or omphalos), Mount Gerizim, again in Palestine, which is expressly named the "navel of the earth," and Golgotha which, for Christians, represented the center of the world.[10]

Jerusalem was similarly regarded in the Hebrew tradition. According to the Judaic apocalypse and the Midrash, Adam was created in Jerusalem. Paradise itself was considered the navel of the world and the center of the cosmos; in some accounts it was located upon the highest mountain in the world.[11]

In Hebrew literature although the cosmos was not actually represented in an arboreal imagery, the Tree of life in Eden acquired a cosmic significance, especially in the Apocalyptic and Rabbinical symbolism, where its roots were said to extend from above downwards, and its branches to spread over the earth. From the waters of paradise ... it was supposed to derive its life-giving properties, and as Eden was closely associated with Eridu where the cosmic tree was rooted in the omphalos, it too tended to symbolize the navel of the earth like Eridu and Jerusalem.[12]

Trees and pillars representing the Tree of Life were an integral part of the pre-Israelite religion in Canaan. These asherim were intimately connected with the cult of the mother goddess known variously as Astarte or Atargatis. This goddess was descended from the ancient Mesopotamian Inanna-Ishtar, who was both a sea goddess and a sacred tree. Upon the arrival of the Hebrews, many of her sanctuaries and rituals were taken over and adapted to Jewish practice with hardly more than a change in name signifying a dedication to Yahweh. Until the Josiah reformation of 621 BC, pillars or trees sacred to the mother goddess were an orthodox feature of Hebrew religious life.[13]

Early Christians further localized the axis mundi to the Mount of Calvary, adopting much of the ancient symbolism in service of the new gospel:

In Christian tradition ... the mystery of redemption and the Cross of Christ often were interpreted allegorically in relation to the Tree of Life in the garden of Eden, and their correlation not infrequently has been given a cosmic significance, Golgotha becoming the omphalos. Thus, in the third century AD the Tree of Life was described poetically as

Figure 5.1 Christ, as the lamb of God, standing atop the cosmic mountain, from which flow the four rivers of Paradise. Sculptured on a sarcophagus in the Vatican, from the earliest ages of Christianity.

Tree of Life, Mythical Archetype

growing to an immense height, its branches stretching out to encircle the whole world from its center on Calvary, with a bubbling spring at its foot. Thither all nations would resort to drink its sacred water and ascend to heaven by way of the branches of the tree. The theme constantly was portrayed in Christian art and decoration, and it was expounded by Hippolytus in the third century in an Easter sermon in terms of the ancient cosmogonic imagery. "This tree, wide as the heavens itself, has grown up into heaven from the earth. It is an immortal growth and towers twixt heaven and earth. It is the fulcrum of all things and the place where they are at rest. It is the foundation of the round world, the center of the cosmos … It touches the highest summits of heaven and makes the earth firm beneath its foot, and it grasps the middle regions between them with immeasurable arms."[14]

Identification of the cross of Christ with the archaic Tree of Life (Figures 5.2 and 5.3) is revealing in light of the symbolism

Figure 5.2 Christ crucified on the axis mundi, symbolized by the fleur-de-lis. Compare this symbol identifying the axis mundi on Figures 5.4 and 5.5. Stars encircle the aura of the Virgin, and a wound is visible on the right side of Christ. (after an illustration from the *Buch der Heiligen Dreifaltigkeit*, early fifteenth century)

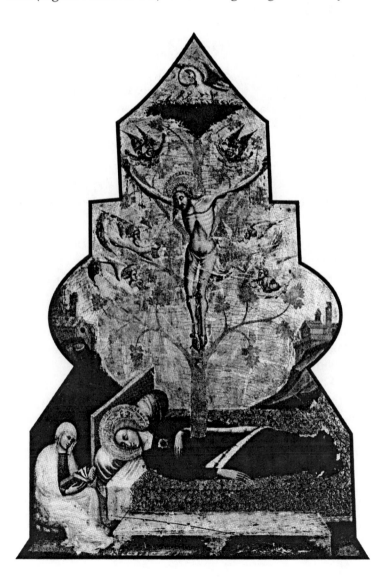

Figure 5.3 The Dream of the Virgin, by Christoforo Simone dei Crocefissi, ca. 1350 AD. Christ is crucified on the Tree of Life, which grows from the navel of the sleeping Virgin. Above, a bird lives in the top-most branches of the tree. Blood flows from a wound in the right side of Christ. Pinacoteca Gallery, Ferrara, Italy.

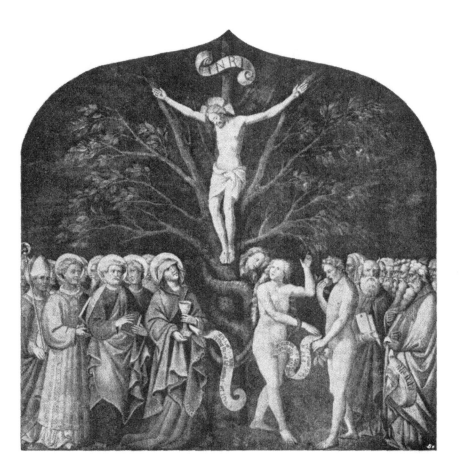

Figure 5.3b Christ crucified on the Tree of Life, Adam, Eve, the serpent, and the saints. Giovanni da Modena; from a fresco in the church of San Petronio, Bologna, Italy.

found in the Roman catacombs during the period of persecutions. The swastika was an early form of the Christian cross and was widely used in the catacombs as the symbol of the Christian faith. Not until the tenth century AD did the familiar Roman cross become the symbol of Christianity in the West.[15]

Nomads of Central Asia ritually localize the axis mundi to their individual dwellings in ceremonies where they bring a tree inside the yurt, its top protruding out the smoke hole in the roof. This smoke hole is oriented toward the polestar, thus linking the tree to the central axis of stellar motion, a common attribute of the axis mundi as we have seen. A similar notion is found in Islam:

Tradition says: the polestar proves that the Ka'ba is the highest situated territory; for it lies over against the center of heaven.[16]

In the ancient world, all observable instances of axial motion occurred in the context of a central shaft. It was around this shaft that the whirling object revolved. The wheel of a cart turned around its axle, the spindle whorl upon its distaff, and the potter's wheel around the shaft attached to the kick wheel. In every case, this axle shaft was located at the hub, or navel, of the rotating object. When human beings observed the rotations of the heavenly bodies, they assumed that the cosmos (or the earth itself) likewise turned about some sort of axle.

The notion of an axis mundi reflects this assumption. The mythical world tree or mountain always exists at the center, axis, or navel of the world, where it was believed to serve as an axle, and this axle was assumed to pass through the earth disk at its exact center point.

The precise point on the earth's surface where this center of rotation was located may have been open to question, but its heavenly position was unambiguous. The celestial poles, both north and south, appear fixed in cosmic space; all the other stars

seem to travel in concentric circles
around them. It was at these poles
that the mythical tree or mountain,
functioning as the world's axle, was
believed to intersect the heavens.

For this reason, myths involv-
ing the Tree of Life—or its related
form as mountain—often contain
references to axial motion. The
three Norns—goddesses of fate in
the Norse myth—live under the
branches of the world tree, Ygg-
drasill. They are described as spin-
ning out the thread of every human
being's destiny. In the *Kalevala* epic
of Finland, the divine creatrix sings
songs about the sampo (a magic
mill symbolizing the axis mundi,
linguistically cognate to the Hindu
skambha) as she works upon her
spindle. In Hindu myth, the gods
churn the ocean with a giant bow
that twirls the axis mundi in the
form of Mount Meru. In Tibet, all
of creation comes into existence
through the whirling of a vortex
represented by the swastika, and
this becomes the name of the Ti-
betan axis mundi—the Nine-Story Swastika Mountain. These
examples illustrate the intimate connection between the axis
mundi in world myth and the countless appearances of potter's
wheels, spindles, vortices, mills, rotating flaming swords, and
similar images that accompany it.

The concept of an axis mundi persisted in western thought
up into the Renaissance, when it became the technical term for
the earth's axis. Figure 5.4 illustrates a fifteenth century engrav-
ing of an armillary sphere, a medieval pointing device for track-
ing planetary motion. The central shaft—marked at the top by
a fleur-de-lis—around which all the celestial bodies revolve, is
labeled "axis mundi."

Figure 5.4 Armillary sphere, a medieval pointing device for tracking planetary and stellar motion. Its central shaft is labeled "axis mundi." A fleur-de-lis marks the northern end of the axis. The celestial equator is marked by a Maltese cross (at 0° lattitude). From Petri Apiani and Gemmae Frisii, *Cosmographia*, Antwerp, 1584. (University of Washington Libraries, Special Collections, from Petrus Apeanus, *Cosmographia*, 1584, UW #28383z)

Source of Immortality

The Tree of Life is, above all, a source of blessings, prosper-
ity, and immortality. In Eden it bears the fruit of everlasting
life. Gilgamesh receives the magic plant The-Old-Man-Shall-
Be-Made-Young while visiting the island of the sacred tree. In
the Aztec legends, a man climbing to the summit of Coatlicue's

mountain could regain his youth. The Norse tree, Yggdrasill, is the sustainer of all life, and Idun—guardian of the apples of immortality—dwells in heavenly Asgard, located at Yggdrasill's height.

Source of Nourishment

Often the Tree of Life furnishes milk, elixir, mead, or other forms of nourishment. In Siberia a goddess united with the tree gives her breast to the hero so that he can drink the milk that increases his strength a hundredfold. Mead drips from the udder of a goat browsing on the highest branch of Yggdrasill. An Egyptian goddess growing out of the sacred tree furnishes food and drink for the souls of the dead. Typically these blessings are said to flow from inexhaustible sources and may be linked to a cornucopia or a cauldron of plenty.

Goddess of Fortune

A goddess is commonly found in proximity to the Tree of Life, or in some cases, actually growing out of it. Usually she is a goddess of fate or fortune, bestowing her bounty of health, prosperity, and long life upon the hero. Lakshmi, the Hindu goddess of fortune, comes into being along with the magic tree when the gods churn the ocean of milk. In Egypt, the tree-goddess Hathor can act as the goddess of fate. In Norse legend, the Norns are associated with the world tree Yggdrasill, and the goddesses Fenya and Menya turn a mill, symbolizing the rotating axis mundi, that grinds out gold and peace—or destruction and disaster. Eve, Medea, and the unnamed wife of Utnapishtim have been mentioned already. These demigoddesses represent the alternative form of the goddess. Eve is the progenitress of the human race; Medea is a sorceress; and Utnapishtim's wife is a human being promoted to divine status after the great flood.

Support of the Heavens

In many cases, an important function of the Tree of Life is to hold up the sky, separating it from the earth below. Typically heaven is held within its highest branches, the earth somewhere in the middle, and the underworld at its roots.[17] The famous pillar destroyed by Charlemagne, the Irminsul of the Germanic tribes, was said to support the sky. Fashioned from a tree trunk, it clearly represented the axis mundi.[18] The skambha of ancient

Figure 5.5 Atlas, with uplifted arms, bearing the heavens. His head bows down below the level of his shoulders in conformance with the typical pattern. The axis mundi (with fleur-de-lis at top) aligns with the Tree of Life (at right), which suffers from an old wound in its side. Atlas is crowned because he is king of Atlantis, and is depicted here standing on his "sea girt island." The inscription is a quote from Virgil's *Aeneid* (1.742–44), which evokes a reference to Calypso's island in the Atlantic (*Odyssey* 5.271–75) since Arcturus is the principal star in Boötes. Significantly, the earth is oriented unnaturally to the celestial motions. The axis mundi intersects the earth's surface in the Atlantic Ocean west of Gibraltar, where the isle of Atlas was believed to be located. The hand of God, in the form of a cloud, twists the axis mundi as if it were the distaff of a spindle whorl. A Maltese cross marks the celestial equator at 0° lattitude. Illustration by John Day in: William Cuningham, *The Cosmographical Glasse,* London, 1559 (Huntington Library: RB 60873).

Figure 5.6 The Egyptian god
Shu holding up the heavens,
which are personified by the
goddess Nut, covered with
stars. Above the shoulders
of Shu are the four pillars of
heaven. At his feet lies Geb, god
of the earth, whose navel aligns
with the central axis of Shu and
Nut.

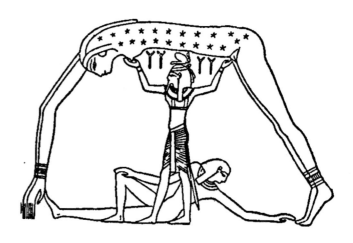

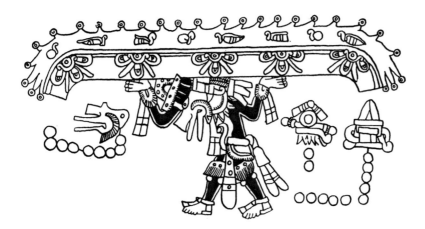

Figure 5.7 Meso-American
figures in this position are termed
"Atlantians" by anthropologists.
This figure is upholding the sky.
Codex Borgia, Mexico, early six-
teenth century.

Figure 5.8 Assyrian god with
upraised arms supporting the
winged disk. Since the winged
disk typically stands over the
Tree of Life (Figures 1.8, 1.11),
it could be argued that the tree
and the god with upraised arms
are symbolically equivalent.

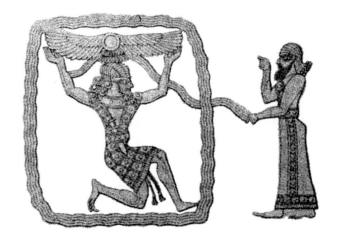

India was likewise a prop that supported the sky. The same concept is also found among remote Indonesian tribes:

> Among the Nad'a of Flores Island … the sacrificial pole is called the "Pole of Heaven" and is believed to support the sky."[19]

Often this supporter of the sky is represented anthropomorphically. The Greek titan Atlas, for example, bears many of the familiar characteristics of the axis mundi. He lives on an island in the western ocean, supports the sky on his shoulders, and lives among the trees that bear the golden apples, which are guarded by a formidable serpent. The posture in which Atlas is typically depicted, with arms upraised to hold the heavens, is common to gods associated with the axis mundi (Figure 5.5). The Egyptian god Shu is characteristically shown in this posture (Figure 5.6), as is the Mexican god Quetzalcoatl in his function as the wind god who lifts up the heavens (Figure 5.7). An Assyrian god assumes this posture as he upholds the winged disk (Figure 5.8).

This form is not limited to male gods, for the Egyptian tree goddesses Nut, Hathor, and Isis are often similarly depicted (Figures 5.9, 5.10, and 5.12). It appears to be an ancient archetype, since the Tree of Life itself is often depicted or described with a bifurcated branching pattern (Figure 5.11).

Ladder Linking Earth, Heaven, and the Underworld

We have noted how among the Semang Pygmies the axis mundi formed a link between earth, heaven, and hell. Such a conception is nearly universal in legends describing the Tree of Life. In Central Asia, the tree trunk placed inside the yurt was believed to act as a ladder leading to heaven, upon which the shaman ascended in his journey.[20] The Kwakiutl believe that a copper pole ascends from the underworld below, passes through the earth, and acts as the door to heaven above. Likewise, the roots of Yggdrasill rest in the underworld, while its branches penetrate heaven. This ladder, path, or bridge whereby the dead are seen to journey toward their place in the afterlife—linked as it is to the Tree of Life motif—figured largely in ancient funerary iconography.[21]

Proximity to Water

Another common characteristic of the Tree of Life is its proximity to water. In many cases this watery element appears as four rivers flowing from the tree in the four cardinal directions,

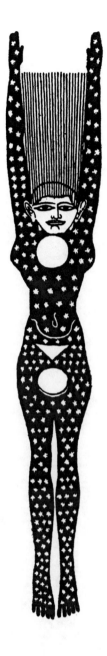

Figure 5.9 Egyptian goddess Nut, covered with stars, arms uplifted in axis mundi posture. At other times she is portrayed as the Tree of Life.

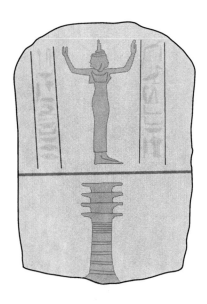

Figure 5.10 Egyptian goddess Isis standing with upraised arms on the Djed pillar, an embodiment of Osiris and the Tree of Life. After a stone stele in the British Museum.

Figure 5.11 Tree of Life with bifurcated branching form, and ogee swastika at center. After an Athenian krater now at the National Museum, Athens (Inv. No. 810).

like the rivers of Eden previously discussed. The legends of Tibet, Siberia, and India provide further examples of this motif. In the mandala sand paintings of the Navajo Indians, four rivers are commonly shown flowing from the center into the cardinal directions, each of which is indicated with a swastika symbol. In Egypt, the sacred persea tree is said to grow from a spring that represents the great watery abyss from which all things were formed. Each of the three roots of Yggdrasill originates in a spring; one of these springs is Hvergelmir, the source of all the world's rivers. In the legends of Babylon, the Tree of Life and the Water of Life are inseparable concepts.

Island Location

Often the tree is said to grow on an island. The sacred carob or cedar grows in the Mesopotamian island paradise of Dilmun; the trees of the Hesperides grow on the island of Atlas; Jumala's oak tree in the legends of Finland grows on the island of Väinämöinen's birth: and a "silver apple tree" grows on the island of joy at the Celtic Elysium.[22]

The Serpent

Specific animals often appear in the myths alongside the Tree of Life. The serpent, which lives at its base, occurs in all parts of the world: In the Norse legends, it is the Midgard serpent; in Egypt, Apophis; in Greek myth, the serpent Ladon guards the tree that bears the golden apples of the Hesperides. In Hebrew legends, the serpent associated with the Tree of Life is sometimes called Lucifer. Gilgamesh slays the "snake who knows no charm" at the base of the huluppu tree. In Siberia, Tibet, and India, the serpent can be found in every legend of the axis mundi, and it occupies a position near the trunk of the tree in the underworld.

Birds

Very frequently a bird or two birds live in the higher branches of the tree, and this bird is typically at enmity with the serpent below. Most commonly the bird is a swan or an eagle, or both. In India, this is the garuda bird, and in Tibet it is the khyung. In Finland, an eagle rests on the single tree spared on the primordial island. In the Norse myths, there are two birds, an eagle and a falcon. The eagle and the Midgard serpent trade insults in their mutual enmity.

Dogs

A dog, or two dogs, appear frequently enough to justify inclusion among the archetypes of the Tree of Life. Cerberus, the Greek hound of hell, guards the entrance of the underworld lest any of the dead should escape (Figure 5.13). In an ancient vase painting, Hercules is depicted in the act of capturing this hound at the base of a conspicuous tree. The hound Garm guards the gate of hell in the Norse myths, and in a variant of this theme, two dogs, Gifr and Geri, guard the citadel of the gods. In Egypt, Anubis, the jackal-headed god, dwells near the gates of the underworld. In Hindu myth, the god Yama owns two dogs who guard the path of the dead.[23] In Mesoamerican mythology, a dog associated with Quetzalcoatl, named Xolotl, guarded the entrance to the underworld.[24]

The Stag

Scholars have noted the close association between the symbolism of the Tree of Life and that of the stag. Evidence of this association is found in early Christian iconography, in the legends of China and the Altaic region, and in the cultures of North and Central America. The most obvious example of this association describes the stags that are said to live in the branches of Yggdrasill. The traditional antagonism between the eagle and the serpent in many of the legends is sometimes replaced by enmity between the stag and the serpent.[25] In chapter 4 we saw trees associated with stags on ceramics from ancient Iraq. In the Navajo sand paintings, swastikas are similarly formed by placing four stags or antelopes in the four cardinal directions. A tribe of Indians from British Columbia tell a legend about how a flaming stag stole fire for the people from a source originally located in a whirlpool at the navel of the ocean.[26] On a Scythian crown dating from the fifth century BC, stags are represented near the Tree of Life (Figure 5.14). And among the Tungus, their folk hero hunted a stag along the Milky Way.[27]

The Goat

Either as a possible variant of the stag motif, or as a separate element in its own right, the goat is also often associated with the axis mundi. One such goat, Heidrun, is said to live in the highest branches of Yggdrasill. In Greek myth, the goat Amalthea nurtures the infant Zeus in a cave on Mount Ida. One

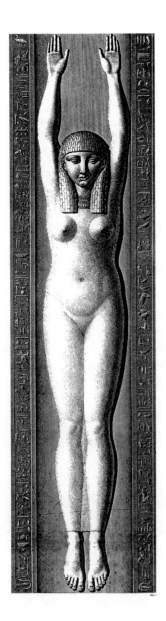

Figure 5.12 Egyptian goddess Hathor, legs together and arms uplifted in axis mundi position. From the temple at Denderah, originally part of a scene depicting the constellations and the zodiac.

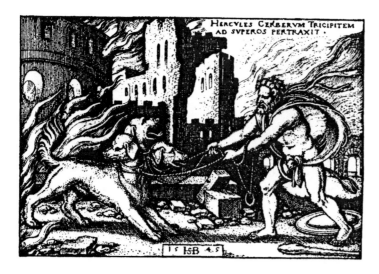

of her horns is later transformed into the cornucopia, and she becomes the constellation Capricorn.

Radiance of the Tree of Life

Respecting the physical appearance of the Tree of Life, there are two traditions. In one, the tree is associated with milk, fleece, snow, cloudiness, and whiteness. In the Norse tradition, for example, the three Norns sprinkle Yggdrasill with water from a spring that turns everything it touches as white as the inside of an egg. In Finland, the sampo is forged from completely white raw materials. In Greece, the home of the gods is upon "snowy Olympus." A milk-white rain falls from the leaves of the Siberian Tree of Life.

The other tradition describes the axis mundi as flaming, radiant, glowing, or luminous. In India, Mount Meru shines like a flame without smoke. In the Hebrew tradition, the Tree of Life is guarded by a flaming sword that turns in every direction. In the *Kalevala*, flame bursts from the sacred oak or birch tree. Often this characteristic is reflected in images of a shining metallic luster such as silver, gold, or other metals. The golden fleece of the Argonauts is a typical example of this usage, as is the golden distaff employed by Helen of Troy, the golden shuttle of the celestial maiden in the *Kalevala*, or the golden pillar of Siberian mythology.[28]

Figure 5.13 Hercules capturing Cerberus, the hound of hell, at the gates of Hades; H. S. Beham, Copper etching.

Figure 5.14 Scythian crown from fifth century BC; stags and the Tree of Life

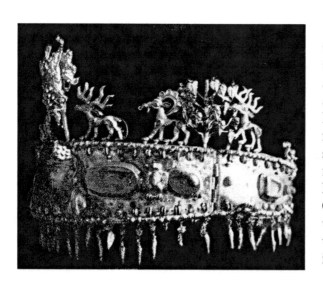

Wound in the Side, Thigh, Genitals, or Leg

I have already discussed at some length the tradition of a heroic quest to the Tree of Life. Often this includes a journey to the underworld and a return, as in the case of Hercules, Odysseus, and Gilgamesh. Not infrequently, the hero or god hangs upon the sacred tree (or on one of its alternate forms), as Odin does upon Yggdrasill, Odysseus upon the ancient fig tree growing above the monster Charybdis, Ixion upon a flaming wheel, Hera upon Olympus, or Christ upon the cross. Often, the hero or god—or even the tree itself—is wounded in the side or in the thigh. Odin is pierced with a sword as he hangs upon Yggdrasill; Christ is pierced in the side at the crucifixion; Odysseus

suffers from an old thigh wound; Hercules is wounded in the thigh in his battle with the sons of Hippocoon. The tree Yggdrasill suffers from a rotten place in its side, while the tree in the *Kalevala* has a worm that eats into its heart. Lilith builds a house in the side of the huluppu tree, and Mount Ida always has a mysterious cave where young gods are hidden.

This archetypical wound or cavity associated with the axis mundi is extremely widespread. In Aztec manuscripts the world tree is often depicted with a gaping hole in its side (Figures 5.12 and 5.13). In some cases, the hole in the side of the tree is seen in the myths as a womb from which a god or hero is born (Figures 5.18, 5.20, 5.21, 5.22, 5.23). When the axis mundi is represented anthropomorphically, the cavity in its side is often portrayed as an irregularly placed birth canal. Buddha was born from his mother's side, Eve from the side of Adam, Dionysus from the thigh of Zeus, and the Egyptian god Set from the side of his mother Nut.

The Symbolism of the Tree of Life

The symbolic nature of the Tree of Life is the subject of much conjecture. The ubiquitous serpent lurking at the base of the tree, for example, seems to represent some feature of the inner or outer life of human beings, some archetype of the conscious or unconscious environment. The typical location of the Tree of Life at the center or navel of the world presents another enigma. In considering this latter question, Mircea Eliade concluded that this great profusion of navels or centers of the world must represent a deep psychological need for human beings to believe that they live near the sacred doorway to the gods.

> There is no sense in trying to "demystify" such a belief by drawing the attention of the reader to the fact that there exists no Center of the World and that, in any case, the multiplicity of such centers is an absurd notion because it is self-contradictory. On the contrary, it is only by taking this belief seriously, by trying to clarify all its cosmological, ritual, and social implications, that one succeeds in comprehending the existential situation of a man who believes that he is at the Center of the World. All his behavior, his understanding of the world, the values he accords to life and to his own existence, arise and become articulated in a "system" on the basis of this belief that his house or his village is situated near the axis mundi.[29]

Even if one takes the point of view suggested in chapter 1, that a center did, in fact, exist and that this center was subsequently localized to many diverse geographical settings, this universal process of localization implies the very psychological

Figure 5.15 Christ pierced in the side by a Roman soldier as he hangs upon the cross; Fiesole, Saint Mark's, Florence.

Figure 5.16 Aztec Tree of Life, with bifurcated branches, bird, and wound in its side. From the *Codex Fejervary*, Mexico, early sixteenth century.

Figure 5.17 Aztec Tree of Life with bifurcated branches, serpent, bird, and wound in its side. From the *Codex Borgia*, Mexico, early sixteenth century.

Figure 5.18 Birth of Adonis from the side of a tree (detail); Hermann van Swanefelt.

dynamics that Eliade describes. The difference is that in the view suggested here, the axis mundi legend is perpetuated in the cultural memory of a given society, rather than being created anew in the imaginative structure or collective unconscious of the human species, as Eliade and Jung suggest. The uniformity and complexity of the myth argues for the view that the legend was prevalent in the very distant past, and that over the course of time it was transferred by migration and transmission to the four corners of the earth. It is conceivable that each individual, whose ego forms the center of his own psychological world, could postulate some corresponding center in physical space and call it paradise. But it is not likely that a diverse multiplicity of individuals, scattered all over the world, would independently create an image of paradise arrayed with four rivers, a sacred tree, a serpent, an eagle or swan, and a wound in its side; and upon which stags and goats produce the elixir of immortality. Such a point of view puts too much reliance on abstract Jungian concepts of a collective and mystical subconscious, when a viable alternative explanation is more logical.

The alternative theory offered in this book does, in fact, explain many of the common features of the Tree of Life legend. It accounts for the tree's location at the point where one river separates into four, as described in so many of the variants. It explains the frequent placement of this tree on an island in the western ocean. It also explains why the tree is so often associated with the titan Atlas, who holds up the heavens. Calypso Atlantis is his daughter, as are the Hesperides, who guard the trees bearing the golden apples, and he is king of Atlantis in Plato's account. The islands of Calypso, the Hesperides, and Atlas were believed in ancient times to be situated off the coast of Gibraltar, precisely where the vertex of the swastika falls. Genesis and many other legends tell

Tree of Life, Mythical Archetype

us that the axis mundi is located at the point where the four rivers join. If Atlas is, in fact, a representation of the axis mundi, then the placement of his island at the vertex of the great Atlantic swastika satisfies all the conditions of the story. Atlas, "who knows the depths of every sea and himself holds the tall pillars which keep earth and heaven apart" must dwell—like his daughter, Calypso—at the navel of the sea. Figure 5.23 illustrates the geography of the Tree of Life according to this conception.

It still remains for us to account for the other attributes of the Tree of Life: the serpent, the birds, the dogs, the stags, the goat, the tree's mysterious luminosity, and its wound. These attributes will be addressed in the following chapters. But first it will be necessary to examine several legends which describe the Tree of Life in more detail so that the generalizations made in those chapters can be evaluated in the light of solid mythological data.

The Esoteric Nature of the Legends

First, however, some additional observations regarding the symbolic nature of the legends are necessary. Descriptions of the Tree of Life in ancient religion are typically cryptic. The full meaning of this symbol was reserved for initiated members of the religious sect, much like the meanings of the parables in the Christian gospels. "He who has ears to hear, let him hear." The reason for this is that the mystery of the Tree of Life was believed to conceal an awesome power—a power that would enable its possessor to realize all human aspirations: for love, wealth, and immortality.

Not infrequently, the axis mundi is personified as a goddess of fortune who bestows fabulous blessings upon the hero, when on his quest he finally arrives at her home at the navel of the world or of the sea. In the Indian Tantric tradition, a mandala was used ceremonially to invoke the goddess of fortune, Lakshmi, represented at its axis. By concentrating on the mandala, Tantric practitioners believed that they could gain all worldly and supranatural powers.[30]

Because the Tree of Life, or axis mundi, was believed to grant great power to those who could reach it, either by performing the magical ritual of the mandala or by undertaking a quest on the seas of the earthly plane, it was considered dangerous to reveal information about this mystery to the uninitiated. Consequently, references to the Tree of Life in the ancient world were shrouded in obliquities, vague allusions, abstract diagrams, and pregnant hints couched in confusing mythological terms. The Tree of Life was an esoteric religious secret, im-

Figure 5.19 Christ with arms upraised in axis mundi position and side-wound. From an Italian minature, fourteenth century.

Figure 5.20 Transformation of Myrrha into a tree and the birth of Adonis from its side; detail from a mid-seventeenth century master.

Figure 5.21 Birth of Eve from the side of Adam. From a French stained-glass window, sixteenth century.

Figure 5.22 Birth of Eve from the side of Adam. Michelangelo, Sistine Chapel, Rome.

bued with power for the initiated, but hidden from the eyes of the profane.

Many of the modern attempts at an interpretation fail to stress sufficiently the fact that all the Vedic passages clearly refer to a mystery, to an esoteric religious symbol: Whoever knows this tree is delivered from death, says the Taittirya rantyaka.[31]

Ancient authors frequently attest to the secretive nature of religious knowledge. Religion in the archaic world existed on two clearly defined levels: first, the esoteric knowledge of the priesthood, whose members were duty bound to hold that knowledge secret upon penalty of death; and second, the watered-down stories and legends imparted to the common people. Diodorus of Sicily, writing in the first century BC, observes that:

the priests, having received the exact fact about these matters as a secret not to be divulged, are unwilling to give out the truth to the public, on the ground that perils overhang any men who disclose to the common crowd the secret knowledge about these gods.[32]

The Greek historian Pausanias was careful not to cross the boundary line between the esoteric and the exoteric. His accounts often stop abruptly, as he reconsiders the propriety of revealing any secret information:

I wanted to go on with this story and describe the contents of the Athenian sanctuary called the Eleusinion, but I was stopped by something I saw in a dream. I must turn to the things it is not irreligious to write for general readers.[33]

A similar theme is echoed by Apollonius Rhodius in his *Argonautica*. He describes how, on the island of Electra, the Argonauts are initiated into certain mysteries that give them power over peril at sea:

Of these [rites] I will make no further mention; but I bid farewell to the island itself and the indwelling deities, to whom belong those mysteries, which it is not lawful for me to sing.[34]

And Herakleitos puts the matter succinctly:

The Lord who prophesies at Delphi neither speaks clearly nor hides his meaning completely; he gives one symbols instead.[35]

The same may be said of the subject matter in these chapters. The truth is not completely concealed, nor is it obvious.

Numerous hints and symbols are there in the myths for the serious seeker to unravel, but they are veiled in many ways meant to discourage the profane. The reason for all this secrecy was that the religious cult endeavored to protect the power inherent in the mystery, retaining that power for the cult's own use.

Despite these ancient precautions, it is now possible to penetrate the mystery of the Tree of Life. Because this theme occurs so widely in world mythology, and because the details of its many variants have been collected and published by anthropologists, it is possible to piece together the main lines of the original legend. Every culture that employed this myth divulged enough detail through its open, exoteric teachings to insure that it would be retained in the memory of the people, but not enough detail to betray its full esoteric significance. Each culture, however, chose different details to withhold. Consequently, when we compare the many worldwide variants of the myth, enough details emerge to reveal what the Tree of Life represented, where it was located, and what it meant to people in the ancient world.

In the next chapter, we will examine the legends of four archaic cultures in detail. These provide a reliable foundation upon which to base a reconstruction of the common myth underlying the many worldwide variants. In the course of this examination a particular feature of the natural world is evoked by the symbolism of the images. The galaxy is a natural phenomenon that appears radiant, white, milky, treelike, and it is surrounded by animal constellations. It is located near the celestial poles and can thus easily be imagined to fulfill the function of axis mundi. It appears like a luminous tree in the heavens, a tree whose branches encircle the sky, and whose trunk appears to touch the surface of the earth far, far away—so far away that a long sea voyage would be required to reach the remote point where it grows in the earth-encircling River Ocean.

Figure 5.23 Transformation of Myrrha into a tree and the birth of Adonis from its side; Jean le Pautre (detail).

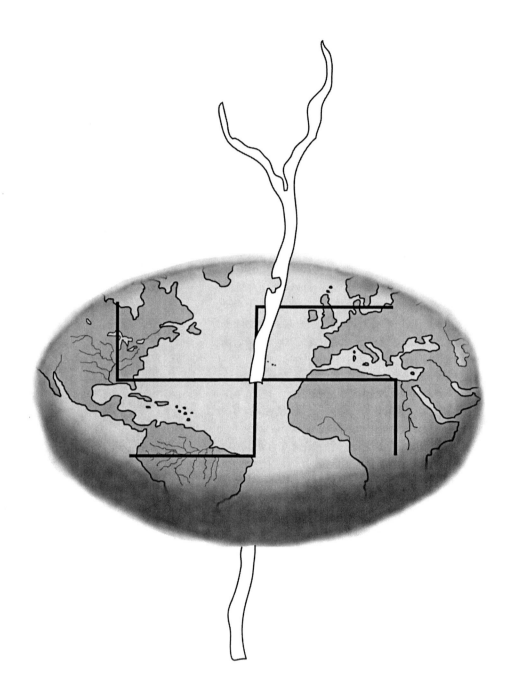

Figure 5.24 Ancient conception of the Tree of Life as abstracted from Eurasian myths; the axis mundi intersects the earth-disk at the vertex of the Atlantic swastika.

Chapter 6

Four Eurasian Mythical Traditions

The highly developed civilizations of the world provide a wealth of mythological records. Their legacy of written documents, architectural monuments, and objects of art preserve creation myths and religious traditions that would otherwise be forgotten. But the geographic and economic conditions that give rise to such centers of power tend also to bring about their destruction. Continuous warfare over resources typically destroys any continuity of their oral traditions.

In contrast, isolated cultures inhabiting regions where the climate is harsh and the soil is poor tend to preserve the myths in their most pristine form. These more remote regions lack the concentrations of wealth that make them attractive targets for conquest. Such obscure cultures living at the periphery of civilization are often more tribal than urban, and the continuity of their religious ideas tends to be simple and conservative. Often the oral tradition has persisted down into the present, providing modern informants where ancient written records are lacking. The unadulterated myths from these cultures, therefore, are often very useful for the purposes of comparison.

The traditions of Siberia, Finland, Iceland, and Tibet represent four major ethnic and linguistic families spanning the length and breadth of Eurasia. Despite their cultural and geographic diversity, the myths that refer to the Tree of Life, or axis mundi, in each tradition are remarkably similar. So great is the agreement among these myths that the conclusion is

inescapable that they must have shared a common origin. Beyond the remarkable consistency they exhibit, each myth contains a few details that can be considered derivative and of local origin only. This is because such details do not appear in the parallel myths of other cultures. On the other hand, when attributes do recur in one or two—perhaps distant—other traditions, they can usually be accepted as genuine and archaic.

This chapter summarizes briefly the Tree of Life myth in each of these four cultures. Concrete examples of the mythical traditions, from which the observations in chapter 5 were drawn, are provided, with emphasis on the recurrence of the fifteen attributes. A table is provided at the conclusion of this chapter which indicates the presence or absence of these fifteen individual attributes in each of the mythical traditions examined here.

I

Iron Mountain and the Siberian Tree of Life

The existence of a Tree of Life, growing from out of its watery source and reaching up to heaven, is a commonly held religious belief among the various peoples who inhabit the region of Siberia. Here too, the alternative form of an enormous mountain sometimes takes the place of the tree, and at other times, is found together with it. Often the tree is said to grow from the summit of the mountain. The legends are emphatic about one point: The tree is located at the navel of the world. It is typically associated with images connoting whiteness or milk, and along with these, frequent celestial references. Uno Holmberg writes:

> At the navel of the earth, in the centre of the universe, according to Altaic tales, the highest tree on earth, a giant silver-fir, raises its crown to the dwelling of Bai-Ylgön ... Generally this tree is also imagined to grow on a high hill or mountain, especially on the central mountain of the earth ... but as this central mountain of the earth-disc is generally believed to hide its summit among the storeys of the sky, the tree itself, for very obvious reasons, has been raised into the sky, where, according to different beliefs and tales it continues to exist ... And independently of whether it rises from the earth, a high mountain, or some storey in the sky, its position always resembles that of the world-pillar ...

In most of the tales it is situated on the brink of some spring, lake or sea, even at times in the water itself. The Ostiaks speak of "the watery sea of the heaven-centre" beside which this tree grows … On the yellow navel of the eight-edged earth, according to one [Yakut tale], there is a dense, eight-branched tree … From the crown of the tree runs foaming a heavenly, yellowish liquid. When passers-by drink of this, the tired among them are refreshed and the hungry become satisfied …

[Another Yakut] tale describes "the First Man" as "the White Youth." "Above the wide motionless depths, below the seven storeys, the nine discs of heaven, in the central place on the navel of the earth, in the quietest place, where the moon does not decline, nor the sun sink, where there is summer without winter and the cuckoo sings eternally, was the White Youth"… In the east he saw a wide, lightish plain, on the plain a mighty hill and on the hill a giant tree … The crown of the tree rose over the seven storeys of heaven … and its roots went deep down into the underground depths where they were the dwelling pillars of the strange mythical beings there …

Walking southward the White Youth saw a calm "lake of milk" in the centre of a green, grassy plain, which lake was never rippled by a breath of wind and on the shores of which were curdled swamps. In the north was a dark forest, where the trees rustled day and night and where all manner of animals moved. Behind the forest rose high mountains, bearing caps that resembled white rabbit-skin; the mountains leaned against the heavens, protecting these from cold winds … [When he approached the tree of life] the leaves of the tree commenced to rustle and a fine milk-white rain dripped from them upon the White Youth. A warm zephyr was felt, the tree creaked, and from under its roots a female being arose up to her waist. This spirit of the tree and of the place is described by the tale as a grave-eyed, middle-aged woman with flowing locks and naked bosom. The goddess offered the Youth milk from her swelling breasts, and having drunk, he felt how his powers had grown a hundred-fold. At the same time the goddess promised him every happiness and blessed him so that neither water, fire, iron nor anything else could harm him …

The Kalmucks relate how a dragon in the sea at the foot of the Zambu tree lay in wait for the leaves dropping from Zambu … In the Buriat poems a mythological snake called Abyrga is said to dwell at the foot of the tree in a "lake of milk." In certain Central Asian tales the Abyrga snake twines round

the tree itself, while at the same time the Garide eagle living in the crown attacks and pecks at it …

The Kalmucks tell how the Zambu tree rises out of the Marvo Sea, which is as deep as it is broad and contains water of eight different elements. From this sea run four great rivers. These are said to flow towards the different point of the compass.[1]

In conformance with the typical pattern, the Siberian tree or mountain is located in the middle of the sea, with four rivers flowing in the four cardinal directions. The Siberian legends also echo the notion that the cosmic tree or mountain connects the three worlds: earth, heaven, and the underworld. The presence of a serpent at its base and an eagle in its branches is a near-universal trait also. The enmity between these two (serpent and eagle) is typical; it can be found in the Norse, Babylonian, Hindu, and Tibetan versions, as well as in Mesoamerican legends. The flag of Mexico depicts an eagle with a serpent in its beak, and this reflects an Aztec myth: the god Huizilopochtli instructed the Aztecs to establish a city where they first found an eagle devouring a serpent on an island in the middle of a lake.[2] The Siberian legend may be the source of the pre-Colombian American myth, since at least some of the early immigrants to America are believed to have come across the land bridge from Siberia during the last ice age.

In the Yakut tradition, the Tree of Life is the conduit for a foaming liquid that satisfies all desires. This is another hallmark of the world tree legend, as we have seen. In the Norse version all the waters of the world have their source in the dripping antlers of a stag that lives in the upper branches of the tree. Heavenly mead drunk by the gods falls down from the udder of a goat that eats leaves from its highest branch. Remember too the descriptions of Aeaea, where the Argonauts find springs running in four directions, gushing with milk, water, wine, and fragrant oil. In the Hindu account of the churning of the Ocean of Milk, the whirling of the cosmic mountain brings forth ambrosia as well as the divinity Sri, who is the goddess of fortune.[3] Likewise in the Siberian myth, we find the image of the goddess who feeds the first man from her breasts.

The great mountain at the center of the world is often described as the Iron Mountain in Siberian legend, and this is further evidence of an ancient belief in its celestial nature. For iron is the metal that falls from the heavens, and meteors were humanity's first source of iron.

Holmberg, who lived among the Siberian tribes for extended periods, also describes their beliefs in a cosmic pillar located at the center of the rotating heavens. In some cases this pillar

is represented by votive objects that hang from the shaman's dress, and which take the form of birds with two heads.

The regular diurnal movement of the stars round an axis at the North Star, the reasons for which never-ending rotation were earlier unknown, gave birth to an idea that this apparent center of the universe was formed by some object which could be represented in concrete form, and which was, in addition, believed to support the roof of the sky. This belief we have seen to be held by the Lapps, etc., and the relics of a similar belief are to be found among most of the peoples of the Northern hemisphere.

From this belief spring the curious names given by the Altaic stocks to the North Star. The Mongols, Buriats, Kalmucks, and the Altai Tatars and Uigurs call the star in question "The golden pillar"; the Kirghis, Bashkirs and certain other Siberian Tatar tribes call it "The iron pillar"; the Teleuts "The lone post," and the Tungus-Orotshons "The golden post." From the similarity of the names given it by these widely separated peoples we may conclude that the conception of a sky-supporting pillar reaches back among the Altaic race to a comparatively early period. In a tale of the Yakuts in which the world is regarded as having gradually developed from a small beginning, this "iron tree" boasts: "When the heavens and the earth commenced to grow, I grew with them."[4]

… Some peoples in North-West Siberia, who have a similar custom, place on the world-pillar a wooden figure of a bird, which sometimes has two heads. What this bird, which is spoken of by the Dolgans as the "lord of the birds," and which hangs on the breast of the Yenisei Ostiak shaman-dress, is intended to represent, the people themselves do not know …[5] (Figure 6.1).

Nor is the image of a celestial goddess lacking among the Siberian tribes. Typical of galaxy goddesses in world myth, she is intimately associated with milk.

Among the eastern Finno-Ugric peoples we have already met with a mighty goddess of birth, called by the Cheremiss and the Mordvins the "Great birth-mother," whose dwelling-place these peoples, like the Votiaks and the Ugrians living on the Ob, believe to be in the sky. The same goddess is known to certain peoples of the Altaic race. When celebrating their spring-festival at the time when the flowers break froth, the Altai Tatars, among other deities, remember a goddess called "The Lake of Milk." In many prayers she is referred to as the "Milk Lake mother" and worshipped as the giver of all life.[6]

Figure 6.1 Ornaments made of iron that hang from the dress of a Siberian shaman. These double-headed birds were used as decorations among the Yenisei Ostiaks. By the 1920's the meaning of these symbols had been forgotten by the people who employed them. Their representation of the branching pattern of the Milky Way is unmistakable. (Source: Holmberg, 1964.)

The *Kalevala* of Finland

In the *Kalevala* epic of ancient Finland, much of the world-tree imagery is associated with the hero Väinämöinen. He is the immortal first-born of creation, his mother being the divine creatrix, Ilmatar. Several different variants of the mythical Tree of Life are described in the *Kalevala*, the first being the great oak tree of the god Jumala.

The story describes a virgin living within the spacious mansions of the air. Weary of her lonely existence, she descends into the ocean, where a teal makes a nest upon her upraised knee. The teal lays seven eggs, and while brooding over them engenders such heat that the virgin—also called Water Mother—jerks her leg back in pain; the eggs crack and fall down into the waves of the ocean.

From the fragments of these broken eggs, the earth, sky, sun, and moon are created. Islands are formed, and pillars of the sky established. For thirty years Väinämöinen grows within the womb of Water Mother and finally, at his birth, falls into the ocean. Standing upon a "sea-encircled island," Väinämöinen sows the seeds of many trees:

> Yet had Jumala's tree, the oak tree,
> Not struck down its root and sprouted.[7]

Four lovely maidens rise from the sea and cut down all the vegetation of the island, raking it into a heap at the very summit. This is then kindled into a great consuming fire. An acorn planted in the ashes of this fire grows into an enormous oak, forking in two directions. Its leaves expand into the air, and its summit rises up to heaven:

> Whence the beauteous plant sprang upward,
> And the sapling grew and flourished,
> As from earth a strawberry rises,
> And it forked in two directions.
> Then the branches wide extended,
> And the leaves were thickly scattered,
> And the summit rose to heaven.[8]

Eventually the tree grows so large that it blocks the light of the sun and the moon, forcing Väinämöinen to think of a way to remove it. When chopped down, the tree bursts into flames, and the pieces scatter far and wide. Significantly, these pieces lie in a north-south orientation, and each piece of the tree becomes a talisman of fortune, providing wealth (prosperity), power (magic), and love:

From the axe, the flame was flashing,
Flame was bursting from the oak-tree.
… And the tree was scattered southward,
And the branches to the northward.
He who took a branch from off it,
Took prosperity unceasing,
What was broken from the summit,
Gave unending skill in magic;
He who broke a leafy branchlet,
Gathered with it love unending.[9]

Once the tree is down, clouds cover the "island's misty summit." Now the trees, the grass, the berries, and all the other plants flourish; only the barley refuses to grow. A titmouse from a nearby tree reveals to Väinämöinen the reason for this. Again the forest must be cleared, he is told. All the vegetation must be cut down and burned. Accordingly the hero levels the forest, sparing only a single birch tree so that birds may rest on its branches. An eagle expresses his gratitude for the tree and then bursts into flames.

Said the bird of air, the eagle,
"Very wisely hast thou acted,
Thus to leave the birch-tree standing
And the lovely tree unfallen,
That the birds may perch upon it,
And that I myself may rest there."
Then the bird of air struck fire,
And the flames rose up in brightness.[10]

Another passage from the *Kalevala* describes the childhood of Väinämöinen. Characteristic images of milk, and of the axial motion of the spindle, evoke associations with the axis mundi. These associations are made explicit in a reference to the Sampo.

And my mother taught me likewise,
As she turned around her spindle,
When upon the floor an infant,
At her knees she saw me tumbling,
As a helpless child milk-bearded,
As a babe with mouth all milky.
Tales about the Sampo failed not.[11]

In the legends of Finland, the Sampo is a mysterious mill, which, like that of Fenya and Menya in the Norse legends, grinds out prosperity for its owner. Etymologically, the word is cognate to the Sanskrit term *skambha*, which designates the world tree as the axis mundi, located at the center of the spinning cosmos. This wooden shaft or tree-trunk is the Hindu Tree of Life.

As for the name Sampo, it resisted the efforts of linguists, until it was found that the word was derived from the

Sanskrit skambha, pillar, pole. Because it "grinds," Sampo is obviously a mill. But the mill tree is also the world axis ... The Sampo is—or was—the dispenser of all good things.[12]

Scholars have recognized that the skambha and the Tree of Life are identical. In ancient Hindu myth it appears both as a shaft supporting the sky and as a tree in the same position. The two forms are functionally equivalent:

> The tree of life is encountered in Indic literature and religion in various guises and is symbolically identifiable and partly co-functional with the universal column, even when the latter is not conceived as an organic tree, or when the tree has been transformed into a colossal stave as in the case of the skambha of Atharva-Veda 10.7 . . . The skambha (supporter), which is the sustainer of the universe, is portrayed . . . as fashioned from the trunk of a tree in a way comparable with the Irminsul of the Saxons. But the same hymn also characterizes the skambha as still possessing branches, so that we must accept the sustainer as symbolically heteromorphic.[13]

The following lines from the *Kalevala* demonstrate that the Sampo was created from entirely white raw materials, including milk. When negotiating for a bride, Väinämöinen is told by the bride's mother:

> But if you can forge a Sampo,
> Weld its many-colored cover,
> From the tips of swan's white wing-plumes,
> From the milk of barren heifer,
> From a single grain of barley,
> From a single fleece of ewe's wool,
> Then will I my daughter give you.[14]

The young woman of Väinämöinen's choice is very lovely, and her dwelling is celestial. We know this because Väinämöinen has to look up very high to see her. This, combined with her rotating reel and her shining luster, suggests that she is another axis mundi goddess:

> Clad in robes of dazzling luster,
> Clad in raiment white and shining.
> There she wove a golden fabric,
> Interwoven all with silver,
> And her shuttle was all golden,
> And her comb was all of silver.
> From her hand flew swift the shuttle,
> In her hands the reel was turning ...
> When he heard the shuttle whizzing,
> High above his head he heard it.
> Thereupon his head he lifted,
> And he gazed aloft to heaven.[15]

But the maiden refuses to wed Väinämöinen unless he builds a boat for her out of the splinters of her spindle. Emphasis on the spindle here is further evidence for her association, or identification, with the axis mundi:

> No I will not yet go with you,
> If a boat you cannot carve me,
> From the splinters of my spindle.[16]

Väinämöinen cuts his leg severely while hewing the spindle to construct the maiden's boat. The evil spirit Hiisi (also called Lempo) causes the axe blade to deflect against the hero's knee. This injury fits the general pattern of the side or thigh wound suffered by gods and heroes associated with the axis mundi:

> But at length, upon the third day,
> Hiisi turned aside the axe-shaft,
> Lempo turned the edge against him,
> And an evil stroke delivered.
> On the rocks the axe-blade glinted,
> On the hill the blade rang loudly,
> From the rock the axe rebounded,
> In the flesh the steel was buried,
> In the victim's knee 'twas buried.[17]

Because this wound is caused by a steel axe blade, a spell must be found that is effective against iron-inflicted wounds. This need prompts Väinämöinen to recite the legend of the origin of iron, which is celestial. The three mothers of iron in Cloudland are bursting with milk from their overflowing breasts. The milk falls down to earth and turns into iron:

> And three maidens were created,
> Three fair Daughters of Creation,
> Mothers of the rust of Iron,
> And of blue-mouthed steel the fosterers.
> "Strolled the maids with faltering footsteps
> On the borders of the cloudlets,
> And their full breasts were o'erflowing,
> And their nipples pained them sorely.
> Down on earth their milk ran over,
> From their breasts' o'erflowing fullness,
> Milk on land, and milk on marshes,
> Milk upon the peaceful waters.[18]

All of these images: a celestial origin, clouds, milk, and the wound in the leg of the hero, are images that are associated with the axis mundi.

Since Väinämöinen has been unsuccessful at forging the Sampo, he attempts to persuade the smith Ilmarinen to undertake the task. Ilmarinen, however, is reluctant to journey to the gloomy northland, so Väinämöinen tricks him into climbing up an enormous pine tree, the branches of which reach up to

heaven. This characteristic suggests that the pine tree is an alternate form of the Tree of Life:

> Then they both went forth to see it,
> View the pine with flowery summit,
> … Then the smith his steps arrested,
> In amazement at the pine-tree,
> With the Great Bear in the branches,
> And the moon upon its summit.[19]

After Ilmarinen climbs up the pine tree, Väinämöinen conjures up a huge wind-storm that carries the smith to Pohja in the north. There, in promise for the maiden, he forges the Sampo out of the four white materials. Again like the Norse mill of Fenya and Menya, the Sampo can grind out both gold and salt:

> [He] forged with cunning art the Sampo,
> And on one side was a corn-mill,
> On another side a salt-mill,
> And upon the third a coin-mill.
> Now was grinding the new Sampo,
> And revolved the pictured cover.[20]

The Sampo was locked inside a stone mountain, also described as a hill of copper. These descriptions, linked to the turning mill, evoke the typical axis mundi mountain, often said to be of gold, silver, copper, or iron. The revolving pictured cover, the whiteness of the salt, the association with prosperity, and the etymological link to the Skambha further identify the Sampo as the axis mundi.

Later Väinämöinen decides to build another boat. Lacking the necessary wood, he orders a companion, Sampsa Pellervoinen, to fell a tree for this purpose. Sampsa finds an aspen three fathoms high, which warns him, however, that its wood is rotten and hollow, because

> Thrice already in this summer,
> Has a grub my heart devoured,
> In my roots a worm has nestled.[21]

This worm appears as a representation of the serpent that lives at the base of the Tree of Life. The injured heart of the tree represents the side wound that the world tree is sometimes said to endure. So Sampsa lets it stand, and journeys on his way until he finds a pine tree six fathoms high. While he is preparing to cut it down, the tree warns him that its wood is full of knots, because:

> Thrice already in this summer,
> In my summit croaked a raven,
> Croaked a crow among my branches.[22]

This bird in the branches of the pine tree corresponds to the bird that lives in the branches of the Tree of Life. Undaunted,

Sampsa continues his journey until he discovers an oak tree nine fathoms high. He fells this oak and takes the wood to Väinämöinen, who constructs the boat from it. But the boat will not float for lack of three magic words, which must be fetched from the Underworld. Väinämöinen travels to Tuonela and asks the mistress of the Underworld for the magic words. She refuses to give them, telling him instead that he must remain a prisoner there forever; and in a single night, she weaves a net to bind him. In this she resembles Circe and Calypso, also said to work their looms on islands amid the waters, and to hold wandering heroes prisoner:

> There's in Tuonela a witch-wife,
> Aged crone with chin projecting,
> And she spins her thread of iron,
> And she draws out wire of copper,
> And she spun of nets a hundred,
> And she wove herself a thousand,
> In a single night of summer,
> On the rock amid the waters.[23]

This brief verse contains many elements of the Tree of Life myth—a goddess who is spinning, an island in the middle of the waters, a location in the underworld, and a thread of (celestial) iron. That the goddess does her weaving at night may also be significant, because that is the time when the revolving stars are visible – another axis mundi marker. Only with great difficulty and much shape-shifting does Väinämöinen finally escape her net. Afterwards he warns all others to shun that underworld land to which many have ventured, but from which few have returned.

Finally, Väinämöinen and his friends set out to recapture the Sampo from within the hill of copper in the far north. But its roots have grown so deeply that it is impossible to move:

> But he could not move the Sampo,
> Could not stir the pictured cover,
> For the roots were rooted firmly
> In the depths nine fathoms under.[24]

These deep roots that have grown from the Sampo are further evidence of its original arboreal nature, and of its identity with the Tree of Life. The heroes harness a gigantic bull and, with its assistance, plow out the Sampo. When his companion asks what Väinämöinen intends to do with the Sampo, he replies that they will take it to an island of immortality, where it can remain forever:

> Thither will we bear the Sampo,
> And will take the pictured cover,
> To the misty island's headland,
> At the end of shady island,

There in safety can we keep it,
There it can remain for ever.
There's a little spot remaining,
Yet a little plot left over,
Where they eat not and they fight not,
Whither swordsmen never wander.[25]

Before they can arrive at this destination, however, they are overtaken, and in the battle that ensues, the Sampo is broken. Väinämöinen gathers the pieces and plants them like seeds on his island, where they grow up and bestow unceasing prosperity on its people. Lest in future any evil should threaten the land, Väinämöinen prays to the god Jumala:

Build thou up a fence of iron,
And of stone a castle build us,
Round the spot where I am dwelling,
And round both sides of my people.
Build it up from earth to heaven,
Build it down to earth from heaven,
As my own, my lifelong dwelling,
As my refuge and protection.[26]

Thus in this final image we have the Sampo/Tree of Life growing on an island in the sea. It bestows blessings and prosperity on a land where there is no death, neither from hunger nor from warfare. A circular castle of stone or iron is constructed from earth to heaven, and this will be Väinämöinen's eternal dwelling place.

III

The Norse Myths

Background

We would know very little about Norse mythology had it not been for the determination of Harald Fairhair to woo princess Gyda in the ninth century. Harald was a minor Norwegian king—one among many others of his time; the country was fragmented into dozens of small autonomous kingdoms. When he dared propose marriage to Gyda, she dismissed him, declaring that she would marry no man who was not king of all Norway.

Harald was a determined man. He vowed not to cut his hair until the day all of Norway was his, and Gyda lay in his arms. Thus began his cruel war of conquest, with its simple ultimatum to the hereditary kings: Pay tribute or die. The army he assembled was large and fierce; early successes only increased his military power, and soon no local king could withstand his assault. One after the other, the kings fell, either to the sword or to self-imposed exile. Loading families and trusted followers aboard the narrow Viking ships, they set out for points west: Ireland, the Orkneys, the Hebrides, or if very courageous, to Iceland.

Iceland had remained nearly uninhabited until the political pressure exerted by Harald made it the destination of choice for the former elite of Norway.[27] It was a highly cultured and well-educated group of immigrants who first staked their claims to the virgin soil of that distant island. A tradition of democracy and independence took root from the very first, in reaction to Harald's tyranny. The literacy rate of its citizens was probably the highest the world has ever seen, then or now. They were not only readers, but also very capable poets and historians. The Icelandic sagas are some of the most compelling and fascinating historical accounts ever composed; among them, stories of the discovery and colonization of America by the Norsemen.

The remoteness of Iceland protected it from the cultural revolutions of medieval Europe, and it was not until the year 1000 AD that the island adopted Christianity. Unlike similar transitions elsewhere, this one occurred peacefully, through a majority vote of the island's citizens. But the old traditions persisted in parts of the countryside and even assumed the status of a respected cultural heritage to be preserved in both oral and written forms. Centuries later, when serious scientific collectors began scouring Iceland for literary manuscripts, they discovered invaluable parchments that had been treasured family heirlooms for generations.

A major source of information about ancient Norse mythology was compiled around the year 1220 by Snorri Sturluson, a highly educated and powerful political figure in thirteenth-century Iceland. His *Prose Edda* provides a narrative covering many aspects of traditional Norse belief, often quoting from sources that would otherwise be unknown. Since Iceland had been Christian for over two centuries when Snorri collected the old legends, some foreign elements had crept in, but for the most part, these elements are easily identified. The vast bulk of Snorri's

Figure 6.2 A clay funeral urn, found containing burnt bones, an iron knife, a needle of bronze, and melted lumps of glass from beads of different colors; from Bornholm.

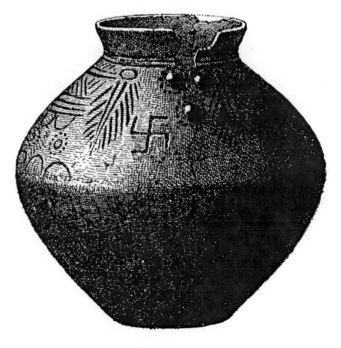

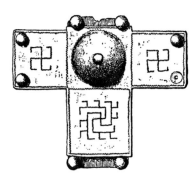

Figure 6.3 Mountings to leather straps, with swastika and gilt knobs; from a bog in Thorsbjerg.

Figure 6.4 Two examples of the Ouroboros symbol.

work reflects the authentic earlier material, especially when he quotes the older sources.

But the oldest and most faithful accounts of the ancient religious beliefs were preserved as skaldic poetry in only a few codices. Those most ancient, sometimes fragmentary, but always powerful verses have been collected and published as the *Poetic Edda*. Although the dates of their original redactions are disputed, the lays were probably written down in the period between the eleventh and the early thirteenth centuries, and were clearly based upon much older oral and written traditions.[28] It is not known whether all the documents discovered were originally produced in Iceland, or whether some had been imported from Norway, but all were found preserved in Iceland.

The Norse Tree of Life

These manuscripts reveal that the Tree of Life was central to northern religious thought. Yggdrasill, as the tree is called, is the chief abode and holy place of the gods, where the high ones meet and deliberate each day. It is conceived as being an immense ash tree:

> The ash is greatest of all trees and best: its limbs spread out over all the world and stand above heaven. Three roots of the tree uphold it and stand exceeding broad: one is among the Aesir [the gods]; another among the Rime-Giants, in that place where aforetime was the Yawning Void; the third stands over Niflheim [hell], and under that root is [the well] Hvergelmir; and Nidhöggr [the serpent] gnaws the root from below.[29]

This serpent is also called Jörmungand, a type of Ouroboros that surrounds the whole earth and bites its own tail (Figure 6.4).[30] True to archetype, the Norse world tree exhibits many of the common features seen in other cultures. It is a link between heaven, earth, and the underworld, for the "Yawning Void" is the primordial birthplace of the first man.[31] The roots of Yggdrasill represent the bridge that was typically believed to link these three worlds. The well Hvergelmir is a vast body of water from which all rivers in the world take their source.[32]

Snorri tells us that Urd, the goddess of destiny, has her home in the heavens, near a spring under the ash tree.[33] The *Poetic Edda* also describes a goddess of fate, but there she appears in the form of a trinity of goddesses, the three Norns.[34] This trio resembles the three Parcae of ancient Rome and the three Moirae of Greece (Figure 6.5). They too are goddesses of fate and, like the three Norns, are typically depicted with spindles. Of the Norns, the seeress Voluspá says:

Tree of Life, Mythical Archetype

An ash I know, Yggdrasil its name,
With water white is the great tree wet;
Thence come the dews that fall in the dales,
Green by Urd's well does it ever grow.

Thence come the maidens mighty in wisdom,
Three from the dwelling down 'neath the tree;
Urd is one is named, Verthandi the next,
And Skuld the third. On the wood they scored,
Laws they made there, and life allotted
To the sons of men, and set their fates.[35]

The image here of the white water which moistens Yggdrasill is a typical reference to whiteness that occurs frequently in world myths associated with the Tree of Life. Snorri provides another example that describes how the tree is sprinkled with water so sacred that it turns all things white. We must infer, therefore, that the tree itself is white.

It is further said that these Norns who dwell by the Well of Urd take water of the well every day, and with it that clay which lies round about the well, and sprinkle it over the ash, to the end that its limbs shall not wither nor rot; for that water is so holy that all things that come there into the well become as white as the film which lies within the eggshell ... Two fowls are fed in Urd's Well: they are called swans, and from those fowls has come the race of birds that is so called.[36]

Here we find a description of the two birds that are frequently placed in association with the Tree of Life. In this case they are swans, a species of bird known for its pure white color and its large size. In an alternate version, Snorri describes two other birds that live in the branches of Yggdrasill: an eagle, with a hawk perched between his eyes.[37] Thus we see both a swan and an eagle associated with the Tree of Life in Norse myth.

Four Rivers

This characteristic whiteness appears again in the *Prose Edda* where we are told how the divine cow, Audumla, emerges from the primordial ice. Four rivers of milk

Figure 6.5 An adaptation from Michelangelo, *The Three Fates*. The Fates were traditionally depicted as spinners: The first spun the thread of a man's life, the second measured its length, and the third snipped the thread at the moment of his death; Pitti Palace, Florence.

are said to flow from her udder.[38] This description evokes images of the divine cow, previously discussed, which figured as the mother of Gilgamesh, and as alternate forms of the goddesses Hera, Nut, Hathor, and Isis. The four rivers flowing from a common source at this divine cow parallel the many other mythical descriptions of four rivers that share a point of confluence. That they flow with milk is a familiar characteristic which echoes the milk-white rain falling from the Siberian Tree of Life, or the stream of milk which flowed from the breast of Hera when Hercules sucked on it with too much force.

We know that Yggdrasill is associated with four rivers because Thor must wade through each of them on his way to the daily council of the gods, which is held near the sacred tree. He would crush the delicate bridge used by the other gods, so he must take the long way around. This bridge is "flaming with fire," as we are told in the *Prose Edda*, and this is yet another familiar characteristic of the radiant and luminous axis mundi. The water of the four rivers—Körmt, Ormt, and the two Kerlaugs—also glows from contact with the flaming bridge.[39]

Stags and Goats

From the *Poetic Edda*, we know that the world tree acts as a conduit for the waters as they flow down from heaven and fill the well Hvergelmir, the source of all the earthly rivers. A stag named Eikthyrnir eats leaves from the highest branch of the world tree (the branch is specifically named Lerad or Laerath). From his antlers flow down drops of water in such profusion that Hvergelmir is filled:

> Eikthyrnir, the hart, on the hall that stands,
> eateth off Laerath's limbs;
> drops from his horns in Hvergelmir fall,
> thence wend all the waters their way.[40]

Snorri mentions four other stags that likewise feed on the branches of Yggdrasill:

> Four harts leap about the branches of the ash and eat the shoots; these are their names: Dáin, Dvalin, Duneyr, Durathrór.[41]

Images of these stags have been discovered as carvings on the wooden doors of stave churches in Norway (Figure 6.6). This icon corresponds to stags pictured on funeral urns of the geometric period in Greece, and to the many swastikas formed by stag patterns on artifacts from early Mesopotamia. The drops, which fall from the antlers of the stag in such quantities as to fill all the rivers of the world, suggest that this motif may be an alternative version of the mythical goat that is also said

Figure 6.6 A stag nibbles the branches of Yggdrasill. Wood carving on the door of the church of Urnes at Sogn, Norway.

Tree of Life, Mythical Archetype

to browse on the highest branches of Yggdrasill. In a similar fashion, drops from her udder create an inexhaustible supply of heavenly mead which fills a cauldron for the spirit warriors of Odin:

> The goat Heidrun stands on top of Valhalla and eats the leaves from the branches of that most famous tree, Lerad. From her udders streams the mead that daily fills a vat so large that from it all the Einherjar satisfy their thirst.[42]

This goat is also described in the *Poetic Edda*, and in that text we find a more explicit reference to the cauldron of plenty typically associated with the world tree, for there it is said that the bowl of mead shall never run dry.[43] This motif is also found in the Greek mythical tradition as the goat Amalthea whose horn produces the cornucopia.

The Hounds of Hell

We also find references in Norse mythology to a hound of hell, or to a pair of such hounds. In the *Poetic Edda* he is called Garm, and there he is said to guard Hell's gate, like the hellhound Cerberus of Greek myth.[44] In the *Poetic Edda*, Odin encounters this dog on his journey to Hell:

> Uprose Odin lord of men and on Sleipnir [his horse] he the saddle laid; rode thence down to Niflhel. A dog he met, from Hel coming.[45]

Two dogs appear in the Lay of Svipdag, the closest Norse equivalent to the classical quest myth. The hero Svipdag must travel the world seeking the goddess Menglod to be his wife. From a great distance he sees a high castle surrounded by flickering flames. Fjolsvith (the god Odin in disguise) is the watchman of this castle, which is said to have gates that gleam like gold.[46] He orders Svipdag to return "on wet ways" from whence he came, implying that the castle is somehow surrounded by water.[47] But Svipdag is persistent. He asks Fjolsvith to tell him about the great world tree which spreads its branches out over

Figure 6.7 A gold bracteate with swastika; from Lingby, Jutland, before 600 AD.

Figure 6.8 Bone comb with swastika; from a bog in Vimose.

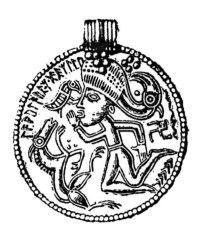

Figure 6.9 A gold bracteate (an amulet worn around the neck for protection and good luck) with swastika; from Scania, before 600 AD.

Figure 6.10 A gold bracteate with swastika; from Broholm, before 600 AD.

the land. He further asks about the two dogs which he sees guarding the palace:

> Now answer me, Fjolsvith, the question I ask,
> For now the truth would I know:
> What call they the hounds, that before the house
> So fierce and angry are?

Fjolsvith answers:

> Gif call they one, and Geri the other,
> If now the truth thou wouldst know;
> Great they are, and their might will grow,
> Till the gods to death are doomed.[48]

This golden castle, flickering with flames on a great height, which can only be encountered "on wet ways," shows characteristics typical of the axis mundi. Menglod, who lives within its walls, is a goddess of healing and help to anyone in need.[49] The two hounds that guard this palace are thus revealed as additional instances of the many guardian dogs associated with the axis mundi in world myth.

The Vortex

In Norse mythology we also find a version of the whirling rivers or vortex theme. Here it appears as a vast mill endlessly churning at the bottom of the sea, similar to the Sampo of the *Kalevala*. The goddesses, Fenya and Menya, who turn the mill before it falls into the ocean are capable of grinding out gold, peace, and prosperity, if they so choose. If they are offended, on the other hand, they may choose to grind out disaster, thus demonstrating their identity with the goddesses of fate or fortune. The text explicitly says that they grind out King Fróthi's fate for him on the mill.

It happened that King Fróthi attended a feast given by King Fjolnir in Sweden, and there he bought two bondmaids whose names were Fenja [Water Maiden] and Menja [Jewel Maiden]. They were both tall and strong. At that time there were in Denmark two millstones which were so large that no man was able to turn them. And these stones had the power to grind out whatever he who turned them bade them grind. This quern was named Grotti, and Hengikjopt the man who had given the king this mill. Fróthi had the maids led to the mill and bade them grind him gold; and so they did, and at first ground for Fróthi gold and peace and happiness. Then he gave them rest or sleep no longer than whilst the cuckoo was silent, or a lay could be sung. It is said that then they chanted the lay which is called "The

Lay of Grotti"; and before it was at an end they had ground this fate for him: on that very night came there the sea king, Mýsing, who slew Fróthi and took much booty—and that was the end of "The Peace of Fróthi." Mýsing took with him the mill, Grotti, and also Fenja and Menja, and bade them grind salt for him. At midnight they asked him whether he had enough salt, but he bade them grind on. They ground but a little while longer before the ship went down. At that spot is now a whirlpool in the sea, where the waters rush in through the eye of the millstone.[50]

The granulated white salt produced by this magic mill, and the question put to Mýsing at midnight, are both suspiciously evocative of galaxy imagery. The close association with axial motion, provided by the mill, and the operation of this mill by the goddesses of fate, reveal additional elements common to Tree of Life mythology. Finally, the description of the present activity and location of the mill—creating a vortex in the sea—suggests that we have here another species of the "whirling rivers" seen in other traditions. The "eye" of the millstone would then be equivalent to the "navel of the sea" as described by Homer.

These goddesses, Fenya and Menya, may actually be alternative names for Urd, the goddess of fate, or her later manifestation as the three Norns. This is evidenced by the etymology of the name Urd, which denotes whirling. Each of the three roots of Yggdrasill reaches into a well or spring of water. The well, Hvergelmir, is the source of all rivers; the well of Urd is the well of fate; and Mimir's well is the source of wisdom. Turville-Petre argues that all three wells ultimately refer to one well, whose name connects it to the concept of turning or spinning:

> Probably the three names all apply to one well, which was basically the well of fate, and hence the source of wisdom. This well would thus correspond with the one beneath the holy tree at Uppsala, in which sacrifices were immersed and auguries were read. Urðr [Urd], the name for fate, is commonly identified with Old English wyrd, said ultimately to be related to Latin vertere (to turn), as if applied to a goddess spinning the threads of fate.[51]

As we have already seen in the whirling rivers of Hesiod, in the Hebrew Havilah, and with the spindle of Ilmatar in the *Kalevala*, an image of spinning, whirling, or turning is often associated with the Tree of Life. The Greek myth of Ixion describes a flaming, rotating wheel, and Ixion is hung on it as punishment.

This typical pattern of axis mundi gods and heroes reemerges in the Norse episode where the god Odin hangs for nine nights on Yggdrasill. He is pierced with a spear as he hangs, thirsts without receiving drink, and cries out in agony. Odin says:

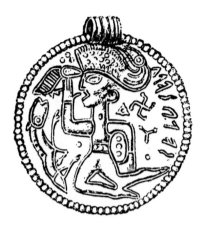

Figure 6.11 A gold bracteate with swastika; from Lelling, Zeeland, before 600 AD.

Figure 6.12 Gold brooch with ogee swastika; from the island of Fyen, Denmark.

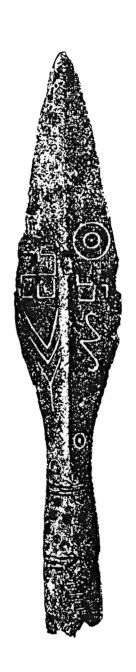

Figure 6.13 Iron spearpoint with swastikas inlaid with silver; from Volhynia, Russia.

> I ween that I hung on the windy tree,
> Hung there for nights full nine;
> With the spear I was wounded, and offered I was
> To Odin, myself to myself,
> On the tree that none may ever know
> What root beneath it runs.
>
> None made me happy with loaf or horn,
> And there below I looked;
> I took up the runes, shrieking I took them,
> And forthwith back I fell.[52]

Turville-Petre has convincingly demonstrated that every aspect of Odin's ordeal is supported by intrinsic Norse traditions. For example, at the great heathen temple in Uppsala, Sweden, it was common in ancient times to see human sacrifices hanging from a tree that was said to represent the Tree of Life.[53]

Just as Odin is pierced by a spear while hanging on Yggdrasill, so the tree itself suffers from a rotting place in its side. Snorri writes:

> The ash Yggdrasill
> endures more pain
> than men perceive,
> the hart devours it from above,
> and the sides of it decay,
> Níðhögg is gnawing from below.[54]

The piercing of Odin while he hangs on the Tree of Life, and the wound in the side of the tree itself, appear as alternative versions of the cosmic side or thigh-wound seen so frequently in axis mundi legends.

Although Odin was considered to be the father of gods and men, the ancient god Heimdall preceded him in this function. Heimdall embodies a significant number of the familiar Tree of Life attributes, and may therefore be seen as one of its anthropomorphic manifestations in the Norse tradition. His name means "the shining one above the world,"[55] and he is called "the White god."[56] He is the guardian of the gods and sits by the end of the bridge that links heaven with the earth. His home is at Himinbjorg (Mount-of-heaven) and:

> He needs less sleep than a bird; he sees equally well night and day a hundred leagues in front of him.[57]

The wakefulness of Heimdall at night, his powers of nocturnal vision, and his ability to see over vast geographical distances, are consistent with a view of his character as a celestial being of the nighttime sky.

The gleaming Gjallarhorn is in Heimdall's possession, and he hides it under the world tree until it is needed to warn the gods of attack. Water from the well of wisdom flows into it from

the Well of Mimir. This Gjallarhorn, usually illustrated in a vertical position rising above Heimdall's head, is both a trumpet and also a vessel out of which the ancient god Mimir drinks the water of knowledge. As such it may be related to other mythological horns, like the cornucopia, that are sometimes associated with the axis mundi.[58]

Heimdall was the progenitor of all human beings, and the Lay of Rig describes how he mated with human women of different social classes. He always walks in the "middle ways," we are told there.[59] According to Snorri, Heimdall is also called by the name "Vindler."[60] This epithet links him to the vortex motion so commonly associated with the Tree of Life.

> The name is a subform of vindill and comes from vinda, to twist or turn, wind, to turn anything around rapidly.[61]

These attributes of Heimdall suggest that the galaxy was seen in the oldest traditions as the anthropomorphic embodiment of an original creator or progenitor god. His location in the middle ways, his white and shining appearance, his associations with vortex motion, his guardianship of the bridge between earth and heaven, and his night vision are all characteristics that evoke the axis mundi in its ancient identification as the Milky Way galaxy.[62]

As the table at the end of this chapter indicates, the Norse legends are some of the most complete of all mythical accounts describing the Tree of Life. Fourteen of the fifteen attributes are represented in this tradition; only an explicit reference to the swastika or the Milky Way is lacking. But indirect allusions to the galaxy are plentiful: the flaming bridge linking heaven with the earth, the "whitest of the gods" Heimdall, the white tree with branches that spread out over heaven, and the castle of Menglod "flickering with flames," to name but a few.

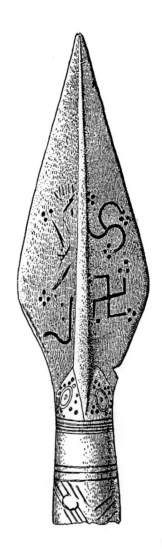

Figure 6.14 A spearhead decorated with swastika and triskelion; from Brandenburg, Germany.

IV

The Bon Po Religion of Tibet

Sir William Jones was a Sanskrit scholar and eminent orientalist who lived and worked for many years in British colonial India. His observations of the similarities among Sanskrit, Greek, and Latin marked the beginning of Indo-European linguistics. He was an internationally recognized expert on Asiatic religion and mythology. In 1786, in a lecture before the Bengal Asiatic Society, Jones stated:

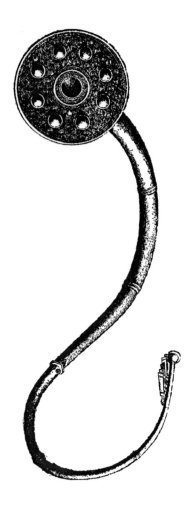

But the largest and richest sort [of fruit] is named Amrita, or Immortal; and the Mythologists of Tibet apply the same word to a celestial tree bearing ambrosial fruit, and adjoining to four vast rocks, from which as many sacred rivers derive their several streams.[63]

The myth described here originated with the pre-Buddhist sect known as Bon Po. In this remarkably succinct statement we find collected most of the essential mythological elements seen elsewhere in conceptions of the Tree of Life.

Like the world tree in other traditions, the tree that bears the fruits of immortality is not an earthly tree; it is celestial. But although the tree itself is celestial, its trunk intersects the earth, and its roots extend down into the underworld. In the Tibetan legend, the place where the celestial tree joins the earth is at the confluence of four sacred rivers, each adjoining its respective continent, or "vast rock."

The Bon Po of Tibet claim that their religion antedates Buddhism by millennia. Their original teacher, Shen-rab, is said to have traveled to Tibet from his homeland in 'Ol-mo lung-ring in the year 16,016 BC.[64] The Bon Po believe that Buddhism was brought to Tibet by a great teacher who was a later incarnation of Shen-rab, and therefore have incorporated many of its tenets into their faith while retaining the original core.[65] That faith is still practiced today; in 1988 the Dalai Lama belatedly recognized Bon as the fifth religious school of Tibet.[66]

Of particular interest to us here is the homeland of Shen-rab. 'Ol-mo lung-ring is said to be located somewhere to the west of Tibet; it is dominated by the great Nine-Story Swastika Mountain, also called Mount Ti-tse. From the base of this mountain there issue four rivers that flow in four different directions, and the mountain is surrounded by four continents. 'Ol-mo lung-ring is located at the base of the tree 'Dzam-bu near a great turquoise lake in front of the snow mountain Ti-tse.

The mythical Mount Ti-tse has been localized to modern Mount Kailasa, which stands more or less at the center of nine rivers originating in Tibet. Four of these rivers have been associated with the rivers of legend, but the ancient Bon texts clearly state that Kailasa merely *represents* the Swastika Mountain, and that the modern Tibetan rivers merely *represent* the rivers of distant western 'Ol-mo lung-ring.

In the tree of 'Dzam-bu we must recognize the Tree of Life, since that tree is central to the Bon religion. Shenrab is said to have planted a juniper tree as an earthly representative of the Tree of Life near a Bon monastery.[67]

The ancient Bon documents repeatedly emphasize that, although Mount Kailasa represents the center of the earth, 'Ol-mo lung-ring (called Shambhala in India[68]) is the center of civilization. Religious teachers are said to have traveled there, passing

Figure 6.15 An ancient Scandinavian battle horn of bronze, carried and used in upright position; from a bog in Fredriksborg Amt, Denmark

through many different lands on the journey, in order to copy important books and return with them to Tibet.[69] 'Ol-mo lung-ring was said to be located somewhere in the west, with a great mountain—called Nine-Story Swastika Mountain—at its center. Four rivers flowed outward from its base into each of the four cardinal directions.

> As for the land of gShen, 'Ol-mo lung-ring,
> Its size is 50 square dpag-tshad (4,000 fathoms),
> It is made in the likeness of Mount Sumeru (Ri-rab) with its four continents …
> At the base of the tree of 'Dzam-bu,
> In front of the snow mount Ti-tse (Kailasa),
> Beside the turquoise lake Ma-phang (Manasarovara),
> At the source of the great four streams,
> … In spite of this seeming identification of 'Ol-mo lung-ring with the area of Kailasa, biographers of gShen-rab in general regularly maintain that Mount Kailasa, lake Manasarovara, and the mountain sPos-ri ngad-idan merely represent those situated in 'Ol-mo lung-ring.[70]

We are fortunate that the Bon records are so explicit, for it is rare that localizations of ancient myth are documented as such. It should be obvious, however, that these characteristics are entirely congruent with the myths that we have already examined. The Tree of Life and the cosmic mountain located somewhere in the west, the four rivers and four continents, the lake, and most importantly, the swastika all support the hypothesis that the interrelationship of the four Atlantic rivers was understood at some point in the distant past. There is evidence that 'Ol-mo lung-ring was itself regarded as an island in Tibetan legend. A Bon geographical text dated to the fourteenth century describes an island at the center of the world said to be composed of copper and gold.[71]

The Tibetan legends also make reference to an underworld located below the central mountain. Directly below Mount Kailasa, called the Nine-Story Swastika Mountain, is an underworld also composed of nine discrete levels.[72] The peak of Kailasa is believed to penetrate the celestial realms. The dwelling of the beneficent khyung bird is there, and he constantly battles the serpent of the underworld. Often he is represented with a snake in his beak.[73]

Particularly illuminating is the relationship of the cosmic mountain to the mandala. Although there are many types of mandala, the most basic one depicts a great mountain at the center of a square representing the earth, and in each of the four cardinal directions is a gate in the form of a double swastika—that is, one that turns both clockwise and counterclockwise (Figures 6.18 and 6.19):

Figure 6.16 A gold bracteate with swastika; from Hitterdal, Norway, before 600 AD.

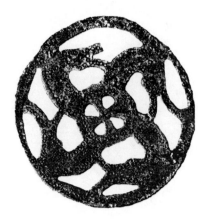

Figure 6.17 A metal ornament from Germany with horse heads in swastika formation; from the Rottweil Collection.

The mountain and the four rivers together make up an immense mandala. In this, the mountain represents the tree at the center of the world, and the four river sources represent the four outer gates.[74]

Outside each of the double-swastika gates in the mandala shown in Figure 6.18 is a river. The four rivers are thus situated at the four cardinal points. This is important because in many mandalas the river symbolism is not explicit. Also note the division of the innermost square into nine subunits, representing the Nine-Story Swastika Mountain.

In every culture where the swastika is used, it appears in both the clockwise and counterclockwise forms, but there appears to be no functional difference in meaning between these two forms. In the Tibetan mandala, or yantra as it is called in the Hindu tantric tradition, the two forms are combined into one symbol—the double swastika.

The following instructions for drawing the King-of-Yantras (Yantra-raja), one of the principal mandalas of the Hindu Tantra (Figure 6.19), are taken from the Mahanirvana Tantra:

> Draw a triangle with the Seed of Illusion (the character hrlm) within. Around it draw two concentric circles. Draw in pairs the sixteen filaments and, besides, the eight petals of a lotus. Around them is the Earthly City, which should be made of straight lines with four entrances and should be of pleasing appearance.[75]

The translator's commentary explains:

> The purpose of this yantra is to create contacts with supranatural worlds. With its help, the worshiper can gain all worldly and supranatural powers. In the center of the yantra, the character hrlm stands for the divinity of fortune, Lakshmi. Around her is the fiery triangle which draws into its ascending movement the coiled-energy (kundalini), the circle surrounding it. The sixteen filaments of the lotus represent the attainment of perfection (sixteen is the perfect number); the eight petals represent the all-pervading ascending tendency, that is, Vishnu.

> The outer circle is creation, the circular movement of which all things are born. The power over the manifest world is shown by the square, symbol of the earth. On the four sides are the four gates leading from the earth to the worlds beyond. To the north (i.e., on the left) is the gate to the way-of-the-gods (devayana). To the south (i.e., on the right) is the gate to the way-of-Ancestors (pitr-yana). To the east (upward) is the gate to the priestly solar way, and to the west (downward) is the gate to the royal way, the way of the lord-of-the-waters (Varuna). The four gates lead to these four directions, forming the cross, symbol of universality.

Figure 6.18 Tibetan Mandala from the Bon monastery of Yungdrung Ling. The nine inner divisions represent the Nine-Story Swastika Mountain. Double swastikas are located in each of the four cardinal directions, and rivers are shown outside each of the four double-swastika gates. (Illustration adapted from Baumer, 1999)

This cross further develops into a double svastika, which indicates the return to the principle through both the left-hand and the right-hand way.[76]

The representation of the goddess of fortune, Lakshmi, at the center of the yantra is consistent with the Tree of Life motif found in many other legends. The goddess, who emerges from the base of the Tree of Life in Siberian myth—promising the hero every happiness and protection, is another instance of this motif.

The power-acquiring ritual involving the double swastika of the mandala develops out of the power inherent in the swastika symbol itself. In Tibet, as throughout the Indian subcontinent, forming this symbol was believed to bring luck, prosperity, and strength. Bon believers traditionally form a swastika with grains of wheat on the ground or floor of their dwelling in order to strengthen their personal vitality.[77]

The Tibetan Bon religion also has a version of the whirling ocean or vortex myth. A vortex appears in the waters, and from it the other elements are churned into existence.

Then, from the cold wind and the heat of the blazing fire, the water element came into being in the form of dew. In turn the dew drops contained the tiniest particles of matter, from which the element of earth developed. These atoms were churned and blended into each other by the wind until earth and mountains were formed out of them. This primordial vortex which is in a state of perpetual motion, is symbolized by the swastika, also called yungdrung.[78]

Figure 6.19 The King-of-Yantras (Yantra-raja). Meditation on this mandala was believed to bestow all earthly powers. At center are the Sanskrit letters indicating Lakshmi, the goddess of fortune. Double swastikas stand at the gates in each of the four cardinal directions.

This primordial vortex, symbolized by the swastika, is the same vortex which is centered on the Nine-Story Swastika Mountain as axis of stellar rotation. As we have seen, the mountain may also be represented as a tree or pillar, and as such becomes the focus of a religious cult. The Bon Po also worshiped at pillar shrines. The one at Draklha Lupuk is centered around a granite pillar six feet in diameter, said to represent the axis of the world. Decorative carvings in the rock are dated to the seventh and ninth centuries.[79]

This pole or pillar representing the axis mundi is represented in religious sanctuaries throughout the ancient world, often as the most sacred focus of a shrine. On Crete, in the ruins of the ancient Minoan civilization, these sanctuaries with pillars as the focus of worship are particularly plentiful, some dating from the third millennium BC. At times trees are depicted growing from the pillar-shrine, demonstrating a symbolical interrelationship between these two.[80]

Within Tibetan tradition we find the axis mundi represented in each of its three principal forms: tree, mountain, and pillar. Its form as the Nine-Story Swastika Mountain is the most revealing for our purposes, since its location at the confluence of the four rivers is explicitly linked, through its name, with the swastika symbol. This link is strong evidence that the swastika is, in fact, a symbol for those four rivers and for the axis mundi at their center. The mandala, which combines images of the double swastika, the four rivers, and the goddess at the center, further confirms the unity of these elements. Here again, the swastika is united with the symbolism of the cosmic center, the four directions, and the axis mundi.

Summary of the Four Eurasian Myths

In this chapter we have seen that the attributes of the Tree of Life recur as patterns in cultures widely separated geographically. These attributes have been grouped somewhat arbitrarily into fifteen mythical components for comparison purposes.

Since some of the categories overlap slightly, and because a few of the elements have been combined for convenience and simplicity, this synopsis can only be considered a visual aid to track the characteristics of the myth. Despite these limitations, general trends are clearly discernable.

The table demonstrates the validity of this set of attributes as a description of the myth within these four Eurasian traditions. In the few cases where an attribute is underrepresented, as with the hound or the goat, these elements will be found abundantly in the mythical traditions yet to be investigated.

We have now reached the point where we can begin to compare this set of attributes to the characteristics of the Milky Way galaxy. This will allow us to evaluate whether or not a significant correspondence exists between that celestial phenomenon and the mythology of the Tree of Life.

Table 6.1 Showing the fifteen attributes of the axis mundi as they appear in the myths of four Eurasian traditions. (Attributes and primary variants in caps.)

Attribute	Siberia	Finland	Norse	Tibet
1. Huge Tree, Mountain, Pillar, or Support of Heaven	X	X	X	X
2. Provides Prosperity, Food, Wisdom, Immortality	X	X	X	X
3. Located near Water, Lake, Rivers, Ocean	X	X	X	X
4. Contains images of Center, Axle, Navel, Spinning	X	X	X	X
5. Mist, Cloud, Veil, Snow, Fleece, Whiteness, Milk	X	X	X	X
6. A Goddess of Fate, Fortune, or Destiny is associated	X	X	X	X
7. Provides link between Earth, Heaven, Underworld	X	X	X	X
8. Described as Radiant, Flaming, Luminous, Golden	X	X	X	
9. Bifurcated Branch, Pillar, or Upraised Arms of Deity	X	X	X	
10. Bird dwelling above	X	X	X	X
11. Serpent dwelling below	X	X	X	X
12. Hound as Guardian		X	X	
13. Goat or Stag			X	
14. Quest, Side-Wound, Visit to Underworld	X	X	X	X
15. Reference to Milky Way or Swastika				X

Figure 6.20 Galaxy god of the Atlas, Shu, Hercules type, as the ancients conceived it. The massive god stands on an island at the navel of the sea, supporting the heavens with his upraised arms.

Chapter 7

Identification of the Celestial Tree

The Mandala

In the previous chapter we compared the Tibetan mandala figure with the quadripartite conception of the world, symbolized by the great Atlantic swastika. The cosmic Nine-Story Swastika Mountain stands at the central axis of the mandala. Four gates open into the four cardinal directions, and rivers are shown outside each one of these double-swastika gates. In the Hindu tantric tradition, the goddess of fortune, Lakshmi, replaces the axial mountain. The mandala is, according to this conception, an archaic geographical map of the Atlantic Ocean, with its surrounding continents and principal rivers. The axis mundi stands at the Navel of the Sea in one of its various mythical formulations.

Contrast this conception with the psychological theory of the mandala as proposed by C. G. Jung. He suggests that the quadripartite world, as symbolized by the mandala, is a vision into the very structure of matter, made possible through a spiritual penetration into the collective unconscious mind. All of life, he points out, is structured around the chemical element Carbon, with its four free electrons. Thus the mandala represents a subatomic map, illustrating this basic element of organic life.[1]

In comparison to this theory of Jung's, the geographical explanation of the mandala seems rather prosaic. It is based on observations of the outer world using the sense organs with

which we are all familiar. It assumes that knowledge about the earth's geography was passed from one human being to the next, with the inevitable distortions that accompany all such multiple transmissions. Its main advantage over Jung's view is that it does not require the existence of a complex and amorphous structure that is inaccessible to ordinary scientific research and verification.

If the Tree of Life is not the nucleus of Jung's carbon atom, nor the projection of the personal ego, as implied by Eliade, then it must symbolize some aspect of reality that is sufficiently well known—and sufficiently important—to justify a place as one of the most sacred concepts in world religion.

Nor can it be one specific natural tree, growing in antiquity somewhere on the globe. The manner in which it is typically described precludes that possibility. For how could a natural tree be at the same time luminous, milky, a link between earth and heaven, with branches that extend over the entire earth, and with a location near the celestial axis of rotation? Equally untenable is the idea that it represents the idealized concept of *tree* in general, a reminder that ancient peoples were dependent on trees for food and shelter. For in that case, the tree would have been described in naturalistic terms: earthly rather than celestial, many-branched rather than bifurcated, opaque rather than luminous, and fully intact rather than suffering from a wound in its side.

In chapter 4 we noted the parallelism between the mountain Mashu, encountered by Gilgamesh in the land of the Scorpion People, and the Milky Way.[2] Its twin peaks, its massive height reaching up to the vault of heaven, its feet in the underworld, and its position at the gate of the sun in Sagittarius, all point to the Milky Way as the intended referent. Since many of these same attributes are often used to describe other forms of the axis mundi—trees, pillars, and titans—it is probable that these symbols also share the same referent. All of the attributes commonly ascribed to the Tree of Life are consistent with the characteristics of the galaxy.

Luminosity

The galaxy is white and luminous. Its frequent association with milk is consistent not only with its appearance, but also with the name we give it—the Milky Way; the word *galaxy* itself is derived from the Greek word meaning "milk." This association accounts for the milky rain that falls from the Tree of Life in Siberian legend, and the lake of milk out of which it grows. The Egyptian goddesses whose breasts protrude from the Tree of Life are additional examples of this symbolism. In the Siberian

story, the mountains that "lean against the heavens" are said to bear [snow] caps resembling white rabbit skin. This is consistent with the Greek myths that describe the dwelling of the gods on "snowy Olympus." Yggdrasill is said to be wet with white dews because the Norns besprinkle it with water from the well that turns everything white. In the *Kalevala*, only white materials are used to forge the Sampo.[3]

Celestial Location

The celestial location of the Milky Way corresponds to descriptions typical of the Tree of Life and the axis mundi. Sir William Jones describes the Tibetan Tree of Life as celestial, and it is often so described in the Siberian traditions. Väinämöinen must lift his head and gaze heavenward when he wishes to see the goddess, whose radiant garments and enormous spindle suggest an axis mundi identity. When the Tree of Life is said to connect heaven, earth, and the underworld, this conforms to the appearance of the galaxy. It rises from the horizon up to the zenith, continues down to the opposite horizon, and then passes all the way around the underside of the earth back to its point of origin. Thus it touches both the heights and the depths, and appears to intersect with the earth at the horizon. Its north-south orientation, passing near both celestial poles, is consistent with the statement in the *Kalevala* that Jumala's flaming oak tree was scattered to the north and to the south.[4]

Yggdrasill is said to have three roots, one in each of the three worlds: heaven, earth, and the underworld. This description corresponds to the appearance of the galaxy in the northern hemisphere, which forms a great Y, with three termination points. The side branch appears to end near the plane of the horizon and so serves as the root that has its origin in Midgard, the world of men. The continuous branch passes both above and below the earth, linking it to both heaven and the underworld.

Bifurcated Tree

The twin peaks of Mashu find their parallel in the bifurcated Tree of Life that appears, for example, in the *Kalevala*, where the great oak of Jumala is said to fork in two directions. Yggdrasill has its branch, Lerad, and depictions of the Aztec and Maya Tree of Life are invariably bifurcated. The Easter sermon of Hippolytus (chapter 5) refers to the Tree of Life and its immeasurable arms extending between earth and heaven.[5] These images are consistent with the appearance of the galaxy, which touches the horizon with the end of the arms created by the

Great Rift. The point where these two arms join is near the zenith, so the Milky Way, like the Tree of Life, can truly be said to encompass the middle regions between earth and the summit of heaven. In the Bhagavad Gita, the universe is described as an inverted tree, the branches of which stretch downward toward the earth. Many of the legends describe the branches of the Tree of Life as spread out over the entire world.[6]

Axial Motion

The proximity of the galaxy to the celestial poles, along with its general north-south orientation, explains why it was taken to represent the axle of the spinning earth in antiquity. From about 19,000 BC to 14,000 BC, the north celestial pole fell directly within the galactic band.[7] The revolutions of the stars across the night sky provide the pattern for the many vortices and images of axial motion common to myths associated with the Tree of Life. It is likely that ancient people who viewed the Milky Way as the axis mundi believed, like Heraclides, that the earth was in rotation, and that the stars were stationary. Such a view would account for the apparent movement of the galaxy along with the stars.

The rotational movement of the stars also accounts for the common occurrence of axis mundi symbols on the Trojan spindle whorls. The wooden distaff at the axis of the rotating spindle represented the Tree of Life in its presumed location at the axis of the earth. The symbolic decorations, inscribed on the ceramic spindle whorls, evoked mythical elements that linked the otherwise mundane work of spinning thread with the divine activity of the galaxy goddess. Daily work thus became sanctified. The domestic work of women in antiquity was thereby raised up to a level of sacred participation with the divine feminine.

Night

A recurring pattern can be detected in myths concerning the Tree of Life and its variants, where the tree is often associated with images of the night. The *Poetic Edda* describes how the seeress Voluspá sits out at night when she wants to observe the well of Mimir, said to be located at one of Yggdrasill's roots.[8] Varuna, the preeminent axis mundi god of India, is said to have a thousand eyes (the stars). The goddess Isis appears shining in the darkness, with stars visible in her garments.[9] An amazing pine tree in the *Kalevala* holds the Great Bear in its branches and the moon upon its summit. These patterns are a clue to the

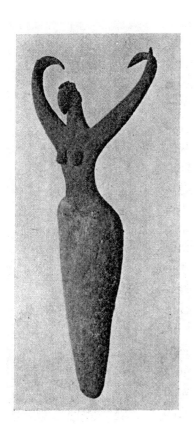

Figure 7.1 Female idol with upraised arms and the head of a bird. Fired clay from the Naqada II period (second half of fourth millennium BC); from a grave at Gebelein, Egypt.

nocturnal location of the Tree of Life and its identity with the Milky Way.

The Headless Goddess

The posture of axis mundi gods, commonly depicted with upraised arms and fused legs, reflects the appearance of the galaxy, with its single column of dense stars connected to the branching pattern at the Great Rift. But the correspondence to a human figure is not perfect. The galaxy lacks a cluster of stars between the two arms that would correspond to the position of a head upon the god's shoulders. The galaxy can easily be seen as a headless goddess with upraised arms (Figure 4.9).

This defect is often reflected in the mythology. Isis, for example, is decapitated by her son Horus for interfering in his battle with Seth, and is then transformed into a headless statue.[10] Bran, the gigantic god of the Celts, instructs his followers to remove his head and use it as a protective talisman.[11] This motif can also frequently be seen in ancient art, where the head of the goddess is typically replaced by the head of a bird (Figures 7.1, 7.2, and 7.3). The source of this substitution can also be

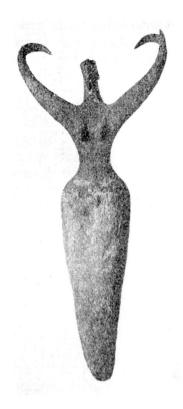

Figure 7.2 Egyptian female figurine with uplifted arms and the head of a bird. Fired Nile mud, prehistoric period; from a grave at Gebelein.

Figure 7.3 Female idol from Greece with uplifted arms, the head of a bird, and fused legs.

found in the configuration of the galaxy. The bird constellation Cygnus (Swan) occurs precisely between the arms of the galaxy where they diverge at the Great Rift, so that this bird is found where the head of the goddess would be expected.

Another solution to this problem was employed by artists in ancient Egypt. The goddess Nut was depicted with arms extending directly from the top of her head, rather than from her shoulders (Figure 7.4). In another variation on this theme, Atlas is often pictured with upraised arms bearing the heavenly spheres; his head is bowed down with the weight of his burden so as to drop below the level of his shoulders (Figure 7.5). In later alchemical emblems, the two branches of the galaxy are depicted as two heads upon one body. Often this symbol is called "the hermaphrodite," and conceived as a male and female joined as one figure. Figure 7.6 makes this posture explicit through the "Y" symbol carried by the hermaphrodite. This symbol corresponds to the Y-shaped figures, called the "Pillars

Figure 7.4 Egyptian goddess Nut arching over the night sky. Her arms attach to her head in imitation of the arms of the galaxy as they branch at the Great Rift. Below, Hathor in parallel posture: two trees rise from her shoulders, which take the form of mountains. Stars indicate the celestial nature of these two goddesses.

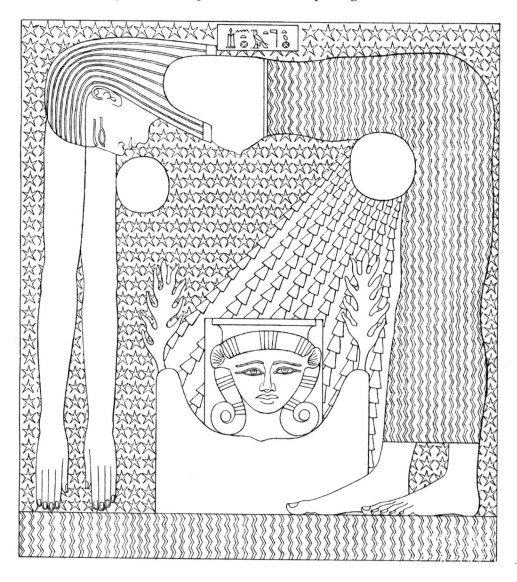

Tree of Life, Mythical Archetype

of Heaven," that are so frequently associated with the Egyptian axis mundi god Shu (chapter 10)[12].

Other Animals Associated with the Tree of Life

Immediately beyond Cygnus, also inside the Great Rift, is a second bird constellation, Aquila (Eagle). Thus two bird constellations occur together within the branches of the galaxy. These correspond with the birds—most often eagles or swans—that appear so frequently in the myths associated with the Tree of Life. In the Norse legend an eagle and a hawk live in the branches of Yggdrasill, and two swans live in the nearby well of Urd. In the *Kalevala*, an eagle is perched upon the tree spared by the hero, and then bursts into flames. Both of these images correspond to features of the galaxy: The eagle represents Aquila, and the flames represent the luminous nature of the Milky Way. This parallel imagery is repeated over and over in world myth.

In addition to these birds, a number of other animals are associated with the axis mundi. These include serpents, dogs, stags, and goats. Like the two birds, these animals also appear as constellations in proximity to the galaxy. Next to Aquila lies the constellation Capricornus (Goat). Its position near a branch

Figure 7.5 The Rebis, a hermaphroditic creature with two heads, often pictured in alchemical texts. The Y symbol in his hand corresponds to the Egyptian sign for the pillars of heaven. It corresponds to the branching pattern of the galaxy. (Illustration from Maier, *Symbolae Aureae Mensae*, 1617.)

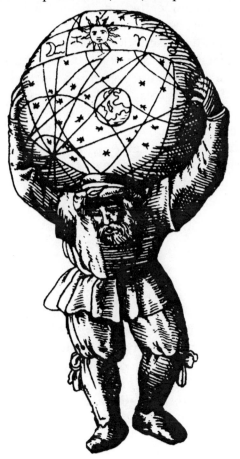

Figure 7.6 Atlas bearing the heavenly spheres on his shoulders. His head drops down below the level of his shoulders in conformance with the branching pattern of the galaxy. (Adapted from an alchemical etching published by Stocius in 1624.)

Figure 7.7 Cosmic serpent in the form of Ouroboros. That he is said to swallow his own tail parallels the form of the galaxy, which circles the earth and meets itself again at the southern end of the Great Rift.

Figure 7.8 Detail from an archaic Boetian (Greek) vase. The galaxy is represented as two serpents surrounded by axis mundi symbols: swastikas, double swastika (as Maltese cross), and Egyptian ankh.

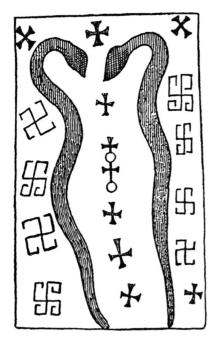

of the galaxy corresponds to the description of the goat Heidrun in the Norse myth. He is said to eat leaves from Lerad, the highest branch of Yggdrasill.

Two constellations represent dogs (Canis Major and Canis Minor). Both are situated near the celestial equator, the line that corresponds to the transition between the earth and the underworld. The myths frequently refer to hounds of hell that guard the gate of the underworld, and the position of these two dog constellations fits the description exactly.

Beyond the celestial equator, in the southern hemisphere, lies the constellation Hydra (Serpent), stretched out alongside the galaxy. If Cygnus is located near the top of the celestial tree, then Hydra is located at its base. The serpent beneath the Tree of Life figures prominently in world mythology, and Hydra's position at the base of the galaxy leaves little doubt that it represents the mythical serpent. Viewed from the middle northern latitudes, the head of Hydra can be seen rising from the underworld just above the celestial equator.

Cosmic Wound

A great lacuna cuts into the Milky Way just below the star Polaris (Figure 7.13). The position of this gash—midway between the point where the galaxy branches, and the point that marks the boundary of the underworld—would place it halfway up the side of the Tree of Life. The many accounts of a cavity, wound, rotten place, or even a womb in the side of the tree refer to this gash. When the axis mundi takes the form of a mountain, the gash often appears as a cave in its side—as

Tree of Life, Mythical Archetype

the cave on Mount Ida where Zeus was nurtured by the goat Amalthea, for example.

But the galactic gash appears most frequently in variants where the axis mundi is portrayed anthropomorphically. It is commonly described as a wound in the side, genitals, thigh, or leg of a god or hero. Sometimes it is an irregularly placed womb in the side or thigh. The birth of Eve from the side of Adam conforms to this pattern, as does the birth of Dionysus from the thigh of Zeus. Buddha was born from his mother's side, and in ancient art, she is typically depicted holding the branch of a tree during his birth. The Egyptian god Set was born from a hole that he forced through the side of his mother, Nut.[13]

These features of the galaxy, and of the sky in its immediate vicinity, closely parallel characteristics of the Tree of Life in world mythology. Its celestial location, its function as a bridge between heaven and earth, its branching appearance, the wound formed by the lacuna, its radiance and whiteness, and its association with various animals, all serve to identify the Milky Way as the original Tree of Life.

Figure 7.9 Hermes (Roman Mercury) holding the Caduceus, composed of two serpents entertwined around a central pillar with wings above. This is a representation, in miniature, of the axis mundi. (Detail from Maier, *Atalanta Fugiens*, 1618.)

The Tree of Life as a Composite Image

Many of the now-secondary elements of the Tree of Life legend can be shown to have been primary elements in another culture, or even in an earlier historical stage of the same culture. The serpent, for example, which lurks at the base of the Tree of Life in most versions, is a vestige of an earlier legend that saw the galaxy itself as a cosmic snake or dragon that encircled the earth. The Great Rift was seen in various ways: as the open jaws of the serpent (often biting his own tail), as a serpent with two heads, as two serpents with their lower halves intertwined, or as two separate snakes (Figures 7.7–7.10).

Apollonius Rhodius records a song of Orpheus that tells how the serpent Ophion ruled Olympus before Cronus gained dominion over it, and how Ophion, defeated, fell into the ocean.[14] The descent of Ophion into the ocean is an archaic version of the image that later became the Tree of Life rising up out of the ocean into heaven. Both represent the galaxy and its supposed intersection with the earth.

Figure 7.10 Double-headed serpent from Egypt. In this figure, the branching pattern of the galaxy is portrayed as the two heads of a serpent, rather than his open jaws.

Figure 7.11 Cadusseus. From an illustration by Holbein; Basel Museum.

Figure 7.12 Zeus battling Typhon; from a Greek hydria now at Munich, ca. 550 BC.

The Greek god Zeus does battle with a giant celestial fire-spitting winged serpent called Typhon. This serpent is said to have been the offspring of Hera alone—a clue that he is a galaxy figure, since the galaxy was originally formed from her milk. Like Ophion, Typhon tries to escape Zeus by diving into the sea. Various authors describe him as touching the stars with his head and attacking heaven. They also describe him as thinking that he has captured the kingdom of heaven and the stars.[15] Apollodorus says:

> From the thighs downward he had huge coils of vipers, which when drawn out, reached to his very head and emitted a loud hissing. His body was all winged: unkempt hair streamed on the wind from his head and cheeks; and fire flashed from his eyes. Such and so great was Typhon when, hurling kindled rocks, he made for the very heaven with hissings and shouts, spouting a great jet of fire from his mouth.[16]

Most of the characteristics described here can be seen as attributes of the Milky Way. The huge serpent coils that reach to his head refer to the circular nature of the galaxy; the tail of the serpent encircles the earth and meets the head again. The wings provide an explanation for the fact that the serpent is located in the sky. The fire flashing from his eyes typifies the luminous nature of all galaxy figures, and this accounts for the jets of fire from his mouth and the "kindled rocks" as well. His lunges at the heavens further suggest his celestial nature. Finally, the name *Typhon* is believed by some to be derived from the Greek (tupho) meaning "smoke" another allusion to the cloudy nebulosity of the galaxy.[17] Another form of this word

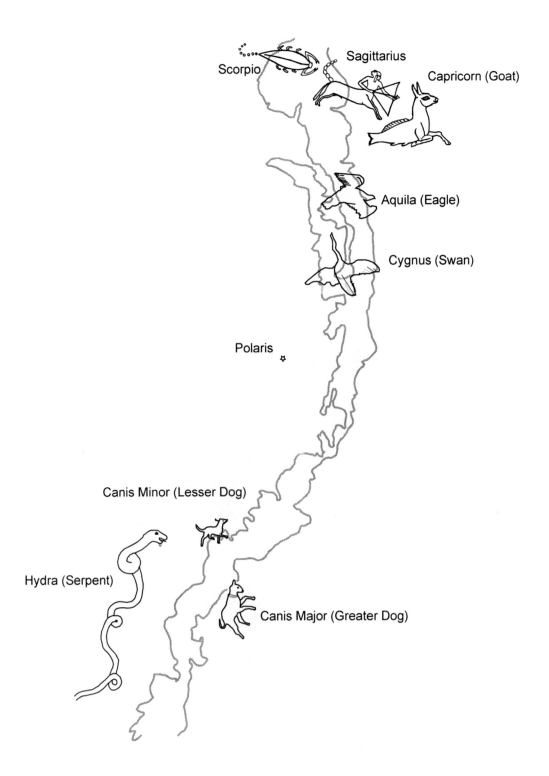

Figure 7.13 Selected constellations in the vicinity of the Milky Way galaxy (includes portions within the southern hemisphere). The path of the sun along the zodiac passes through the constellations Scorpio, Sagittarius, and Capricorn. The southern hemisphere (underworld) begins at Canis Minor and Aquila, which are located near the celestial equator.

in ancient Greek means "whirlwind," the source of the modern word "typhoon," which conveys the notion of axial motion so frequently found in association with galaxy gods.[18]

Many cultures have combat myths—legends in which a god or hero battles a cosmic dragon or serpent. These can be understood as vestiges of a historical transition from a cosmologic belief system that regarded the galaxy as a serpent to another belief system in which the serpent was displaced by an anthropomorphic figure. Hesiod describes the serpent Ladon as guarding the tree that bears the golden apples in the far west:

> And Ceto was joined in love to Phorcys and bare her youngest, the awful snake who guards the apples all of gold in the secret places of the dark earth at its great bounds.[19]

In this version of the legend, the serpent is reduced to a secondary position. As a concession to the earlier belief system, he is incorporated into the new myth and lives on as a vestige. Typically a mythological element in this later "reduced phase" will be relegated to a subordinate constellation in the vicinity of the galaxy. Hence that other many-headed snake, the Hydra, who is born under a plane tree near a fathomless lake (both allusions to the Tree of Life) and is later killed by Hercules, was placed in the heavens at the base of the Milky Way galaxy; it still survives there in modern astronomy as the constellation Hydra.

In the Hebrew tradition, Leviathan is the great serpent vanquished by Yahweh. Isaiah calls him the "dragon which is in the midst of the sea."[20] In the book of Job his attributes evoke familiar galaxy imagery. His scales are so close together that no air can come between them—a reference to the density of stars within the galaxy. When he sneezes a light shines, and sparks go out of his mouth. Flames issue from his mouth and he leaves a shining path after him; smoke is emitted from his nostrils. These are clear references to the luminosity and nebulosity of the galaxy. His alternative name, *dragon*, means "seeing clearly"—an allusion to the high vantage point offered by the galaxy with its many "eyes," the stars. In the book of Job, God asks:

> Canst thou draw out leviathan with an hook? . . . I will not conceal his parts, nor his power, nor his comely proportion.
> Who can discover the face of his garment? Or who can come to him with his double bridle?
> Who can open the doors of his face? His teeth are terrible round about.
> His scales are his pride, shut up together as with a close seal.
> One is so near to another, that no air can come between them.
> They are joined one to another, they stick together, that they cannot be sundered.

By his neesings [sneezings] a light doth shine, and his eyes are like the eyelids of the morning.

Out of his mouth go burning lamps, and sparks of fire leap out.

Out of his nostrils goeth smoke, as out of a seething pot or caldron.

His breath kindleth coals, and a flame goeth out of his mouth.

In his neck remaineth strength, and sorrow is turned into joy before him.

The flakes of his flesh are joined together: they are firm in themselves; they cannot be moved…

He maketh the deep to boil like a pot: he maketh the sea like a pot of ointment.

He maketh a path to shine after him; one would think the deep to be hoary.

Upon earth there is not his like, who is made without fear.

He beholdeth all high things; he is a king over all the children of pride.[21]

Like Typhon in the Greek myth, Leviathan appears later at the base of the Hebrew Tree of Life as a secondary figure, and also in an adversarial capacity as the serpent that tempts Eve. Many other familiar features reappear in the biblical version of the legend: the mist, the central location of the tree, the provision of food and immortality, the river and its four divisions, the presence of God in the vicinity, and the rotating flaming sword.

In contrast to the view of the galaxy as a cosmic serpent, some of the oldest cultures saw it as a celestial river, or a river of light.[22] This may be one of the most archaic views of the galaxy, since it reappears as a central element in so many versions of the myth. In Sumerian legend, the sacred Tree of Life grows in the mythical land of Eridu, which is located at the source of two rivers, the earthly and the celestial.[23] The book of Genesis speaks of one river that "was parted, and became into four heads."[24] These images can be seen as references to the point where the galaxy was believed to intersect the Atlantic Ocean, and then part into the four rivers previously discussed.

In Hindu tradition, the cosmic river—called the heavenly Ganges—descends from the sky and pours out on Mount Meru, where it too parts into four rivers, flowing in the four cardinal directions. This heavenly Ganges is explicitly identified with

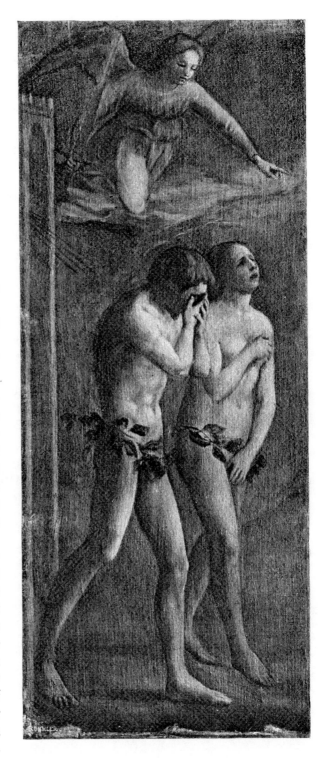

Figure 7.14 Angel with rotating flaming sword that bars return to Eden by Adam and Eve. Masaccio, Carmelite Church, Florence.

the Milky Way galaxy in Indian mythology (see chapter 11). In the Norse myth, the stag Eikthyrnir eats leaves from the highest bough of Yggdrasill. From his antlers fall drops of water that fill all the rivers of the world.

The Tree of Life is almost universally associated with water or with rivers. This reflects the ancient conception of the galaxy as a river or a heavenly ocean. Its later appearance as a river that divides into four branches flowing near the sacred tree, reflects the historical transformation in which the dominant view became that of the galaxy as a celestial tree. The older river image was, like the serpent, incorporated into the composite legend in a subordinate capacity.

In some ancient cultures, the galaxy was seen as a giant white bird flying in the night sky. This view persisted until modern times in the Baltic region of Northern Europe, and the galaxy is still called the Bird Way in Estonia. The name refers to a mythical white swanlike bird that was said to guide the seasonally migrating flocks on their journey along the path marked by the galaxy. Estonians also believed that the world was created by a bird resembling a swan, and the image of this bird has been preserved in ancient Karelian rock carvings.[25]

In Greek mythology, Zeus often assumes the form of a bird, and this may reflect his original mythical nature. Pausanias says that he changed into a cuckoo in order to seduce the goddess Hera,[26] and Ovid says that he impregnated Asterie while in the form of an eagle.[27] Apollodorus and others tell of the rape of Leda, which Zeus accomplished in the form of a swan, and of the subsequent birth of Helen of Troy.[28] The Greeks believed that the constellation Cygnus was the swan whose form Zeus took.[29]

The rape of Leda was a favorite subject in ancient art. It is of interest here because its imagery is related to the galaxy and to the Tree of Life. The constellation Cygnus is located between the two arms of the galaxy, precisely at the point where the Milky Way divides at the Great Rift, so that if Leda was an archaic galaxy goddess (with the twin branches of the galaxy representing her legs rather than her arms), the constellation Cygnus would be positioned directly in her lap (Figure 7.15). The description is even more explicit in Euripides, where Helen of Troy is made to say:

> Zeus took the feathered form of a swan, and that being pursued by an eagle, and flying for refuge to the bosom of my mother, Leda, he used this deceit to accomplish his desire upon her.[30]

The reference here to a swan pursued by an eagle exactly parallels the position of the two constellations, Cygnus and Aquila within the arms of the Great Rift. Helen, the offspring of

this galactic union is considered by many authorities to have been, originally, a pre-Hellenic tree goddess.

According to one legend, cited by Pausanias, Helen was hanged on a tree at Rhodes. Pausanias adds that Helen was said to be living with Achilles on an island in the Danube called White Island—another allusion to the galaxy.[31] Hence, the rape of Leda by Zeus in the form of a swan and the characteristics of Helen, the offspring of that rape, strongly link Zeus both to

Figure 7.15 Leda, ravished by Zeus in the form of a swan. Ancient legend holds that the constellation Cygnus was the swan whose form Zeus took in his encounter with Leda. First half of the fifth century BC, Capitoline Museum, Rome.

Figure 7.16 Coin from Gortyna (ca. 430 BC.); Europa as a tree goddess with an eagle between her legs. Zeus, as a bull, on the reverse side. This composition further identifies Europa as a galaxy goddess of the Leda type. She reflects the form of the Milky Way with the bird constellations between the branching pattern of the Great Rift; from the British Museum Catalogue of Coins.

a tree goddess and to a goddess associated with the Milky Way galaxy. The view of the galaxy as a giant white bird, hovering in the night sky was, like the serpent, incorporated into the composite Tree of Life myth in a subsidiary position as the bird or birds living in its branches.

In another of his amorous adventures, Zeus took the form of a shower of gold:

> Some say that Zeus had intercourse with [Danae] in the shape of a stream of gold which poured through the roof into Danae's lap. When Acrisius [her father] afterwards learned that she had got a child Perseus, he would not believe that she had been seduced by Zeus, and putting his daughter with the child in a chest, he cast it into the sea.[32]

The myriad stars of the galaxy, sparkling like a river of gold in the night sky, have been associated with raindrops—raindrops in such vast numbers that they form all the rivers of the world. Galaxy imagery is evident in this stream of gold, and its celestial nature in the fact that it pours through the roof. Again too, there is the image of the sea; this is the location where the ancients believed the galaxy intersected the earth. Also, as we saw in chapter 3, Perseus is associated with Atlas and the Tree of Life that grows on his island, where, with the Gorgon's head, he transformed Atlas into a mountain of stone.

Many cultures viewed the galaxy as a god or goddess. The legends that tell how Zeus seduced mortal women, nymphs, and goddesses may well preserve a record of historical conquests of Zeus-worshipping Greeks over local pre-Hellenic cultures where the galaxy was worshipped as a Hera, a Leda, or a Danae. This holds true particularly in the case of Hera, whose name originally meant queen of the sky.[33]

Figure 7.17 Danae impregnated by Zeus as a shower of gold; Titian, Prado Museum.

Finally, the galaxy is associated in the myths of many cultures with a bull. Gilgamesh and Enkidu kill the bull of heaven, and Enkidu later tears out the bull's thigh and throws it at Ishtar, as we saw in chapter 4. The image of a cosmic bull reappears again in Greek myth, where Zeus assumes the form of a white bull (with a single black streak between his horns) in his abduction of Europa, who was also frequently depicted as a tree goddess (Figure 7.16).[34] Referring to this bull, Ovid repeats this image of whiteness three times, as if to urge his audience to read between the lines:

He's white—precisely like untrodden snow, like snow intact.[35]

Asterius, or Asterion, the Minotaur of Crete, was said to be the son of a white bull. His name means "of the stars" or "of the heavens," a clue to his galactic origins. He is killed by Theseus, who, like Hercules, makes a perilous journey to the underworld and later returns. It is on this adventure that Theseus loses the flesh on the back of his thigh when Hercules pulls him up abruptly from a bench to which he was stuck (Figure 7.18 and 7.19).[36]

The bull of heaven is represented in Hebrew mythology by the figure of Behemoth. His immense size, and an association with a cedar tree, link him to the Tree of Life/galaxy motif. He is ...

a "super ox" of mythic proportions and possessing supernatural characteristics, hence the "Beast" par excellence … Behemoth is clearly no ordinary beast: an awesome ox-like being that eats grass but is equally at home in the water as on land, with bones of metal and a tail (or penis?) comparable to a mighty cedar tree.[37]

Traditions of celestial bulls also existed in ancient Egypt. The citation that follows suggests an image reminiscent of the four rivers, flowing from the four cardinal points:

[In the oldest texts] mention is made of the heavenly bull with four horns, one for each cardinal point. Accordingly in earlier tradition Osiris often has the form of a bull.[38]

Osiris, along with his wife Isis, also regularly assumes the form of the sacred Tree of Life. His transformation into a variety of galaxy symbols parallels that of Zeus in Greece. All these accounts suggest that at some remote period in history the galaxy was viewed as a heavenly bull, the two branches separated by the Great Rift presumably representing his horns. The constellation Taurus (Bull) may be the vestige of this earlier image in the same way as the Hydra appears be a vestige of the an-

Figure 7.18 Theseus slaying the Minotaur at the center of the labyrinth. Here the action takes place near a pillar suggesting the axis mundi.

Tree of Life, Mythical Archetype

cient serpent which represented the galaxy. Taurus is situated directly alongside the Milky Way.

The Tree of Life is a composite myth formed from earlier beliefs about the nature of the galaxy, and these older vestiges can still be seen as secondary elements in the myth that replaced them. We do not know when this composition was created—or by whom—but it must have been in a very remote period of prehistory. In the next chapter we will look at remarkably close parallels that occur in the mythology of the Western Hemisphere. The similarities between these legends and those of Eurasia are so numerous as to preclude the possibility of independent origin.

Figure 7.19 Two coins from Gortyna (ca. 430 BC.), each showing Europa as tree goddess with Zeus as bull on the reverse. From the British Museum Catalogue of Coins.

Figure 7.20 Center of the labyrinth with Theseus slaying the Minotaur at an axis mundi pillar. Note the swastikas in the decorative pattern adjoining the Minotaur. From an Attic red-figured vase ca. 450-430 BC. From the British Museum

Figure 7.21 A coin from Knossos depicting the Minotaur, with a labyrinth in swastika form on the reverse side. From the Mc-Clean collection, Cambridge.

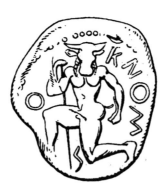 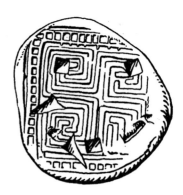

Tree of Life, Mythical Archetype

Part II

Confirmations in World Myth

Prefatory Remarks to Part II

The location and identity of the Tree of Life as it was conceived by ancient peoples, recorded in their mythologies, and inscribed on their votive objects, have been described in the preceding chapters. Evidence from four remote cultures has been presented in support of these interpretations. Fifteen generalized attributes of the myth have been identified and linked to a familiar referent in the physical world.

It remains for us to investigate the religious beliefs of several more advanced civilizations, and to determine whether these either support or contradict the views already presented. The highly developed cultures of Mesoamerica, Egypt, India, and Greece have left writings, monuments, and artworks that reflect their underlying belief-systems, and these provide ample raw materials on which to base further conclusions. By and large, it will be seen that the same patterns apply here as they did in the four Eurasian traditions already explored.

The following chapters illustrate how the Tree of Life functioned within the religious frameworks of these more developed cultures. New World parallels to the Eurasian myths are strong evidence that early communication occurred between the hemispheres. This would be expected if navigators in the remote past had mapped the major rivers tributary to the Atlantic

Ocean and derived the swastika symbol from them. Remarkable similarities between artifacts found at Troy and those discovered along the Amazon River support this hypothesis. Additional evidence is presented suggesting that the area south of the equator was regarded as the underworld in the oldest traditions.

The mythology of Egypt is both copious and complex, creating barriers that tend to deter a deeper exploration by students of ancient religion. Gods and goddesses with different names and cult centers fulfill equivalent or overlapping functions. Nearly all these gods have changed their attributes over the five thousand years of ancient Egyptian history, and they alternate in their ascendancy according to the political ranking of the cities that control their various centers of worship. This condition reflects the lack of any orthodoxy among the Egyptian city-states, where each region regarded the cult of its own local god as supreme in the religious pantheon. A pharaoh born in Memphis, for example, might raise the gods of Memphis to an elevated status in the monuments constructed during his reign. A later pharaoh from the delta might inaugurate changes in doctrine that would persist for hundreds of years in the architectural record and in the papyrus scrolls found entombed with the mummies.

Nevertheless, the Tree of Life persisted as a religious symbol throughout the historical period of ancient Egypt. Using the fifteen attributes of the myth, it is possible to trace out what may be the most significant chain of continuity within the often bewildering chaos of Egyptian myth. Reduced to its simplest form, worship of the Tree of Life, and of the various gods that embodied the Tree of Life throughout the ages, was a central aspect of religion along the Nile River. The many examples cited in chapter 10 will illustrate that the same attributes continue to mark the many variants of the myth with a pedigree unmistakably related to the traditions already described.

Only a small sampling of mythological data from ancient India is presented in chapter 11, because the amount of material preserved in the Sanskrit language that has survived from remote ages is truly vast. But the few examples given demonstrate that the cult of the Tree of Life was pervasive in this ancient Indo-European culture. The mountain or tree located at the center of the world from which four rivers flow into the four cardinal directions are concepts firmly rooted in the Indian texts. An ocean of milk is created from the vortex motion of this axial mountain by means of an underworld serpent. These images linking the galaxy with the axis mundi are frequent, and they occur in multiple variations throughout Indian mythology.

The literature of ancient Greece provides countless allusions to the Tree of Life, the axis mundi, and the galactic referent, but here they are particularly opaque. Perhaps more so than any of

the other cultures described in this book, Tree of Life images were treated as an esoteric mystery by the Greeks. But because the allusions are so plentiful and at the same time so largely veiled, efforts expended in their discovery are amply rewarded. The turbulent marriage of Zeus and Hera, for example, which has so thoroughly perplexed scholars, can be understood as an accommodation between two initially hostile cultures, each of which worshipped one of these two gods as the embodiment of the galaxy.

Because of the many similarities between the decorative motifs on Greek geometric pottery and the symbols found on the Trojan spindle whorls, conclusions can be drawn about the earliest strata of Greek religion. The titans, an older set of deities which was later displaced by the Olympian gods, are especially associated with axis mundi imagery. Two of these titans, Atlas and Prometheus, figure prominently in the myths, and their respective functions are further explored in chapter 12. A deeper understanding of early Greek religion leads then to clues about the underlying themes in the epic poems of Homer, some of which we have already explored in chapter 2.

Chapter 8

The Tree of Life in Ancient America

In the fall and winter of 1891-92 American archeologist Warren K. Moorehead led a team of researchers that excavated an Indian burial mound in Ross County, Ohio. This mound formed part of the so called Hopewell Interaction Sphere, a vast network of villages and small cities along the Mississippi River and its tributaries in the Illinois and Ohio Valleys that flourished during the period from about 100 BC to about 300 AD. Similarities in burial customs, shared iconographic features and a sumptuous economic life mark this distinctive culture.

The Hopewell Mound, as this site came to be called, stood 18 feet above the natural ground. At its base, two skeletons were found buried side by side, surrounded by bountiful grave deposits consisting of pearl beads, copper hatchets, panther tusks, sheets of copper, and numerous other objects. Thomas Wilson, who was present at the time, writes:

> About five feet above the base of the mound, they struck a mass of thin worked copper objects laid flat one atop the other, in a rectangular space, say three by four feet square. These objects are unique in American prehistoric archeology.[1]

The most remarkable of these objects were five swastikas about four inches in size, formed from sheets of copper which had been pounded thin without the use of heat (Figure 8.1). The copper itself was of native origin, from the area around Lake Superior, 150 miles to the north.

Figure 8.1 Copper swastika found at the Hopewell Mound, Ross County, Ohio, ca. 100 BC – 300 AD. (After an artifact in the Field Museum of Natural History, Chicago.)

Two years after this discovery, Wilson—a curator at the U.S. National Museum—published an extensive report on the history, distribution and significance of the swastika. His inquiry was exhaustive; it described many of the artifacts found throughout the world which bear this symbol. He concluded that the swastika is too complex to have arisen independently in the widely dispersed locations where it has been found, but that it must have undergone a process of diffusion from its place of origin in the distant past.

No conclusion is attempted as to the time or place of origin, or the primitive meaning of the Swastika, because these are considered to be lost in antiquity. The straight line, the circle, the cross, the triangle, are simple forms, easily made, and might have been invented and re-invented in every age of primitive man and in every quarter of the globe, each time being an independent invention, meaning much or little, meaning different things among different peoples or at different times among the same people; or they may have had no settled or definite meaning. But the Swastika was probably the first to be made with a definite intention and a continuous or consecutive meaning, the knowledge of which passed from person to person, from tribe to tribe, from people to people, and from nation to nation, until, with possibly changed meanings, it has finally circled the globe.[2]

Four centuries after the decline of the Hopewell culture described above, a new phase of shared cultural attributes began to take form. The so-called Mississippian Interaction Sphere flourished from about 700 AD until about 1200 AD. The primary sites of this interaction sphere are located along the Mississippi River, with a linked network of villages and towns extending throughout the southeastern United States and reaching, in some cases, as far as the Atlantic coast.

This cultural complex shows strong Mesoamerican influence, with ties to the Aztec and Mayan civilizations in southern Mexico and Guatemala. Engraved shell gorgets displaying pronounced swastika motifs are plentiful in Mississippian sites. Often these designs take the form of birds or snakes with body parts extending outward in a swastika configuration (Figure 8.2 and 8.3). This fact may be an indication that the mythology behind these designs was derived from a Eurasian prototype, since the bird and snake figure so predominately there in conceptions of the axis mundi.[3]

A peculiar characteristic of some Mississippian artifacts is the design motif known as the "forked eye." A meandering stream of water flows downward from the outside eye in the faces at each of the four quarters and at the center. The crossing pattern at the center may represent the confluence of the four Atlantic rivers as in the typical swastika motif, with the water

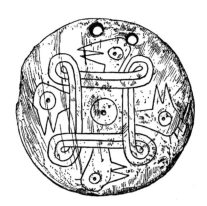

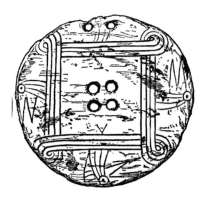

Figure 8.2 Shell gorgets, with birds in swastika formation, from the Mississippian Interaction Sphere (ca. 700-1200 AD); Tennessee.

Tree of Life, Mythical Archetype

running from the weeping eyes providing a symbolic parallel to the outer arms of the swastika in their representations of rivers. A similar concept can be found in Egyptian mythology. The god of the earth, Geb, weeps for his wife, the sky goddess, Nut. She has been separated from him by the god Shu who stands in an Atlas-like posture with upraised arms separating the earth and sky. In his grief, the tears of Geb form all the rivers of the world.[4]

The most preeminent of the Mississippian sites, called Cahokia, is located across the river from the city of Saint Louis. It formed an immense complex of pyramid-shaped ceremonial mounds, villages, farms, and a unique circular astronomical observatory similar to Stonehenge but constructed of wood. At the very center of this complex is an earthen pyramid over one hundred feet high called the "Monk's Mound." Joseph Campbell identifies this central mound as a representation of the axis mundi, and connects it with the familiar notion of forming a bridge between the earth and heaven. His association of this axial mountain to the quadripartite division of the world is reminiscent of the four continents or four vast rocks which border the central world mountain or Tree of Life in Eurasian mythology:

> Since it is in the middle of the site, its symbolic function, as representing the axial height joining earth and sky, is evident. The idea of such a generative center is already represented in the Spiro Mound gorget [Figure 8.2a] which is an unmistakable representation of the mythological archetype of the quartered cosmos, an "elementary idea" of which the swastika and equal-armed cross are abstractions. The prominence of these symbols in the figures speaks for the importance of this concept in Mississippian thought.[5]

The Mississippian religious focus on the world axis as a mountain, tree, or pole is typical of the beliefs of many other Native American cultures. Its further association with the quadripartite cosmos is consistent with the concept seen in Eurasian cultures where the axis mundi intersects the earth at the vertex of the four rivers and four continents. The Kwakiutl Indians of the Pacific Northwest, for example, explicitly associate the axis mundi with the galaxy.

> The Kwakiutl believe that a copper pole passes through the three cosmic levels (underworld, earth, sky); the point at which it enters the sky is the "door to the world above." The visible image of this cosmic pillar in the sky is the Milky Way.[6]

As in Eurasian traditions, this concept is often linked to the notion of a cosmic ladder, or stairway, which conducts the souls of the dead to the heavenly realms. The ancient Maya also

Figure 8.3 Artifacts from the Mississippian Interaction Sphere: (a) shell gorget with swastika formed from crested birds around a second swastika at the center; (b) shell gorget with swastika formed by four birds, with a cross at the center.

a

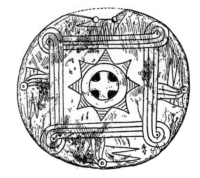

b

regarded the Milky Way as a giant tree connecting the earth, heaven and hell as though by a great umbilical cord. It bore the shape of a huge tree, a cosmic Tree of Life. Modern descendants of the Maya continue to view the Milky Way as a pathway to heaven:

> There is a second roadway of the stars, often neglected by Western culture but particularly important among people who live in the American tropics, especially because it is so prominently visible from the latitudes in which these cultures developed. The Milky Way is visible as a 10°–15° wide band of diffuse light that passes all the way around the sky at about a 60° angle to the daily direction of motion of the stars. It is best viewed when it crosses the zenith from north to south on late summer evenings. The Maya thought of it as the umbilical cord that connected heaven and the underworld to the earth and as the cosmic tree of life. Some contemporary Maya groups still regard it as a great celestial roadway. … The Milky Way is also described as a celestial river that carries the paddler gods and First Father, our creator, into and out of the underworld, Xibalba. Maya epigrapher Linda Schele has discerned a pattern in Maya iconography that can be related directly to the Popol Vuh, or the story of creation as told in the sky, in which the Milky Way provides the background set for the tale. In this scenario the ecliptic is a two-headed serpent and the constellations positioned at the location where it crosses the Milky Way are especially important.[7]

Many classical Mayan vase-paintings depict scenes from the Popol Vuh. In one of these, the Tree of Life with its bifurcated branching pattern can be seen reflecting the two arms of the Milky Way galaxy where it branches at the constellation Cygnus. The presence of the bird-god, Seven Macaw in the crotch of the tree exactly parallels the location of the bird, Cygnus, in western astronomy. A scorpion at the base of the tree parallels the western system, where the constellation Scorpius is located at the base of the Milky Way where the latter intersects the ecliptic as we saw in the Gilgamesh epic. The constellation Scorpius is represented by a scorpion figure in the Mayan cosmology as in the western system.[8]

Other correspondences between the western and Mesoamerican astronomical systems can be inferred from the legends. Like the dog Cerberus, which guards the entrance to the underworld in Greek myth, Mesoamerican legends tell of a dog, Xolotl, who guarded the western entrance to the underworld.[9] Likewise, the constellation Aquila (Eagle) in the Eurasian system was represented as a hawk by the Quiché Maya.[10]

Some scholars have seen a relationship between the Mayan concept of the Milky Way and a celestial tree. Others favor the view that, for the ancient Maya, the Milky Way was more likely seen as a sky serpent. As we have already noted, parallels to both images exist in Eurasian mythology. These Mayan conceptions corroborate the notion of the Tree of Life as a cosmic pathway between the earth, heaven, and the underworld, and its identification with the galaxy:

> Maya images of the Milky Way as a celestial river and a sky serpent may reflect ancient archetypes, for such images are quite widespread across the world. Among the Quechua of South America, such images are particularly well developed; there the Milky Way is a celestial river that circulates the waters of the cosmos (Urton 1981). The association of the Milky Way with the dead is also common. Edward Krupp (1993) notes that among the Lapps, the Milky Way is the road for the dead leaving earth, and similar images are found in the transformational notions in Siberia, where the Milky Way is a path of migrating birds whose departure is compared to the soul's departure from Earth. Indeed, the link between the Milky Way and the realm of death is so widespread that it may have been part of the traditions brought over during the Pleistocene migrations.[11]

Sosa (1985:432) records a Yuctec prayer that refers to a great *roble* or oak tree (tin oh bèek) in the white road (sak beh) in the sky.[12]

Joseph Campbell's statement linking the swastika symbol to a fundamental conception of the "quartered cosmos," so common among the Native American cultures, is consistent with the legends of the Hopi Indians. Reference was made to this in chapter 2 when discussing the migration patterns of the Hopi clans in a swastika formation.[13]

The design of the Hopi kachina rattles provides additional evidence of a link between the swastika symbol and the Milky Way galaxy in Hopi cosmology. These rattles are constructed from spherical gourds representing the earth through which a stick is inserted representing the axis mundi. A swastika symbol is prominently painted on the gourd and is surrounded by signs depicting the constellations of the Milky Way:

> The flat round face of the gourd represents the earth. The circle inside symbolizes the sun, whose radiating rays give it warmth and life. The swastika symbol may show clockwise rotation with the sun, or counterclockwise to indicate the earth. The stick thrust through the gourd for a handle symbolizes the north-south axis of the earth, at whose ends sit the Hero Twins, Poqanghoya and Palongawhoya, who

Figure 8.4 Hopi Kachina rattle. These rattles are often made from gourds with a stick inserted to form an axis, then decorated with a swastika and with signs representing the Milky Way (see Waters, *Book of the Hopi*, 166). The rattle illustrated here is made with the natural neck of the goard as the axis, an alternative method of construction.

Figure 8.5 Beaded garter with swastika design; Sac Indians, Cook County, Kansas.

keep the planet rotating. The markings shown on the side represent the constellations in the Milky Way.[14]

The U. S. National Museum possesses a large number of these Kachina rattles, typically marked with swastikas, and sometimes made with the gourd's natural neck rather than with an inserted stick (Figure 8.4). The form of this Kachina rattle is remarkably similar to the model of the earth (with the galaxy at its axis) abstracted from the Eurasian myths, and illustrated in Figure 5.24. Both the physical form of the rattle, and the mythology associated with it, link the axis mundi, the swastika, and the Milky Way.

In most of the cultures we have examined, the center or navel of the earth was localized to the vicinity of the group's geographical homeland. To the Tibetans, it was Mount Kailasa; to the Hebrews, it was the Tigris and Euphrates, later Jerusalem; to the Greeks, it was Delphi; to the Hopis, it was the southwestern United States.

The Plains Indians of North America also used the swastika as a primary ornament. In their beadwork they call it the "luck" or "good luck." Among these tribes are the Kickapoos, Sacs, Pottawatomies, Iowas, and the Winnebagoes (Figure 8.5). That these tribes refer to the swastika as the "luck" further suggests a common origin of the tradition, for the Eurasian swastika is also typically associated with the goddess of fortune or fate.

During the period between 900 AD and 1200 AD, Navajo tribes migrated south and west from their former homeland in Canada and settled in the American Southwest. As part of their religious ceremonies, Navajos traditionally construct sand paintings which incorporate the swastika symbol in numerous ways. Figure 8.6 illustrates one such sand painting, used as part of a healing ceremony.[15]

Other Navajo sand paintings depict a place of emergence marked by a ladder, from which rivers flow into each of the four cardinal directions. Antelopes at each extremity form a swastika pattern.[16] This notion corresponds closely with the Mayan and Aztec legends which tell of an original island homeland. Among the Maya, this land is explicitly located somewhere in the eastern sea (the Atlantic). The most frequent Aztec name of this homeland is Aztlan; the Maya generally call it Tulan. In the Popol Vuh, three patriarchs of the Maya resolve to make a journey to the east, to the land of their fathers:

> "We are going to the east, where our fathers came from," they said, then they followed their road ..."We're not dying. We're coming back," they said when they went, yet it was these same three who went clear across the sea. And then they arrived in the east; they went there to receive lordship. Next comes the name of the lord with dominion over those of the east, where they arrived. And then they came before

Tree of Life, Mythical Archetype

the lord named Nacxit, the great lord and sole judge over a populous domain … From across the sea, they brought back the writings about Tulan.[17]

This passage recalls journeys to the western Olmolungring made by the great teachers in ancient Tibet with a similar purpose of retrieving sacred books. The Tibetans traveled west, the Mayas east, to reach the original place of emergence and repository of knowledge. Like the Tibetans, the original homeland of the Maya was also characterized by a prominent mountain. This is described in the Popol Vuh; when another related clan requests fire from the Maya, they plead:

"Wouldn't you take pity on us if we asked to remove a little something from your fire? Wasn't it found and wasn't it revealed that we had just one home and just one mountain

Figure 8.6 Navajo sand painting used as part of a healing ceremony. Rain gods create a swastika around a central cross. The center point denotes water. The arched rainbow (galaxy?) goddess is positioned with her head at the north, and her two feet in the south.

when you were made, when you were modeled? So please take pity on us," they said.[18]

In a second Navajo sand painting many of the same elements are represented, with the circle at the center again representing water. From this center, four gods extend outward into each of the cardinal directions. A left-hand-turning line projects from the head of each god, thus together they form a swastika oriented to the four cardinal points. Near each of the gods is a smaller swastika drawn with a circle at its center. Four plants are depicted growing from the vertex. Although the semicircular god surrounding the whole composition is typically referred to as a rainbow, its form and placement suggests a possible origin as a representation of the Milky Way (Figure 8.7).[19]

The division of the world into four parts, with a religious significance given to the four directions, is a common theme that can be observed in much of pre-Columbian Native American art. This is tied-in with the conception of a place of emergence or ancestral homeland located at the vertex of the four directional lines. A panel from the early Mexican (ca. 1500 AD) Codex Borgia illustrates "The Tree of the Middle Place" (Figure 8.8). A bifurcated tree is surmounted by a bird at its branching point. The "alligator of the abyss" lies at its base, indicated by the serpentine form with spines rising from its back. It stands at the center of the "World Sea," shown by the circular form. The

Figure 8.7 Navajo sand painting with swastikas in the four directions. Rainbow (or galaxy) goddess arches over all.

Tree of Life, Mythical Archetype

entire tree arises from the navel of the earth-goddess, Tlalteu-tli.[20] Many of the familiar attributes of the world tree myth are present here: the location of the tree at the middle place in the sea, its bifurcated branches with a bird at their point of separation, and the serpent at its base. The location of the Tree of Life at the navel of the earth-goddess parallels the notion expressed by Homer where the island of Atlas' daughter is located at the navel of the sea.

A similar panel from the Aztec Codex Fejervary (Figure 8.9) depicts another version of the Place of Emergence (at center) and the four cardinal directions. Like the Navajo sand paintings which formed a bi-directional swastika through the placement of the stags and coyotes at the extremities, the same form is created here with bifurcated Trees of Life. Each tree shows a bird at the branching point. The tree at the left, marking the northern direction, shows a conspicuous wound in the side of its trunk. Four streams of blood are said to flow towards the vertex.[21]

The world conceptions of the Aztec and Maya were similar in many respects; in both traditions a great world tree stood at the center of the cosmos. A page from the Mayan manuscript known as the Codex Cortesianus (Figure 8.10) shows the "Plate

Figure 8.8 The Tree of the Middle Place. A bifurcated Tree of Life with a bird at its branching point, growing from the middle point of the "World Sea," (shown by the circular form at the center). The entire tree arises from the navel of the earth-goddess, Tlalteutli. The "Alligator of the Abyss" (with spines) lies below. (Aztec; After an illustration in the *Codex Borgia*, early sixteenth century, here simplified.)

Figure 8.9 Bifurcated trees, with birds at the branching points, are positioned in each of the cardinal directions. The tree representing the northerly direction (at left) shows a wound in its side. Aztec, early sixteenth century, *Codex Fejervary.*

of the Bacabs," believed to represent the gods of the four cardinal directions. At its center is the familiar bifurcated Tree of Life. In the Maya legends, gods representing water sources, called "sprinklers," are found in each of the four directions. These define the overall orientation of the world. In the legends of the Aztecs:

> It consisted of four quadrants or spaces extending out from the cosmic center, or navel of the earth, each quadrant representing one of the four directions as they related to the passage of the sun. Each quadrant was named according to its direction and was associated with its own sacred tree, which was envisioned as one of the four sky bearers.

> ... the Maya saw the sky, considered male in this context, as multitiered and supported at its corners by four Bacabs, gigantic Atlantean gods known as "water sprinklers"... The sky was also imagined as being supported by four different species of trees, each a different color, with the sacred green ceiba tree positioned as a world tree at the center.[22]

The Divine Quetzalcoatl

The existence of a sacred tree at the "navel of the earth," with a water source in each of the four cardinal directions, is an image which incorporates many of the elements of the Tree of Life myth as described in chapter 5. This connection is further reinforced by details provided in the legends of the god Quetzalcoatl. He was instrumental in raising the heavens after they had fallen. First he made four roads that cross at the center point of the earth, then he transformed himself into one of the trees that support the sky. He and Tezcatlipoca then created the Milky Way for their home.[23]

It is not surprising to discover that the Milky Way was the home of Quetzalcoatl, as he shares a number of other galaxy attributes. In addition to his role as the heaven-sustaining tree, he sometimes took the form of an Atlas-like titan in the form of the wind god Ehecatl. In the year 1900, two stone images of him were found in Mexico City:

> Both figures are slightly bent over and raise their arms high alongside their heads, the tops of their heads and hands forming a flat, horizontal upper surface. The posture of the pair indicates that they served as a type of figure called atlantean, that appears in Mesoamerica as early as the Olmec era (ca. 1200 – 400 BC).[24]

Figure 8.10 Plate of the Bacabs. A bifurcated Tree of Life at center is surrounded by the gods of the four directions. From the Mayan *Codex Cortesianus*.

The name *Quetzalcoatl* means "feathered serpent." As described in chapter 7, a winged serpent was one of the early forms used to represent the galaxy in Eurasian conceptions, often as Ouroboros. The posture, which Quetzalcoatl assumes in his role as Ehecatl with upraised arms, is also typical of galaxy personifications in Mediterranean contexts, exemplified by Atlas, Hera, Nut, Hathor, and Shu.

In a sketch included within the Codex Chimalpopoca (1558) the outlines of Tollan (Tula), the mythical Aztec land of emergence, are depicted: Quetzalcoatl stands at its center point as would be expected by an axis mundi god.[25] In another painting from the Codex Borgia, Joseph Campbell identifies him as the god creating fire with a fire drill shown in Figure 8.13, thus linking Quetzalcoatl with axial motion and the axis mundi. The fire drill is placed at the navel of the recumbent goddess.[26] He appears to be represented symbolically in swastika formation on a mosaic from Chichén-Itzá (Figure 8.12).

As in Eurasian myth, the world tree of ancient Mesoamerica served as a conduit between the earth, heaven, and the underworld. The sarcophagus lid of the Mayan king Pacal, who ruled Palenque from 615 – 683 AD, is decorated with a scene of his fall into the underworld via the Tree of Life.[27]

The location of the Tree of Life at the navel or center of the world was also considered the place of origin or emergence for the Aztecs. The name of the island, Aztlan, means "whiteness." It was located within a great sea, from whence the Aztecs sailed to their later home in Mexico:

> Our forebears dwelt in that blissful, happy place called Aztlan, which means "Whiteness." In that place there is a great hill in the midst of the waters ...[28]

Figure 8.11 Two Olmec carved-stone figures of the type called "atlantean" by archeologists. Found near Potrero Nuevo in the state of Vera Cruz, Mexico.

The great hill at Aztlan also had the power to confer immortality as does the typical Tree of Life or axis mundi mountain in Eurasian myth. When the Aztec king wished to revisit the ancestral place of emergence he sent his sixty sorcerers on a quest to find it. If possible, they were to present gifts to Coatlicue, the mother of the great god Huitzilopochtli. When they were successful in locating her home on the legendary mountain, she demonstrated its ability to rejuvenate. An old person had only to climb to a position on the mountain which corresponded with the age he desired to become; if he wished to regain his youth, for example, he climbed to the very top.[29]

Quetzalcoatl's identification with the axis mundi can be seen again through his relationship to Tezcatlipoca, of which he was one aspect and with whom he lived together in the Milky Way as noted above.[30] Quetzalcoatl is only one particular development of Tezcatlipoca, who himself possesses clear axis mundi characteristics. For example, he had his seat at the north pole where he was said to have created fire. He was the god of

whirlwinds, and waterspouts, thus demonstrating his association with the cosmic vortex motion. He was also characterized as the axis, the Northern Wheel, "the heart of heaven and the heart of earth," and as possessing only one leg.[31] This last characteristic is an attribute common to many of the palladium-style representations of galaxy gods with fused legs. It parallels the formation of the galaxy with its one column of light below the branching arms at the Great Rift. This resembles an anthropomorphic figure with legs either fused together or else tightly placed one next to the other.

Mesoamerican anthropologists recognize Quetzalcoatl as a representation of the planet Venus[32], but the close parallels to axis mundi and galaxy imagery described above would suggest an earlier identification with the Milky Way.

The Human Quetzalcoatl

The god Quetzalcoatl described above must not be confused with the legendary Toltec king Ce Acatl Topiltzin Quetzalcoatl. The latter was reputed to have been a great king or high priest of Tula, who introduced numerous cultural innovations and technologies. He is described as a heavily bearded man living among a race which typically had little or no facial hair. This has led to speculations that he may have been a visitor from one of the culturally advanced Eurasian civilizations, but so far no evidence other than his description has been produced that would substantiate such conclusions. His cultural contributions included the arts of sculpturing in stone, gem cutting, metallurgy, feather working, and writing. In an account composed around the year 1580, based upon information supplied by native informants, Bernardino de Sahagún writes of Quetzalcoatl:

Figure 8.12 A mosaic disk formed of semi-precious stones. Four divinities, presumed to be plumed serpents (Quetzalcoatl), in swastika formation. From the Mayan-Toltec culture at Chichén-Itzá. (After a piece in the Museo Antropologico, Mexico City.)

Figure 8.13 Quetzalcoatl twirls a fire stick at the navel of a recumbant goddess. Aztec, Mexico, early sixteenth century. (After an illustration in the *Codex Borgia,* here simplified.)

His face … [was] not made like that of men. And his beard was very long— exceedingly long. He was heavily bearded.

And the Toltecs, his vassals, were highly skilled. Nothing that they did was difficult for them. They cut green stone, and they cast gold, and they made other works of the crafts- man and the feather worker. Very skilled were they. These started and proceeded from Quetzalcoatl—all craft works and wisdom.[33]

In addition to the above innovations, Quetzalcoatl put an end to human sacrifice among the Toltecs. In so doing, how- ever, he earned the enmity of Tezcatlipoca, their supreme god. In revenge, Tezcatlipoca, in company with other sorcerers, cor- rupted the king with the fermented drink, pulque:

> Well, it is told and related that many times during the life of Quetzalcoatl, sorcerers tried to ridicule him into making the human payment, into taking human lives. But he always refused. He did not consent, because he greatly loved his subjects, who were Toltecs. Snakes, birds, and butterflies that he killed were what his sacrifices always were.

> And it is told and related that with this he wore out the sor- cerers' patience. So it was then that they started to ridicule him and make fun of him, the sorcerers saying they wanted to torment Quetzalcoatl and make him run away.

> And it became true. It happened.[34]

While the different versions of the legend generally agree that Quetzalcoatl succumbed to the corrupting influences of these sorcerers and as a result departed from the city, they vary in their description of his end. In some accounts he offered himself up in flames. His ashes ascended into the sky, and he became a star. Other evidence indicates that, in the year 987 AD, he and an army of followers marched south and reoccu- pied the previously abandoned city of Chichén Itzá, ushering in a Mayan renaissance. There he was known under the name Kukulcán.[35] In the most widely accepted Aztec version of the legend, however, Quetzalcoatl sailed east towards the mythical homeland Tulan. But before departing from the Gulf coast of Mexico he vowed to return.

He even specified the date—it would be in the year of his name CE ACATL of the Aztec calendar—a date which would prove fateful for the Aztecs. For in that year (1519 in the Chris- tian system) Hernán Cortéz landed with his men at Vera Cruz. The Aztec king, Moctezuma, had been expecting the arrival of the legendary god-king that year, and therefore assumed that the bearded Cortéz was Quetzalcoatl. But something had gone dreadfully wrong. Instead of the promised reunification her-

alding in a new golden age, only destruction would follow for the ancient civilizations of America.[36]

Mayan legend also predicted a return of the bearded white god, Kukulcán; such a tradition was quite common throughout the tribes of pre-Columbian America. The Hopis also had a legend of a lost white brother who would some day return to them from across the eastern sea. At the beginning of their history, Pahána as he was called, was sent to live among the people in the east. One day he would return to inaugurate a new age, combining the best cultural aspects of both East and West. In order to identify himself, or his representative, upon his return, he was given the corner of a stone tablet containing distinctive marks, including a swastika. This stone would fit together in the right way with the original tablet, thereby establishing his identity and authority.

Prior to the great swastika migrations, the god Másaw had presented this sacred tablet to the leader of the Fire Clan with instructions for its use. Sometime in the distant future strange men would arrive on the land, threatening the Hopi way of life. Pahána would then return and lead them into an era of universal brotherhood. The story of this covenant was related by the Hopi elders:

> When they first had landed on this Fourth World, a certain person had been sent east to the rising sun. Upon reaching there, he was to erect a shrine and rest his forehead on the ground once. Then he was to return with the people of the rising sun and they would all become brothers again in fulfillment of the universal plan. If he rested his forehead more than once, it would take much longer, hundreds of years longer, for him to return. This lost white brother's name was Pahána (from *pásu*, salt water). When he left, a piece of the sacred tablet was broken off and given to him so that when he rejoined his brothers this piece would match the tablet it had been broken from and identify him as their lost brother.[37]

The date set for this reunion was the year 1519, the same year Quetzalcoatl promised to return to the Aztecs. There was also a provision in case of possible delay—five, ten, fifteen, or twenty years—and a specific meeting place set for each of these contingencies. Twenty years later (actually February, 1540) Francisco de Coronado sent a party of soldiers to plunder the Hopis. Needless to say, these soldiers did not possess the sacred stone, nor did they seem to know anything of the ancient pact. The Hopis knew right away that something had gone wrong; the plan which had been so carefully crafted had failed. As the Hopi elders tell it:

Nevertheless, the Spaniards were escorted up to Oraibi, fed and quartered, and the agreement explained to them. It was understood that when the two were finally reconciled, each would correct the other's laws and faults; they would live side by side and share in common all the riches of the land and join their faiths in one religion that would establish the truth of life in a spirit of universal brotherhood. The Spaniards did not understand, and, having found no gold, they soon departed.[38]

Was it mere coincidence that Cortéz and Coronado both arrived in the years stipulated by the native traditions? Most commentators believe so. After all, no evidence of any prior communication between the hemispheres has come to light. It is remarkable, however, that this method of identification—breaking a single object into two parts—was known also in ancient Greece:

> σύμβολον [symbolon], each of two halves or corresponding pieces of a [bone] or other object, which two [strangers], or any two contracting parties, broke between them, each party keeping one piece, in order to have proof of the identity of the presenter of the other.[39]

This is significant because an independent European tradition also describes a stone, the two halves of which fit together in the right way, one coming from the East the other from the West. This tradition bears a striking resemblance to the Hopi Indian legend in that it also describes how East and West were intended to join together in peace and brotherhood for the well-being of all humanity, and to share their material resources in common.

Rosicrucian Alchemists and the *Sibylline Prophesy*

Nearly eighty years after Coronado's soldiers encountered the Hopis in a remote region of the American Southwest, a book appeared in the German city of Oppenheim composed of cryptic verses and enigmatic illustrations. *Atalanta Fugiens* (1618) by Count Michael Maier was a lavish publication for its day, containing some fifty original copper engravings and a text in Latin. This book could be described as a treatise on Rosicrucian alchemy, that is, a type of alchemy having nothing to do with the pursuit of gold through the transmutation of base metals. But using the vocabulary of ancient alchemy, it purports to reveal—to those able to understand its arcane symbolism—secrets hidden within Greek mythology and later texts. Maier follows the common alchemical practice of hiding his meaning behind a veil of contradictions and intentional obscurities. He is

quite open about this allegorical method, stating that it is absolutely required by initiates who would refer to these mysteries in any public manner:

> Such are the philosophical doctrines which escape the notice of most, but to those who are clever they are easy to understand. Where one name is said, another is intended, thereupon he who equates them is deceived. But the philosophers are not only given permission to speak in this way, they are commanded to do so.
>
> … For those things which are true, even if concealed under a veil of allegories, agree wonderfully among themselves.[40]

In alchemical writings, the reader must look, not for overall consistency, but rather for a thread of meaning despite intentional decoys and contradictions. Much irrelevant material is placed around the symbols in order to distract the merely curious and the unprepared. Maier alludes to these decoys quite directly:

> Let these emblems stand before your ears and eyes,
> But then let your reason fall upon their secret meaning:
> I have laid these before your observation so that your understanding
> May take from these decoys what value they conceal.[41]

In *Atalanta Fugiens*, Maier describes two stones that fit together in the right way, one from the East, the other from the West. Using this allegorical language, he connects these two stones with an episode in Greek myth. In the cryptic manner typical of alchemical writing, he attaches an illustration that both supplements and revises the textual information.

> EPIGRAM XLVI
> Jupiter, from Delphi, twin eagles sent
> They say, to the east and western lands:
> When he desires to seek out the middle place of the earth-disk,
> As tradition has it, they return to Delphi at the same time.
> But they are a matching pair of stones, one from the east,
> The other from the west, which fit together in the right way.[42]

In classical belief, Delphi was the omphalos, or navel of the world. Zeus (here called by the Latin name Jupiter) wished to verify this fact, and so devised an experiment. He released two eagles at the same moment, sending one to the East, and the other to the West, with orders to return to him immediately upon arrival. Assuming equal velocities of flight, if one eagle arrived back at Delphi later than the other, this would indicate a greater distance in that direction, thereby disproving its central

position. Their simultaneous return, however, verified that Delphi was, indeed, the omphalos.

But contrast this text with the illustration associated with the epigram (Figure 8.14). Zeus is clearly depicted standing on an island as he releases the two eagles. It is emphatically *not* the Delphi in Central Greece that is indicated. The whole point is that the omphalos to which the text refers is located on an island in the sea.

The following epigram and illustration from *Atalanta Fugiens* continue the thread of the discourse (Figure 8.15):

EPIGRAM XLVII

From here, where the sun rises, the Wolf comes, but where it sinks into the sea
From there comes the dog, swollen with rage:
Goading and biting each other in raving madness,
And savage, with wide-open jaws was each one seen.
These are the twin stones, which are given away freely everywhere
To everyone and at all times, may you understand them.[43]

We learn here that the meeting of East and West is not felicitous. Conflict rather than harmony ensues at the meeting of the two stones that were intended to fit together in the right way. These images evoke the historical encounters between Spanish conquistadores from the East, and the indigenous people of the western hemisphere. Confirmation that this is Maier's intended

Figure 8.14 Zeus releasing two eagles from the omphalos, here located on a sea-girt isle. One flies to the east, the other to the west. Maier, *Atalanta Fugiens,* 1618.

meaning is given in the commentary that follows the epigram, where he explains the matter by quoting from an earlier alchemical letter:

> These stones are the truest Bezoar, of which the most excellent is sent from the East Indies, produced from the belly of wild animals; but Peru in the West-Indies gives another which is less effective, taken from tame animals. So that the East gives the very cruel wolf, and the West gives the dog familiar to men … Where the two meet in combat for the first time, they strike against each other, one after the other, and each bites the other in return. The dog, owing to its extraordinary size, obtains the first victory, overthrowing the wolf and rendering him half-dead. But the wolf, regaining its strength, afterwards attacks the dog persistently at every opportunity, until he is utterly destroyed. Meanwhile, its own wounds are not fewer or less lethal than those inflicted upon the dog, resulting in their mutual annihilation.[44]

The qualification that these stones come from the bellies of wild animals is an example of the use of decoys as previously described. This text confirms the identities of the wolf and dog as representatives of the eastern and western hemispheres. Its description of their first meeting parallels the historical events at the discovery and conquest of the Americas. We are also told that the dog and wolf are the two stones which belong together. Therefore we must understand that the stones are likewise

Figure 8.15 Dog from the West battling with Wolf from the East. Maier, *Atalanta Fugiens*, 1618.

associated with the respective hemispheres, precisely as they were described in the Hopi legend.

Maier's illustration, showing the dog and the wolf in combat, closely resembles an earlier one by Lambsprinck, printed in another emblem-book from 1599, in which the wolf and dog are also depicted in battle. The motto there reads:

The Wolf and the Dog are in one home,
Afterwards, however, out of these there may be unity.[45]

There is no doubt that Maier knew this earlier book because it too describes a wolf from the east and a dog from the west, stating that both originally descend from the same stock. After killing each other, they are restored to life, and so become a great remedy for the earth.[46] This treatise has been dated to the first half of the fifteenth century, which, if accurate, would place it before the voyages of Columbus.[47]

But there is another, even earlier document that uses the imagery of dog and wolf, and which describes the unity that could and should have arisen out of their mutual collaboration. This document appears in the books of the Sibylline Oracles, originally written in Greek and going back five centuries before the present era. These were ecstatic prophesies uttered by divinely inspired women, and were held in deep veneration by the ancients. Although widely distributed in antiquity, a special collection was maintained in Rome to be consulted only in very dire circumstances. But the books kept at Rome were destroyed by several fires, and it is unknown how much of the original material was preserved and re-collected in the documents that now exist. For the most part, the Sibylline books that we now possess are the products of Jewish and early Christian writers working in Alexandrian Egypt between 150 BC and about 300 AD. Versions of the Sibylline Books in various forms were also known and used during the Middle Ages.[48]

Maier makes reference to the wisdom of the Sibyl in another publication entitled, *A Subtle Allegory*, and so we know that he was familiar with the Sibylline Books. This is proved beyond doubt by the close parallels between Epigram XLVII from *Atalanta Fugiens* quoted above, and the passage from the Sibylline Oracle which follows. This passage also bears a striking resemblance to the idealistic prophecy of the coming harmony between East and West, as described in the Hopi legend about the lost white brother:

Figure 8.16 Michelangelo, *The Libyan Sibyl*, Sistine Chapel, Rome.

Tree of Life, Mythical Archetype

From Sibylline Book XIV

But when wolves shall with dogs
Pledge in a sea-girt island solemn oaths,
Then shall there be the raising of a tower,
And the city that suffered very many things
Men shall inhabit. For deceitful gold
Shall no more be nor silver, nor acquiring
Of the earth, nor much-laboring servitude;
But one fast friendship and one mode of life
With cheerful soul; and all things shall be common
And equal light among the means of life.
And wickedness shall sink down from the earth
Into the vast sea. And then near at hand
Is come the harvest-time of mortal men.
There is imposed a strong necessity
That these things be fulfilled. And at that time
There shall not any other traveler say,
In this conjecturing, that the race of men
Though perishable shall ever cease to be.
And then a holy nation shall prevail
And hold the sovereignty of all the earth
Unto all ages with their mighty sons.[49]

Figure 8.17 Michelangelo, *The Delphic Sibyl,* Sistine Chapel, Rome.

The phrase, "sea-girt island," in the second line is particularly revealing. In the original Greek of the Sibylline Oracles, these are the exact Greek words used by Homer (*Odyssey* 1.50) where Athena pleads with Zeus to release Odysseus from the clutches of Calypso, who holds him prisoner on a sea-girt island at the omphalos of the sea.[50] Maier's emblem showing Zeus releasing eagles from an island at the omphalos, along with references to the wolf and dog, create very strong parallels to the Sibylline verse, and suggest that he knew of them and intentionally connected them. His response to the historical meeting between East and West appears to be conditioned by prior knowledge of the high hopes of the Sibylline prophesy. Note too, that in the concluding line of Maier's epigram the phrase "at all times " parallels a phrase in the concluding line of the Sibylline Oracle, "Unto all ages." This is additional evidence that Maier alludes to the Sibylline prophecy in his epigram. Through this parallel imagery, he links the image of the two stones, which represent the eastern and western hemispheres, with the Sibylline prophecy of a coming universal brotherhood.

These two texts, *Atalanta Fugiens* and the *Sibylline Oracles*, show four significant parallels that are unlikely to have occurred by chance. Both refer to a sea-girt island at the omphalos. Maier's reference to the omphalos is explicit. The Sibyl's reference is implicit through her quote of the phrase used by Homer to describe Calypso's island. Both refer to a wolf and a dog that represent human communities which encounter each

Figure 8.18 Michelangelo, *The Cumaean Sibyl*, Sistine Chapel, Rome.

other. Although the outcomes are different in each case, in both texts the wolf and the dog are symbols for groups of human beings. Both texts end with references to eternity. And finally, both texts refer to Atlas, or to his island. When the Sibyl says, "And wickedness shall sink down from the earth / Into the vast sea" she reminds us of the fate of Plato's island Atlantis, which sank down into the sea because of the growing wickedness of its inhabitants (Appendix 1). This island was located outside the Straits of Gibraltar where we have identified the position of the Tree of Life. That Maier also connects his book with the Tree of Life is evident by the innumerable references to it in the text. Even the title, *Atalanta Fugiens*, is such a reference since, in the Greek myth, Atalanta acquires the apples that originally grew on the sacred trees of the gods, guarded by the serpent and by the Hesperides. The close resemblance in the names, Atalanta—Atlantis, is also significant; both are derived from the name of the titan Atlas.

By associating the Sibyl's prophecy of universal brotherhood with his image of the two stones that fit together in the right way—one representing the eastern hemisphere, and the other the western—Maier creates a picture that exactly corresponds to the Hopi prophesy. This correspondence could hardly have occurred by chance. The three elements of the prophecy—the stones that fit together, the meeting of East and West, and the coming universal brotherhood between them—are each very complex concepts. A correspondence between any one of these would be significant. That all three agree exactly, and that the predicted meeting between East and West occurred precisely in the year prophesied in both Aztec and Hopi legends, results in an impossible string of coincidences.

It is more likely that communication between the hemispheres had occurred at an early date, just as the Hopi tradition describes it. Knowledge about these matters could have been transmitted from generation to generation within restricted European circles in the same way that it was kept alive among the Hopis. Such a conclusion accounts for all the facts, and only requires that we take the Hopi legend seriously.

The swastika symbol in itself implies an ancient knowledge of the orientation of the four Atlantic rivers, and such knowledge presupposes early contact between the hemispheres. Traces of this contact are preserved in the European quest myths. Plato's account indicates that Egyptian priests knew of the great continent on the other side of the Atlantic; the terms in which it is described are unequivocal (Appendix 1).

European alchemical representations of the Ouroboros depict a serpent in circular form, his tail meeting up again with his head. These illustrations typically show the serpent with legs

Figure 8.19 Ouroboros with legs and wings. Lambsprinck, 1625.

and wings, both of which are unnatural characteristics (Figures 8.19 and 8.20). Similar depictions from the Aztecs of pre-Columbian America can hardly have been independently conceived. A plate from the Codex Borgia combines three symbols that we have come to recognize as fundamental to axis mundi iconography: the Ouroboros, the swastika, and the navel. In this codex, the legs of the serpents are oriented as a right-hand-turning swastika. Plumes stream from the back of each serpent's head and tail, and each is shown in the form of an Ouroboros. Finally, the navel of the human figure in the lower right quadrant is approximately aligned with the vertex of the cross (Figure 8.21). There can be little question that the symbolism

Figure 8.20 Ouroboros with legs and wings. Detail from *Commentariorum Alchymiae,* 1606.

represented here stems from a common source. The only question is when this contact occurred.[51]

The following chapter will provide evidence from the Amazon basin that adds even more weight to the case for early cultural contact. Of particular interest are the similarities between artifacts found there with other ancient objects found in the vicinity of the Mediterranean Sea.

Figure 8.21 Four winged serpents in Ouroboros formation with the tail curving back to meet the head. The orientation of their legs forms a swastika pattern with the center, thus linking the Ouroboros and swastika in the Aztec iconography. (After the *Codex Borgia*, early sixteenth century, Mexico.)

Chapter 9

The Amazonian Underworld

When Heinrich Schliemann began his excavations at Troy, archaeological methodology was in its infancy; there was hardly any precedent for the kind of painstaking precision which has now become standard. Schliemann has been criticized for some of his rough and ready methods, but his accomplishments are widely respected. At his own expense and against incredible odds, he unearthed a period of history and civilization until then entirely unknown. What we now term the "Bronze Age," that remarkable period between 1500-1100 BC in the eastern Mediterranean, was brought to light through his efforts. Nine discreet levels of occupancy were found to have existed on the site of Hissarlik, including the famous city whose siege was celebrated by Homer.

Most spectacular was his discovery of Priam's treasure, as he called it, a collection of golden artifacts which was smuggled to Germany and later stolen by the Soviets at the fall of Berlin. After denying possession of these objects for a half century, the Russians finally put them on display in Moscow where they remain today. But, in addition to these, Schliemann uncovered many thousands of objects dating from the city's founding around 3600 BC to its final abandonment around 1500 AD.[1]

Perhaps the most provocative of all the finds at Troy were the many thousands of ceramic spindle whorls, many of them decorated with mysterious markings. Speculations about these have been offered from time to time, beginning with Schliemann himself, but even recent attempts to extract a coherent meaning from these objects have been frustratingly unsuccessful. Of

Figure 9.1 Leaden Idol found by Schliemann at Troy, with swastika in elongated triangle on vulva.

particular note are the recurring depictions of swastikas on the spindle whorls, and on various other objects as well.

One of these, in particular, merits closer attention. It was a female figurine made of lead, approximately three inches in height. Scholars generally agree that it represents the Asiatic goddess known in Chaldea as Nana, in Assyria and Babylon as Istar, in Phoenicia as Astarte, and in Greece as Aphrodite. The arms are crossed over the breast, and the legs are fused in typical "palladium style" similar to the white figurines commonly found in the Cyclades Islands in the southeastern Aegean. The primary decoration on this "leaden idol," as it came to be called, is a prominent swastika engraved on a triangular shield which covers the genitalia of the goddess (Figure 9.1). Schliemann writes:

> The vulva is represented by a large triangle ... The most curious ornament of the figure is a Swastika, which we see in the middle of the vulva ... So far as we know, the only figures to which the idol before us has any resemblance are the female figures of white marble found in tombs in Attica and in the Cyclades. Six of them, which are in the museum at Athens ... represent naked women ... The vulva is represented on the six figures by a large triangle.[2]

Thomas Wilson, writing for the U.S. National Museum in 1894, recognized the similarity of this triangular covering to certain objects in his collection of South American aboriginal art. Females living on the Island of Marajó, located at the mouth of the Amazon River, wore triangular ceramic plaques to cover their sexual organs, some of these decorated with swastikas (Figure 9.2). He remarked on the mysterious coincidence between these and the "leaden idol" found at Troy, but offered no explanation except for the remote conjecture that perhaps migrations had occurred in the distant past from the west coast of Africa to Brazil:

> The aboriginal women of Brazil wore a triangular shield or plaque over their private parts . . . The consideration of the leaden idol of Hissarlik, with a Swastika, as though for good luck, recalled to the author similar plaques in his department from Brazil . . . The specimen shown . . . from the Caneotires River, Brazil . . . is of the same geometric character as the incised decoration ornament on other pieces from Marajo Island. Midway from top to bottom, near the outside edges are two Swastikas. They are about five-eighths of an inch in size, are turned at right angles, one to the right and the other to the left.[3]

The swastika symbol is a complex form and is unlikely to have arisen independently in its various world-wide locations for that reason. As Wilson indicated, it is more likely that some

type of cultural diffusion has occurred. But in the archeological finds described above we encounter additional complexities. In both Troy and South America it is used as a covering for the female genitalia, and in both cases it is placed inside an elongated triangular plaque or shield. Such a combination of use and design could hardly have originated independently; some type of cultural contact must have occurred.

Ice Age Sanctuary

During the last ice age, sea level reached its lowest historical levels. Colder temperatures locked up the world's water in glaciers and in the accumulated polar ice packs. It has been confirmed that sea level in the thirteenth millennium BC was approximately four hundred feet lower than its current position. The steep rise in sea level which we now know to have occurred between 13,000 and 7,000 BC corresponds closely with Egyptian records of widespread flooding in ancient times, recorded by Plato (Appendix 1).[4]

The land bridge beneath the Bering Straits was exposed at that time, providing access to the American continents and resulting in an influx of Asiatic people. In Europe at that time, the polar ice pack moved south into the lower Scandinavian peninsula, causing a mass migration of ancient Teutons across the Baltic Sea and into what is now Germany. Memories of this frigid epoch remain as vestiges in the Norse myth, where it is called the "fimbulvetr." The Norse god Thor and his perennial conflict with frost giants reflects the embattled mentality of those displaced by the encroaching ice.

The Indo-Aryans also preserved a memory of this ancient cosmic winter. Iranian texts tell of an expedition to the underworld where a remnant of humanity could survive the devastating ice age. Contrary to the conception of the underworld as being located underground, the conditions described there are temperate and lush:

> In Videvdat 2.20-41 and in later texts such as the Bundahisn there occurs the theme of Yama Xsaeta's vara, a subterranean enclosure Ahura Mazdah orders him to build to shelter choice specimens and germs of human and other species against an impending "cosmic winter," an eschatological crisis resembling the Old Norse fimbulvetr that precedes the ending and regeneration of the world. This myth is strange on several counts. The vara is described as complete with waters and grasslands ... The contradiction of being underground yet green and watery is the same that opposes the Greek Happy Isles or the Elysian Fields to the subter-

Figure 9.2 Ceramic plaques used as genital coverings by females on Marajó Island, Brazil, decorated with swastikas. In the collection of the Smithsonian Museum.

ranean (or otherwise gloomy) Hades, with the result that Hades also exhibits horse-breeding meadows.[5]

The contradictions expressed in this passage are removed once it is understood that the underworld was not buried underground, as writers in the classical period imagined. Mythological references to the underworld are only comprehensible if one accepts that the origin of the concept refers to that portion of the earth near or beyond the equator, at the very edge of the earth and below it, according to ancient belief. Homer's description of the Elysian Fields, "where life is easiest for men. No snow is there, nor heavy storm,"[6] accords with the accounts given by ancient travelers such as Odysseus, Jason, Hercules, and Gilgamesh, who visit the underworld on sea voyages and then return home to tell their stories.

The now torrid equatorial climate of the Amazon region would have been more temperate during the ice age, and would therefore match the halcyon descriptions which remain in myth. The location of the Amazon conforms to the orientation of the southern arm of the great Atlantic swastika, providing evidence that its geographical position was known in the distant past. And the Hebrew record which tells of the river Pison, one of the four emanating from Paradise, encompassing the land of Havilah where there is gold, bdellium and the onyx stone, also suggests that this region may have been known long ago in some circles. Finally, the occurrence of indigenous artifacts bearing the swastika symbol in exactly the manner as preserved in Bronze Age Troy, strongly suggests early cultural contacts.

Nor were the Greeks and Iranians alone in conceiving the underworld to be a place of wide fields and fine weather. The culture of Vedic India shared the same belief, as did the Celts. Their legends memorialize the common belief that an idyllic underworld existed in the west, and across the sea:

> The Vedic Yama likewise had to make his way along great water-courses ... while settling the Otherworld, ending up with a gavyuti—"pastureland."[7]

> Sea voyages and Otherworld notions are often interlinked in Celtic lore, implying Elysian isles or sunken paradises in the West (Mag Mell "Field of Pleasure," Tir na n-Og "Land of the Young," Land of Lyonnesse, City of Is, etc.)[8]

A story which parallels the Iranian legend where a small remnant of humanity is to be saved from an intense and prolonged winter by traveling to a "subterranean enclosure" is also preserved in Norse legend. Threatened by a similar cosmic winter, the Teutonic people are preserved from the ravages of the fimbulvetr by the providence of the god Mimir who prepares a "subterranean asylum:"

Caused by the same powers hostile to the world, there occur in this epoch such disturbances in nature that the original home of man and culture—nay, all Midgard—is threatened with destruction on account of long, terrible winters. A series of connected myths tell of this ... Freyja, the goddess of fertility, is robbed and falls into the power of giants. Frey, the god of harvests, falls sick. The giant king Snow and his kinsmen Þorri (Black Frost), Jökull (the Glacier), etc., extend their sceptres over Scandia ...[9]

From this we see that migration traditions remembered by Teutons ... in spite of their wide diffusion and their separation in time, point to a single root: to the myth concerning the primeval artists and their conflict with the gods; to the robbing of Idun and the fimbul-winter which was the result. The myth makes the gods themselves to be seized by terror at the fate of the world, and Mimir makes arrangements to save all that is best and purest on earth for an expected regeneration of the world. At the very beginning of the fimbul-winter Mimir opens in his subterranean grove of immortality an asylum, closed against all physical and spiritual evil.[10]

Völuspá, the seeress of the Poetic Edda, foretells a rebirth of the earth following the destruction brought about through the battle of the gods. She tells how the earth will later rise up out of the sea to form a new home for humanity. She describes this regenerated land using the Old Icelandic phrase, *iðja græna*. About this, the Norse scholar, Rydberg, writes:

> The common interpretation is *iðjagræna*, "the ever green" or "very green," and this harmonizes well with the idea preserved in the sagas mentioned above, where it was stated that the winter was not able to devastate Gudmund-Mimir's domain ... [but] the composition *iðja-græna* has a perfectly abnormal appearance, and awakens suspicion ... I may be permitted to present the possibility that *iðja* is an old genitive plural of *iða*, an eddying body of water. If the conjecture is as correct as it seems probable, then the new earth is characterized as "the green earth of the eddying fountains."[11]

Rydberg's interpretation would be another example of the "whirling rivers" of Hesiod and the Havilah of the Hebrew accounts describing the river Pison. As Rydberg points out, the concept exists already in the Norse legends. Hvergelmir, the "roaring" or "furious" cauldron, was a spring located at the source of all the rivers of the world. Fed from a mighty stream of dew-drops descending from the heavens, it lay at one of the roots of the world tree, Yggdrasill.

An ice-age sanctuary along the coast of Brazil, while plausible, remains a mere conjecture.[12] Yet the archaeology of Marajó

Figure 9.3 Carchi Urn from Ecuador. (University of Pennsylvania Museum of Archaeology and Anthropology, Philadelphia.)

Figure 9.4 Etruscan bulla.

Island provokes some intriguing questions. Why, for example, does the evidence indicate that its culture was significantly more advanced than the surrounding region? And why are there no archaeological remains of earlier, intermediate stages of development, instead of a culture that appears to spring onto the pages of history at an advanced stage?[13]

One factor that hampers the kind of detailed archaeological investigation that would be necessary to answer these questions is that the post-glacial rise in sea level has submerged a vast area of Brazil's former coastal plain. During the period when the sea level was lowest, Brazil's coastline at the mouth of the Amazon was nearly two hundred miles farther eastward, in what is now the Atlantic Ocean.

Etruscan Connection?

The swastikas found at Marajó Island, however, are by no means isolated occurrences. In Ecuador, for example, at the opposite end of the Amazon, ceramic urns have been found that are decorated with a highly distinct form of the swastika symbol; the outer arms angle significantly inwards from the perpendicular (Figure 9.3). These strongly resemble swastika decorations found on ancient Etruscan artifacts (Figure 9.4). Because the Etruscans were well-known for their maritime connections, this similarity may provide another clue to the cultural influences between the hemispheres.[14]

Swastika symbols on funeral urns were very common among the ancient Etruscans, and innumerable examples could be shown. Typically these urns were fashioned in the form of small ceramic huts which were then placed inside tombs cut into the soft sandstone (Figure 9.5).[15]

Another peculiar form of the swastika used by the ancient Etruscans is illustrated in Figure 9.6. In this variant, an additional series of angles occurs at the four terminal line segments. Possibly this design is a mere geometrical embellishment. But the close congruence between this type of swastika design and the sea course for entering the Baltic is remarkable. The almost labyrinthine angular course necessary to navigate from the mid Atlantic, north of Jutland, south to the southerly tip of Sweden, east past the end of the Swedish peninsula, and finally north into the Baltic, exactly matches the form typically added onto these swastikas (Figure 9.7).

Little is known of the Etruscans; their cities were destroyed by the emergent Romans in early times. But it is clear from the few remains available that they were an advanced and wealthy civilization. Could they have known of the maritime amber route and concealed it symbolically in this unusual swastika

design? And could they have known also of the other swastika rivers, especially the Amazon and its gold fields?

The swastika designs from Ecuador and Brazil, which so closely parallel those found in the ancient Mediterranean, strongly suggest that contacts had occurred in the remote past. The Aztec and Maya legends which tell of bearded white men arriving in ships and teaching metallurgy and other advanced technical methods, and later departing eastward across the Atlantic Ocean, may reflect a memory of those early contacts.[16]

Search for the Lost Paradise

Such legends are found also in Brazil. Beginning long before the arrival of the Portuguese, a tribe of indigenous people had for centuries migrated up and down the Atlantic coast in search of their lost land of origin. They had also made voyages into the Atlantic Ocean on this quest, for their legends say that the original homeland was located on an island eastward in the middle of the sea. Anthropologists first discovered these tribes of Guarani Indians in 1912, but some of them continue the search even today. Other tribes believe that Paradise is located at the highest point of heaven and at the center of the earth.[17]

Although difficult to reach, this earthly paradise is said to be a real, physically accessible place beyond the sea. It is an island where sickness, suffering and death are unknown. As with

Figure 9.5 Etruscan Hut Urns from the Bronze Age, with swastika decorations.

a

b

Figure 9.6 (a) Gold plated Etruscan ornament, Late Villanovan I; (b) Pottery bell helmet, mid Villanovan I. (Museo Archeologico, Florence); (c) Ornamental swastika on Etruscan silver bowl; Cervetri, Etruria.

the Aztec and Maya legends, the Guaranis tell of a civilizing hero who formerly taught them the way to this lost homeland. They say that it:

> … exists here on earth: it is situated on the other side of the ocean or in the center of the earth. It is difficult to reach, but it is located in this world. Although it seems to some extent supernatural—since it entails paradisiacal dimensions (for instance, immortality)—the Land-without-Evil does not belong to the Beyond. It cannot even be said to be invisible; it is simply very well hidden. One arrives there not—or, more accurately, not only—in soul or spirit, but in flesh and bones … But one must know the route—and this knowledge is almost completely lost today. In ancient times, one could find the way because people had confidence in Nanderykey, the civilizing hero: the latter came to meet humans and guided them toward the paradisiacal Island.[18]

From our prior investigations we can recognize that both descriptions about the location of this island are consistent with the Tree of Life myth. The tree's intersection with the earth occurs at an island in the Atlantic—at the "center of the earth"—and its vertical position at that point connects it with the zenith. The attribute of immortality is another hallmark of the Tree of Life, and its occurrence here is further evidence that the island of the Guaranis is that same mythical island referred to in the Eurasian legends.

Rosicrucian Links to the Amazon

In the previous chapter we examined evidence showing that Count Michael Maier linked the Sibylline Oracle to the early sixteenth century conquest of the Americas. Parallels between his

Tree of Life, Mythical Archetype

epigrams and the Hopi legends concerning the two stones that belong together raise compelling questions. His writings also link the identity of the underworld with the country of Brazil.

In the previously mentioned *A Subtle Allegory*, Maier describes making a pilgrimage in search for the elixir of immortality, called variously "the Phoenix, the Medicine, or the Golden Fleece." From his native home in Germany (he mentions the amber found along the shores of the Baltic) he travels to Teneriffe, one of the Canary Islands formerly called the "Islands of the Blessed," where he finds an enormous tree, down which flows a great quantity of water. It should be mentioned parenthetically that Teneriffe has a long history of being identified with the axis mundi; Ptolemy made it Longitude 0 in his geographical system. In *The Cosmographical Glasse*, a 1559 work by William Cuningham on the subject of geography and navigation, we hear of:

> ... the hougie and hie Mountaines, and Hilles: Of whiche, some of them are supposed to be 60 miles in height. As the Hille in the Iland of Teneriffe, (whiche Ptolomaeus nameth one of the fortunate Ilandes) and is beyonde Hercules Pillers.[19]

Sixty miles is a prodigious height for a mountain, considering Everest is only five and a half. Further evidence that the axis mundi is indicated here can be found by inspecting an etching from the same book, depicting Atlas supporting the spheres (Figure 5.4). In that illustration, the axis mundi can be seen intersecting the earth (in accord with ancient belief) at a point in the sea west of Gibraltar. Like the Azores, the Canaries lie very close to the position of the great swastika's vertex.

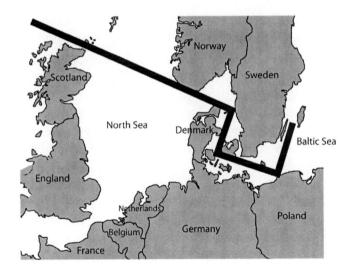

Figure 9.7 Sea route from the mid-Atlantic Ocean into the Baltic Sea.

Continuing the narrative in *A Subtle Allegory*, Maier—leaving Teneriffe—then travels to Brazil where he remarks the presence of black poplar trees. Before leaving the country on his further journeys, he collects a piece of the black wood:

> I took with me a very heavy and valuable piece of a certain kind of wood, the most precious I saw here in Brazil, and which is remarkable for its brilliant ebony color, for this black color seems proper to America by reason of the *blackish poplars* and the soil dyed with various hues.[20]

Maier leaves Brazil and continues his search for the earthly paradise. He describes a meeting with the Greek hero Jason, mentions "the center of the world" and a "confluence of certain rivers" and "Atlas that bears up the heavens on his shoulders." He then visits the Sibyl, who tells him he must traverse the Nile River. There he finds Hermes, who shows him the long-sought-after Phoenix, the source of immortality.

In connection with his journey to Teneriffe, Maier praised how Hercules secured the golden apples of the Hesperides, the golden cup, and was such a great seeker of the "Medicine." His subsequent mention of Jason and the Golden Fleece serves to link his own pilgrimage with the quests of those heroes. With the reference to the black poplars in Brazil, he ties this allegory to the voyage of Odysseus. Recall that Circe told Odysseus about the tokens by which he would recognize the underworld: the groves of Persephone and the black poplars:

> Son of Laertes and seed of Zeus, resourceful Odysseus, let no need for a guide on your ship trouble you; only set up your mast pole and spread the white sails upon it, and sit still, and let the blast of the North Wind carry you. But when you have crossed with your ship the stream of the Ocean, you will find there a thickly wooded shore, and the groves of Persephone, and tall black poplars growing ...[21]

Maier's allusions to the heroes of the Greek quest myths, along with references to the Nile, the Baltic (through the mention of amber) and Brazil, suggest a belief that the Greek heroes visited the swastika rivers. His belief that the region of Brazil represented the underworld in those migration legends is indicated by his association of it with the black poplars. All together, these facts suggest that information about the four Atlantic rivers was transmitted through a Eurasian tradition from earliest times. The Tree of Life legend also reflects this esoteric information, as do the quest myths.

Vestiges of this tradition are also found in Semitic literature, where much ancient lore has there been collected in the Arabic stories associated with the Romance of Alexander. It is said that Alexander once traveled to the far West, to the place where the

sun sets. Four peoples dwell there: Nsik and Munsk, Hwl and Kwl:

> They are considered as the dwelling places of the remains of vanished peoples; sometimes it is the "children of Moses" who have taken refuge there in the time of Saul or Nebukadnezar … In them are gathered innumerable riches and jewels … They are places of death and desolation …[22]

Further details are provided in the Book of Henoch:

> Henoch is brought to the fire of the West, which receives every setting of the sun. Here he sees the great river and the great darkness, the mountains, the mouth of the ocean …[23]

In this tradition we find many elements typically associated with the underworld. The great darkness, the land of the dead, and the profusion of wealth parallel descriptions of the voyage of Gormo, and by extension, that of Odysseus. The great river conforms to the position of the Amazon as the most southerly of the four swastika rivers. Even the name of a people dwelling there, Hawil, is suspiciously close to Havilah (root HWL[24]), the name given in Genesis to the land through which the river Pison flows.

Summary

In summary, we know that the Tree of Life myth existed in the Americas from ancient times, and that its form was essentially identical to that of Eurasia. The swastika symbol was used by cultures inhabiting both the Mississippi and the Amazon River areas, and in some cases this occurred by 200 AD or earlier. Unusual configurations of the swastika form, and highly specific contextual parallels, exist among civilizations inhabiting both the Amazon and Mediterranean regions. Mysterious synchronicities between Native American legend and European arrivals in the year 1519 raise questions of possible communication in the distant past.

Indo-European textual records of a balmy, underworld sanctuary established during a severe period of cold weather lead to possibilities that some type of colony may have existed in the vicinity of the Amazon River, the memory of which was also preserved in ancient European quest myths. Finally, the axis mundi, the swastika and the Milky Way galaxy are grouped in association on ceremonial artifacts used by the Hopi Indians. Such groupings support a conclusion of shared symbolic function and mutual relation among these designs. This suggests, in turn, that the galaxy was understood as the physical

axis mundi, and that the swastika was the symbolic representation of its earthly location. Aztec, Mayan, and Navajo depictions of the quadripartite world link the swastika symbol with rivers flowing in the four cardinal directions. And traditions of an island homeland or "place of emergence" in the eastern ocean support the notion that such a place is identical to the Eurasian paradisiacal homeland at the vertex of the great swastika formed by the four Atlantic rivers.

Chapter 10

Egyptian Tree of Life

The Goddess Isis

Human habitation along the Nile River began over one-hundred thousand years ago. Flint hand axes from the early Paleolithic can be found in the gravel terraces running alongside the Nile in Upper Egypt. By about 11,000 BC implements made of wood or bone with embedded microlithic cutting edges were used in hunting, fishing, and harvesting of wild grains.

In the early sixth millennium ceramics with unique decorative styles begin to emerge. The manufacture of sophisticated pottery may indicate Near Eastern influence, while axes constructed of Nubian stone show that cultural exchanges with civilizations farther south were taking place at that time. Sculpted ivory in animal and human forms were produced by the Badarian culture, and these demonstrate a high degree of artistic and technological development beginning from about 4400 BC. Burials furnished with plentiful grave goods consisting of beautifully fashioned ceramics, carved ivory, cosmetic implements, bracelets of bone and ebony, necklaces of turquoise, and copper beads, are common. These finds evidence the beginning of the elaborate funerary cult which was to dominate the Nile Valley for the next five thousand years.[1]

The fourth millennium Naqada culture marks a major advance in artistic techniques and decorative imagery. To traditional ceramic materials are added objects constructed of marl clay and Nile silt. Elaborately carved hard-stone vessels are created for the storage of unguents and cosmetics. Among these objects, complex decorative motifs of an obscure religious significance begin to appear on ceramic vessels; the designs include boats, ladders, stags, and goddesses (occasionally gods) with curiously upraised arms (Figure 10.1, 10.2). Ceramic figurines of such goddesses are of particular interest, since they are typically fashioned with the heads of birds upon anthropomorphic bodies with upraised arms (Figure 10.3). The meaning of this characteristic gesture has been a source of puzzlement for art historians:

> The wide diffusion of this motif is evidence of the symbolic nature of this unusual posture. Its interpretation as a "dance" is not wholly satisfactory, but rather raises the question of what this dance attitude is supposed to express. Is it an act of human homage to a divinity? Or is it the goddess herself, a "Great Mother," lifting her arms up to heaven? Or are the arms supposed to imitate the cow's horns of the sky-goddess?[2]

The characteristic pose of these ancient figures becomes stylized as one of the most prominent artistic themes in the later dynastic period. It is assumed by the god Shu, for example, as he upholds the heavens in a function equivalent to the Greek Atlas (Figure 10.4), and by the goddess Isis (Figure 5.10) who stands in central alignment with the Djed pillar of Osiris. This pillar was a representation of the sacred tree which had enclosed the body of Osiris after he was murdered by his brother Set. His wife Isis searched everywhere for his body, but it had floated across the sea to Phoenicia, and a tree had grown up around it:

> The king of the country, admiring the tree, had it cut down and made a pillar for the roof of his house; it is this tree trunk which is referred to by the hieroglyphic sign [the djed pillar] and which is continually used in the texts with reference to Osiris ... The four cross-bars ... are intended to indicate the four branches of a roof-tree of a house which were turned to the four cardinal points. When Isis heard that the tree had been cut down, she went to the palace of the king ... and was made nurse to one of the king's sons.[3]

Thus the goddess with uplifted arms who stands over the axis of the Djed pillar is associated with a sacred tree that enclosed a god in its side, and which grew near the sea in Byblos. The tree was later made into a pillar, the representation of which includes markers for the four cardinal directions. Isis provides milk for the young prince, and as Plutarch tells the

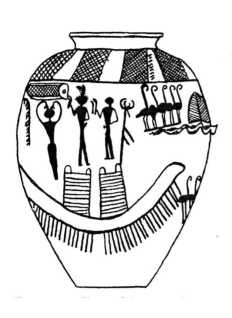

Figure 10.1 Vase depicting a figure with upraised arms, second dynastic period.

story, later places him in the fire each night in order to make him immortal, transforming herself into a swallow and hovering around the pillar. The boy's mother spies on the goddess one night and seeing her son in flames cries out, thereby breaking the spell.

The milk, the flames each night, immortality, the bird, the sea, the four cardinal directions, the sacred tree, the pillar, the goddess and her quest for the tree, her posture with upraised arms; we can recognize all these as markers for the Tree of Life. Could the Naqada vase-paintings, in which the goddess with uplifted arms is surrounded by stags and ladders, represent an ancient precursor to those stylized designs of the later dynastic period of which Isis is an example? If so, this figure would be one of the earliest representatives of the galaxy goddess whose uplifted arms mirror the two branches of the Milky Way, considered as both axis mundi and as ladder leading the dead to their heavenly abode.

The figurines of the same period, which are constructed with the heads of birds (Figure 10.3), parallel the position of the constellation Cygnus at the branching point of the galaxy, where the head of the hypothetical goddess would be located. The otherwise headless form of the galaxy is completed by the bird constellations at Cygnus and Aquila, both located inside the extending galactic arms. This feature may also be preserved in the Isis myth, where the goddess is said to hover around the pillar each night in the form of a swallow.[4]

The motif appears again in another episode of the Isis myth as told by Plutarch. Horus the son of Isis battles with Set, the murderer of his father Osiris. At a decisive moment, Isis releases Set from his bonds, thereby saving him from certain death; in anger for this interference Horus decapitates his mother. We are then told that Hermes (the Egyptian god Thoth) gave her a helmet in the shape of a cow's head, or in another version, transformed her old head into that of a cow and replaced it upon her shoulders.[5] This story links Isis with the alternative theme whereby the branching arms of the galaxy at the Great Rift represent the horns of a cow as manifested, for example, by Hathor, Nut, or even the Greek goddess Hera whose common epithet is "cow-eyed."[6]

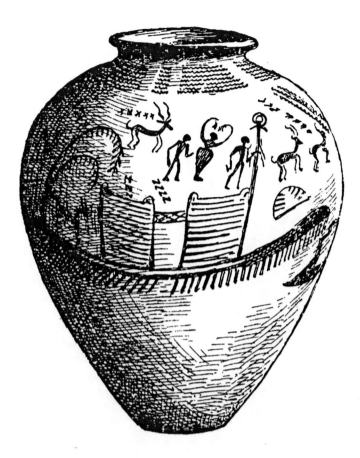

Figure 10.2 Marl clay pot depicting female figure with upraised arms, ladders (?), stags, and a boat; Naqada II period (second half of the fourth millennium BC).

Figure 10.3 Female figure with the head of a bird, upraised arms, and fused legs. From a grave at Gebelein.

Plutarch's authority on these subjects is validated by evidence found in much older Egyptian documents that confirm many of the details he provides:

> Plutarch, though Greek and writing of times already long past, was evidently well informed; for in ancient texts we find frequent references to the events he relates, notably in those texts which the old kings of the sixth dynasty had engraved inside their pyramids—twenty-five centuries before him.[7]

The god Osiris, who was enclosed within the pillar formed from the Tamarisk tree in Plutarch's account, is often depicted as an embodiment of the Tree of Life (Figure 10.6). In some cases, he is portrayed as identical with the Djed pillar, with only his arms and characteristic insignia extending from its sides (Figure 10.7). Identification of this pillar with the Tree of Life is evidenced by its origins:

> [It was] a simple fetish which seems to have been his primitive form in the days when he led his prehistoric followers into battle. The "Djed" was originally the trunk of a fir or some other conifer; but in classical times it was a kind of pillar with four capitals.[8]

In the many different renderings of the story, Isis was variously considered to be the wife, sister, or mother of Osiris, or any combination of these roles. Her position in the Egyptian pantheon was central, having acquired the attributes of many local goddesses in her ascendancy:

> It is correct to say that from the earliest to the latest dynasties Isis was the greatest goddess of Egypt … Isis was the great and beneficent goddess and mother, whose influence and love pervaded all heaven, and the earth, and the abode of the dead, and she was the personification of the great feminine, creative power which conceived, and brought forth every living creature, and thing, from the gods in heaven, to man on the earth … [and] what she brought forth she protected, and cared for, and fed, and nourished, and she employed her life in using her power graciously and successfully, not only in creating new beings but in restoring those that were dead.[9]

As mother of the stars she also symbolized the sky of night. She is identified with other celestial goddesses, above all with the heavenly cow Hathor, etc., and hence she often bears the horns of a cow on her human head, as a symbol of heaven. Thus she is even identified with her own mother (Nut), with the tree of heaven and of life (notwithstanding the fact that Osiris also was identified with this).[10]

From the above, it is clear that Isis shares many attributes of the Tree of Life/axis mundi. Looking again at the Coptic legends, which so often reflect the older mythology of Egypt, we learn that the Mary and Jesus of early Christianity were identified with the Isis myth:

> Another legend, which was popular among the Copts, to the effect that the Virgin Mary once hid herself and her Son from their enemies in the trunk of the sycamore at Heliopolis, and that it is based upon an ancient Egyptian myth recorded by Plutarch which declared that Isis hid the body of Osiris in a tree trunk.[11]

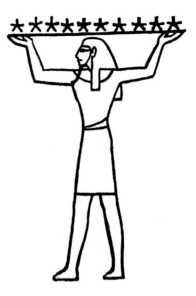

Figure 10.4 The Egyptian god Shu; like the Greek titan Atlas, he upholds the sky.

The Tree of Life

The Tree of Life played a prominent role in Egyptian religion. In addition to Osiris, numerous goddesses could be depicted within—and forming an integral part of—the sacred tree. Isis, Nut, and Hathor are particularly noted for this characteristic. Hathor, as we have already noted, frequently functioned as a goddess of fate in this setting, but Isis served in a similar capacity as did the goddess Sekhait, who more specifically represented the goddess of fate (Figure 10.8). Each of these goddesses is linked directly to the Tree of Life:

> As goddess of fate Sekhait sits at the foot of the cosmic tree, or, in other words, in the nethermost (southern) depths of the sky or at the meeting-place of the upper and lower sky; and there she not only writes upon this tree or on its leaves all future events, such as length of life (at least for the kings), but also records great events for the knowledge of future generations, since everything, past and future ... is written in the stars.[12]

Although the Egyptian Tree of Life was celestial, it had earthly representatives that served as cult objects of veneration. These terrestrial trees never supplanted the belief that the actual tree of life was celestial and intimately connected to the stars:

> Another early concept describes the sky as a huge tree overshadowing the earth, the stars being the fruits or leaves which hang from its branches. When "the gods perch on its boughs," they are evidently identified with the stars. The celestial tree disappears in the morning, and the sun-god rises from its leaves; in the evening he hides himself again in the foliage, and the tree (or its double of evening time) once more spreads over the world ... This thought of the celestial or cosmic tree or trees, which is found among so many nations, also underlies the idea of the tree of life, whose fruit keeps the gods and the chosen souls of the dead in eternal

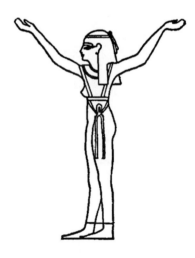

Figure 10.5 Personified pillar of the sky.

Figure 10.6 Osiris within the celestial tree; from a sarcophagus in the Museum of Cairo.

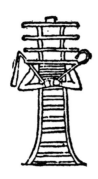

Figure 10.7 Osiris hidden within the Djed Pillar holding his characteristic emblems.

youth and in wisdom in Egypt as elsewhere. The tree of fate, whose leaves or fruits symbolize events or the lives of men, represents the same thought: the past as well as the future is written in the stars. Osiris, as the god of heaven, is frequently identified with the heavenly tree or with some important part of it, or is brought into connection with its fruit or blossom.

Egyptian theology tries to determine the terrestrial analogy of this tree. As the world-tree it is thus compared to the widest branching tree of Egypt, the sycamore; more rarely it is likened to the date-palm or tamarisk, etc.; sometimes it is the willow, which grows so near the water that it may easily be associated with the celestial tree springing from the abyss or the Osirian waters. In connection with the Osiris-myth, however, the tree is mostly the *Persea* or (perhaps later) the fragrant cedar growing on the remote mountains of Asia, or, again, the vine through whose fruit love and death entered into the world; while as the tree of fate it is once more usually the *Persea* of Osiris. These comparisons may refer to the inevitable attempts to localize or to symbolize the wonderful tree on earth. By a transition of thought it is described as localized in a part of the sky. Thus "a great island in the Field of Sacrifices on which the great gods rest, the never vanishing stars," holds the Tree of Life, evidently between the ocean and sky, between the upper and the lower world, where the dead, passing from the one realm to the other, may find it.[13]

The great religious center of Heliopolis, located near the apex of the Nile delta, was the reputed location of the earthly representative of the celestial Tree of Life, which could be represented as a lotus tree or as a sacred Persea tree.[14] Its sanctuaries contained a sacred pool near the base of the tree, and this was traditionally understood as representing the watery abyss from which the tree originated:

> Heliopolis contained the earthly proxy of the tree of heaven, the holy Persea, and the sacred well which to this day is called "the Sun's Well" and in which the sun was believed either to bathe himself morning and night or to have been born at the beginning of the world, when he arose from the abyss, etc. Thus the pool was not merely a type, but a real remnant of the primeval flood.[15]

The Tree of Life embodies the positive characteristics of heaven as an abode of peace and pleasure. The dead are clothed in white, as befits a galaxy setting, eating the fruit of immortality provided by the Tree of Life:

And he [the deceased] sits down, clothed in white linen and wearing white sandals, with the gods by the lake in the Field of Peace, and partakes with them of the wood (or, tree) of life on which they themselves live that he also may live … and we also have mention of a heavenly fig-tree and a heavenly vine, the fruit of which is eaten by the beatified.[16]

This "Field of Peace" is associated with the circumpolar regions where the stars are at rest, as opposed to the other parts of the heavens which are forever rushing from east to west across the night sky:

The dead … are not merely with the gods, but they completely share their life of luxury. They sit on thrones in the circumpolar region of the sky, where the highest divinities dwell; or they perch like birds on the branches of the celestial tree, i.e. they become stars.[17]

Figure 10.8 Sekhait, goddess of fate, inscribing the king's destiny on leaves of the Tree of Life.

The Bird and the Serpent Motif

As is typical of the Tree of Life myth in many cultures, a bird lives in its summit. In the Egyptian version, this bird is explicitly associated with common galaxy markers: fire and flames:

The Bennu, a bird of the heron species was identified with the Phoenix. This bird is said to have created itself, and to have come into being from out of the fire which burned on the top of the sacred Persea Tree of Heliopolis.[18]

The serpent which lives at the base of the Tree of Life is a major figure in Egyptian mythology. His most common name is Apep (also spelled Apop) which is derived from the Egyptian word meaning "to fly," hence he is a cosmic, flying serpent. [19] He is also called Nak, but in later periods he is identified with Set, the evil brother of Osiris:

We also find pictures of a serpent at the foot of the celestial tree (i.e. in the watery deep), where it is cut into fragments by a divine cat.[20]

The attributes of this serpent suggest an ancient identification with the galaxy as seen in countless other contexts (Figure 10.9). He is fiery like Leviathan of the Hebrew legend, or else is condemned to perish in flames. The ancient *Books of Overthrowing Apep* describe step by step the process of destroying the monster. Chapter 6 is entitled:

Chapter of putting fire upon Apep … [The] serpent is first to be speared, then gashed with knives, and every bone of

his body having been separated by red-hot knives, and his head, and legs, and tail, etc., having been cut off, his remains were to be scorched, and singed, and roasted, and finally shriveled up and consumed by fire.[21]

In the *Papyri of Hunefer, and Ani, and Nekht* we are told of the serpent, there called Nak, who has been vanquished. In this case, not only is the fiend consigned to the fire, but in addition, his two arms have been cut off. Two arms, as we have already seen, is a galaxy marker more typically associated with gods and goddesses. In many ancient depictions of the Ouroboros, however, the serpent is shown with two arms and wings. He is described here as having fallen, evoking an image reminiscent of the fall of Typhon in Greek myth:

> The serpent-fiend Nak hath fallen, and his two arms are cut off … The serpent-fiend hath fallen, his arms are hewn off, the knife hath cut asunder his joints … the serpent-fiend Nak hath been condemned to the fire.[22]

In chapter 6 we observed several instances where iron was associated with the Milky Way, probably because the galaxy was considered to be the origin of meteors. The same concept is found in Egypt, where Set is typically called Typhon by Greeks. We are told that:

> In Egypt … iron represents "Typhon's bone."[23]

We have already noted the thought that the sky is water and that it forms a continuation of the Nile or of the ocean, on which the solar barge pursues its way. It is not clear how this was harmonized with the parallel, though rarer, idea that the sky was a metal roof, a belief which may have been derived from observation of meteorites … This conception of a metal dome explains some expressions of later times, such as the name of iron, be-ni-pet ("sky-metal").[24]

In a probable reference to the four primordial rivers which share a point of confluence, Egyptian myth repeatedly refers to the "four sources of the Nile," or the "four Niles."[25] These are somewhat vaguely localized to the cataract region of Upper Egypt, but their association with the cosmic serpent suggests a more mythical origin (Figure 10.10). We are told of:

> "the many-headed serpent," whose four heads symbolize the four sources of the Nile.[26]

In some cases, these four sources were depicted as vases containing the "water of life" which are provided by a goddess:[27]

> The Asiatic tradition of four rivers flowing to the four cardinal points has left a trace in the Egyptian idea that the deeper sources of the Nile at Elephantine were four in num-

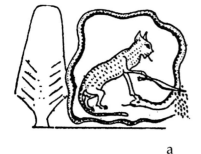

a

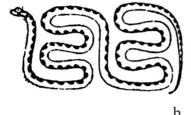

b

Figure 10.9 (a) The cat-god killing a serpent in the form of an Ouroboros at the base of the heavenly tree; (b) The serpent Apophis.

ber, so that the water of life flows from four jars presented by the cataract-goddess.[28]

Particularly interesting is the association of these mysterious four sources of the Nile with the four cardinal directions:

> … they grow from a flower … which springs from the throne of Osiris…As coming from the abyss (i.e. Osiris) they are symbolized in later times as four heads growing from a serpent who holds the hieroglyphic symbol of life [the ankh, Figure 10.10] … On the other hand, a very old parallel interpretation considers them to be celestial; in other words it identifies them with the four Horuses dwelling at the four cardinal points.[29]

Figure 10.11 illustrates these four gods emerging from a flower that has its roots in the watery abyss below the throne of Osiris. This relationship is explained by the fact that Osiris was originally a river or water god.[30] As we have already seen, Osiris has clear axis mundi attributes through his associations to the Djed pillar and the Tree of Life. Therefore it is not surprising that he should also be linked to the watery abyss and to the four directions. The earth-god Geb (or Seb) tells Horus, "Go where thy father swam!"

> We therefore find "Horus in the ocean" and as "the star traversing the ocean." Thus both Horus and Osiris are born from the waters of the deep.[31]

Another myth links the god Set—in his role as the cosmic serpent—to the axis mundi. Here we find the hawk-headed god Horus atop a staff or pole which traps Set at its base. This image is reminiscent of the caduceus of Mercury, where a staff surmounted by wings is entwined by two serpents rising from its base:

> After these things Set changed himself into a serpent which hissed loudly, and he sought out a hole for himself in the ground wherein he hid himself and lived, whereupon Ra said, "the monster hath turned himself into a hissing serpent, let Horus, the son of Isis, set himself above his hole in the form of a pole on the top of which is the head of Horus, so that he may never again come forth therefrom"… and Horus the son of Isis stood upon him in the form of a pole, or staff, on the top of which was the head of a hawk.[32]

Set's place of imprisonment is said to be located in the western ocean. This is consistent with the notion, previously described, of an intersection between the galaxy/axis mundi and the surface of the earth in the Atlantic Ocean. The Egyptian *Book of the Dead* tells us:

Figure 10.10 (a) The four sources of the Nile carried by a serpent holding an ankh; (b) Standing before their father, the sons of Osiris guard the fourfold serpent of the abyss; (c) The four sources of the Nile in serpentine form.

Furthermore I have sent the soul of Seth to the west, exalted above all gods; I have appointed guardians of his soul, being in the boat.[33]

Here again, we discover that infallible galaxy marker: the side, thigh, or genital wound. Set (or Seth), the cosmic serpent, is castrated by Horus in battle:

In very early times a combat took place between Horus and Set, wherein the former destroyed the virility of Set.[34]

Accordingly it is possible that originally the testicles of Seth, which were torn from him, were found in the belemnites.[35]

It was only in later times, however, that Set was seen as the embodiment of evil. Originally he was a friend of the dead, even having assisted Osiris in his journey to heaven:

Egyptians thought that they could climb on to the iron floor of heaven by going to the mountains, the tops of which it touched in some places. At a later period it was thought that a ladder was necessary … The god Osiris even was believed to have needed a ladder, and to have been helped to ascend it by … Horus and Set.[36]

Consequently, the souls of the dead are advised to recite the verse:

Homage to thee, O divine Ladder! Homage to thee, O Ladder of Set! Stand thou upright, O divine Ladder! Stand thou upright, O Ladder of Set! Stand thou upright, O Ladder of Horus, whereby Osiris came forth into heaven.[37]

In the older belief, Set was a god of the night sky. In the later Roman period, many of the old Egyptian myths were incorporated into the emerging Christian belief system. Early Copts inherited the view of Set as an evil cosmic serpent, and this was later blended with the concept of a remote place of punishment:

In [the Coptic] "Pistis Sophia," we have the Virgin Mary asking Jesus, her Lord, to give her a description of "outer darkness," and to tell her how many places of punishment there are in it. Our Lord replies, "The outer darkness is a great serpent, the tail of which is in its mouth, and it is outside the whole world, and surroundeth the whole world."[38]

We can thus trace the development of the Ouroboros from a beneficent earth-encircling serpent of light which assists the dead in their onward journey, to that of a fiendish evil-doer and lord of hell in later times. In both roles, however, he retains his galaxy attributes.

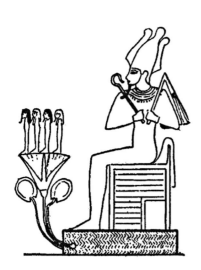

Figure 10.11 The four sources of the Nile standing on a lotus flower that rises from the watery abyss under the throne of Osiris.

The Hound of Hell

As noted earlier, the hound of hell is a common feature of galaxy/axis mundi mythology. In Greek myth he is Cerberus; in the Norse he is Garm. The Egyptians preserved this notion in the figure of the dogs which guard Isis and Osiris:

> Diodorus (i.85) [says] that a dog was the guardian of the bodies of Osiris and Isis, and that dogs guided Isis in her search for the body of Osiris, and protected her from savage beasts.[39]

That these dogs were not merely terrestrial animals can be seen from the following citation, where the dog is regarded in a celestial setting. Like the location of Canis Major and Canis Minor at the threshold of the underworld in the equatorial night sky, the dog—represented by the god Anubis—was conceived in the position where the heavens and the underworld meet:

> On the subject of Anubis Plutarch reports some interesting beliefs. After referring to the view that Anubis was born of Nephthys, although Isis was his reputed mother, he goes on to say, "By Anubis they understand the horizontal circle, which divides the invisible part of the world, which they call Nephthys, from the visible, to which they give the name of Isis; and as this circle equally touches upon the confines of both light and darkness, it may be looked upon as common to them both—and from this circumstance arose that resemblance, which they imagine between Anubis and the Dog, it being observed of this animal, that he is equally watchful as well by day as night." In short, the Egyptian Anubis seems to be of much the same power and nature as the Grecian Hecate, a deity common both to the celestial and infernal regions.[40]

Although Anubis is often regarded as a jackal, his identity is ambivalent:

> Anubis was originally a black jackal (or possibly a dog; often the wolf, jackal, and dog cannot easily be distinguished).[1]

Gods and Goddesses of the Sacred Tree

Egyptian gods are often shown rising up out of the cosmic Tree of Life. In most cases these gods are not shown merely within the tree, but as actually forming a part of its branches and structure. In this way, it is clear that the intent is to portray them as heteromorphic beings. On the one hand they are

the celestial tree, on the other they are gods in typical anthro-pomorphic appearance. In the Norse and Siberian myths, the goddess is described as standing or seated near the Tree of Life, from which place she determines the hero's destiny or furnish-es him with milk from her breast. In Egypt, her breast is shown as integral to the tree itself.

The four divinities who commonly share this double form are Nut, Osiris, Hathor, and Isis. In each case, they are consid-ered as helpers and providers for the souls of the dead; often streams of water (sometimes four) or milk emanate from their bodies or the trees of which they form a part. Not infrequently they possess unmistakable celestial characteristics, which dem-onstrate their identification with the stars. Of the three goddess-es, each is often portrayed with uplifted arms, thus linking her with the branching pattern of the Milky Way.

The Goddess Nut

While these four divinities possessed clear celestial associa-tions, it was Nut who was specifically believed to represent the sky, particularly the night sky. But this characterization did not prevent her from also being linked to the sea and to the depths of the oceanic abyss through her ancient role as wife of Nu. Her early connection with the celestial river and her later role as both the night sky and the cosmic Tree of Life is evidence of her fundamental galaxy identification:

> She was the personification of the heavens and the sky.[42] [By] the 18th Dynasty, whenever one or other of these forms is found in good papyri it is the Night-sky which is referred to in the text. We have already seen in the paragraphs on the god Nu that he had a female counterpart called Nut, who represented the great watery abyss out of which all things came, and who formed the celestial Nile whereon the Sun sailed in his boats; this watery path was divided into two parts, that whereon the Sun sailed by day, and that over which he passed during the night. The goddess Nut, whom the texts describe as the wife of Seb, is for all practical pur-poses the same being as Nut, the wife of Nu.[43]

In the Egyptian language, the (t) ending of a word denotes its feminine form. The wife of Ra was Rat; the wife of Nu became Nut. In most cases, the male and female forms merely denoted complementary aspects of one original divinity rather than two distinct individual gods with disparate functions. Hence the clear association of Nu with the watery abyss certainly links Nut with that element even though her later development was as the night sky and wife of Geb, who is himself associated with

the waters of the world. They flow from his eyes after being separated from his wife:

> Geb was left inconsolable by the separation and he cried so fiercely that his wailing could be heard day and night and his tears filled the oceans and seas.[44]

This transformation of Nut's function should not be surprising given our hypothesis concerning the galaxy and its various representations as celestial river and as cosmic tree. That one should, over time, merge into the other can be seen as a natural development. This viewpoint is supported by another attribute of the old god Nu; he was seen as the originator of the cosmos which he formed upon his potter's wheel. The image of axial motion embodied in the rotating potter's wheel is one commonly associated with galaxy/axis mundi personifications. The spindle whorl of Ilmatar, the divine creatrix in the *Kalevala*, is one example of this image, the whirling rivers of Greece, and the spinning Norns of Scandinavia, are others. In Egypt, we are told of:

> ... the god Nu, the prince who advanceth at his hour to vivify that which cometh forth upon his potter's wheel.[45]

Nut never quite lost the oceanic attributes which formed her original essence. Even when she became intimately associated with the sky and the celestial tree, she was commonly depicted in the action of pouring out water from a container into the thirsty mouths of departed souls (Figure 10.13):

> Sometimes she appears in the form which is usually identified as that of Hathor, that is as a woman standing in a sycamore tree and pouring out water from a vase.[46]

> Nut was always regarded as a friend and protector of the dead, and the deceased appealed to her for food, and help, and protection just as a son appeals to his mother ... [The deceased is told] thy mother Nut hath spread herself out over thee in her name of "Coverer of the sky."[47]

Also like Hathor and Isis, Nut acquired the form of a heavenly cow. In this character she was linked to the four cardinal directions through her four legs. Each was positioned in connection with one of the four mysterious Children of Osiris, or of Horus, who as we have already seen, embodied the four directions and the four sources of the Nile:

> The whole body and limbs of the goddess are bespangled with stars ... According to another myth Nut was transformed into a huge cow, the legs of which were held

Figure 10.12 Nut, the Egyptian goddess of the night-sky. She arches over the earth in the same way as the Milky Way appears; from the highest vault of heaven she touches the earth at the two horizons. The position of Nut's arms reflects the position of the two branches of the galaxy formed by the Great Rift. They part near the zenith and extend to a point near the horizon. (After the Greenfield papyrus, *Book of the Dead of Nesitanebtasheru*, first millennium BC, British Museum.)

in position by the Four Children of Horus, whilst her body was supported by Shu, as the body of Nut when in the form of a woman was borne up by this god.[48]

On a mummy-case at Turin the goddess appears in the form of a woman standing on the emblem of gold ... Below her is the sycamore tree, her emblem, and in it sits the great Cat of Ra who is cutting off the head of Apep, the god of darkness and evil. In the form in which she appears in this picture Nut has absorbed the attributes of all the great goddesses, and she is the type of the great mother of the gods and of the world. On coffins and in many papyri we find her depicted in the form of a woman whose body is bent round in such a way as to form a semi-circle; in this attitude she represents the sky or heaven, and her legs and arms represent the four pillars on which the sky was supposed to rest and mark the position of the cardinal points.[49]

The role of Nut as celestial cow, along with her link to the watery abyss, parallels the image in Norse myth where the heavenly cow Audumla is the source of four rivers of milk flowing from her teats. The pictorial depictions of Nut with outstretched arms find a corresponding explanation in the myth. She is said to be stretching her arms out to welcome the souls of the dead as they ascend into the heavenly realms.

> All the evidence as to the position of the region Aaru [dwelling place of the dead] shows that originally it was thought to be in the sky ... [the deceased] is arrayed in the apparel of Horus, and in the garmet of Thoth, and as Isis is before him and Nephthys is behind him, Apuat openeth a way for him, and Shu beareth him up, and the Souls of Annu make him to mount the steps that they may present him to Nut who stretcheth out her hands to him.[50]

The characteristics shared by the three goddesses of the Tree of Life may indicate an original identity between them, since the Egyptians often saw them as forms of each other. It is fairly typical in world myth for various gods who share the same function to be regarded as siblings or children to one

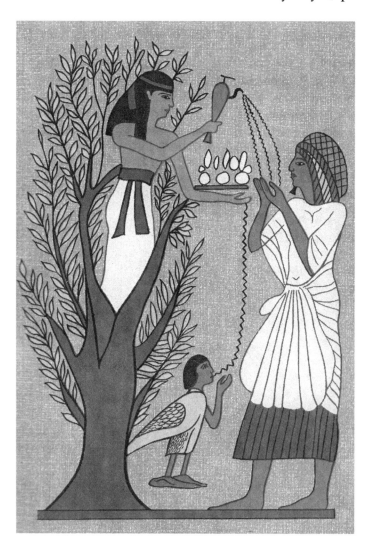

Figure 10.13 Nut, identified with the Tree of Life, dispensing four streams of water to a man and his soul.

another. Thus Nut is said to be the mother of a number of other gods who bear characteristics of the axis mundi:

> In Thebes Nut was identified with Isis, the god-mother, the lady of Dendera ... and so she became a form of Hathor ... her five children [were] Osiris, Horus, Set, Isis, and Nephthys.[51]

As with a multitude of other galaxy gods, Nut shows evidence of the typical cosmic side-wound. In her case, this is connected with an abnormal birth experience like those of Zeus, Dionysus, Adonis, Adam, Aphrodite, Skanda, and others:

> According to Plutarch (De Iside et Osiride, xii) Set broke through the side of his mother Nut. "Typho came into the world, being born neither at the proper time, nor by the right place, but forcing his way through a wound which he had made in his mother's side."[52]

The Goddess Hathor

The identification of Nut with Hathor was particularly strong. This was because both goddesses were seen as personifications of the celestial Tree of Life, both provided streams of living water for the dead, and both were generally considered to be sky goddesses (Figure 10.15):

> The representation of the sky in human, feminine form, which Hathor might also assume, led to the identification with many goddesses who were originally local ... For the nocturnal sky in particular, the prevalent personification is Nut, who, in conformity with her name, is generally understood to be a celestial counterpart of the abyss Nuu (or Nun?), i.e. as the heavenly waters which form a continuation of the ocean that flows around and under the earth ... She is often represented as a dark woman covered with stars, bending over the earth-god as he reclines on his back ... Nut, the mother of the stars, is united with the stellar tree of heaven, in which she is hidden, or whose branches are formed by her limbs ... correspondingly, all goddesses identified with the vault of heaven may likewise take the place of the nocturnal sky, especially Hathor.[53]

Typical of Tree of Life goddesses in many traditions, Hathor provided a bounty of food and drink. Like Isis and the Greek Hera, she is closely associated with the provision of milk. Hathor's galaxy associations are strengthened by the function she fulfills as holder of the ladder that conducts the dead up to heaven. She is one of the most ancient deities of Egypt, and in many legends, plays the role of divine creatrix:

Figure 10.14 Ornamental motifs from Egyptian tombs at Thebes, Old Kingdom.

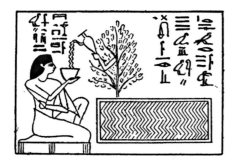

Figure 10.15 Streams of water flowing from a personified Tree of Life, itself growing out of the watery abyss below.

Hathor nourished the living with her milk. We see her giving her breast to the king whom she holds in her arms or on her knees and, again, in the form of a cow, suckling the Pharaoh ... She was also called "the Lady of the Sycamore," for she would sometimes hide in the foliage of this tree on the edge of the desert and appear to the dead with the bread and water of welcome. It was she, they believed, who held the long ladder by which the deserving could climb to heaven.[54]

The goddess Hathor is one of the oldest known deities of Egypt, and it is certain that, under the form of a cow, she was worshipped in the early part of the archaic period ... the name of the goddess means the "House above," i.e., the region of the sky or heaven.[55]

[She was the] "mother of the light," the birth of which was the first act of creation; her next creative act was to produce Shu and Tefnut ... as the lady of the "southern sycamore," she has the head of a cow ... and the whole of her body is sometimes marked with crosses, which are probably intended to represent stars ... She was, in fact, the great mother of the world...and she was the mother of every god and every goddess.[56] Hathor is called Nubt, i.e., the "Golden One."[57]

We have seen in many traditions that the Tree of Life was strongly associated with the provision of immortality. As a goddess who could assume the form of the sacred tree, Hathor held the key to this possibility for the dead. Like Osiris, she held dominion in the underworld, and was strongly linked to the four cardinal directions. She was also the protector of foreign lands:[58]

Hathor, as lady of the Underworld, played a very prominent part in connection with the welfare of the dead, for without her friendly help and protection the deceased could never attain to everlasting life.[59]

Hathor was identified with the four great and ancient goddesses ... the four typical goddess of the four quarters of the world and of the four cardinal points.[60]

She also acts a goddess of fate or destiny, in keeping with the typical galaxy-goddess pattern:

As the goddess of the sky in cow-form Hathor assumed many of the functions of the Asiatic Queen of Heaven ... This goddess has been multiplied into the group of the "seven Hathors" who foretell the future, especially of every child at his birth.[61]

The God Osiris

We have already spoken of the close similarities between Nut and Hathor. Osiris is also identified with Nut, as described in the Egyptian *Book of the Dead*:

> Thou [Osiris] art stablished in the body of Nut, who uniteth herself unto thee, and who cometh forth with thee.[62]

Nut was usually regarded as Osiris' mother, but other—perhaps older—versions have Isis as his mother, with the legend that she conceived him by eating a fruit from the Tree of Life:

> Earlier ideas are that she [Isis] conceived [Horus] from the fruit of the cosmic or fatal tree ... or from another part of this tree; these views are, however, applied also to the birth of Osiris, who is after all, as we have so often observed, identical with his son.[63]

Osiris can also be portrayed in circular form where his feet reach around to reunite with his head, in a form similar to the Ouroboros. This pose links him to the earth-encircling cosmic serpent, and thus to the earth-encircling Milky Way (Figure 10.17):

> The god Nu is seen holding up the boat with his hands, which "come forth from the water, and bear up this god." A little distance away from the boat is a sort of island which is formed by Osiris, the body of the god being bent round in such a way as to cause the tips of his toes to touch the back of his head; the text says that it is Osiris himself who forms the encircling border of the Tuat [underworld].[64]

Figure 10.16 Osiris embodied within the Djed pillar.

As part of the inquisition which the dead must undergo to determine their fitness for heaven and immortality, they must answer questions given to them by the god Thoth. In one of these questions we can observe the identification of Osiris with several galaxy attributes, including his fiery appearance in the sky, his association with serpents, and his rising up from a stream of water:

> Thoth questions him [the deceased] further as to the fitness of his condition and as to the identity of the being "whose heaven is of fire, whose walls are living uraei [serpents], and the floor of whose house is a stream of water." In answer to these questions he says that he is "purified from evil things," and that the being whose house is described is Osiris.[65]

When the god is depicted in this "Ouroboros form" he is explicitly associated with the underworld. In other cases, the

connection is with the steps or ladder that the dead must ascend, and with the cosmic serpents:

> We see the body of the god [Osiris] bent round backward in such a way as to form the region of the Tuat or Underworld. Sometimes the god is seated on a throne, which is supported on the back of a monster serpent that rests on the top of the mythological flight of steps.[66]

The Cosmic Wound of Osiris

We have already seen how the body of Osiris was removed from the side of the Tree of Life after Set killed him, but the association of Osiris with the cosmic wound theme is pervasive. He was said to have castrated his father Geb in a manner that has been compared with the emasculation of Uranus by his son Cronos in Greek myth.[67] But Osiris himself suffered the same fate. Plutarch describes how after Isis had retrieved his body from the pillar fashioned from the great Tamarisk tree in Byblos, she hid his corpse in the marshes of the lower Nile. Set, however, was out hunting one night and happened upon it unexpectedly. Furious, he hacked it into many pieces and scattered them throughout Egypt. When Isis discovered the outrage, she went searching everywhere for the lost body parts, but:

> notwithstanding all her search, Isis was never able to recover the privy-member of Osiris, which having been thrown into the Nile immediately upon its separation from the rest of the body, had been devoured by … fish.[68]

Another, much older version is preserved in the Book of the Dead. There we are told that the castration of Osiris was self-inflicted in remorse for the violation of his mother Isis. In this version he is represented by Horus who was considered his son and reincarnated self:

> But the most characteristic feature, the remorseful self-emasculation of Osiris or the sun-god Re, is as old as the Book of the Dead … it dates from the Middle Empire. A variant of this myth is found in the Harris Magic Papyrus … Here Horus (i.e. the young Osiris) violates his mother Isis, whose tears at this outrage make the Nile overflow, while its water is filled with the fish said to have arisen when the virilia of Osiris were thrown into it, evidently by himself in remorse for his sin; elsewhere these fish devour them.[69]

Figure 10.17 The birth and death of the sun. Osiris is depicted at top, his body in the form of an Ouroboros that encircles the underworld. At the bottom of the illustration, the god Nu, who formed the creation on his potter's wheel, stands with upraised arms in the posture typical of axis mundi gods.

The God Shu

Another Egyptian god with axis mundi attributes is Shu, said to be the grandfather of Isis and Osiris. Like the Greek titan Atlas, Shu's primary function is to support the sky upon his upraised arms (Figure 10.18)[70]. Other versions show him holding one of the pillars of heaven, which in themselves mirror the branching form of the galaxy where it divides at the Great Rift:

> The face of heaven was supported by the four gods [the four sons of Horus or Osiris] by means of the four scepters which they held in their hands, and these four scepters took the place of the four pillars, YYYY, of the god Shu which, according to an older myth, supported the four corners, i.e., the four cardinal points of the great iron plate that formed the floor of heaven and the sky above the earth.[71]

In addition to his role as supporter of heaven, and his associations with the four cardinal directions, Shu possessed many of the typical galaxy characteristics: he was considered the god of light; he held dominion over serpents; the gates to the underworld were said to be his, and in this capacity he assisted the dead in their ascent to heaven on the great ladder and also provided them with nourishment. He was associated with water and the Nile:

> An examination of the texts shows that Shu was a god of light, or light personified … his abode was the region between the earth and the sky, and he was a personification of

Figure 10.18 The god Shu upholding the heavens with upraised arms. Below him is Geb (or Seb), the god of the earth, with Nut, goddess of the night sky above him. Shu holds four ankhs, the symbol of life. A large ankh, hanging from Shu's right arm, bears the four cross-bars typically depicted on the Djed pillar. The position of Shu is directly over the navel of Geb and under that of Nu. At left and right are the boats of the sun in ascending and descending position.

the wind of the North ... The gate of Tchesert in the Under-world was called the "gate of the pillars of Shu." ... Shu was believed to possess power over serpents, and he it was who made the deceased to stand up by the Ladder which would take him to heaven ... The deceased was nourished with the food of Shu.[72]

The Papyrus of Ani, like other early manuscripts of the Book of the Dead, still depicts the alleged air-god [Shu] as the deity of the Nile and covers even his body with lines to represent water.[73]

Thus Shu, like Osiris, represents a personification of the galaxy in a form similar to the Hindu Skambha, that is, as an upright pillar supporting the heavens, whereas the goddesses Nut, Hathor, and Isis embody the galaxy in its form as arching over the celestial vault. Each of these deities retains attributes attesting to an origin in the watery abyss. This is parallel to what we saw of Atlas, where Homer says that he knew the depths of every sea, and places his home on an island in the western ocean.

The galaxy nature of the Egyptian goddesses Nut and Hathor has also been recognized by scholars:

Surrounding the world was the Great Green or Circuit, the Okeanos, and at its boundaries were a chain of mountains on which the vault of heaven rested personified as the goddess Nut or Hathor, the celestial cow whose under belly, according to one account, was studded with stars, and whose four legs were the posts on which the sky stood and constituting the milky way along which the boat of the sun pursued its course.[74]

These goddesses were considered the Milky Way, divinities of fate, providers of nourishment, celestial cows, and Trees of Life. They were also associated with the western ocean and with the four cardinal directions. Often depicted with upraised arms, they combine most of the important attributes of axis mundi personifications.

Figure 10.19 Multiple axis mundi symbols combined, suggesting their mutual identity. Out of the Djed pillar below, an ankh arises in central alignment. From the shoulders of the ankh rise the uplifted arms of the galaxy goddess, embracing the sun. All of these align with the center of the axis mundi mountain, which extends up to the iron plate of heaven.

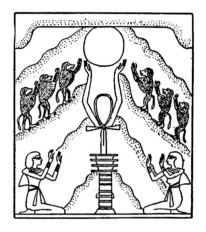

Tree of Life, Mythical Archetype

Chapter 11

Mount Meru: Indian Axis Mundi

The axis mundi in Hindu tradition takes two functionally equivalent forms: *Skambha* is the name given to the enormous pole that serves as the axis of celestial rotation. It supports and separates the sky from the earth; it is the pivot or axle at the very center of the cosmos. In some contexts, the skambha is treated as a wooden pole or stave, but in its original form it retains the branches and arboreal character of the Tree of Life.[1]

In other contexts, the axis mundi takes the form of a colossal mountain, described in some texts as being 350,000 miles high. Mount Meru (sometimes called Mount Sumeru, or Mount Mandara) extends an equivalent distance below the earth as well. It is said to be located at the exact center of the world. At its summit, Mount Meru is covered with tall trees, and is the meeting ground and dwelling place of the gods. Its slopes are covered with divine herbs that glow in the darkness, providing illumination and resembling a flame without smoke. The Buddhists say that it rises up out of the ocean.[2]

Four wide rivers flow from its heights. In the Rig Veda, the oldest of the sacred texts of India, it is said of the god Indra:

> That, nigh where heaven bends down, he made four rivers flow full with waves that carry down sweet water.[3]

Originating as a single stream, the heavenly Ganges River, whose source is in the matted hair of the god Shiva, flows past the crescent moon on his brow. White as milk, it passes through the abode of Vishnu; following divine channels, it inundates

the sphere of the moon. When it reaches the abode of Brahma, it divides into four separate streams. The first river, called the Sita, flows eastward into the salt ocean. The Chaksu gains great force and flows to the western ocean. The Alakananda flows south through India, finally discharging into the southern sea. And the fourth river, the Bhadra, becoming swift and wide, flows through the north Kuru country, bringing satisfaction to the inhabitants, and eventually falling into the northern ocean.[4]

The divine river Ganges connects heaven, earth, and the underworld. Its heavenly manifestation is said to be the Milky Way galaxy. On earth it is the familiar Ganges River. Its underworld stream originates in the Himalayas and flows south from the sacred city of Benares, said to be the "lotus of the world:"[5]

> The holy Benares is at the point where the three Ganges cross one another. These are the celestial Ganges or Milky Way, the earthly river, and the subterranean stream called the "underworld Ganges".[6]

Like Yggdrasill in the Norse myth which has a root in each of the three worlds, so here the celestial river of India likewise has its three branches. The "lotus of the world," in this context, is an expression equivalent to the "navel of the world" in other traditions. Thus the Milky Way galaxy is identified with the bridge located at the center of the world that links heaven, earth, and hell; this is the familiar axis mundi. The Rig Veda also describes a bird, or two birds, that rest on the branches of a tree:

> Two birds, beautiful of wing, inseparable friends, dwell together on the same tree. One of them eats the fruit, the other looks on but does not eat.[7]

In the Mahabhrata we are told that "geese and vultures go to Mount Meru."[8] In many myths the goose and the swan are interchangeable, as are eagles and vultures, both pairs being closely related to each other zoologically. Hence this image from the Rig Veda parallels the Norse myth where swans and an eagle are said to live on or near the world tree Yggdrasill.[9] In Greek myth, an eagle is said to have chased a swan into the lap of Leda. All three legends reflect the positions of the constellations Cygnus and Aquila which are located between the two branches of the galaxy.[10]

The ritual of forming the swastika symbol for good luck, common in both India and Tibet, invokes the great global vortex, the tree of immortality, and the goddess of fortune. This notion of a vortex located in the ocean and connected with immortality and prosperity appears as an episode in Hindu mythology called "The Churning of the Ocean of Milk." This legend tells how the gods manufactured Amrita, the divine ambrosia that confers immortality. For this purpose they constructed an

immense bow like the kind used to kindle fire by friction, and strung it with the thousand-headed serpent which lives below the waters (Figure 11.1).[11] With this bow, they spun Mount Mandara with such great force that giant trees flew off the whirling peak and the friction of the colliding wood set the mountain on fire. The sap of these trees constituted ambrosia; mixed with the liquid gold that was in the water, it conferred immortality. As the gods continued to churn, the water turned to milk. The goddess Sri (another name for Lakshmi) emerged dressed in white, and along with her, the cosmic tree and the wish-fulfilling cow. Finally a god arose, holding a white pot that contained the ambrosia.[12] Lakshmi's face and breast are snowy white, as she is made of light streaming from the god Shiva. Like the Greek Hera and the Egyptian Isis, she wears a veil.[13]

A goddess in association with the Tree of Life has ancient roots in India, for in the Indus River civilization of Mohenjo-daro we find a horned-goddess depicted within a tree.[14] The

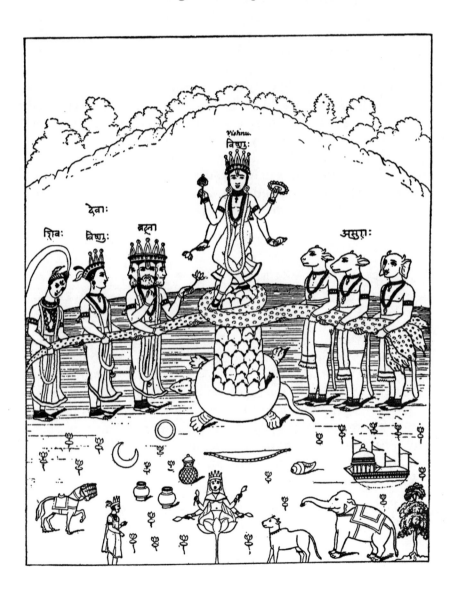

Figure 11.1 The churning of the ocean of milk. The gods (Siva, Vishnu, and Brahma) stand to the left of Mount Mandara, which rests upon a tortoise. To the right are the demons. The serpent Vasuki is the cord which is used by the two opposing sides to twirl the mountain, churning ambrosia from the ocean of milk.

whirling action of the mountain parallels the whirling action of the four rivers as expressed in the form of the swastika, and the whirling of the stars around the axis mundi.

The several images of whiteness in the Hindu Churning legend also reflect the appearance of the Milky Way. The goddess Sri is dressed in white, the water of the ocean is turned to milk, and the ambrosia is contained in a white pot. The luminescence of the galaxy is symbolized by the image that describes Mount Mandara as encompassed by flames.

The Mandala

In the description of the sacred mandala (chapter 6) the doors formed by the double swastikas lead into each of the four cardinal directions. The characteristics of these directions are familiar: The way of the south leads to the gateway of the ancestors, and this is the direction in which Odysseus travels in order to visit his mother and other departed souls in the underworld.

The way of the east is toward the rising sun. Toward the west is the way of the lord-of-the-waters, the great western ocean, which is ruled by Varuna. In Hindu legend, Dvrak (City of Doors), the mythical birthplace of the god Krishna, is located on the shore of the western ocean, the domain of the god Varuna.[15] North is often the way toward the gods in world myth. In contrast to all the other stars, which continually rotate around the axis, the polestar remains stationary. It is a place of peace, a sanctuary where the gods are said to congregate, and where the goddesses of fate decide the individual destinies of all living beings.[16]

Varuna

The gateway to the god Varuna's domain in the western ocean is worth particular note, for Varuna plays a special role in Vedic cosmology. He is one of the older generation of gods, and many of his attributes are typical of deities identified with the galaxy. He is, like the Egyptian god Shu and the Greek titan Atlas, the upholder of the sky, separator of earth and heaven, and like other galaxy gods, a source of abundance and prosperity. His robe is said to be shining, and his mantle golden. He can be seen in the highest heaven, and is lord of light and lord of rivers:

> The might of [Varuna] ... has propped asunder even the two wide worlds. He has pushed away the high lofty firmament and the day star as well; and he spread out the earth ... he, the wiser, speeds the experienced man to wealth ... Let us

have prosperity in possession, in prosperity also in acquisition. Do ye protect us evermore with blessings.[17]

Besides Indra, Varuna is the greatest of the gods of the Rig Veda … He is far-sighted and thousand-eyed … He wears a golden mantle and puts on a shining robe … The fathers behold him in the highest heaven … Thus Varuna is lord of light both by day and by night. He is also a regulator of the waters. He caused the rivers to flow; by his occult power they pour swiftly into the ocean without filling it. It is however, with the aerial waters that he is usually connected. Thus he makes the inverted cask (the cloud) to pour its waters on heaven, earth, and air, and to moisten the ground.[18]

Varuna is also a god of fate, and of all that is mysterious in the night.[19] He created the channels of the rivers, and is master of the ocean. Knowledge about him is an esoteric secret to be kept hidden from the uninitiated, and he lives in each of the three worlds: earth, heaven, and underworld. He is also the ruler of serpents. Typical of galaxy gods, he is radiant and white. His palace is called "starry night" and is situated in the middle of the waters. He is specifically referred to as "two-armed," and he is linked to a swan:

He is the creator and sustainer of the world, having inherited the prehistoric function of the Sky (Dyaus) … His laws are unassailable and rest upon him as on a mountain … Varuna is far-seeing and pushes up the firmament far above the trees of the forest. He is the support of the spheres … He dug channels for the rivers which flow by his command and never fill the ocean … His secrets and those of Mitra are not to be revealed to the unwise … In the Mahabharata and all later texts Varuna appears as the lord of the waters, the ruler of the sea or the subterranean waters … He rules over the rivers and their genii. The serpent gods, the nagas, are his subjects … He is the regent of the western direction. His domain is the Western Ocean … His name refers to all that is mysterious, cryptic, hidden. Varuna is also the lord of the causal waters that surround the world. With visible moisture he alone covers the three worlds … Two armed, he stands on the back of a swan … He is surrounded by serpents, rivers, the sons of Yadu, and the oceans. Smiling, gentle, the color of snow, lotus, or moon … he stands happily surrounded with an auspicious, cool radiance.[20]

In the Rig Veda verses quoted below, Varuna is associated with paths and long life. When the poem refers to his "spies" this is an allusion to the stars of heaven which look down upon human beings on earth and monitor their activity,[21] for Varuna is also concerned with human morality. Again, we find reference to the radiance of his appearance:

May that Aditya [Varuna], very wise, make fair paths for us all our days:
May he prolong our lives for us.
Varuna, wearing golden mail, hath clad him in a shining robe.
His spies are seated round about.[22]
In the Rig Veda, Mitra and Varuna are ... the lords of Rta [order] and light, and the "luminous dominion" is theirs.[23]

This luminous dominion is a feature of the night sky which is the particular abode of Varuna. He is even said to embrace the night in his two arms, evoking images of the gesture we saw in the Egyptian goddesses Isis, Nut, and Hathor:

During the night ... Varuna's nether world then extends over the earth as the night-sky. The cosmic waters are at that time a celestial ocean ... Varuna "clasps the night in his arms."

... The same god [Varuna] holds the roots of the cosmic tree, while its branches are hanging down. The "inverted tree" is well-known from many mythologies ...

[In] the Rig Vedic passage [we are told] "In the unfathomable space king Varuna, he of purified intelligence, upholds the tree's stpa-; they [the branches] stood directed downwards. May their rays be fixed in us." In the speculations of the Maitri-Upanishad on the mystical brahman-tree, the "three-footed brahman" is said to have its roots above ... It is Varuna who holds the tree.[24]

It is not difficult to interpret the image of the inverted cosmic tree. As seen in the illustration of the galaxy in the northern hemisphere (Figure 4.9) the tips of the two branches formed by the Great Rift appear to reach downward toward the horizon, while the middle of the tree (near the star Polaris) is located closer to the zenith. Thus it could easily be seen as a tree with the branches extended downward. This image is consistent with the depictions of the Egyptian goddess Nut whose two arms extend downward from the heights, touching the earth at her hands (Figure 10.12).

Additional evidence for Varuna's identification with the axis mundi is provided by his link to Sesa, a cosmic serpent located at the world's axis, who later inherited from Varuna the function as supporter of the heavens. Sesa was himself eventually supplanted in this role by Mount Meru. Varuna, said to be "everywhere visible"[25] is consistently linked to images of the axis mundi and the Tree of Life:[26]

Originally Varuna was the root of the Tree of Life, the source of all creation ... From his navel the undying World Tree sprang until Varuna was supplanted by Prajapati and

subsequently by Vishnu. From the waters or from the navel of Vishnu came the lotus from which Brahman emerged.[27]

These passages provide strong evidence that Varuna was considered, at least originally, to be identical with the axis mundi, and its physical manifestation as the Milky Way.[28]

The Hounds of Hell

Like the Norse, Greek, and Egyptian legends where dogs guard the gates of hell, a verse from the Rig Veda describes a similar dog that meets the dead on their journey to the land of the fathers. A dead man is addressed first, and then the god Yama:

> Run on the right path, past the two brindled, four-eyed dogs, the sons of Sarama, and then approach the fathers who are easy to reach, and who rejoice at the same feast as Yama. Yama, give him over to your two guardian dogs, the four-eyed keepers of the path, who watch over men.[29]

Thus Anubis of Egypt, Garm of Scandinavia, Cerberus of Greece, Xolotl in Mesoamerica, and the Vedic sons of Sarama establish a pattern of guardian dogs located near the gates of the underworld.[30]

These recurring patterns of dogs, serpents, and birds, indicate that the star constellations in use by the originators of the Tree of Life myth were remarkably similar to those used by modern astronomy. While our knowledge about astronomy in the ancient world is limited, we know that the Greeks, at least as early as Homer and Hesiod (ca. 800 BC), employed many of the same designations for constellations and star groupings presently in use, as, for example, the Great Bear, Orion, Boötes, and Canis Major (called "Orion's Dog"). Ursa Minor, the "Little Bear," was known at least as early as Thales (ca. 585 BC). The constellations of the zodiac appear to have been imported into Greece during the sixth century BC from the Babylonians. The Egyptians employed the same system, probably also derived from Mesopotamian usage. By the fifth century BC the system of constellations used in Greece was practically identical to the modern conception. The age of its origin in the Babylonian system, however, appears to be older than 3000 BC.[31]

The Soma Tree

In the description given at the beginning of this chapter, we saw that the magic tree, Lakshmi, the wish-fulfilling cow, and

soma were produced from the churning of the ocean of milk. The relationship between Lakshmi, the magic cow, and the Tree of Life has already been discussed, but the soma tree requires a few words. Soma was, first of all, an elixir of immortality, said to be pressed from a plant of uncertain species and used in ancient Vedic ritual. But the soma stalk, soma plant, or soma tree appears in the Rig Veda as a celestial tree with decided axis mundi characteristics. It is white, located at the navel of the universe, and is a pillar of the sky located in the highest heaven. Soma is associated with milk, clouds, and fleece, and it encircles the world. Four hidden springs gush from the soma tree which is worshipped at the central point of heaven. Of the god Soma, we are told:

> He unites with the sky's seed that grows great with milk. With kind thoughts we pray to him for far-reaching shelter. He who is the pillar of the sky, the well-adorned support, the full stalk that encircles all around, he is the one who by tradition sacrifices to these two great world-halves ... The honey of Soma is a great feast ... Child of dawn, the bull who rules over the rain here, leader of the waters, worthy of hymns, the one who brings help here. Butter and milk are milked from the living cloud; the navel of Order, the ambrosia is born ... Relentlessly they flow down into the filter of a thousand streams... Four hidden springs pouring forth butter carry down from the sky the ambrosia that is the oblation. He takes on a white color when he strains to win; Soma the generous Asura ... let him hurl down from the sky the cask full of water ... sated with waters your juice runs through the sieve made of wool.[32]

Countless hymns from the Rig Veda could be cited, all praising the celestial soma plant, comparing it to a fleecy whiteness, and locating it at the navel of the universe. Soma flows brightly between earth and heaven, he is luminous with a thousand rays. His association with milk is nearly universal, and because soma is purified through a sieve of wool, it is called Pavamana (the purified one):

> Far-sighted Soma, Sage and Seer, is worshipped in the central point
> Of heaven, the straining-cloth of wool ... The Tree whose praises never fail yields heavenly milk among our hymns.[33]

> High heaven's Sustainer at the central point of earth, raised on the fleecy surface Pavamana stands ... Soma flows bright and pure between the earth and heaven ... He, clad in mail that reaches heaven, the Holy One, filling the firmament stationed amid the worlds ... The ceaseless watery fountains with their hundred streams sing, as they hasten near, to him the Golden-hued ... Him, clad in robes of milk, swift fingers

beautify on the third height and in the luminous realm of heaven … The Golden-hued is poured forth, with his hundred streams, Wealth-bringer, lifting up his voice while purified … Fain to be cleansed, thou, Pavamana, pourest out, like wondrous Surya, through the fleece, an ample sea … The wave of flowing mead hath wakened up desires: the Steer enrobed in milk plunges into the streams.

Borne on his chariot-sieve the King hath risen to war, and with a thousand rays hath won him high renown.[34]

The following Rig Veda verse, in addition to references alluding to the glittering, brilliant, shining characteristics that we have come to recognize, makes explicit connection to Vanaspati, one of the ancient names for the Vedic Tree of Life.[35] Here also is an indication that the soma tree is located in the sea:

Enkindled, Pavamana, Lord, sends forth his light on every side in friendly show, the bellowing Bull … He, Pavamana, Self-produced, speeds onward sharpening his horns: He glitters through the firmament … Brilliant like wealth, adorable, with splendour Pavamana shines mightily with the streams of mead.

O Pavamana, with the mead in streams anoint Vanaspati, the ever-green, the golden-hued, refulgent, with a thousand boughs.[36]

Milking the heavenly udder for dear mead, he hath sat in the ancient gathering place … The living drops of Soma juice pour, as they flow, the gladdening drink, intelligent drops above the basin of the sea, exhilarating, finding light … Far-seeing, lovely, guided by the men, the God whose home is in the sea.[37]

The Cosmic Wound

Buddha is said to have been born from his mother's side.[38] This scene is illustrated in a stone bas relief from India (Figure 11.2) and in a drawing from Tibet (Figure 11.3). Confirming the axis mundi symbolism, Buddha's mother is, in both cases, depicted with her hand grasping a tree. Often in this representation the infant Buddha is received onto an open lotus flower, which in Hindu and Buddhist traditions often represents the navel of the universe.[39] This imagery is also common in Mesopotamia, where the lotus is depicted blooming on

Figure 11.2 Buddha's birth from the side of his mother, whose hand rests on the branch of the World Tree. From Loiyan Tangai, Calcutta Museum.

shrubs representing the Semitic Tree of Life, or on the Iranian tree from which the Elixir of Immortality is secreted.[40] Horus, the son and reincarnation of Osiris, is typically seated upon a lotus in the iconography of ancient Egypt.[41]

The gods Skanda, Indra, and Shiva show similar characteristics. Skanda bears a child when a thunderbolt strikes his side, Indra loses his manhood in retaliation for seducing a sage's wife, and Shiva allows himself to be castrated by a band of outraged ascetics.[42]

In addition to giving birth from his side, Skanda possesses a large number of other axis mundi characteristics. He also suckles milk from all the mothers of the world who support the universe, and he is said to cleave the air with his two arms. Once, when an evil demon attacked the gods from a white mountain, he threw his spear and split the mountain wide, thereby opening a passage for geese and other birds to fly through it. When pierced by Skanda's spear, the white mountain left the earth and flew upward.[43]

In the brief account of the Skanda myth at least six of the fifteen axis mundi attributes are present, leaving little doubt that the myth refers to the Milky Way, the Great Rift, and the bird constellations between the two galactic arms.

Figure 11.3 A Tibetan depiction of Buddha's birth from the side of his mother, Maya. Her hand rests upon a tree in the Garden of Lubini, typical of this scene in Buddhist art.

Summary

What emerges from these texts is an ancient cosmological image. Four rivers meet at the navel or axis point of the world. An enormous tree, a mountain, or a celestial river is located at this central point, and it forms a link between heaven, earth, and the underworld. It is radiant with cool light, and may be associated with images of clouds or fleece. Ambrosia flows down from heaven and its drink confers immortality. Birds, serpents, and dogs appear in the descriptions, as well as an anthropomorphic god who upholds the heavens with his two arms. In some instances by explicit reference, in others by associated identifying characteristics, this celestial river, mountain, tree, or god is linked to the Milky Way galaxy.

Chapter 12

Myth and Symbol in Ancient Greece

Mount Olympus

The axis mundi of ancient Greece is Mount Olympus, the dwelling place of the gods. Homer and Hesiod frequently call it "snowy," but this description conflicts with other references where the mountain is said to be free from snow:[1]

> So saying, the goddess, flashing-eyed Athena, departed to Olympus, where, they say, is the abode of the gods that stands fast forever. Neither is it shaken by winds nor ever wet with rain, nor does snow fall upon it, but the air is outspread clear and cloudless, and over it hovers a radiant whiteness.[2]

These contradictions disappear, however, when both are understood as allusions to the luminous characteristic of the Milky Way galaxy—that world of light beyond the reach of atmospheric weather.

Olympus is often described as many folded. Hesiod tells of a battle, fought long ago, when the gods captured it from opposing powers:

> Tell how the gods and earth arose at first ...
> And how the gods divided up their wealth
> And how they shared their honors, how they first
> Captured Olympus with its many folds.[3]

These many folds of Olympus may reflect the crenellated edges of the galaxy and its varying degrees of opacity, appearing like folds in a thin veil.

At other times, the axis mundi is called Mount Ida. As a child, Zeus is hidden in a cave on its summit and is fed ambrosia from the udder of the goat Amalthea. To protect him from discovery, she hangs his cradle on a tree.[4] Later, when Zeus wishes to lie in love with Hera on the peaks of Mount Ida, he says:

> "You need not be afraid that any god or man will see us. I shall hide you in a golden cloud too thick for that. Even the Sun, whose rays provide him with the keenest sight in all the world, will not see us through the mist."

> … In this they lay, covered by a beautiful golden cloud, from which a rain of glistening dew drops fell.[5]

The galaxy is invisible when the sun is shining, therefore it can never be seen by the sun god. The "golden cloud" reflects the nebulous luminescence of the galaxy, and drops of dew, falling from it, often figure as the source of the world's water.

Another description of Mount Ida combines images of both mountain and heavenly tree. In typical axis mundi fashion, this tree reaches up through the mists into heaven, and a bird sits on its branches:

> There Sleep halted, before the eyes of Zeus saw him, and mounted up on an exceedingly tall fir tree, the highest that then grew in Ida; and it reached up through the mists into heaven. On it he sat, hidden by the branches of the fir, in the likeness of a clear-voiced mountain bird.[6]

In contrast to the tradition that places the home of the gods on Olympus, Ovid says that they live on the Milky Way. He refers to the galaxy as the Palatine of heaven, a reference to the hill in Rome where its most illustrious citizens lived:

> There is a track across the heavens, plain to see in the clear sky. It is called the Milky Way, and is famous for its brightness. It is by this road that the gods come to the palace of the mighty Thunderer, and to his royal home. On the right hand and on the left stand the houses of distinguished gods, filled with crowds that throng their open doors. The ordinary inhabitants of heaven live elsewhere, in different places. Here the powerful and noble divinities have made their homes. This is the spot which, were I allowed to speak boldly, I would not hesitate to call the Palatine district of high heaven.[7]

Ovid here identifies the Milky Way as the dwelling place of the gods. But since we also know that they live on Olympus, Ovid effectively equates the two locations.

The mythology of ancient Greece combines the religious beliefs of many different traditions. Geographically these include: the mainland, Peloponnese, Thrace, colonies on the coast of Asia Minor, Crete, and the many smaller islands. These localities had developed independent legends about the gods, often incorporating elements from indigenous populations into their beliefs. A strict consistency, therefore, cannot be expected from the mythological accounts. Variations differ in both story line, and in the names and personalities of the deities who represent religious concepts.

It is not surprising that several different gods should show characteristics that mark them as having originally represented the galaxy as axis mundi. In the examples that follow, their conformance to this general type can be evaluated by the degree to which they share the fifteen attributes, commonly associated with the mythology of the Tree of Life.

Hercules, the Galactic Center, and Resurected Gods

The labors of Hercules, and his migrations to the four Atlantic rivers, have been discussed already; these, along with his other attributes, link him strongly to the axis mundi. By sucking too forcefully on Hera's breast he spilled her milk, thereby creating the galaxy. He suffers a thigh wound in his battle with the sons of Hippocoon.[8] Like Atlas, he is massive, and these two take turns supporting the heavens when Hercules acquires the golden apples. He kills the serpent Ladon and the Lernaean Hydra. Once, during a visit to Troizen, near Corinth, he leaned his club against an image of Hermes. "It struck root, sprouted, and is now a stately tree."[9]

In Greek myth, Hercules is almost always accompanied by his club—typically he carries the club over one shoulder and his bow over the other. Given his multitude of axis mundi characteristics, it is reasonable to seek for these two weapons within the physical features of the Milky Way. One likely possibility is that these attributes represent the two arms of the galaxy separated by the Great Rift, one of which (as seen from Mediterranean latitudes) ends in the great club-like bulge located between the constellations Sagittarius and Scorpio (Figure 7. 13). Being the location of the true galactic center, this is the widest, most luminous, and most beautiful part of the galaxy.

One characteristic of this mysterious and alluring object is that, because of its very southerly position, it does not rise high enough above the horizon during the months of November,

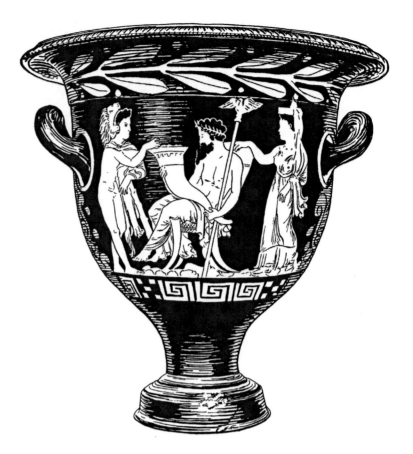

Figure 12.1 Hercules in Olympus, taking fruit from the cornucopia of Zeus. (Athenian bell-crater from the Hope collection at Deepdene.)

December, January, and February to be seen well from the Mediterranean area. If, aside from being viewed as the club of Hercules, this luminous cluster of stars were associated with certain divinities, then this may explain why a number of them are said to sleep, die, or sojourn in the underworld, for one-third of the year.

One example of these is the Phoenician god Melqart, often called Hercules Melqart, who has inherited many characteristics of the Babylonian god Nergal. Melqart underwent a periodic slumber from which he awakened every year in the month of Peritios (February–March). Scholars identify Melqart with the infamous "King of Tyre," anathematized by the biblical prophet Ezekiel (Ezek 28:1–19) using abundant axis mundi imagery: "Thou hast been in Eden, the garden of God … Thou wast upon the holy mountain of God; thou hast walked up and down in the midst of the stones of fire."

Another god of this type is the Greek Adonis, called Tammuz by the Semites, Baal by the Phoenicians, and said to be modeled on the Egyptian god Osiris. Festivals were celebrated in honor of Adonis that included a wailing for his death, followed by a rejoicing for his rebirth, since he was condemned to spend one-third of the year with Persephone in the underworld. Crops were harvested at the time of his disappearance in the fall, with the sowing of seeds (in "Adonis Gardens")

traditionally practiced at the festival of his rebirth. These facts correspond well with the periodic setting of the galactic center at the end of October and its rising at the end of February. The birth of Adonis from the side "halfway up the trunk" of his mother, who was transformed into a myrrh tree, links him strongly to axis mundi imagery. The legend also reports that the myrrh tree was spilt by the sword of Cinyras, a clear allusion to the Great Rift. Adonis likewise suffers the proverbial side-wound. He is gored in the genitals by a wild boar.

Persephone was the daughter of Demeter. When Hades abducted her from the earth, dragging her down to his abode in the underworld, Demeter, in her sorrow, caused all the plants to wither and die. Alarmed, Zeus commanded that Persephone be returned to the upper world. But because she had eaten three pomegranate seeds in the land of Hades, she was forced to return to him during the four months of winter. Each year in the springtime she was allowed to rise again.

In addition to serving as the source of Hercules' club, this galactic bulge probably was also the natural referent for the oar that Odysseus carried over his shoulder at the end of his life (mistaken for a winnowing fan by non-seafaring people). Compare also the story that the axis mundi god Hermes (Roman Mercury) was laid upon a winnowing fan when he was born. Finally, the galactic center could well have been the original source of the mythical golden balls or golden apples which axis mundi goddesses (Aphrodite, Hera, Athena, Atalanta, Eve, etc.) typically reach for, and for the pomegranate in the Persephone story described above. The round shape of the galactic center, composed as it is by myriads of stars packed tightly together like the seeds of a pomegranate fruit, could easily have given rise to this image. Its sojourn of four months in the underworld supports this hypothesis.[9]

Another perplexing myth tells how, after completing his twelve labors, Hercules is sold as a slave to Queen Omphale. She dresses him in a woman's shawl and sets him to work, teasing wool from a basket and spinning it into yarn.[10] But, when understood as axis mundi symbolism, the interpretation of this episode is straightforward. The name *Omphale* means "navel," the shawl evokes the veil-like character of the Milky Way, and the spindle represents the axial motion of the stars.

Hercules is frequently associated with flames; even his eyes flash with a gleam of fire.[11] A shirt he wears bursts into flames, and when he lies on his funeral pyre, he ascends to heaven in a blaze. After death, Zeus wraps him in a cloud and sets him in the sky among the bright stars.[12] He becomes a god, guarding the gates of Olympus during the night. But this is not surprising, since, even while living as a mortal on earth, "he preferred a night under the stars to one spent indoors."[13]

After a successful battle, Hercules was presented with the Horn of Amalthea, also known as the Cornucopia. This horn had the power of providing an inexhaustible supply of food and drink, in whatever form might be wished.[14] Because Amalthea had nurtured Zeus in his infancy, she was immortalized as the constellation Capricorn.

Attributes of the Tree of Life/Axis Mundi		Characteristics of Hercules
1. A huge Tree, Mountain, Pillar, or Support of Heaven	X	Captures the apples from the trees of the Hesperides in the garden of the gods. His club grows into a tree. Supports the heavens while Atlas is away. "Pillars of Hercules" a locality near Gibraltar.
2. Provides Prosperity, Food, Wisdom, Immortality	X	Zeus makes him immortal after his earthly death. Cornucopia provides inexhaustible supply of food and drink.
3. Located near Water, Lake, Rivers, Ocean	X	Visits all four "whirling rivers."
4. Contains images of Center, Axle, Navel, Spinning	X	Spins thread as slave to Queen Omphale; her name means "navel."
5. Mist, Cloud, Veil, Snow, Fleece, Whiteness, Milk	X	Sucks milk from Hera's breast. Zeus wraps him in a cloud among the stars. Queen Omphale dresses him in a shawl.
6. A Goddess of Fate, Fortune, or Destiny is associated		
7. Provides link between Earth, Heaven, Underworld	X	He forms the connection between the earth and heaven while upholding the heavenly spheres for Atlas.
8. Described as Radiant, Flaming, Luminous, Golden	X	Eyes gleam like fire; his shirt bursts into flames; ascends to heaven in a blaze.
9. Bifurcated Branch, Pillar, or Upraised Arms of Deity	X	Supports the heavens like Atlas, who is typically depicted with upraised arms.
10. Bird dwelling above	X	Kills the Eagle that plagues Prometheus. Kills the Stymphalian Birds.
11. Serpent dwelling below	X	Kills Ladon at the trees of the Hesperides. Kills the Lernaean Hydra.
12. Hound as Guardian	X	Captures Cerberus from Hades.
13. Goat or Stag	X	Receives the cornucopia from the goat Amalthea. Captures Ceryneian Hind.
14. Quest, Side-Wound, Visit to Underworld	X	Thigh wound from battle with the sons of Hippocoon. Quest for the apples of the Hesperides. Visits underworld while capturing Cerberus.
15. Reference to Milky Way or Swastika	X	Creates Milky Way from Hera's milk.

Hercules was widely worshiped at pillars set up in his honor throughout the Mediterranean region, from Phoenicia in the east, to Gades on the Atlantic coast of Spain.[15] The most famous of these was said to be located at the Straits of Gibraltar, called the "Pillars of Hercules" in antiquity. But the most probable origin of this designation was a belief that Hercules, like Atlas, supported the pillars upholding the heavens. He stood, just west of the Straits that bore his name, on an island that was also home to the Hesperides, the serpent Ladon, and the golden apples of immortality born by the Tree of Life.

Prometheus

The pillar motif occurs again when Hercules frees Prometheus from the chains with which Zeus bound him to a pillar.[16] Apollodorus tells how Hercules found him "on the opposite mainland" when he crossed the Atlantic Ocean from North Africa in the golden goblet, calling this land the "Caucasus." But by this he cannot not mean the mountains, known by that name, east of the Black Sea, for they are nowhere near the Atlantic Ocean.[17] We saw the same confusion in chapter 2 when Circe's island, Aeaea, was also located east of the Black Sea, despite Homer's placement of it in the Atlantic. But the far east and the far west are often confused in ancient legend, much in the same way that Columbus later believed that he had discovered a sea route to India.[18]

As with his brother Atlas, the axis mundi characteristics of Prometheus are numerous. Although Apollodorus says that Zeus chained him to a pillar, we hear from Hesiod that the pillar (or shaft) was actually driven through his middle, probably meaning his navel. In typical fashion, Prometheus suffers from a wound to the side; it is inflicted by an eagle that eats at his liver each day (Figure 12.02):

> Prometheus he bound with inextricable bonds, cruel chains, and drove a shaft through his middle, and set on him a long-winged eagle, which used to eat his immortal liver.[19]

Blood relatives of Atlas often share associations with the axis mundi. Four of his daughters, the Hesperides, guard the Tree of Life. Another daughter, Calypso, lives on an island at the navel of the sea. Both Prometheus and Atlas are linked to pillars, and they are both *titans*. The word means "white chalk," evoking the white and granulated appearance of the galaxy. Prometheus is also associated with fire. For the benefit of humanity, he stole fire from the gods, concealing it inside a hollow fennel-stalk.[20] This image of a plant, bush, or tree that glows with fire occurs frequently in axis mundi mythology. Mount

Meru is said to be covered with magic plants that shine in the darkness, and Moses encounters a divine bush on Mount Horeb (also called Sinai) that burns but is never consumed by the fire.[21]

In Greek myth, Prometheus is the creator of human beings, having fashioned them from clay.[22] In this function he joins the ranks of creator-gods—or father-gods—who are themselves hung on the axis mundi in world mythology. Odin, called All-father, hung on Yggdrasill. The infant Zeus—called the father of gods and men—hung in his cradle on a tree at Mount Ida. Prajapati, the Hindu creator-god was sacrificed at the world pillar:[23]

He [Prajapati] is the progenitor, the only Lord, and upholds with his arms the falling heaven and earth[24] … Within this universal Man the three worlds [earth, space, and sky] appear. The earthly world, supporting all, is called his feet; because it is the highest, the sky world (dyu-loka) is his head; the sphere of space, because of its depth, is his navel.[25]

Kullervo is an early ancestor in the Finnish *Kalevala*. He is burned in a fire that fails to consume him, then hung on an oak tree.[26] His axis mundi associations can be seen from the circumstances of his birth in a previous incarnation—as his own father. He was a swan born from a tree trunk later carried off by an eagle.[27] Finally, Christ, the Christian creator of the world, is sacrificed on the cross at Golgotha.[28]

Figure 12.2 Prometheus bound to a pillar with an eagle ravaging his liver. From a Greek kylix.

Gods formerly worshipped as embodiments of the galaxy, and who are later displaced by Zeus in that capacity, are traditionally hung, pierced, or fixed to pillars at the axis mundi. This treatment by Zeus in the mythology serves two purposes. First, it acknowledges the origins and former domain of these demoted gods, and second, it places them in a position there that is subordinate to Zeus. In addition to Prometheus, Atlas, Hera, and Ixion share this fate.

Prometheus also protects his creatures like a father. When Zeus would destroy the entire human race in a fit of anger, Prometheus pleads their case. It was because he stole fire for humanity that Zeus caused his body to be nailed to the mountain.[29]

Attributes of the Tree of Life/Axis Mundi		Characteristics of Prometheus
1. A huge Tree, Mountain, Pillar, or Support of Heaven	X	Chained to a pillar. Carries the stolen fire in a fennel stalk. Counsels Hercules about apples of the Hesperides.
2. Provides Prosperity, Food, Wisdom, Immortality	X	Teaches the technical arts to humans.
3. Located near Water, Lake, Rivers, Ocean	X	Hercules frees him when crossing the Ocean from Libya.
4. Contains images of Center, Axle, Navel, Spinning	X	A pillar is said to pierce his middle. Depicted at Thurii holding fire drill.
5. Mist, Cloud, Veil, Snow, Fleece, Whiteness, Milk	X	The word *titan* means "white chalk." The mountain where he is chained is said to be snowy.
6. A Goddess of Fate, Fortune, or Destiny is associated		
7. Provides link between Earth, Heaven, Underworld		
8. Described as Radiant, Flaming, Luminous, Golden	X	Steals fire from the gods.
9. Bifurcated Branch, Pillar, or Upraised Arms of Deity		
10. Bird dwelling above	X	An eagle attacks him each day.
11. Serpent dwelling below		
12. Hound as Guardian		
13. Goat or Stag		
14. Quest, Side-Wound, Visit to Underworld	X	Side wound is caused by the eagle eating his liver daily.
15. Reference to Milky Way or Swastika		

Furthermore, he taught men the arts and sciences, including architecture, astronomy, mathematics, navigation, medicine, and metallurgy.[30] In these actions Prometheus assumes the role of the deity conferring blessings and prosperity, commonly associated with the axis mundi. He is further linked with the Tree of Life in that he counsels Hercules about acquiring the apples of the Hesperides.

Table 12.2 Characteristics of Prometheus as compared to the fifteen attributes of the axis mundi.

Hera

Because Hera dared to lead a rebellion against her husband Zeus, he hung her, as punishment, on the axis mundi. She was suspended from Mount Olympus by golden bracelets, and anvils were tied to her feet. Later, when she tries to interfere with his management of the Trojan War, Zeus warns her:

Do you not remember when you were hung from on high, and from your feet I suspended two anvils, and about your wrists cast a band of gold that might not be broken? And

in the air among the clouds you hung, and the gods were indignant throughout high Olympus; but they could not come near and loose you.[31]

Mentioning the same story, Apollodorus says that "Zeus hung her from Olympus."[32]

Scholars have puzzled over this episode, calling it "hopelessly opaque."[33] But Hesiod frequently calls her "the goddess white-armed Hera."[34] In her suspended position she would certainly have resembled the Milky Way—her two extended arms reflecting the position of the two white branches of the galaxy on each side of the Great Rift. Hera also suffers a side wound when Hercules pierces her breast with an arrow.[35] Homer's description of Hera's white veil evokes characteristics of the Milky Way:[36]

> And with a veil over all did the fair goddess veil herself, a veil fair and bright, all glistening, and it was white as the sun. [37]

The golden apples of the Hesperides, and the trees on which they grow in the garden of the gods, belong to Hera. This garden is later localized to the familiar range of mountains in Northwest Africa that lies closest to the vertex of the Atlantic swastika. According to Apollodorus:

> When Zeus married Hera, the gods brought presents to the bride. Among the rest, Earth brought golden apples, which Hera so much admired that she ordered them to be planted in the garden of the gods beside Mount Atlas.[38]

Figure 12.3 The goddess Hera rising from her bath with upraised arms and veil. Ludovisi Relief, Terme Museum, Rome, fifth Century BC.

The cult of Hera in ancient Greece was often associated with wood and trees. At Plataea her effigy was carved from the wood of a gigantic oak, later dressed in women's clothes and worshipped as a bride. At the Hereum at Samos, she was believed to have been born under a willow tree, considered the oldest tree in the world.[39] In Thrace, a wooden ladder linked her home on Olympus with the earth below:

> The priest-king of certain peoples of Thrace … threatened to desert his subjects by going up a wooden ladder to the goddess Hera; which proves that such a ritual ladder existed and was believed to be a means whereby the priest-king could ascend to Heaven.[40]

Like the Egyptian goddesses who could appear as both the Tree of Life or the heavenly cow, Hera also shares cow attributes. A common epithet was "cow-eyed Hera." At Argo it was believed that when a drop of her milk fell from heaven, a white lily would sprout from the earth. When depicted on coins, Hera is shown crowned by a garland of fleur-de-lis, a symbol that came to represent the axis mundi. This symbol is still used widely to indicate True North on the compass rose.[41]

The attempted rape of Hera by Ixion provides additional galaxy associations. The version given by Apollodorus is very succinct:

> Ixion fell in love with Hera and attempted to force her; and when Hera reported it, Zeus, wishing to know if the thing were so, made a cloud in the likeness of Hera and laid it beside him; and when Ixion boasted that he had enjoyed the favors of Hera, Zeus bound him to a wheel, on which he is whirled by winds through the air; such is the penalty he pays. And the cloud, impregnated by Ixion, gave birth to Centaurus.[42]

At first sight, this episode bears little resemblance to the Tree of Life myth; no tree or mountain is even mentioned. The involvement of Hera, on the other hand, raises suspicions, given her role in the formation of the Milky Way. Creation of a cloud in her likeness by Zeus evokes the nebulosity of the galaxy, and Ixion's impregnation of the cloud signifies the characteristic presence of a goddess. Zeus binding Ixion on a wheel that spins through the air is another familiar axis mundi image, since the wheel connotes axial motion, and the binding of Ixion links him to the hero

Figure 12.4 Ixion bound. His limbs are tied to the four spokes by serpents, while flames rise from the wheel. From a painting on a Campanian amphora from Cumae, now at Berlin.

who typically hangs from the axis mundi. That his wheel is located in the air—in the sky above the earth—fits with the galaxy's observable location. Other versions of the myth describe the wheel of Ixion as fiery—this attribute is supported by vase-paintings found by archaeologists. According to the Vatican Mythographer, the wheel of Ixion was said to be entwined with snakes.[43] In the sixth century BC, Anaxagoras called the Milky Way "the shining wheel." This statement supports the interpretation of Ixion's wheel as a form of the axis mundi (Figure 12.4).

These numerous galaxy references suggest the following interpretation: Another cultural group, who worshipped Ixion as an embodiment of the galaxy, came into conflict with the dominant Greek faction. Rather than suppress this cult outright, Greek myth condemned Ixion to eternal punishment on the fiery, rotating, cloudlike, axis mundi—the Milky Way. Scholars have also puzzled over the meaning of the name, *Ixion*, but this

Table 12.3 The characteristics of Hera as compared to the fifteen attributes of the axis mundi.

Attributes of the Tree of Life/Axis Mundi Characteristics of Hera

		
1. A huge Tree, Mountain, Pillar, or Support of Heaven	X	The trees bearing the golden apples of the Hesperides belong to her.
2. Provides Prosperity, Food, Wisdom, Immortality	X	Confers immortality on Menelaus.
3. Located near Water, Lake, Rivers, Ocean	X	Often bathes in spring of Canathus in order to renew her virginity.
4. Contains images of Center, Axle, Navel, Spinning		
5. Mist, Cloud, Veil, Snow, Fleece, Whiteness, Milk	X	Traditionally wears a veil. Hidden in a golden mist on Mount Ida. Drops of her milk cause growth of white lilies on earth. Milky Way created by her milk.
6. A Goddess of Fate, Fortune, or Destiny is associated		
7. Provides link between Earth, Heaven, Underworld	X	The Thracians believed that a wooden ladder linked her to the earth.
8. Described as Radiant, Flaming, Luminous, Golden	X	Her veil was fair and white, as bright as the sun.
9. Bifurcated Branch, Pillar, or Upraised Arms of Deity	X	Arms held outstretched by golden bracelets when punished by Zeus.
10. Bird dwelling above	X	Ravished by Zeus in form of cuckoo.
11. Serpent dwelling below	X	Sends serpents to kill infant Hercules.
12. Hound as Guardian		
13. Goat or Stag		
14. Quest, Side-Wound, Visit to Underworld	X	Wound in breast from Hercules' arrow.
15. Reference to Milky Way or Swastika	X	Her milk creates the Milky Way.

may simply reflect his position. Phonetically, it is very close to *axōn*, a Greek word meaning "the axis of the celestial sphere."[44]

Zeus

The primary cult center of Zeus was at Dodona where he uttered oracles from within a sacred oak tree. These oracles were:

> heard in the rustling of the leaves … it was the identification of Zeus with water and the oak at Dodona rather than his capacity as the Sky-god *par excellence* that was emphasized there.[45]

> … The oak, so intimately associated with Zeus, doubtless represents the Cosmic Tree as the substructure and foundation of the earth.[46]

In other locations, Zeus is worshiped as a pillar or as an omphalos.[47] He also exhibits the characteristic cavity in his thigh. This is recorded in the myth that describes the birth of "twice-born" Dionysus:

> Zeus, snatching the sixth-month abortive child from the fire, sewed it in his thigh … But at the proper time Zeus undid the stitches and gave birth to Dionysus, and entrusted him to Hermes.[48]

At Thurii, Zeus and Prometheus were depicted together holding a fire-drill, an image associating both gods with axial motion.[49] Zeus was said to have employed the golden fleece of the Argonauts in order to climb into the sky.[50] The characteristic whereby the Tree of Life serves as a bridge between earth and heaven, is here attributed to the golden fleece and linked to Zeus.

Figure 12.5 Zeus, Pillar, and Eagle. From a well-mouth of Luna marble, Naples Museum.

Etymology of *"Zeus"*

The word Zeus has related forms in most of the other Indo-European languages. The English day name *Tuesday*, for example, is derived from the Germanic sky god Tiw. Latin *Jupiter* is a compound, where the second element *-piter* means "father." The words *divine, deva,* and *July,* are derived from the same root, the original sense of which meant "to shine."

Many languages use this word to designate a progenitor god who was the chief of the Indo-European pantheon. He is generally regarded as a sky god, whose name is believed to signify the concept "bright sky" or "daytime sky."[51]

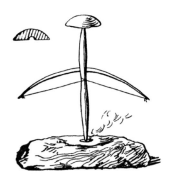

Figure 12.6 Fire-drill of the type said to have been used or invented by Prometheus (also attributed to Hermes-Mercury). Whipping back and forth with the bow rotates the central shaft, causing friction and heat in the wood block beneath.

Figure 12.7 Zeus and his Eagle. From a Spartan kylix now in the Louvre.

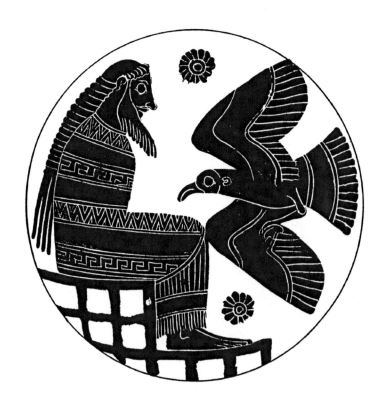

But the cognates of this root in the various Indo-European languages reveal a multitude of galaxy attributes. Not once do these include references to the sun, nor do they often reflect the notion of the bright, glaring light of day. Much more frequently they refer to characteristics similar to those possessed by the galaxy in the night sky: "twinkling, glistening, sparkling, delicate, graceful, charming, elegant, lovely, luminous, gleam, radiate, glow, luster." Several of the cognates suggest qualities associated with the galaxy's conspicuous position in the sky: "immense, distinct, clear, evident, visible, obvious, huge." In some cases, they denote: "prosperity, success, fame, glory, honor, or advantage." These are also qualities connected with the axis mundi and the deity of fortune or fate commonly associated with it. Some cognates express the concepts: "watching, looking, staring, peering," that evoke the notion of the stars as eyes in the night sky.

Another group of these cognates includes concepts such as: "whirl, eddy, fly, hover, swirl, whirlpool, vault, soar, ascend and vortex." Among these is the Greek (dinos) the specific word used by Hesiod when referring to the "whirling rivers." This last group, although identical in form, is often considered by scholars as a separate root because they have failed to see the semantic relationship between the connotations of "glistening" and those of "whirling." But as complementary attributes of the galaxy/axis mundi they occur together countless times in world mythology. They belong together etymologically as well.[52]

Because a few derivatives of this root indicate the concept "day," commentators have thought that the name *Zeus*, and words related to it, may refer to the "bright sky of the daytime." But when the notion of *day* does appear among these cognates, it is found to be more specifically connected to the notion of the twenty-four hour time interval, as in the expression, "I'll see you in three days," rather than to the period when the sun is shining.[53]

It was a peculiarity of many ancient Indo-European cultures that the day was considered to begin at nightfall and to end at dusk twenty-four hours later. Hence a day was, in actuality, the night and the following day. This explains why some holidays are celebrated beginning on the previous evening as, for example, Halloween, Christmas Eve,

and New Years Eve.[54] Given the other connotations of the root, described above, the original reference to "day" more likely refers to the galaxy and to the time interval between its successive appearances.[55]

Odysseus

After nine years of fighting at Troy, the Greek soldiers were becoming impatient at the excesses of Agamemnon and the military stalemate. Odysseus reminds them of an omen that had predicted that nine years would pass before their ultimate victory in the tenth:

> "One day, just when the ships had staged at Aulis, loaded, every one, with woe for Priam and the men of Troy, we gathered round a fountain by the altars, performing sacrifices to the gods under a dappled sycamore. The water welled up shining there, and in that place the great portent appeared. A blood-red serpent whom Zeus himself sent gliding to the light, blood-chilling, silent, from beneath our altar, twined and swiftly spiraled up the tree. There were some fledgling sparrows, baby things, hunched in their downy wings—just eight of these among the leaves along the topmost bough, and a ninth bird, the mother who had hatched them. The serpent slid to the babies and devoured them, all cheeping pitifully, while their mother fluttered and shrilled in her distress. He coiled and sprang to catch her by one frantic wing. After the snake had gorged upon them all, the god who sent him turned him to an omen: turned him to stone, hid him in stone—a wonder worked by the son of crooked-minded Kronos—and we stood awed by what had come to pass."[56]

The purpose of the expedition to Troy was to retrieve Helen, who had been abducted or seduced by the Trojans. Scholars recognize that Helen is an ancient tree goddess whose status was later demoted to that of a human being with many divine attributes. She was, for example, reputed to have been the most beautiful woman in all of Greece—the daughter of Zeus (in the form of a swan) and the goddess, Leda. As a young woman she was abducted by Theseus, another traveler to the underworld who suffered a thigh wound. Some say Helen appears in the atmosphere as the electrical discharge known as St. Elmo's fire.[57] In Greek mythology her divine status had faded into that of a mortal woman. Nevertheless, she retained many of the attributes that mark her as a galaxy goddess.[58]

Ancient authors tell of a "Helen's Tree" in Sparta, and she was also hung on a tree at Rhodes.[59] Some say that Helen stayed

in Egypt during the course of the Trojan War, and that Paris had only carried a phantom of her, fashioned from the clouds.[60] In the *Odyssey*, we find Helen back at Sparta after the Trojan War, spinning with a golden distaff. Her husband, Menelaus, is guaranteed eternal life in Elysium because of his marriage to her.[61]

Thus Helen possesses a multitude of characteristics that are commonly associated with the Tree of Life: She is a tree goddess, spins with a golden distaff, confers immortality, is radiant (as St. Elmo's fire), hangs on a tree, is transformed into clouds, and has an earlier husband Theseus—who like Hercules—bears a thigh wound and travels to the underworld.

Odysseus plays a decisive role in the Trojan War. The idea for the Trojan Horse was his—the ruse that finally broke the city's defense. Most importantly, he stole the Palladium from its sanctuary inside the walls of Troy. This was a magic talisman that protected the city from all attackers, given by Zeus to the king:

> Having prayed to Zeus to give him a favorable sign, on the following day he saw lying before his tent the Palladium, which had fallen from heaven. It was three cubits (4 ½ ft.) long, its feet were joined; in its right hand it held an uplifted lance, in its left a distaff and spindle.[62]

The Palladium is an image of a goddess that confers protection. Her fused legs, the spindle she holds, and her role as the object of Odysseus' search, mark her—like Helen—as a representation of the galaxy goddess. In that other goddess at the navel of the sea (Calypso/Circe), and in the omen at Aulis, we encounter additional instances of the basic image standing behind the Homeric epic: a mythical quest for the Tree of Life.

During his voyage home, Odysseus' raft is sucked into a whirlpool by the undersea monster Charybdis.[63] He saves himself by clinging to the overhanging branch of a massive fig tree:

> Its roots spread far below and its branches hung out of reach above, long and great, and overshadowed Charybdis.[64]

Nearby is the mountain of Scylla, whose peak rises to heaven and is always surrounded by a cloud:

> No mortal man could scale it or set foot upon the top, not though he had twenty hands and feet; for the rock is smooth, as if it were polished. And in the midst of the cliff is a dim cave, turned to the West.[65]

This cave of Scylla, in the side of the mountain, is reminiscent of Lilith's house in the side of the huluppu-tree that Gilgamesh cut down for Inanna's bed. The western orientation of the cave is consistent with the position of the great lacuna in the galaxy, for it too always faces towards the west.

Also like Gilgamesh, Odysseus fashioned a bed for his beloved wife Penelope. He made it from the wood of an ancient olive tree that had formerly stood where their house was constructed. The girth of this tree was "like a pillar," and Odysseus had "bored it all with the auger ... inlaying it with gold and silver and ivory."[66] Like the huluppu-tree—with its axis mundi imagery—that was used to construct Inanna's bed, this ancient olive which, "no mortal that lives, however young and strong ... could easily pry it from its place," bears unmistakable galaxy characteristics. The axial motion of the auger, the radiance of the metals and ivory, its girth like a pillar, and its construction by a hero who has traveled to the underworld and returned, all connect it to the Tree of Life and to the earlier Gilgamesh epic.

A further link to this theme is provided by the veil of Leucothea that saves Odysseus from drowning.[67] Driven by the wrath of Poseidon to the last extremity of his endurance, his raft

Figure 12.8 Leucothea feeds the infant Dionysus from the cornucopia. A serpent climbs from below, and birds nest at the branching point. Antique bas-relief, Lateran Museum, Rome.

Attributes of the Tree of Life/Axis Mundi		Characteristics of Odysseus
1. A huge Tree, Mountain, Pillar, or Support of Heaven	X	Hangs from huge fig tree over the vortex created by Charybdis, near Scylla's mountain. Fashions a bed for Penelope from an olive tree with girth "like a pillar." Tree with bird above and serpent below in omen before Troy.
2. Provides Prosperity, Food, Wisdom, Immortality	X	Said to be very clever, of "many devices." Circe offers him immortality.
3. Located near Water, Lake, Rivers, Ocean	X	Journey to the "whirling rivers." Hangs from a branch over the ocean. Long quest across the seas. Captive on islands.
4. Contains images of Center, Axle, Navel, Spinning	X	Whirlpool of Charybdis. Augers wood from a tree used to construct Penelope's bed. Grain mill of servant.
5. Mist, Cloud, Veil, Snow, Fleece, Whiteness, Milk	X	Saved from drowning by the veil of Leucothea (White Goddess).
6. A Goddess of Fate, Fortune, or Destiny is associated	X	Captures Palladium. Prayer, uttered by servant turning a grain mill, is taken as a sign of victory.
7. Provides link between Earth, Heaven, Underworld	X	Peak of Scylla's mountain reaches up to heaven, "no mortal could climb it."
8. Described as Radiant, Flaming, Luminous, Golden		
9. Bifurcated Branch, Pillar, or Upraised Arms of Deity	X	Hangs by two arms from a branch of the massive fig tree over an ocean vortex.
10. Bird dwelling above	X	Odysseus' description of the omen seen before his journey to Troy includes birds perched in the branches of a tree.
11. Serpent dwelling below	X	Charybdis is a monster living in the sea below the fig tree from which Odysseus hangs. A serpent creeps from the water, and climbs up tree in omen before Troy.
12. Hound as Guardian	X	His old dog, Argos, guards the entrance to his house.
13. Goat or Stag	X	Kills an enormous stag on Circe's island.
14. Quest, Side-Wound, Visit to Underworld	X	An old thigh wound gives away his identity. Visits underworld. Quest to retrieve Helen of Troy (a former tree goddess), later quest to return home.
15. Reference to Milky Way or Swastika		

Table 12. 4 Characteristics of Odysseus as compared to the fifteen attributes of the axis mundi.

destroyed by a raging storm, he is pitied by the goddess Leucothea. She rises from the depths of ocean and lends him her veil of immortality. With its assistance, he will not suffer or perish. As we have already noted, the veil is a common axis mundi marker, symbolizing the wispy, diaphanous nebulosity of the galaxy. It is one of the most typical emblems of the goddesses Hera and Isis, both linked so intimately with the Milky Way.

The name *Leucothea* means "White Goddess." Not only her name, but also the context in which she is placed in Greek iconography, confirms her association or identification with the Tree of Life. Figure 12.8 shows an antique bas relief depicting this goddess feeding ambrosia to the young Dionysus. He is seated in a cleft half way up the tree, clearly identified as the Tree of Life by the serpent twining around its trunk, and by the birds in its branches. The Cornucopia is another axis mundi marker; it dispenses an inexhaustible supply of nourishment and often confers immortality. Dionysus was born from the thigh of Zeus, and his position at the cleft on the side of the Tree of Life is an allusion to this irregular birth.

The goats at the base of the tree as well as the cornucopia—which was said to have been one of the horns of the goat Amalthea—link the tree to the constellation Capricorn. Amalthea fed Zeus and his foster-brother Pan with ambrosia inside a cave on Mount Ida—which explains the presence of Pan.[68]

Two rather gratuitous incidents in the *Odyssey* suggest that the author of the epics intentionally included axis mundi imagery in the narrative. When Odysseus finally reaches home after twenty years away, he meets his old dog, Argos, sitting on a dung heap and keeping watch at the doorway. The excitement of seeing his master is too much for the dog; it causes him to fall over dead. Later, while plotting revenge on the suitors who have been tormenting his wife, Odysseus hears the prayer of a servant woman. She is grinding grain on a hand mill, and she implores heaven to bring her master Odysseus home soon. He takes this as an omen that his battle with the suitors will be successful.

These incidents serve to incorporate three classical elements into the narrative: the dog guarding the entrance to the underworld, axial motion (symbolized by the mill), and the goddess of fate who typically turns a spindle or a mill, here represented by the prophecy of the servant. Taken together, the events in Odysseus' life reflect, to a remarkable degree, the attributes of the Tree of Life. Like Helen, he must originally have been a galaxy god of the Gilgamesh/Hercules type, who later faded to human status in the mythology.[69]

Greek Geometric Art

Elements of the Tree of Life myth appear in pictorial form on Greek ceramics of the early geometric style. Stags, trees, swastikas, river-meanders, water birds, and serpents occur widely in the designs used on funeral urns and other objects in the tenth through seventh centuries BC.

While a single depiction of a stag or of a river-meander, for example, does not necessarily indicate a particular mythological complex, when these various symbols occur together in combinations, their axis mundi reference becomes more certain. The Greek geometric style was used primarily as decoration on funeral urns, either holding the cremated remains, or standing above the grave as a memorial (Figure 12.10).[70] This use reflects the view of the Tree of Life as a bridge linking earth, heaven, and the underworld. Its depiction on funeral urns symbolized the survivors' wishes for the deceased: good fortune and a safe journey to the afterlife. This use of the swastika, in particular, occurs widely in antiquity. It was depicted alongside lotus flowers on tombstones in a Roman cemetery in Belgium. In Tibet it is used as an ornament for the shroud placed upon the dead. We have already noted its use on Etruscan and Peruvian funeral urns (chapter 9), and in Denmark it was inscribed upon sepulchral vases.[71]

A detail from a Greek vase shows a line of stags in browsing position, with swastikas and water birds (Figure 12.11).

On a vase from Camiros in the Rhodian style (Figure 12.12) a series of stags is surrounded by swastikas and water birds. Lotus flowers are depicted naturalistically (below), and schematically (above, far left), here representing the ancient concept of the Tree of Life in the iconography of the geometric style.

Figure 12.9 Attic vase of the geometric period. Goddess with upraised arms, animals, and swastikas.

Figure 12.10 Detail from a vase in the geometric style depicting funerary scenes: corpse on bier, mourners, and swastikas with river-meanders. Detail from a Greek amphora, Athens.

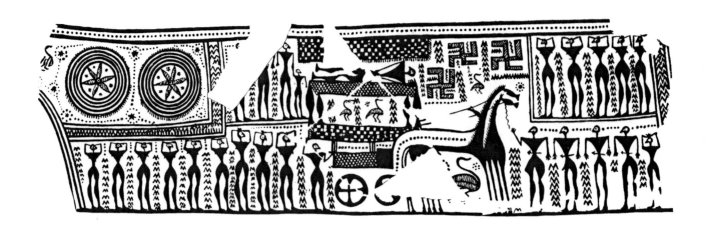

Tree of Life, Mythical Archetype

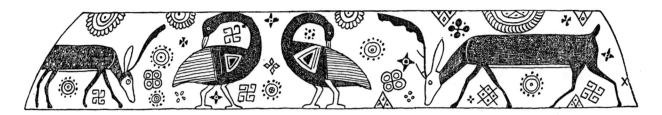

A kylix found at Athens is decorated in the geometric style with swastikas and stylized lotus (Figure 12.13).

A charming ceramic pyxis with horses on its cover shows geometric style swastikas, meandering frets, and wave patterns (Figure 12.14).

A Melian vessel from Athens shows the juxtiposition of the stag motif with swastikas (Figure 12.15).

Figure 12.11 Detail from a Greek vase (ca. fifth to sixth century BC), showing stags, swastikas, water birds, and river-meanders. Found in Naukrautis, Egypt.

Figure 12.12 Vase from Camiros, in the Rhodian style, depicting stags, swastikas, birds, and lotus.

Figure 12.13 Kylix, in the Greek geometric style, found at Athens. Swastikas and stylized lotus. Private collection, Paris.

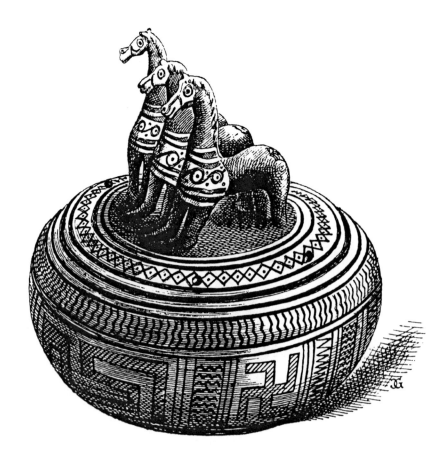

Figure 12.14 Ceramic Pyxis with horses, meanders, and swastikas. Athens, Museum of the Archaeological Society.

Figure 12.15 Stag and swastikas from a Melian amphora. Athens, Ministry of Public Education.

A coffer from Thebes depicts a human figure of the axis mundi type with upraised arms, horse, and swastikas of both directional types (Figure 12.16).

A detail from a Rhodian vase of the geometric period shows a highly stylized lotus as axis mundi, with water birds and swastikas (Figure 12.17).

Details from a Cyprian amphora illustrate the extremely abstracted forms of the lotus employed in the geometric period. Swastikas are abundantly associated with this highly reduced form of the Tree of Life (Figure 12.18).

A skyphos from Athens is decorated with a central lotus with two flanking felines and swastikas (Figure 12.19).

The art and literature of ancient Greece provide a wealth of mythological evidence, often bearing identifiers that we have come to recognize as the fifteen attributes of the axis mundi. Occurring alone, these could be dismissed as insignificant. But

Figure 12.16 A coffer from Thebes decorated in Boeotian geometric style. Figure is depicted with upraised wings(?), surrounded by direct and reverse swastikas. Berlin Museum.

when found together as a unified symbolic set, definite conclusions can be drawn about their intended meaning. The imagery seen on Greek ceramics is found again in the symbols etched on the spindle whorls at Troy. Swastikas, stags, rivers, and trees are the most common decorations found there, and these must likewise represent the axis mundi and the Tree of Life.

Figure 12.17 Detail of a Rhodian vase from the geometric period: stylized lotus, water birds, and swastikas.

Figure 12.18 Detail of a Cyprian amphora from the geometric period: stylized lotus with swastikas. Metropoliton Museum of Art, New York.

Figure 12.19 Skyphos found at Athens: Tree of Life, flanking felines, and swastikas (ca. seventh century BC). British Museum, London.

Tree of Life, Mythical Archetype

PART III

Ancient Artifacts and Later Transformations

Chapter 13

The Trojan Artifacts

Ancient artists often chose to produce votive objects that were highly schematic in form. The goddess Athena was sometimes represented iconographically by her sacred bird, the owl, which was sometimes indicated by the merest suggestion of a beak and uplifted wings (Figure 13.1a). In other examples, the form is represented even more schematically, consisting of only a few characteristic curves (Figures 13.1b, and 13.1c).

Archeologists encountering one of these highly schematized objects would have difficulty identifying its underlying significance were it not that variations on the same theme exist in the full range of specificity, from the most naturalistic to the most reduced. By studying the gradual progression from the simplest type to the most complex, scholars learn to recognize the icon in its full range (Figure 13.2).

Religious objects of the late Neolithic and early Chalcolithic are particularly noted for this feature. The reasons for this process of schematic reduction do not reflect a lack of artistic ability. Naturalistic depictions often occur in immediate proximity to the most abstracted examples, at times even occurring together on the same artifact. The attempt to evoke the broadest religious imagery with the least representational material may be related to the esoteric nature of the cult.[1]

Figure 13.1 Trojan votive objects with bird's head and uplifted wings, believed by Schliemann to represent the goddess Athena.

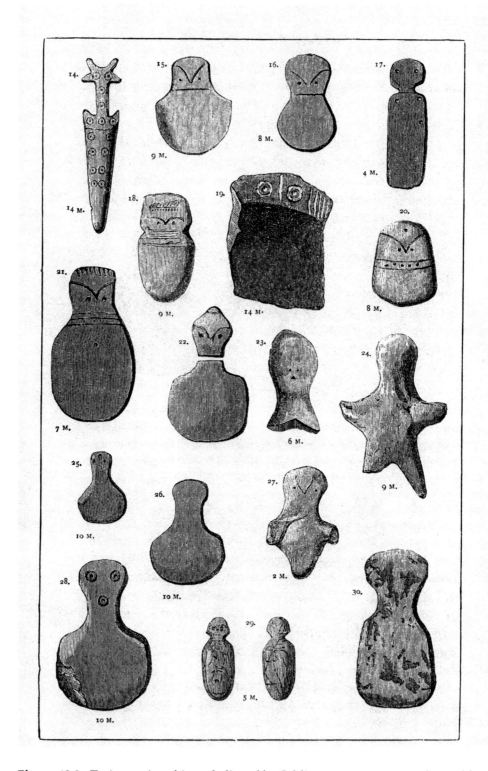

Figure 13.2 Trojan votive objects, believed by Schliemann to represent the goddess Athena, (Schliemann, 1875).

Designs on Etruscan funeral urns exemplify this process and have been illustrated by researchers (see, for example, Hencken, 1968). Figure 13.3a shows a sketch of a reindeer herd incised on the wing bone of an eagle from Dordogne. The vast majority of the heard is indicated symbolically, mere wisps of lines suggesting antlers. These would be unrecognizable without the fully rendered animals at each end. In Figure 13.3b, a spatula handle from the Matty Islands is decorated with abstract forms, only clearly revealed as lizards through comparison to motifs on other objects. Decorations on the Trojan spindle whorls can best be understood in this light. They are highly reduced, stylistic representations of mythological images. Let's examine a few of the most common motifs.

The Stag

The stag motif is well-represented on the Trojan spindle whorls. Figure 13.4 illustrates the stag in its most archetypal form: head and tail erect, four legs, sexual anatomy clearly visible, and prominent antlers. But even within this single whorl, variations occur. The stag on the right is shown without a penis, and the lower stag lacks prominent antlers.

In some cases, the stag has as many as eleven legs, in other examples as few as three. The head and tail may be shown as simple, short, upturned lines, or even further reduced to a barely perceptible horizontal extension of the back. The penis may be either omitted altogether, or elongated to the length of the legs. Occasionally it is indicated by a dot.

The design shown on Figure 13.5 was believed by Schliemann to represent a fiery altar, with the legs of the alter-table below and the flames rising above.[2] Gimbutas, familiar with the symbol from her

Figure 13.3a An example of the schematic reduction common in ancient art. A herd of raindeer in both naturalistic and abstract representational styles. Excavated at the Grotto de Teyjat, Dordogne.

Figure 13.3b Naturalistic and stylized forms used as decorations on wooden spatula handles from the Matty Islands (western Pacific). The two naturalistic examples (above) provide a key to the larger, schematic example (below), revealing these abstract decorative forms as lizards. From the Edge-Partington Collection.

Figure 13.4 Trojan spindle whorl with three stags.

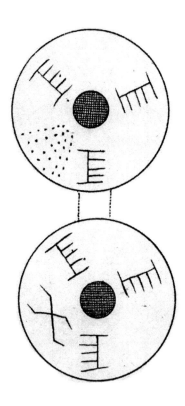

Figure 13.5 Trojan spindle whorl: stags in highly schematic form, dew drops, and a bi-directional swastika.

work in the Balkans, believed that it represented a comb or hairbrush of the fertility goddess.[3] At first sight, the design is ambiguous, but seen in association with less schematized examples, its identity as a variant of the stag is revealed. The horizontal line at the top is its back. The two short lines rising above the back at each end are the head and tail. The two lines below the back at each end are the forelegs and hind legs. And finally, the middle line below the back represents the penis. The cluster of dots in the lower left quadrant represents the mist, which, in the myth, is said to flow from the antlers of a stag in proximity to the Tree of Life.

In Figure 13.6 both schematic and naturalistic representations are present. The stag just above and to the left of the central axis is depicted in realistic form. The penis is in proper proportion to the rest of the body, and the head and tail are easily recognizable. Mist from the antlers is evident. On this same whorl, above and slightly to the right of center, is another stag, depicted in the abbreviated and highly stylized form found on many of the other whorls. Here the penis is omitted and the head and tail are ambiguous. Two dots above the back may indicate the mythical drops of water.

A highly stylized representation of the stag can be seen in Figure 13.7 where the animal is reduced to a mere three parallel lines denoting legs, and a short horizontal line indicating the back. In Figure 13.8, even the back is omitted; the stag is represented by three vertical lines alone.

Although the stags depicted naturalistically differ greatly from the highly schematized forms, intermediate stages are amply represented in the archeological finds. A morphological progression from one extreme to the other, using selected examples, demonstrates their common identity as stags (Figure 13.9).

Stags found on Trojan spindle whorls bear a remarkable resemblance to decorations appearing on older artifacts from Hungary (Figures 13.10 and 13.11a). In both figures, the stag is depicted with legs as vertical lines below a horizontal back, with antlers rising vertically and then inclining backward at an angle. The mysterious appendage appearing on the antlers of the stag from Hungary is paralleled by a similar structure on the Trojan stag (Figure 13.11b). This correspondence suggests that the spindle whorls at Troy reflect much older traditions.

Tree of Life

Schliemann recognized the treelike figures that appear in such profusion at Troy as examples of the Tree of Life, a motif that occurs widely in Middle Eastern iconography. He writes:

Tree of Life, Mythical Archetype

Upon a ball, found at the depth of 8 meters there is a tree of this kind surrounded by stars, opposite a swastika, beside which there is a group of nine little stars [Figure 13.12]. I therefore venture to express the conjecture that this tree is the tree of life, which is so frequently met with in the Assyrian sculptures, and that it is identical with the holy Soma-tree, which, according to the Vedas … grows in heaven, and is there guarded by the Gandharvas, who belong to the primeval Aryan period, and subsequently became the Centaurs of the Greeks. Indra, the sun-god, in the form of a falcon, stole from heaven this Soma-tree, from which trickled the Amrita (ambrosia) which conferred immortality. Fr. Windischmann has pointed out the existence of the Soma-tree worship as common to the tribes of Aryans before their separation, and he therefore justly designates it an inheritance from their most ancient traditions. Julius Braun says, in regard to this Soma-tree: Hermes, the rare visitor, is regaled with nectar and ambrosia. This is the food which the gods require in order to preserve their immortality. It has come to the West from Central Asia, with the whole company of the Olympian gods; for the root of this conception is the tree of life in the ancient system of Zoroaster.[4]

Schliemann's identification of the Tree of Life with the heavenly soma tree is consistent with the statement cited by Sir William Jones regarding the celestial nature of the Tibetan Tree of Life, and with the nature of the soma tree as discussed in chapter 11. His mention of the Centaurs and the Gandharvas raises the question as to whether these animals correspond to the stag motif treated above. The link is plausible, since the Vedic Gandharvas are specifically figured as half-animal, celestial guardians of the heavenly tree. Figure 13.12 illustrates examples of spindle whorls and a terra cotta tripod inscribed with the Tree of Life symbol (see also Figures 1.3 – 1.6 and Appendix 2).

The Rivers of Paradise

Schliemann interpreted the frequently occurring curved parallel lines on the spindle whorls as rising suns, concluding that the Trojans must have been a nation of Aryan sun worshipers.[5] But, because of the context in which they appear, these symbols should be seen rather as borders of the four rivers, said in mythology to meet the Tree of Life at their confluence. The hole at the center of the spindle whorl, and the distaff that was formerly inserted there, will have represented the axis mundi. Thus the axial motion of the spindle whorl around its distaff parallels the rotation of the earth around its axis. This

Figure 13.6 Trojan spindle whorl: naturalistic and schematic stags, swastikas, and a river.

Figure 13.7 Trojan spindle whorl: swastikas and a highly schematic stag (upside down at top).

Figure 13.8 Trojan spindle whorl: a highly schematic stag near the axis of rotation.

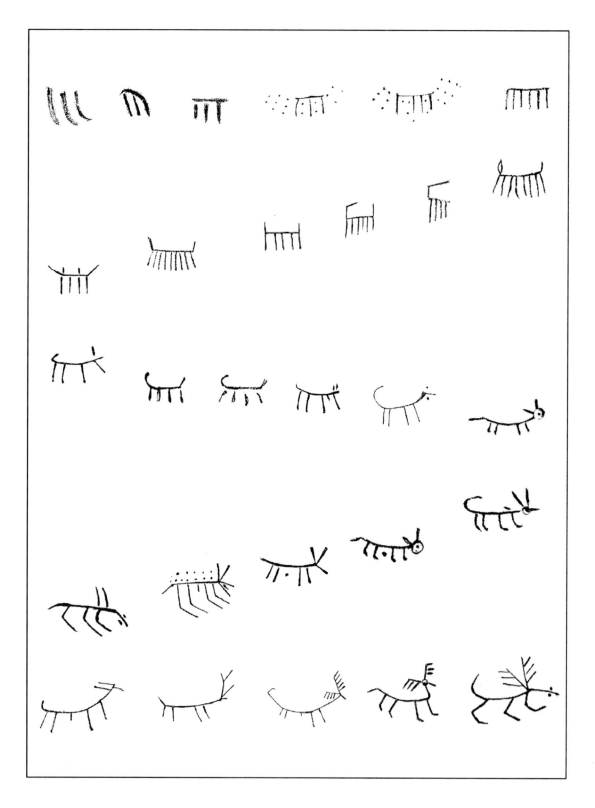

Figure 13.9 Development of the stag motif from most abstract to most naturalistic. Examples are selected from the Trojan spindle whorls as reproduced by Schliemann (see Appendix 2 for additional examples). Dew drops occur on several of the representations (see also whorl 465 in Appendix 2).

parallelism—microcosm to macrocosm—explains why Tree of Life symbolism appears so plentifully on the spindle whorls at Troy. Sometimes as few as two rivers are depicted; in other cases, there can be five or six. Frequently, however, there are four, as one would expect from the mythology. Variations in these numbers can be explained as the normal development of a symbol when its original meaning is no longer understood, and its use has become merely traditional. Often another axis mundi identifier marks the confluence of the rivers; this can be a tree, a stag, a swastika or a goddess with upraised arms (Figure 13.13).

The designs on the whorls illustrated in Figure 13.14 make the river symbolism even more explicit. Meandering lines (top row) are added to the negative space between the wedge-shaped areas (the four continents) in order to clearly convey the watery nature of the intersecting rivers. As the border lines of these rivers approach a condition of parallelism, the entire figure becomes more cross-like. Whorl 320 illustrates an example of this development and may be a key to understanding the origin of the cross symbol in ancient times as a representation of the quadripartite world. The geographical range of this symbolism is illustrated by a ceramic disk from Bampur-Makran in southeastern Iran, dating from 2800 – 2000 BC (Figure 13.15). Whorl 322 is archetypical. It illustrates the axis mundi (the former wooden distaff at the central hole) at the vertex of an ogee swastika representing the four Atlantic rivers. This is surrounded by circles in each of the four quarters suggesting the continents. The figure parallels representations of a quadripartite world with a distinct center point, know as the quincunx. This type of diagram can be found throughout Eurasia, as in the mandala for example, but it is particularly important in the religious conceptions of ancient America.[6] Whorl 455 also strongly evokes the "four vast rocks" of Tibetan mythology, which are said to adjoin the Tree of Life in an Asiatic form of the quincunx.

The Goddess with Upraised Arms

Whorl 471 (Figure 13.13) depicts the galaxy goddess with upraised arms representing the axis mundi in anthropomorphic form and standing at the confluence of four rivers. In Figure 13.16 the figure is accompanied by three stags as it stands near the axis. Schliemann interpreted this figure as a man praying to heaven, and at first believed that the central hole represented the sun.[7] But the axis mundi symbolism of the whirling distaff and the stags, in association with the upraised arms of the figure, argue otherwise. Its resemblance in type to the previous figure who stands at the confluence of the four rivers (471) further links this motif to the Tree of Life.

Figure 13.10 Ceramic loom weight from western Hungary, ca. 5000 BC: stag with appendage on antlers.

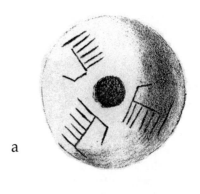

a

b

Figure 13.11 Spindle whorls from Troy: (a) stag with form similar to Figure 13.10; (b) stag with appendage on antlers.

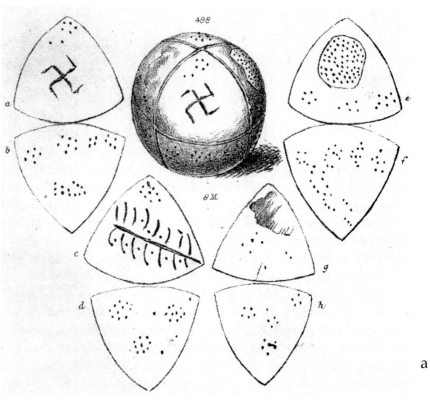

a

b

Figure 13.12 Examples of Trojan artifacts bearing depictions of the Tree of Life: (a) terra cotta sphere with swastika, stars, and tree; (b) top of terra cotta tripod with bi-directional swastika and tree; (c) spindle whorl with four trees arranged symetrically around the axis; (d) jar lid with tree and wheel; (e) tree at confluence of rivers.

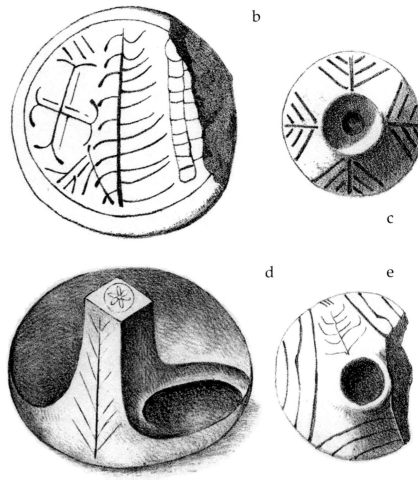

c

d

e

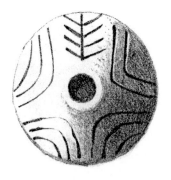

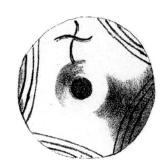

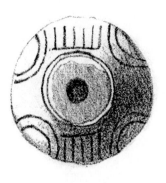
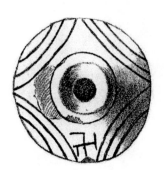
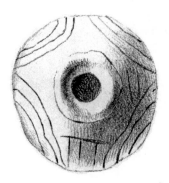

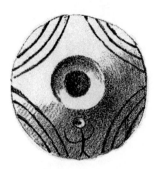
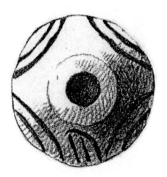

Figure 13.13 Trojan spindle whorls. The negative space between the curved parallel lines represents the mythological rivers said to flow from the axis mundi at their confluence. A wooden distaff was originally inserted into the central hole. Often an additional axis mundi marker acts as a label: swastika, stag, goddess with upraised arms, or the Tree of Life itself.

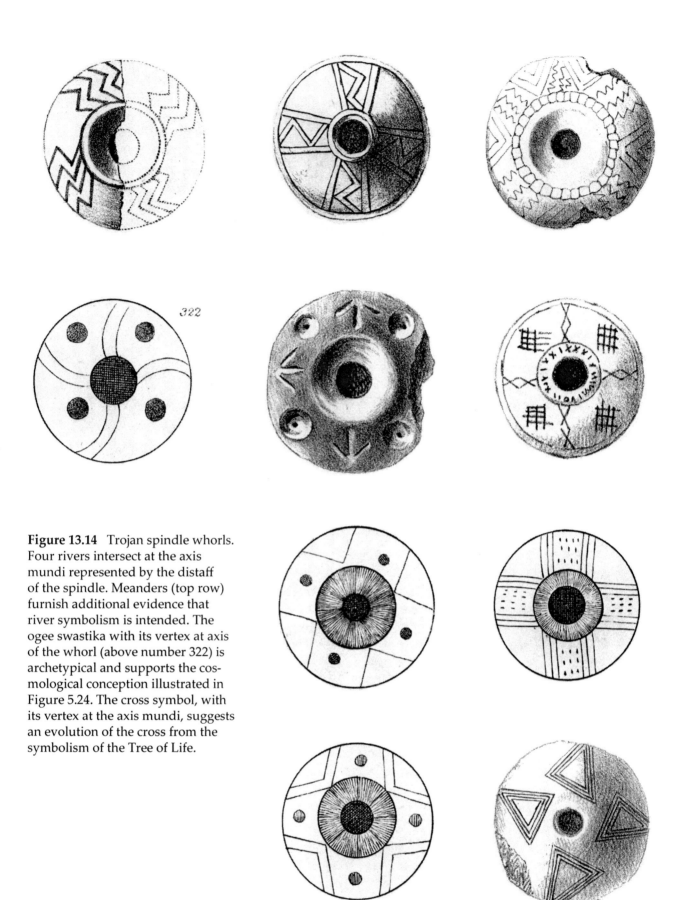

Figure 13.14 Trojan spindle whorls. Four rivers intersect at the axis mundi represented by the distaff of the spindle. Meanders (top row) furnish additional evidence that river symbolism is intended. The ogee swastika with its vertex at axis of the whorl (above number 322) is archetypical and supports the cosmological conception illustrated in Figure 5.24. The cross symbol, with its vertex at the axis mundi, suggests an evolution of the cross from the symbolism of the Tree of Life.

Schliemann associated the upraised arms of this figure to the "owl-faced vases" with upraised wings found frequently at Troy.[8] In a form parallel to the goddess figurines—with bird's heads and uplifted arms—found in Egypt, the Trojan vases are shown with owl's eyes and uplifted wings. A cross or a swastika may be depicted at the navel (Figure 13.17). Schliemann believed these to be representations of the goddess Athena, whose common epithet "owl-faced" reflects her ornithomorphic attributes. In Greek literature Athena frequently transforms herself into a bird.[9] She is often represented in Greek sculpture holding a spindle, and as the patron goddess of textile workers and potters, she was known as Athena Ergane.[10] The close association she has with serpents also suggests her original role as a galaxy goddess.[11]

Figure 13.15 Ceramic disk from Bampur-Makran, southeastern Iran, ca. 2800–2000 BC. Four rivers intersect from the four cardinal directions. Meander (wave) patterns provide evidence that water symbolism is indicated.

Ladders

Ladders occur in association with Trees of Life on Figure 13.18 and in association with possible star clusters (or dew drops) in Figure 13.19. This imagery parallels axis mundi legends in Siberia and in Egypt, where ladders represent the galaxy in its function as a path or bridge from earth to heaven, or to the underworld. Ladder-like features also appear on Naqada vases from the lower Nile, and these are often found in association with stags and goddesses with upraised arms. These contexts suggest that the ladders are axis mundi symbols in both Egypt and Troy.

The Swastika

Three types of the swastika symbol appear on Trojan artifacts: left-hand turning, right-hand turning, and a bi-directional variant (Figure 13.20). No functional or symbolic difference exists between the left-hand and the right-hand turning types, since both often appear in equivalent contexts and sometimes together. Considered primary by some scholars, the right-hand turning type is more frequent.[12] A popular misconception that one type represents good and the other evil is entirely unfounded.

At essence, the swastika symbol represents the orientation of the four Atlantic rivers, and by extension, the axis mundi believed to intersect the earth at their point of confluence. Because the symbol already contains the imagery of axial motion, it was quite natural for it also to be applied to the circumpolar motion of the stars. But the stars at each pole rotate in different directions. Looking north, the stars appear to turn in a

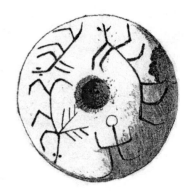

Figure 13.16 A goddess with upraised arms stands near the axis mundi with three stags.

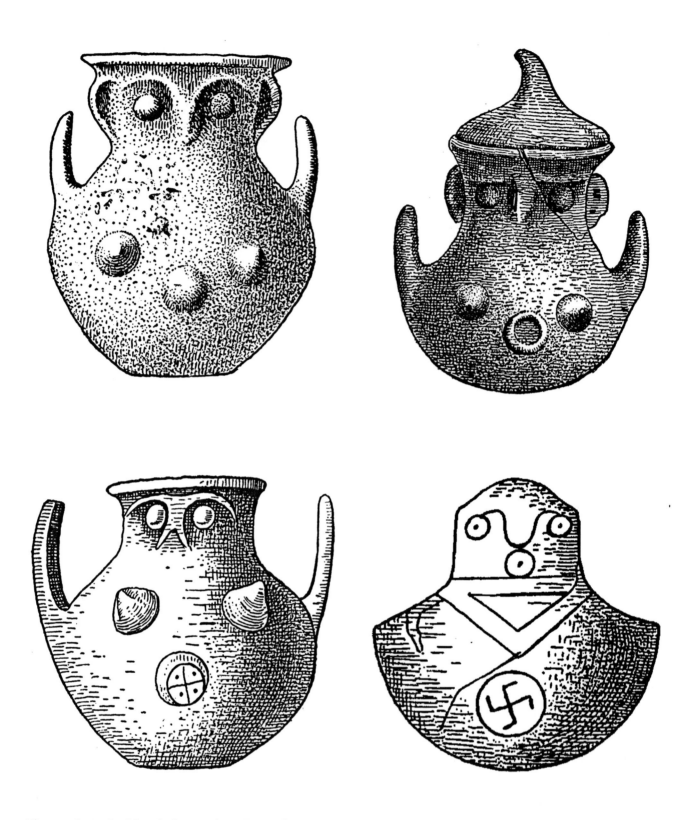

Figure 13.17 Owl-headed vases from Troy. The characteristic face identifies this pattern with the owl emblem of Athena. Upraised wings parallel the galaxy symbolism of the goddess with upraised arms (Figure 13.16).

Tree of Life, Mythical Archetype

counterclockwise direction, while looking south they appear to turn clockwise. These different directions of rotation account for the two basic swastika types, and both types came to represent the axis mundi.

This interpretation is confirmed by contexts in which a bi-directional type of swastika is sometimes found. This is a swastika in which one or two of the legs bend in a direction contrary to the others. Initially this type of swastika appears to betray sloppy workmanship, but the evidence indicates otherwise, for it appears in specific situations where neither type of directional rotation would predominate. Such a condition exists at the latitude of the equator where both celestial poles are equally visible, a condition illustrated on several of the terra cotta spheres that Schliemann found at Troy. On one of these (Figure 13.21), latitudinal lines clearly indicate the position of the sphere's axis. On the same sphere, the equator is marked by a line of bi-directional swastikas. On another sphere (Figure 13.22) a different type of bi-directional swastika appears, also on the sphere's equator.

Bi-directional swastikas on the Trojan artifacts can be observed in three basic types (Figure 13.24):

1. The clumsy, primitive types, which are asymmetrical, imbalanced, and awkward. One of the legs turns contrary to the others, lacks a turning direction entirely, or else attempts to turn in both directions (Figure 13.24a).

2. The second refines the previous type into a balanced, symmetrical form, but it still shares one characteristic of the clumsy type. By turning in contrary directions, it continues to convey a sense of opposition (Figure 13.24b).

3. The third type of bi-directional swastika has become symmetrical and graceful in its orientation. Essentially, it takes the form of a regular swastika, but with a line segment turning both left and right at the end of each cross-arm, inclining at a slight angle away from the center. Because each leg of the figure turns together both left and right, it overcomes the oppositional characteristic of the other two types (Figure 13.24c).

The close association of these three swastika types on some of the whorls is evidence of their co-functionality. The third type of bi-directional swastika probably evolved into the form later known as the Maltese cross. A bronze fibula from Etruria (Figure 13.23) shows two Maltese crosses and two swastikas, suggesting a possible identity between the two symbols. A detail of an archaic Boetian vase (Figure 7.8) combines swastika, Maltese cross, and ankh. It associates these with two serpents, further evidence of the intended axis mundi symbolism.

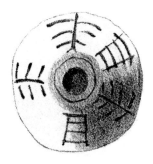

Figure 13.18 Ladders and Trees of Life on a Trojan spindle whorl.

Figure 13.19 Ladders with stars or dew drops (?) on a Trojan spindle whorl.

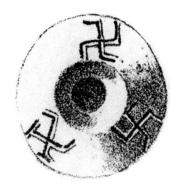

Figure 13.20 Trojan spindle whorl with three types of swastika: left-hand turning, right-hand turning, and a bi-directional type with legs turning in contrary directions.

Figure 13.21 Right: terra cotta sphere from Troy. Latitudinal lines indicate the position of the sphere's axis and its equator. The equator is marked with a series of bi-directional swastikas. The rows of circles appear to denote the tropics of Cancer and Capricorn.

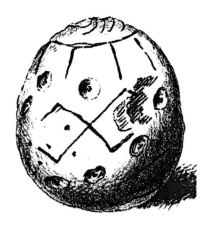

Figure 13.22 Terra cotta sphere from Troy. The axis is marked with a circle and radiating lines while the equator is marked with a bi-directional swastika.

Renaissance cartography provides evidence that the Maltese cross either evolved out of the bi-directional swastika, or inherited its function. Numerous examples exist where the Maltese cross is depicted in a position that unmistakably represents the earthly or celestial equator, thus paralleling the Trojan spheres. It appears as a symbol on the scale of latitudes at the zero point marking the celestial equator on armillary spheres (Figures 5.4 and 5.5), and it marks the earthly equator on a Venetian chart of Africa.[13] In later periods it became a common cartographical symbol for "East" (Figures 13.25 and 13.26).

The use of the bi-directional swastika as a symbol for the equator supports the interpretation of the simple swastika as a representation of stellar motion. Although the south celestial

Figure 13.23 Bronze fibula from Etruria with swastikas and Maltese crosses.

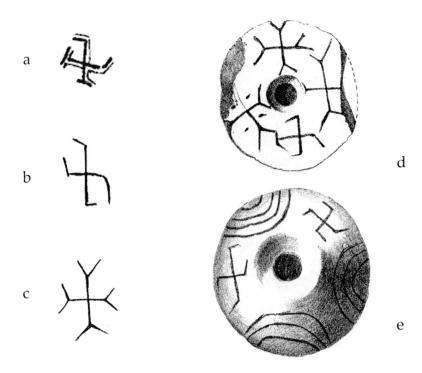

Figure 13.24 (A) – (c): three types of bi-directional swastikas, as depicted on Trojan spindle whorls, (d) and (e).

Tree of Life, Mythical Archetype

pole can not be seen from the northern latitudes, enough of the sky in the southern hemispheres is visible to observe the rotational direction of the southern stars. For this reason, either type of swastika can represent the axis mundi, and both forms are employed for this purpose throughout the world.

But use of the swastika as a representation for the axis mundi is clearly derivative. For this purpose, any symbol with an axial form could have been used with any number of arms denoting the whirling motion of the earth. The familiar four-armed swastika must originally have represented the confluence of the four rivers, located at the point where the axis mundi was believed to intersect the earth's surface. That association would have been the basis for its later use as a generalized symbol for the earth's axis of rotation, and for the Tree of Life.

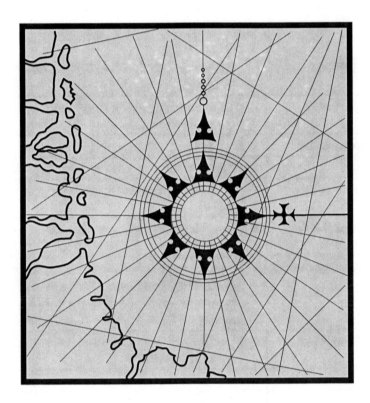

Figure 13.25 Portolano of the Red Sea, Anonymous (School of Dieppe), ca. 1538. A Maltese cross marks East on the compass rose.

Figure 13.26 Map of Cypress. Maltese cross marks "East." (Bartolommeo dalli Sonetti, Venice, ca. 1485. Detail from a map in the British Library (84.d.14).

Table 13.1 Characteristics of the Trojan spindle whorls as compared to the fifteen attributes of the axis mundi.

Attributes of the Tree of Life/Axis Mundi		Characteristics of Trojan Spindle Whorls
1. A Huge Tree, Mountain, Pillar, or Support of Heaven	X	Trees are frequently depicted on the spindle whorls.
2. Provides Prosperity, Food, Wisdom, Immortality		
3. Located near Water, Lake, Rivers, Ocean	X	Rivers are frequently depicted.
4. Contains images of Center, Axle, Navel, Spinning	X	Axial motion is inherent in the spindle whorl.
5. Mist, Cloud, Veil, Snow, Fleece, Whiteness, Milk	X	Dew drops are shown near the antlers of stags.
6. A Goddess of Fate, Fortune, or Destiny is associated	X	Figures with upraised arms are probably gods or godesses since this gesture is typical of axis mundi deities, and goddesses of fate are typically spinners.
7. Provides link between Earth, Heaven, Underworld	X	Ladders appear as decorations on the spindle whorls.
8. Described as Radiant, Flaming, Luminous, Golden		
9. Bifurcated Branch, Pillar, or Upraised Arms of Deity	X	Anthropomorphic figures, with upraised arms, are found on spindles whorls.
10. Bird dwelling above		
11. Serpent dwelling below		
12. Hound as Guardian		
13. Goat or Stag	X	Stags are frequently depicted on whorls.
14. Quest, Side-Wound, Visit to Underworld		
15. Reference to Milky Way or Swastika	X	Swastkas are frequently depicted on spindle whorls.

Chapter 14

Quest Myth Transformed

In the ancient world, the quest for the Tree of Life, as a narrative theme, assumed the status of a sacred story. The Gilgamesh epic, the Jason cycle, the labors of Hercules, and the poems of Homer are examples of the way this theme acquired a quasi-religious significance. The hero endures suffering and deprivation as he journeys to a mysterious land which may lie at the navel of the world, at the source of all rivers, or near a sacred tree guarded by a serpent.

Upon his arrival, he enjoys the patronage of a goddess. He may attain great wealth, love, and the prospect of immortality. Under her guidance, he achieves another aim that many men aspire to: he communes with human beings who have been dear to him in life, but who have since died. Unlike others who travel to the underworld and never leave, he returns to life and tells his story. Often he receives assurances that, when his own earthly life comes to an end, he will not suffer the fate of ordinary mortals. Instead he will be received by the gods in glory, and live among them like a god himself. In short, all human aspirations are fulfilled upon completion of this quest.

But the journey is fraught with difficulties. He must wander for many years before he discovers a way to the hidden land. Monsters and demons single him out for torment; by his wits he just manages to elude them. The road to paradise is a long and weary way, but the ultimate reward justifies all his efforts.

The origin of this narrative is lost in the remote past. Although preserved in the earliest writings, it must have been old long before writing was even invented. For millennia it persisted as an oral tradition, told in thousands of variations on the same basic theme. Later, it formed the core of ancient religious life. The story became embellished in countless ways, but the heart of it remained fundamentally unchanged.

When the classical civilizations of Greece, Rome, and Egypt collapsed at the beginning of the present era, the story went underground. Although vestiges were incorporated into the newly-minted state-sponsored religion that dominated Europe for the next millennium, the form it assumed under Roman Catholicism was decidedly lacking in vitality. Little room remained for the kind of heroic individualism that we find in the stories of Odysseus, for example. During the Middle Ages, the only way to heaven passed through the hierarchy of the church: its priests, its bishops, and its popes. A life of free thinking and free action was proscribed under the new regime; the individual was bridled and saddled by a highly organized and bureaucratized master.

But the old narrative found obscure channels through which to flow during the ensuing period. It reappears here and there as it can, but in every case, it must assume the garb of orthodoxy in order to avoid suppression by the authorities. Snorri Sturluson's collection of the old Norse legends, for example, is prefaced by a decidedly thin euhemeristic account of how the traditional Scandinavian gods were originally human kings who had migrated to the north from ancient Troy. By this device, the divinity of the old gods was denied; they were only men who had been later deified by misguided heathen folk. Thus the church was appeased.

At about the same time as Snorri wrote his accounts, we find a literary revival in France that takes as its basis the Welsh and Irish echtra. These are ancient Celtic myths that describe a hero's journey to fairyland. Typically this is a land of immortality where lavish feasts are made possible by a cauldron (or horn) of plenty. It is commonly situated on an island in the sea, somewhere vaguely to the west.[1] Often it is hard to find, enveloped in mists, invisible to any but those heroes who have been marked out for the encounter by fate.[2] Once he arrives, the hero discovers a country where:

> There is no sickness nor age nor death; where happiness lasts for ever and there is no satiety; where food and drink do not diminish when consumed; where to wish for something is to possess it; where a hundred years are as one day.[3]

The narratives described in these stories of fairyland are as old as any records we possess, and are clearly based on much older oral traditions. Glimpses of them can be found in the

collection of Welsh myths know as the Mabinogi, but they also exist in numerous variants within the Irish tales.

This primitive Celtic mythology—indigenous as it was in the former lands of Gaul—could not dare to raise its head in twelfth and thirteenth century France without a serious transformation. Under the superficial cloak of a warmed-over Christianity, concocted by wandering troubadours, the old Celtic legends were resurrected. In deference to the new religion, the knights emblazon their shields with crosses, confess their sins to monks, and pepper their talk with allusions to the Catholic mass. The lance of the old Celtic god Lug reappears here as the spear that pierced the side of Christ on the cross.[4] The ancient goddess of Ireland, who was always pictured with an overflowing horn of plenty, reappears as the virgin who carries the Eucharist. The search for that magic cauldron of plenty, a central theme in the old Celtic mythology, became the medieval quest for the Holy Grail.

Scholars have long been aware of this source for the grail legends. A particularly readable description of the evolution of this tradition can be found in *The Grail: From Celtic Myth to Christian Symbol*, by Roger Sherman Loomis. He, along with many other reputable researchers, has traced the episodes and personalities that appear in the many variants of the grail legends back to specific events and characters that figure in the oldest Celtic myths. It is clear that Christian trappings to the stories were added much later under the influence of the oftentimes hostile Catholic clergy. But what is not understood at all is that the ancient Celtic echtra were simply variants of the archaic quest for the Tree of Life. All of the main features of the familiar quest myth can be seen repeated in the events described in the echtra and in its later development as the grail cycle.

The search for the Holy Grail is described in several variants, but the most literary is the rendition given by Wolfram von Eschenbach around the year 1210. He calls his account *Parzival*, after the name of the Grail Knight who serves as the hero protagonist. The tale is a long one, too long to narrate here even in condensed form. A few brief vignettes will provide a basis for the following generalizations about its relationship to the archaic legends of the Tree of Life.

A Brief History of the Grail

The story tells how, one evening after a long day of weary travel, Parzival arrives at a lake in the middle of a lonely forest. There he observes a fisherman, dressed like a king, in a boat anchored in the water. Because it is close to dark, Parzival inquires of this Fisher King if he knows of any lodging to be had nearby.

He is directed to a castle on a hill surrounded by a moat. This castle is so perfectly round in shape that it looks as if it had been turned on a lathe. Unless its enemies were able to fly, or ride the wind, they would have no hope of any successful attack against it, not even if they comprised all the armies of the world.

Parzival is welcomed warmly at this castle, and he remarks on his good fortune. He enters a large hall illuminated by a hundred chandeliers, all blazing with candlelight. Joined then by the infirm Fisher King who was, he learned, the lord of the castle, he sits down for the evening's meal. At this point, he observes several mysterious events. A squire, carrying a lance dripping with blood, enters the room. He parades around the circumference of all four walls before making his exit. At this, the multitude of people in the great hall begin to lament. Soon afterwards, a queen enters the hall. She is as radiant as the rising sun, and she carries a mysterious object. It is described as:

> ... the perfection of the Earthly Paradise (der wunsch von pardise), both roots and branches. It was a thing men call the Grail, which surpassed every earthly ideal.[5]

All the guests in the hall then partake of a sumptuous meal. The Grail itself provides unlimited food and drink of all kinds. The guests have only to wish for the victuals they desire and these mysteriously appear. Parzival wonders greatly about the meaning of these things, but out of a misguided politeness, forebears asking questions that might seem impertinent. Later he is taken to a sleeping chamber where four maidens serve him fruits of the kind that grow in paradise, bearing them on a white cloth.[6]

On awakening the next morning, Parzival finds the castle empty. He mounts his horse and rides out to discover what has become of the people. Instead, he happens upon a woman sitting in a linden tree lamenting her dead lover (in some versions, the corpse is beheaded[7]). He learns from her the meaning of what had occurred the night before. It seems that the Fisher King is suffering from a grievous wound that will never heal. If only Parzival had asked about the meaning of these mysteries, the king would have been magically restored to health, and all the kingdom with him.

Having failed in this obscure duty, Parzival rides forth as if under a cloud. In the forest he encounters a fair lady who has been scorned and mistreated by the foul knight, Orilus. As Parzival prepares to do battle with this knight, he notices the insignia on his shield and helmet. These are dragons so lifelike that they seem to rear their heads as if alive:

Parzival deserved great honor that he could thus defend himself against one man and a hundred dragons too. One dragon was sorely wounded, the one in Orilus' helmet.[8]

Much later Parzival arrives at a desolate hermitage where the resident monk tells him even more about the Grail. He learns that the Fisher King, Anfortas, was once a valiant knight. Once, while fighting against a heathen, Anfortas was pierced in the testicles with a poisoned spear. Upon returning to the Grail castle, the doctors removed the spear-head that had lodged in the wound, but no remedy was successful in causing the wound to heal. They even traveled to the four rivers of paradise in search of a healing herb, but all this to no avail.

The pain that wracks Anfortas day and night is only lessened slightly by piercing the wound anew with the spear that caused it. This is the same spear with the bloody tip that is sent through the castle nightly to remind everyone of the king's anguish. Sometimes when the pain is especially unbearable, he is carried down to a nearby lake where the cool waters soothe the wound temporarily. From this habit he acquired the title by which he is known: the Fisher King.

Because of his great torment, the king ardently longs to die. But his subjects in the castle prevent this, for once having seen the Grail, one cannot die soon, and since Anfortas is shown the Grail daily, he knows that death will never come. If Anfortas is ever to recover from is wound, a certain knight must arrive and ask, with no prompting, a timely question.[9]

The old hermit goes on to tell Parzival how the knights of the Grail castle are provided with the necessities of food and drink:

> They live off a stone. Its nature is very pure. If you have not recognized it, it will be named for you here: it is called lapsit exilis. Through that stone's power the phoenix burns up so that it turns to ashes, but those ashes bring life to it. Therefore the phoenix throws off its molt and gives off a very bright glow afterwards, so that it becomes more beautiful than before. Also, never did such illness overcome a man that if he sees that stone one day he cannot die during the week that comes soonest after it. Also, his color never deteriorates. They must admit that his skin is of the same color as when he saw the stone, man or woman, as if his or her best years had just begun. And if he were to see the stone for two hundred years, nothing would change, except that his hair might turn gray. Such power does the stone give to man that his flesh and bone receive youth without delay. The stone is also called the grail … The stone receives all that smells good on earth, of food and drink, like the highest perfection of paradise: whatever the earth may bear. Moreover, the stone shall always allow the game that lives

under the sky to multiply, whether it flies or runs, and hovers. The power of the grail gives sustenance to the brotherhood of knights.[10]

The meaning of the name given here for this magic stone, *lapsit exillis*, is disputed among scholars. The words are ambiguous and have been interpreted as either "a stone fallen from heaven," or as "the Philosopher's Stone."[11] Whichever interpretation is correct, it is clear that there are multiple references here to some kind of celestial stone with miraculous properties, and that this stone is identical with the Holy Grail.

Eschenbach interrupts his tale to describe parenthetically how the Grail was first discovered. A Jew named Flegetanis, who was descended from King Solomon on his father's side, was highly regarded for his great wisdom. He first discovered the Grail by reading the stars:

> The heathen Flegetanis could tell us how all the stars set and rise again and how long each one revolves before it reaches its starting point once more. To the circling course of the stars man's affairs and destiny are linked. Flegetanis the heathen saw with his own eyes in the constellations things he was shy to talk about, hidden mysteries. He said there was a thing called the Grail whose name he had read clearly in the constellations. "A host of angels left it on the earth and then flew away up over the stars."[12]

At times the Grail is seen by pious monks, where it is located "wholly in the air." They must look upward to see it.[13] Eschenbach employs an archaic German phrase to describe the Grail. He calls it the "wunsch von pardise." This has been translated as "the perfection of paradise," as the word *wunsch* suggests notions of a high ideal. It is cognate to the English word *wish*, with connotations of "desiring" or "longing," but in Middle German it could also mean "fortune, property, or wealth."[14]

The Grail is frequently associated with paradise in the texts. In another version of the tale, *Perlesvaus* (ca. 1225), the castle inhabited by the Fisher King was located near one of the four rivers that flow out of paradise and was named "Edein." Numerous other versions of the legend place the castle of the Fisher King at or near the earthly location of paradise, and scholars have recognized the identification of this castle with the Elysium of Welsh mythology. This castle is sometimes described as a glass tower in the middle of the ocean, and in other cases it is said to be a revolving tower (Caer Siddi), surrounded by the sea.[15]

The original prototype of the Fisher King is considered by scholars to be Brân the Blessed, a mythical figure described in the *Mabinogi of Branwen* (ca. 1060). He is said to be a man of gigantic proportions who possesses a horn that provides

whatever food is desired, and who lives on an island of immortality. Brân also suffers a wound in his thigh (in some accounts, his foot). Later, he becomes king of Britain, but defeated in battle, he orders that his head be severed and used as a talisman to protect the country against attack. The place in London where this head is buried is called "White Hill."[16]

The *Perlesvaus* version of the Grail cycle also includes an image that has puzzled scholars. A white animal approaches Perceval [as he is named in this text]. She must be a dog, because she later gives birth to twelve hounds near a cross. Because Perceval offers her no comfort, she must bear her whelps alone.[17]

The episode in Eschenbach's account, described above, where Parzival awakens in the morning and finds the castle deserted, is clearly a development of a common occurrence in the old Celtic traditions. Frequently the hero, who crosses the sea to fairyland, partakes of revelry and mirth throughout most of the night. After finally falling asleep, he awakes in the morning and finds the castle has disappeared.[18]

In another incident from the *Perlesvaus* text, three damsels arrive at King Arthur's castle in carts. The first carries the head of a king, later understood to be the head of Adam. The second damsel has a hound at her side. She carries the head of a queen which is later discovered to be that of Eve. Although the third damsel arrives on foot, we learn that she finds a cart outside the hall to which are harnessed three white stags. The first "Loathly Damsel," we learn, is another form of the radiant queen who had carried the Grail at the castle of the Fisher King. The narrator of that tale relates that she is a personification of Fortune, and that her cart is a symbol for the wheel of fortune.[19]

In another adventure, Perceval travels by ship for many days until he arrives at an island, called the Isle of the Ageless Elders. Here he meets two men whose hair and beards are as white as freshly fallen snow. He sees a marvelous castle located near a great and beautiful tree, with a crystal-clear fountain at its base, and surrounded by golden pillars. All the inhabitants on the island are cloaked in white, and many of the fixtures are made of gold and ivory.

Perceval leans his shield against the great tree, observing that it is covered with the most beautiful flowers in the world. In the clear fountain at the base of the tree is a large cask made of glass, inside of which is held a knight who will never speak. Later, Perceval enters the castle and witnesses a golden chain descend from heaven. It passes into the earth and reaches as far as Hell, where the tormented cries of the damned are audible. After all these events, Perceval leaves the island, promising to return at the earliest opportunity.

Figure 14.1 Parzival begins his career as a knight. E. von Steinle, Munich, Almegg Castle.

Analysis of the Legend: the Grail and the Tree of Life

Many more episodes in the grail cycle could be described. But those related above are sufficient to demonstrate that images encountered in these legends frequently bear a resemblance to the features of the archaic Tree of Life. The medieval search for the Grail parallels the classical heroic quest, where the hero wanders in search of paradise. The following evaluation refers to the fifteen attributes generally used to describe the Tree of Life in the ancient texts:

1. *There exists a huge Tree, Mountain, Pillar, or Support of Heaven*

The woman, who informs Parzival of his failure at the castle of the Fisher King, is described as sitting in a linden tree. In several versions she is holding the head of her dead lover in an ivory vessel. This detail suggests that the linden tree is a variant of the Tree of Life, since one of its ancient forms was that of a headless god or goddess. When the Grail is called, "the perfection of Paradise, both *root and branch*," we are provided with a

Tree of Life, Mythical Archetype

link between the Grail, the arboreal characteristics of the Tree of Life, and to paradise itself.

The concept of a Tree of Life appears frequently in Celtic myth. Apple trees and rowan berries grow on the islands of the Celtic Elysium, and these confer immortality on the gods. In the tale, *Diarmaid and Grainne*, we are told how one of the gods carelessly dropped a rowan berry onto the earth:

> From it grew a tree, the berries of which had the effect of wine or mead, and three of them eaten by a man of a hundred years made him youthful. It was guarded by a giant. A similar tree growing on earth—a rowan guarded by a dragon, is found in the tale of Fraoch.[20]

Special mention is made of a fair tree on the Isle of the Ageless Elders, at the base of which flows a fountain of clearest waters. The text describes this fountain as "set about with rich golden pillars." This imagery, which combines a great and beautiful tree on an island of immortality in the sea, with the sacred waters and the pillars beneath it, is unmistakable. In other cases, the axis mundi takes the form of a tower or castle at the center of the island. When this tower is described as having been made of glass or crystal, the symbolism becomes even clearer. The shining quality of glass corresponds to the brilliance of the galaxy.

2. *It provides Prosperity, Food, Wisdom, or Immortality*

One of the most conspicuous characteristics of the Grail is its ability to provide an inexhaustible supply of food and drink. This reflects the traditional horn (or cauldron) of plenty that is invariably encountered on the western islands of the Celtic Elysium. The immortality conferred by the Grail also corresponds to this attribute. It healed the sick, kept mortals from growing old, and prevented death. When Eschenbach refers to the Grail as the "Wunsch von Pardise," he is linking it both to the Tree of Life in paradise, and to the source of prosperity and good fortune.

3. *It is located near Water, Lakes, Rivers, or the Ocean*

Parzival and the other Grail knights frequently travel across the ocean to various islands of immortality. The Grail castle of Anfortas is surrounded by a moat, and the location where this Fisher King is first encountered is upon the water of a lake. His very name associates him with the watery element. His doctors travel to the four rivers of paradise in search of a healing herb, thus providing another direct link to the Tree of Life myth. This image is reinforced by descriptions in the *Perlesvaus* legend where the castle of the Fisher King is said to be located on one of the rivers of paradise.

4. *It is associated with images of a Center, an Axle, a Navel, or with Spinning*

The cart of the three damsels—with wheels representing the wheels of fortune—is an instance where the notion of axial motion enters the Grail myth. Another instance occurs when Flegetanis spies the Grail in the night sky, linked with the "circling course of the stars." Hence the Grail is seen here in the midst of a cosmic vortex. A further hint of this image reappears in the Grail episode when Parzival first encounters the castle of the Fisher King. This castle is described as so round that it appears to have been turned on a lathe.

This image of axial motion finds its most archetypal form, however, in the Caer Siddi (revolving tower) of the older Celtic myth. In a poem by the bard Taliesin we hear:

> Perfect is my seat in the fort of Sidi, [*Caer Sidi*, the Fortress of the Fairies]
> Nor pest nor age plagues him who dwells therein:
> Manawyddan and Pryderi know it.
> Three organs play before it about a fire.
> Around its corners Ocean's currents flow,
> And above it is the fertile fountain,
> And sweeter than white wine is the drink therein. [21]

Other texts refer to the Caer Sidi as a fortress or castle of glass, or as a tower of glass in the middle of the sea. It is hard to miss the axis mundi imagery here: The crystalline-appearing Milky Way revolves like a high tower on an island in the center of the ocean. From above, a stream of heavenly mead flows down the tower, and all the inhabitants are immortal.

5. *It is associated with Mist, Veils, Clouds, Snow, Fleece, Milk, or Whiteness*

Ivory is a material that is frequently found in the Grail accounts. The severed heads are often kept in vessels of ivory, as is the Grail itself.[22] These many references to ivory suggest the whiteness of the Milky Way. The inhabitants on the Isle of the Ageless Elders are clothed in white; their hair and beards are as white as snow.

In the older Celtic myths, the Elysian isles are often shrouded in mist as, for example, the isle of Avalon. One echtra describes an adventure of King Conn of the Hundred Battles, who loses his way in a thick mist. He meets a rider who leads him to a house "with a white-gold ridge-pole," situated next to a golden tree. Mead is poured for him by a queen whose name is the Sovranty of Ireland. The house with the king and queen then vanish into thin air.[23]

While the mere presence of mist is not necessarily symbolic, its association with a golden tree, a goddess, and a conspicuous

ridge-pole suggests that the mist here is part of a set of symbols that together evoke axis mundi associations.

6. A Goddess of Fate, Fortune, or Destiny is associated with the Tree of Life

In the Parzival legend, the radiant queen who carries the Grail is considered by scholars to represent the ancient Celtic goddess known as the Sovranty of Ireland. She reappears at the castle of King Arthur as the Loathly Damsel, being one of a trinity of goddesses representing fate or fortune. Like Fenja and Menja in the Norse myths, she can appear in both her positive and negative aspects.

7. The Tree provides a link between Earth, Heaven, and the Underworld

In the Celtic echtra, heaven is typically represented as a kind of fairyland. The path to this otherworld commonly leads through a dense mist, in which unsuspecting travelers become disoriented. Suddenly they find themselves in an unfamiliar place with a golden tree or with other magical appurtenances of the otherworld. This mist can be seen as the nebulosity of the galaxy, which thus acts as a link between the two realms.[24]

As we have already noted, Brân the Blessed is the old Celtic mythical source for the Fisher King of the Grail legends. In the echtra *Branwen, Daughter of Llr*, Brân and his followers must cross a magic river. The peculiarity of this river is that, because of magnetic stones at its bottom, no ship can ever cross it. Brân offers to act as a bridge. He stretches himself from shore to shore, and his followers walk across his back to the other side.[25]

In the ancient world, magnetic stones were invariably lodestones, chunks of magnetized meteoric iron, and these were often associated with axis mundi imagery in the legends. The Iron Mountain of Siberia, the mothers of iron in Finland, and the iron roof of the sky in ancient Egypt are three instances where iron is linked to the galaxy as axis mundi. The legend of Brân thus provides a Celtic parallel to this motif.

8. Radiant, Flaming, Luminous, or Golden

In that remarkable description of the Grail given to Parzival by the old monk, the Grail is identified with a celestial stone (or the Philosopher's Stone), and by its power the Phoenix burns and is then resurrected. This image evokes the eagle in the Kalevala who perches on the Tree of Life and is then consumed by flames. The bennu bird of Egypt, which creates itself out of flames burning from the top of the sacred Tree of Life, is another example of this motif. The same attribute reappears when Parzival enters the castle of the Fisher King; it is said to be

illuminated by a hundred chandeliers, all blazing with candle-light. This is reinforced by the appearance of the radiant queen who carries the Grail: She appears like the light of the rising sun.

9. *Bifurcated Branch, Pillar, or Upraised Arms of a Deity*

The many severed heads, which appear in the Grail legends and in the Celtic echtra, suggest the ancient headless god (or goddess) motif. This reflects the perceived form of the galaxy with a missing head between the two arms formed by the Great Rift. That so many of these decapitated heads are carried in ivory vessels supports this identification through the image of whiteness. Indirectly then, the severed head motif evokes a view of the galaxy as an anthropomorphic figure with upraised arms. Brân the Blessed is a principle example of this motif. Because he was so tall, he was forced to walk through the sea from Wales to Ireland; no ship could contain him. Likewise he always slept outside in a tent, since no house was large enough to hold him.[26]

10. *A Bird dwells above*

The Welsh echtra, *Branwen, Daughter of Llr*, tells how Brân allows the king of Ireland to marry his sister Branwen. When Branwen is later treated scornfully by her new husband, she sends a message home to Wales tied under the wing of a starling. The bird flies across the sea and alights on the shoulder of Brân. Upon finding this note, Brân sets off to rescue his sister.[27]

In this episode, we find an image which corresponds to the many figurines from Egypt and Greece depicting a god with upraised arms and the head of a bird. The starling perched on the shoulder of Brân forms a parallel to this motif, further confirming Brân's identity as a galaxy god.

The inclusion of the Phoenix, in a description of the Holy Grail given by the monk to Parzival, is peculiar. It suggests a conscious attempt by Eschenbach to conform his account to the ancient model, where a bird frequently rests on the Tree of Life. The Phoenix is particularly emblematic of Tree of Life mythology, since it shares the additional attributes of flames and immortality.

11. *A serpent dwells below*

The galaxy serpent appears in the Grail legend as the insignia on the shield and helmet of Orilus, who Parzival overcomes in battle. Eschenbach makes a special point in describing how Parzival deserved great honor in vanquishing this serpent along with the knight who carried it. The description of the dragon, as seeming to be alive, emphasizes this point. With it, Parzival

joins the ranks of Hercules, Jason, Gilgamesh, and Adam, who contend with an adversarial serpent in a context associated with the axis mundi.

12. *Hound as Guardian*

The cross symbol often represented a form of the axis mundi in medieval iconography. This reflects the classical traditions where Odin hangs on Yggdrasill, Ixion on the flaming wheel, Hera on Olympus, and Prometheus on his mountain. When, in the Grail legend, the small white animal bears her hounds under a cross, this suggests a location in the vicinity of the axis mundi.

In the Welsh echtra, *Culhwch and Olwen*, we encounter this guardian hound undisguised. King Arthur has sent a party of men to search for Olwen, the daughter of a giant, to be a bride for his cousin Culhwch:

> They went forth until they came to a big, open plain; there they saw a fort, the most splendid in the world. They traveled all that day, but when they supposed they were nearing the fort, they were no closer than before. And they traveled a second and a third day, and with difficulty they got there and reached the vicinity of the fort. There they saw a vast, boundless flock of sheep and a skin-clad herdsman on top of a mound tending them, with a curly-haired mastiff bigger than a stallion of nine winters beside him. It was the custom of this shepherd that he never lost a lamb—much less a full-grown animal; no troop ever ventured past him that he did not wound or slay, and his breath could burn the dead wood and tufts that were on that plain right down to the bare ground.[28]

Celtic myth frequently describes a castle or fort that is the most splendid, beautiful, or fairest in the world. Such descriptions typically occur in situations where other axis mundi identifiers are present, and therefore suggest a reference to the Milky Way. This assumption is supported by descriptions of the difficulty these warriors experienced in reaching the fort. No matter how far they traveled, they were no closer to reaching it. This alludes to the rainbow-like character of the galaxy; although appearing to touch the earth's horizon, it continually recedes into the distance as it is approached. The vast, boundless flock of sheep supplies the imagery of whiteness, and the hill on which the herdsman sits evokes the traditional axis mundi mountain.[29]

In addition to all of these other galaxy markers, an enormous dog acts as a guardian. He prevents anyone from passing the hill just like Cerberus or Garm in the Greek and Scandinavian traditions. The breath of this dog can set dead wood on

fire, an allusion to the celestial tree (or wood) that appears to glow with flames in the night sky. Another dog, appearing in context with axis mundi symbols, is the dog which accompanies the three goddesses of fortune at King Arthur's castle.

13. *Goat or Stag*

The Wheel of Fortune, which accompanies the three damsels, can be none other than the rotating axis mundi. We see the same image with the three Norns who spin out the destiny of human beings near Yggdrasill. These damsels at King Arthur's castle are accompanied by a cart drawn by three white stags, an image that associates the stags with the axis mundi.

In the Alexandrian age of postclassical Greece, the goddess Fortuna had superseded all of the formerly dominant Olympian gods. Every major city had a shrine in her honor, and she was usually described as holding a wheel and a cornucopia. Thus the Sovranty of Ireland—or her alternate identity as the three damsels—represents the Celtic version of the universal axis mundi goddess of fate. This suggests that the stags drawing her cart are mythological cognates to the stags associated with the Norse Yggdrasill and to other stags that appear in context with axis mundi symbolism in many cultures.

14. *Quest, Side-Wound, Visit to Underworld*

After his failure at the castle of the Fisher King, Parzival dedicates his life to a renewed search for the Holy Grail. This theme becomes generalized to include all the knights of King Arthur's round table. They vow to each seek the Grail, no matter how long it takes to find it. Thus the ancient quest for the goddess of fortune on the island of the blest, the search for the Tree of Life and its fruits of immortality, is transformed into a quest for a Christian relic, said to have contained the blood of the crucified Jesus. Although the legend has undergone serious transformation, the ancient quest theme persists.

The wound in the genitals, suffered by the Fisher King, has its origin in the thigh wound of Brân the Blessed—no doubt a vestige of a much older tradition. Brân is clearly an axis mundi god whose thigh wound has its parallels in the legends of Odysseus, Hercules, Prometheus, and Osiris, to name just a few. Characteristics that mark Brân as a galaxy god are numerous. These include: his horn of plenty, his gigantic size, his dwelling on an island of immortality in the sea, his severed head with its talismanic function, the location of his grave at White Hill, his role as a bridge, his association with meteoric iron, and the bird that rests on his shoulder.

Perceval's visit to the Isle of the Ageless Elders conforms to a type of voyage commonly seen in both the Grail legends and in the older Celtic myths. Elysium is typically located in the

Atlantic Ocean somewhere in the West. At the end of his life, King Arthur is carried to the Isle of Avalon on a mysterious ship sailed by a crew of women. He goes there to recover from his grievous wound, but he will someday return to save his people. Another echtra tells how Saint Brendan and his crew of fourteen monks sail southwesterly from Ireland and make landfall on a remote island. They find there an abbey of incredible beauty, inhabited by monks who sustain themselves on food provided by God. The earliest maps of the Atlantic Ocean (from the year 1426 onward) show islands in the position of the Azores labeled as the Islands of Saint Brendan. The same maps often show a circular island west of Ireland called "Brasil," while other maps of that period use this designation for the Azores group. The derivation of this name is uncertain.[30]

15. *Reference to Milky Way or Swastika*

Although the Milky Way does not figure explicitly in the Grail legends, allusions to it can be found in many of the texts. The circular castle of the Fisher King, for example, is said to be unassailable except to an enemy that was able to fly. This alludes to the celestial location of the galaxy. We see this again when the monks observe the Grail suspended magically in the air; they have to look upward to see it. Flegetanis sees the Grail in the constellations, and this comprises a mystery about which he is reluctant to speak.

The absence of people at the Grail castle, in the morning after Parzival awakens, reflects a common occurrence in the echtra. When the traditional hero awakens in the morning only to find that the fairy castle has disappeared, this is a veiled allusion to the galaxy, which is visible only at night. It always disappears the next morning with the bright light of day.

* * *

These examples illustrate some of the ways that the later Grail legends preserve components of the Celtic echtra in their narratives. In both traditions we find ample representations of a much older mythological strata that reflects the ancient quest for the Tree of Life. Whether these symbols were consciously and deliberately employed by poets who understood their significance, or whether they remain as mere unconscious vestiges of a long forgotten tradition, we may never know. The frequent cleverness of the symbolism argues for the former view, but the truth is probably a combination of the two.

Later transformation of the legend into a Christian allegory was both conscious and accidental. The word Grail, for example, is derived from the older "graal," which designated a broad, shallow bowl in which food was served for the nobility. When this word came to be associated with the mythical cauldron of plenty, it was often prefaced with a word meaning

"holy." In French this took the form "le saint graal." But because the final consonant of the word "saint" is typically not pronounced in French, the word sounded something like "sangraal." This was misunderstood later as if it had been derived from a combination of *sang*, meaning "blood," and *graal*; hence the mistaken notion that the Grail was the chalice said to have caught Christ's blood at the crucifixion.[31]

But while the quest for the Holy Grail could be conceived as a search for this sacred chalice in the physical world, it later acquired a more transcendent meaning among the knights who dedicated their lives to finding it. It became a path of personal and moral development that they believed would eventually lead to a direct experience of God. This could be seen as a revival of the old independent tradition whereby the individual could find his own way to the divinity, bypassing the middlemen of the church hierarchy. The Grail knights sought firsthand knowledge of the truth through a life of action. Their task was to avenge the wrongs committed by unscrupulous men against the weak. In serving others, they set their own interests aside. This led to a refinement of their inner life, and they had faith that this refinement would lead eventually to a moral perfection and unity with God.

Figure 14.2 Tree of Life imagery used to portray the apotheosis of man as he conquers his lower nature and becomes a warrior in the service of God. Reni, *Saint Michael*, S. M. della Concezione, Rome.

Tree of Life, Mythical Archetype

Chapter 15

The Celestial Stone

Because commentators have failed to recognize that the Grail represents the Milky Way in its ancient role as the axis mundi, they have been puzzled by Eschenbach's identification of the Grail with the Philosopher's Stone—or with a stone that descends from heaven. This descent is a symbolic representation of the galaxy as it falls from the zenith and appears to intersect the earth at the horizon.

The metaphor whereby the Milky Way is referred to as a stone, has a long and fascinating history. Hints of it can be seen in the Greek myth where Perseus transforms the axis mundi-titan Atlas into a stone mountain. But the most complete tradition which describes the galaxy as a stone, can be found in the Indo-Aryan mythology of ancient India and Iran.

Agni, the god of fire, is protean in his ability to assume a wide variety of forms. He lives within the cook-fire on the hearth of each household, and he is the inner flame that warms the body of every human being. During the day he manifests himself as the fiery sun traveling across the sky from east to west. At night, he journeys back again from west to east so that he can rise again the following morning. But the form he takes in this nightly journey is mysterious. The legends describing the nocturnal transformation of Agni form part of the esoteric religious teachings of the ancient Indo-Aryans. Agni mysteriously unites himself with a deity of the night sky.[1]

As we have already observed (chapter 11), the night sky is represented in Indo-Aryan mythology as the axis mundi-god Varuna. Like the archaic titans in Greek myth, Varuna is one of an older generation of gods. He wears a shining robe, and—like Atlas—he supports the celestial spheres. Knowledge about him was restricted to esoteric circles of the initiated members of his cult. His arms hold the night, and he supports the inverted cosmic tree by its roots. He supports heaven by its axis. Thus the sun as a form of Agni, when it sinks below the western horizon at night, is transformed into the god Varuna.[2]

This transformation of the sun into the Milky Way at night is not unique to the Indo-Aryan tradition. In Egypt, for example, the sun enters at night into the mouth of the goddess Nut, travels through the length of her body, and is born again from her womb each morning (chapter 10). The sky was seen as a huge tree looming over the earth; the stars were the fruits hanging from its branches. In the morning this tree disappears as the sun rises from its leaves. Again the sun makes its journey across the sky from east to west from morning until evening. Then it hides itself again in the foliage of this great tree, which once more extends itself out over the world.[3]

In the Indo-Aryan cultures, this sacred tree was the god Varuna. His home is "the navel of the radiant firmament," a clear reference to the galaxy conceived as the axis mundi. He dwells in the western ocean, and thus he is said to be "born from the waters." But here the ancient texts use a peculiar expression to describe the house of Varuna; it is called "the stone house," and Varuna is said to be "born from the stone:"

Varuna's "lofty dwelling," his "house with a thousand doors" is also called a "stone house"... Agni is born in this stone house before becoming the navel of the radiant firmament. The notion of darkness appears to be intimately associated with this "stone house"...

When Varuna is said to support earth and heaven by means of the cosmic axis, it may safely be inferred that he must have been conceived as holding the foundations of the cosmic hill and the roots of the cosmic tree while sitting in his "stone house." Since this mountain [lies] upon the waters and is their receptacle, it must also be in the celestial ocean of the nocturnal sky.

The presence of the sun in Varuna's dwelling cannot surprise us, as the sun is only one of the forms of the god Agni. As was seen above, the sun sets there where Rta is hidden (i.e., in Varuna's domain), the sun when setting becomes Varuna, and Agni becomes Varuna in the evening ... there

is a form of Agni in the nether world into which the setting sun "enters" and from which it arises in the morning. From this nether world Agni is every day born anew. He is, indeed, born "from the waters, from the stone."[4]

This stone, which embodies the gods Agni and Varuna, was the luminous galaxy standing at the axis of the universe. Ancient people conceived that the sun was fragmented into the thousands of tiny stars that each night constitute the Milky Way. In the morning, these stars were believed to re-coalesce as the sun once again. Hence the galaxy could be described as the Midnight Sun. This was an object of great veneration in the Isis cult of Egypt, as we know from Apuleius, who, describing his initiation into the Isis mysteries, wrote: "About midnight I saw the sun shine."[5]

The little we know about the Isis cult of antiquity comes to us primarily from the accounts of Apuleius. He would have described his initiation ceremony in much greater detail, he says, if it had been lawful to tell more. But both our ears and his tongue would "incur the like pain of rash curiosity," had he divulged more than was permitted by the mysteries.

Like the Isis cult of Greco-Roman Egypt, the cult of Varuna among the Indo-Aryans was part of an esoteric mystery religion. The aspiring neophyte was gradually led to an understanding of the "fire that leads to heaven." The culmination of his initiation was a vision of Agni in the darkness of the stone house, a name for the axis mundi mountain:

> …Varuna's nether world is called a "stone house" because he dwells in the depth of the cosmic mountain. It is no mere coincidence, indeed, that an epithet of the mountain, viz. "whose dwelling is firmly fixed," is also applied to Mitra and Varuna.

> Thus we are entitled to state that according to the Rigveda Yama's and Varuna's world contains the eternal light and is luminous … Agni's birth, or the vision of the sun in the darkness, was the central theme of what can be denoted by no other term than Aryan mysticism. Indeed, what the seer aspires to see is the mystery of Agni's presence in the darkness of the "stone house," just as it had been seen by those gods and mythical seers who … descended into the nether world as "sun-finders."

> As we know from the Veda, this aspect comprised initiation and apparently was (like many religions concerned with the gods of the nether world) a mystery religion.[6]

It is clear from these descriptions that, in the mystery religion of the Indo-Aryans, a central focus of the cult was the pursuit of a mystical stone. The characteristics of this stone are familiar: It is observable in the night sky. As a manifestation of Agni, it is fiery, and in particular a "fire that leads to heaven." It is located "at the navel of the radiant firmament," and this is associated with the god Varuna, whose dominion is the western sea. It is associated with the cosmic mountain and the celestial tree. Finally, knowledge about this mystical stone is an esoteric secret, not to be divulged to outsiders.

These characteristics closely parallel the description of the Holy Grail as discovered by the Jewish sage, Flegetanis. He observed the Grail—also a stone—among the constellations of the night sky, and was reluctant to speak about these "hidden mysteries." It would be surprising if these parallels were merely coincidental. But if the similarity of these two traditions represents a genuine historical link, it would imply an extraordinary continuity of religious transmission, extending across a time span of over three thousand years. The Indo-Aryan period is generally dated to about 2000 BC, while the Grail texts are from the thirteenth century AD.[7] That such a link is plausible, however, is evidenced by Persian texts from the time of Zarathustra (ca. 600 BC). These indicate that religious beliefs and practices of that period bear a remarkable similarity to the ancient Indo-Aryan worship of the midnight sun, said to be located in the stone house of Agni.[8]

This Zoroastrian doctrine persisted well into the classical, and even into the Alexandrian, periods. The three wise men, who were present at the nativity of Christ, were Persian Mages of this type. Six centuries earlier, the Greek commentator Herakleitos had branded the Mages as "Nightwalkers," and as participants in unholy mysteries.[9] By the third and second centuries BC, communities of Persians had established themselves throughout the eastern Mediterranean region, extending as far as Egypt.

The Stone Which Is Not a Stone

In the second century BC, one of these Persian Mages, Ostanes, lived in the cosmopolitan, Greco-Roman city of Alexandria, located at the mouth of the Nile. He was said to be the teacher of Demokritos, the well-known Greek philosopher who first formulated the atomic theory of matter. Little is known directly about Ostanes, for none of his writings—if he wrote at all—has survived, but the subsequent literature quotes him extensively, and many later works were attributed to him. It is certain that he continued the strict tradition of secrecy concerning

the teachings of the mysteries. A Syriac manuscript tells of the care Ostanes took to conceal the mystery of the Philosopher's Stone. He forbade transmission of the secret to any unworthy persons and initiated the practice of using allegorical language to hide the meaning of the discourses.[10]

Despite this cover of secrecy, the principal theme in the philosophy of Ostanes is quite clear. The supreme goal of his teaching was to guide his students toward the discovery of a mysterious substance called the Philosopher's Stone. This substance was variously described as an elixir of immortality, an infallible medicine, a catalyst for the production of gold, and also as a state of personal illumination that transcended ordinary consciousness. The seeker who found the Philosopher's Stone had reached the epitome and pinnacle of human existence, a state of personal perfection and a union with the divine.

It was probably inevitable, however, that for a large number of his followers, the primary interest in the teachings of Ostanes should center around the production of gold. The ambiguity of his doctrine and the symbolic nature of the language used to describe it, could easily have fostered the delusion that it hid the secret of transmutation. Probably this misconception was used playfully by the true adepts to disguise the religious and philosophical aims of the cult. But there can be little doubt that the investigation into the properties of physical matter was always a part of this tradition, along with the pursuit of spiritual knowledge.

The alchemical teachings of Ostanes perpetuated both the Persian and the older Indo-Aryan belief in the divinity of the galaxy. By examining a few of the documents purporting to describe his philosophy, it is clear that the term "Philosopher's Stone" was a designation for the stone house of Agni, visible in the night sky as the Milky Way. He tells us, for example, that the stone is generally known by the "crowd," but under a common name. The hints describing the Philosopher's Stone often link it to fires, trees, and mountains. It is white, visible against a black background every night, and shrouded in secrecy. The following is a selection of these allegorical references taken from an Arab alchemical manuscript entitled, *The Twelve Chapters by Ostanes the Philosopher on the Philosopher's Stone*:

> Those who have defended the secret at sword-point and have abstained from giving it a name or at least from giving it the name under which the crowd knows it: they have hidden it under the veil of enigmas.

> … It is a liquid that bursts in flame at contact with wood into a violent fire; a fire that lights itself at stones in the countries of Persia; a tree that grows on the peaks of mountains.

... I have heard Aristotle say: "Why do these seekers turn away from the stone? It is however a well-known thing, characterized, existent, possible."

I replied, "What are its qualities? Where is it found? What is its possibility?"

He told me, "I'll characterize it by telling you it's like lightning on a dark night. How can one fail to recognize something white showing up against a black background? The separation isn't painful for anyone accustomed to distance. Night cannot be dubious for him who owns two eyes."[11]

The passages selected here are considerably more transparent than much of alchemical literature. In many cases, the convoluted descriptions effectively mask the symbolism beyond recognition, and not infrequently the writer appears to be merely confused. But where a thread can be found at all, it typically employs symbolism that refers to the archaic Tree of Life. In another book attributed to Ostanes, we hear of the Philosopher's Stone in terms that clearly evoke axis mundi imagery:

Maria the Egyptian or Kopt is also mentioned. A book attributed to Ostanes tells how the philosophers, having seen a mysterious stone with an admirable color, could not make out what it was, and so made a search all over the world to find the mine from which it came, but could learn nothing. Then they wrote to Maria to tell her of the wonderful color and substance of the stone, about which they had inquired in vain. They added that the characteristics of this stone were that it was soft to the touch and shone in darkness. They begged her to tell them what it was if she knew. She replied that her predecessors in the great work had been of the opinion that this stone came from a mountain in the midst of the sea and that it shone from the bottom of abysses like a torch in a dark night.[12]

That this passage locates the Philosopher's Stone on a mountain in the middle of the sea links it to the many other traditions that view the axis mundi as a shining mountain, and place it at the navel of the sea. Here again, the nocturnal visibility of the stone is a clue to its identity, and the reference to the abyss is an allusion to the underworld out of which the galaxy emerges.

The most illustrious pupil of Ostanes was Demokritos, considered by some to be the founder of alchemy proper. Although none of his works has survived, he is known to have been encyclopedic in the breadth of his interests and literary output. Concerning the Philosopher's Stone, Demokritos called it "a Stone that is not a Stone."[13]

The Rosicrucian Enlightenment

The history of alchemy, as it passed through the middle ages, is beyond our present scope. But from the form which it took in seventeenth century Europe, we can infer that the discipline retained its essential resemblance to the ancient archetypes. The symbolism continues to reflect a conspicuous preoccupation with the axis mundi and the Milky Way galaxy as the center of its secret doctrine. By this time, however, its most articulate practitioners had explicitly disavowed the vain pursuit of goldmaking.

Two significant personalities stand out as representatives of the alchemical art in this period: Thomas Vaughan in England and Michael Maier in Germany. Both wrote in defense of the recently established society known as the Rosicrucian Brotherhood, and both were assumed to be among its members. This fraternity published a series of manifestoes, beginning in the year 1616, outlining their principles and aims. They practiced strict adherence to a moral life dedicated to the service of humanity. Each member was required to be a trained medical practitioner who would serve the poor without payment. The attainment of the Philosopher's Stone remained the primary focus, but, as with the fraternity of the Grail knights, it had become a spiritual goal entirely identified with the pursuit of moral perfection and unity with god.

Thomas Vaughan, Alchemist

Evidence of the continuity between the teachings of Ostanes and those of the Rosicrucians is easy to produce. The allegories of Thomas Vaughan consistently invoke images of a mountain resplendent with scintillating light. A seeker of impeccable virtue is led by a goddess to the summit of this mountain, and there he receives the sacred elixir of immortality, wealth, and power. But he must not use any of these for his own selfish ends, rather they must be put into the service of humanity.

The mountain is located at the center of the world. Although it must be approached at night, not just any night will do; it must be a very dark night. This injunction reflects the practical problem commonly encountered when attempting to view the Milky Way. It is nearly imperceptible except on a clear, dark night. Near sunrise or sunset, the light of the sun obscures it; when the moon is out, it is invisible. This mountain at the center of the world is described as both soft and stony, corresponding to the gentle, fluffy appearance of the galaxy, and to the notion of it being the stone of the philosophers. Like the ancient association of the goddess of fortune with the axis mundi,

the mountain of Vaughn's allegory conceals great treasures for those able to find it. The mountain is encompassed by cruel beasts and ravening birds, also allusions to the animal constellations surrounding the galaxy, including a fearful serpent:

> There is a Mountain situated in the midst of the earth or center of the world, which is both small and great. It is soft, also above measure hard and stony. It is far off and near at hand, but by the providence of God invisible. In it are hidden the most ample treasures, which the world is not able to value. This mountain—by envy of the devil, who always opposes the glory of God and the happiness of man—is compassed about with very cruel beasts and ravening birds—which make the way thither both difficult and dangerous. And therefore until now—because the time is not yet come—the way thither could not be sought after nor found out. But now at last the way is to be found by those that are worthy—but nonetheless by every man's self-labor and endeavors.

> To this Mountain you shall go in a certain night—when it comes—most long and most dark, and see that you prepare yourselves by prayer. Insist upon the way that leads to the Mountain, but ask not of any man where the way lies. Only follow your Guide, who will offer himself to you and will meet you in the way. But you are not to know him. This Guide will bring you to the Mountain at midnight, when all things are silent and dark. It is necessary that you arm yourselves with a resolute, heroic courage, lest you fear those things that will happen, and so fall back. You need no sword nor any other bodily weapons; only call upon God sincerely and heartily.

> When you have discovered the Mountain the first miracle that will appear is this: A most vehement and very great wind that will shake the Mountain and shatter the rocks to pieces. You will be encountered also by lions and dragons and other terrible beasts; but fear not any of these things. Be resolute and take heed that you turn not back, for your Guide—who brought you thither—will not suffer any evil to befall you. As for the treasure, it is not yet found, but it is very near.[14]

Another passage from the writings of Vaughan is equally transparent. In this case he describes the White Magnesia, one of the many alternate names for the Philosopher's Stone. He poses this description in the form of a riddle, instructing the reader to "catch her if you can." The reference to Mercury in the second sentence reflects common practice in alchemy. Mercury (quicksilver) is another frequently used expression for the

Philosopher's Stone—often called Philosophical Mercury in the literature. The emblems that traditionally accompany alchemical writings often depict the god Mercury (or his Greek equivalent Hermes) at the central axis of the illustration. This positioning represents the axis mundi identity of the Philosopher's Stone (Figures 15.1, 15.2, and 15.3).

Vaughan employs images that consistently evoke the Milky Way. The subject of this riddle is white, transparent, celestial, with a transcendent brightness. Her husband is fire. She is neither animal, vegetable, nor mineral, and is the source of great treasures. A milky substance exudes from her breasts. She possess a secret white crystal of great luster that she bestows on he who can gain her favor:

> [The White Magnesia] is exceeding white and transparent like the heavens. It is in truth somewhat like common quicksilver, but of a celestial, transcendent brightness, for there is nothing upon earth like it. This fine substance is the child of the elements and it is a most pure sweet virgin, for nothing as yet hath been generated out of her. But if at any time she breeds it is by the fire of Nature, for that is her husband. She is no animal, no vegetable, no mineral, neither is she extracted out of animals, vegetables or minerals, but she is pre-existent to them all, for she is the mother of them. Yet one thing I must say: she is not much short of life, for she is almost animal. Her composition is miraculous and different from all other compounds whatsoever. Gold is not so compact but every sophister concludes it is no simple; but she is so much one that no man believes she is more. She yields to nothing but love, for her end is generation and that was never yet performed by violence. He that knows how to wanton and toy with her, the same shall receive all her treasures. First, she sheds at her nipples a thick, heavy water, but white as any snow: the philosophers call it Virgin's Milk. Secondly, she gives him blood from her very heart: it is a quick, heavenly fire; some improperly call it their sulphur. Thirdly and lastly, she presents him with a secret crystal, of more worth and lustre than the white rock and all her rosials. This is she, and these are her favours: catch her, if you can.[15]

Figure 15.1 An alchemical emblem depicting Mercury standing at the axis of the earth, with arms outstreched and holding the caduceus. Two birds rest at the end of his arms. *Secret Symbols of the Rosicrucians*, Altona, 1788.

Figure 15.2 Mercury at the axis of the Fountain of Life (holding the caduceus at top). Stephan Michelspacher, *Cabala Spiegel der Kunst und Natur*, 1616.

Michael Maier and the Attack of the Sun and Moon

In alchemical literature, the quest for the Philosopher's Stone was often referred to as the "Art," or the "Great Work." A curious theme is frequently encountered, both in the texts and the emblems, indicating that the Work is only possible when the sun and moon are conjoined. An example of this theme can be found in a text first published in 1625, known as *Museum Hermeticum*:

> This Art is so well hidden that no mortal on earth can discover it unless Sol and Luna meet.[16]

An emblem from Michael Maier's book, *Symbola Aureae Mensae* (1617), depicts this union of sun and moon. The text reads:

Figure 15.3 A diagram of the cosmos with the sign of Mercury at the central axis. Surrounding it are the signs of the planets and constellations. Mercury, as a designation for the axis mundi, is distinct from the planet Mercury (the symbol of which appears in the circle of the planets next to Venus). From *Musaeum Hermeticum*, 1625.

Sun is the father of the union, the white moon the mother, but a third element—fire—governs it.[17]

This third element, as depicted in the emblem, is the legendary alchemist Hermes Trismegistus. In his right hand he holds a model of the celestial spheres by its axis—the axis mundi (Figure 15.4). His other hand is outstretched in a gesture as if to direct the conjunction of the sun and moon. Although a flame separates these two bodies, the emblem suggests that Hermes is the one who governs them, and thus represents the fire referred to in the text.

Another variant of this theme appears in Emblem XXV of *Atalanta Fugiens*. A man (labeled as the sun) and a woman (representing the moon) stand on each side of a dragon, and they attack him with clubs (Figure 15.5). The text reads:

Figure 15.4 Hermes upholds the cosmos by its axis (axis mundi) as he directs a conjunction of the sun and moon. Maier, *Symbola Aureae Mensae,* 1617.

> The Dragon does not die unless he is destroyed by the sun and the moon, who are his brother and sister.[18]

In Maier's commentary on this emblem, he provides additional clues concerning the identity of the dragon. Associating him with the dragons that guard both the apples of the Hesperides and the golden fleece captured by Jason, Maier states that, in the alchemical Work, the dragon is an allegory that always signifies Mercury. He goes on to associate this dragon with the serpent that devours his own tail—the Ouroboros.[19]

This identity between the serpent and Mercury is elaborated in Emblem XIV, which depicts a dragon as Ouroboros (Figure 15.6). The text reads:

> This is the dragon, devouring his tail.[20]

In the commentary, Maier reiterates the statement that the dragon is Mercury. Serpents and dragons live near the sources of rivers, he says, and that is why Philosophers so frequently refer to them in their writings. He cites the serpents in the Hercules and Jason legends as examples. Winged snakes also inhabit parts of Africa, he adds, and these flying serpents are analogous to the winged Mercury, the volatile quicksilver.[21]

In Emblem XXXVI, Maier explicitly identifies Mercury with the Philosopher's Stone. The text associated with that emblem reads:

> The stone, that is Mercury, is projected onto the earth and raised up onto the mountains; it lives in the air and is fed in the rivers.[22]

Figure 15.5 Sun and Moon attack the dragon. Maier, *Atalanta Fugiens*, 1618.

Maier's source for this text can be found in a passage from manuscripts attributed to Arnaldus de Villanova (1234 – 1309), who describes the location of the Philosopher's Stone:

> You ask, in what place it may be discovered: and willingly will I tell you. It is found upon two mountains: and if you desire to encounter it most completely, ascend a mountain higher than this world: because at that place our stone is concealed: and know that in another place it shall not be found.[23]

The two mountains described here evoke the twin mountain of Mashu, which Gilgamesh encountered on his journey to the source of all rivers. Maier's mention of rivers—and the sources of rivers—only serves to strengthen that parallel. Villanova tells us that this mountain, where the stone can be found, is higher than this world, suggesting a celestial location.

Based on the above, we can now successfully interpret that emblem which illustrates the sun and the moon attacking a dragon (Figure 15.5). The dragon is Mercury, and Mercury is the Philosopher's Stone. As such, "The Dragon does not die unless he is destroyed by the sun and the moon . . ." can just as well be read as: The Philosopher's Stone is not obliterated unless it is obscured by the light of the sun and the moon. This reading is consistent with that earlier passage from the *Museum Hermeticum*, which states that no mortal on earth can discover the Art (i.e., the Philosopher's Stone) unless Sol and Luna meet.

To put this in astronomical terms, the sun and moon conjoin only once per month, causing the especially dark condition known as the new moon. At all other times, the light of the sun

or that of the moon obscures the faint stars of the galaxy. In other words: this conjunction is the only time that the Milky Way is revealed, the only time that the Philosopher's Stone can be found.

Figure 15.6 The Dragon as Ouroboros. Maier, *Atalanta Fugiens,* 1618.

Origin of the Stone in Paradise

Like the Grail, the Philosopher's Stone is associated with Paradise. Maier relates the legend that describes how Adam carried it with him, when he left the Garden of Eden.[24] The early Greek writers, Eustathius and Suidas, interpreted the Hercules myth—his battle with the serpent and subsequent acquisition of the golden apples of the Hesperides—as an alchemical allegory.[25] Maier too adopts this theme. In *Symbola Aureae Mensae,* he quotes a passage from a 1588 work by Greverus which equates the "Philosophical Tree" with the tree in the Garden of the Hesperides, guarded by a dragon, and bearing golden apples of immortality. A seeker who can find that tree, he says, will experience the fulfillment of his every desire. The original text of Greverus uses language that strongly evokes axis mundi imagery:

> In this selfsame mountain, my child, you have seen what is considered to be the kingly garden of the Hesperides ... But at the peak of the mountain you will see the highest of towers keeping watch over the garden, with two ramparts that are all aglow with flames.[26]

Tree of Life, Mythical Archetype

The two flaming ramparts described here are again reminiscent of the two celestial mountains of Villanova and the twin mountain of Mashu, representing the two shining branches of the galaxy at the Great Rift.

The Earth Is His Nurse

Another emblem from *Atalanta Fugiens* illustrates the geographical archetypes traditionally associated with Tree of Life mythology. This emblem depicts a personified earth-sphere nursing a child at her breast (Figure 15.7). The associated text reads: "Its nurse is the earth."[27] The position of the earth's axis in this emblem can be determined from the faint radial lines drawn like circles of latitude around a central point. This center coincides with both the navel of the mother and the navel of the child. Continents and oceans are lightly depicted on the surface of the globe. Only one land mass is highlighted; this is an island located at the center of the radial lines, aligned with the navel of the earth-mother. In the foreground, the infant Zeus is suckling milk from the she-goat Amalthea, while Romulus and Remus, the mythical founders of Rome, drink milk from the teats of a wolf.

This emblem encapsulates many of the concepts that we have come to expect in association with axis mundi symbolism. An island at the navel of the sea lies at the location of the

Figure 15.7 The earth as nurse of the Philosophical Child. Maier, *Atalanta Fugiens*, 1618.

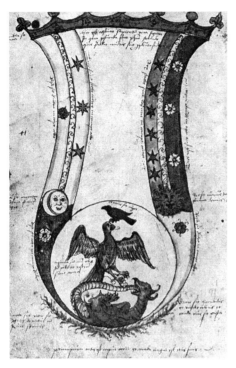

earth's axis. Associations with the Milky Way are provided by the image of the child suckling milk at the position of the axis mundi, and this association is emphasized by the depictions of other mythical figures whose legends evoke elements of the axis mundi archetype.

Another emblem, taken from the alchemical text *Aurora Consurgens* (1625) illustrates the intimate link between alchemy and the archaic symbolism of the Tree of Life. The subject of this drawing is an Alchemical Retort, a container commonly described in the literature of Alchemy. It was used in the laboratory for holding substances said to produce the Philosopher's Stone. Inside the retort are the principal animals that figure in Tree of Life mythology. The resemblance to the Norse legends is particularly strong: A dragon as Ouroboros lies below two birds, one perched on the forehead of the other. This configuration parallels the myth where Jörmungand, the Norse Ouroboros lives at the base of Yggdrasill, while an eagle—with a hawk perched between his eyes—lives in the branches above (chapter 6). The message is straightforward: The Philosopher's Stone produced in the alchemical retort is the celestial Tree of Life. The same motif can be seen in Figure 15.9.

These are but a few examples of many that can be cited to illustrate the arcane symbolism of alchemy and its oblique reference to the galaxy as axis mundi. The connections are not obvious, but rather buried under a mountain of "decoys." Nevertheless, underneath it all is the archaic conception of the Tree of Life—the luminous galaxy at the axis of the universe which was the focus of ancient Persian mysticism. The quest for the Philosopher's Stone, like the quest for the Holy Grail, reflects the same tradition that inspired the quests of Gilgamesh and Hercules, of Jason and Odysseus. The symbolism varies, but the cosmological concepts behind them remain the same.

Figure 15.8 The Alchemical Retort. The Philosopher's Stone, produced within the retort, is shown by symbols representing the Tree of Life. *Aurora Consurgens,* 1625.

Figure 15.9 The Alchemical Retort. Here the older conception of the galaxy as a cosmic serpent is depicted as the Philosopher's Stone within the retort. (J. C. Barchusen, *Elementa Chemicae,* Leiden, 1718.)

Tree of Life, Mythical Archetype

Chapter 16

Concluding Remarks

I. One Possible Historical Reconstruction

Early observers marveled at the mystery of the Milky Way. They came to regard it as the physical manifestation of a divinity who controlled human destiny—a god or goddess of bounty and blessings. Its position near the celestial poles led to the belief that it stood at the axis of celestial rotation, an unmoved mover rotating the world in the same way that an earthly spinner twirls a spindle.

Over extended time periods, religious cults gradually developed with this deity as the focus of their worship. They created rituals and magical formulae that were believed effective in propitiating and gaining its favor. These rites and incantations were the secret and powerful possessions of the cult, carefully guarded from uninitiated outsiders.

This galaxy god or goddess appeared to touch the earth at the distant horizon. Travelers, in search of this location, discovered that the Milky Way extends beyond the horizon into the region regarded as the underworld abode of the dead. Consequently this god also acquired funerary attributes and was assigned the additional role of conducting the deceased to his final home in the afterlife.

While some cultures viewed this galaxy god anthropomorphically, others saw it as a serpent encircling the earth. Still

others imagined it as a tree with uplifted branches, a celestial river, or a giant bird. All attempts to locate the exact place where this divinity stood on the earth's surface failed. Like the end of a rainbow, the apparent intersection point moved along with the movement of the seeker. Since it could not be found anywhere on land, an assumption was made that this secret and elusive point must be located in the middle of the far off and inaccessible sea.

Some time before, or coincident with, the earliest stages of the ancient kingdoms of Egypt and Mesopotamia, a precocious civilization developed the art of shipbuilding and navigation. Explorations revealed the four major rivers flowing from the four continents bordering the Atlantic Ocean. The position of these rivers was charted and discovered to be axial in its orientation. The vertex of the geometric figure abstracted from this orientation was accepted as the center (or navel) of the known world. Based on the principle of symmetry, an assumption was made that this axis point of the rivers must coincide with the axis of the rotating stars. This belief was plausible because the terrestrial location of the actual North Pole was unknown or ambiguous. Exploratory voyages were made into the region beyond the Straits of Gibraltar in search of this sacred locality.

Although the great divinity was not located physically, several small islands in the vicinity were discovered and outposts established on them. These resembled the monasteries on the Irish island of Iona, or those in the mountains of Tibet, and they became repositories of religious and scientific knowledge. These outposts maintained a cultural continuity that persisted even after the demise of the civilizations that had originally established them.

At some point a cosmology was created that grafted many of the various traditional conceptions of the galaxy into one coherent synthesis. The divinity of the axis mundi was declared to be arboreal, but other prevalent beliefs were also given a place in the system. In this new model the galaxy serpent was incorporated as a provider of knowledge and as guardian of the tree. The celestial river was included as the source of the four axial rivers emanating from the island outpost. The goddess was incorporated as the intermediary who provided abundance, and sometimes immortality, to mankind. The remaining features of the old galaxy worship were also amalgamated into the composite legend. Star constellations were coordinated, harmonized, and standardized with this cosmological conception.

The swastika became the emblem of this culture and of its religion. The new synthetic cosmology was disseminated widely and became the first religious orthodoxy. In addition to its commercial interests, the civilization represented on these island outposts—and at related continental locations—provided

Figure 16.1 Adam and Eve, God, serpent, Tree of Life, and tree of the knowledge of good and evil. From the Alcuins Bible, British Museum, London.

guidance on matters of religion, arts, and sciences. Later, its objectives became entirely self-serving. It began to coerce and to dominate rather than to assist when called upon. Accounts which Plato committed to writing preserve ancient historical records that tell of wars initiated by this former seat of learning and culture. Earthquakes and volcanic activity ultimately destroyed the island outposts, and lava covered any physical remains left on the landscape. Nearly all traces of this culture were lost.

Only a dim memory of that once great civilization remained in the legends of diverse people on both sides of the Atlantic. Vestiges of the myth lingered in conceptions of a quadripartite world with an island paradise at its vertex. The divinity of the galaxy continued to be localized there, and this was held as an esoteric secret within the various religious cults, just as it always had been. These secrets concealed details of transatlantic geography, sources of valuable natural resources, and the jealously guarded location of the goddess of fortune. Symbolic expressions of these secrets were, however, permitted. These took the form of the decorations on the Hopi kachina rattles, for example, on the mandalas of Tibet, and on the spindle whorls of Troy.

A few cultures maintained a fairly high level of religious continuity in the succeeding millennia. Through the vehicle of a self-perpetuating priesthood the ancient lore was transmitted from generation to generation. Hopi, Aztec, and Mayan legends of a returning culture-hero reflect actual agreements for future cooperation made at a much earlier date. Mystery religions or esoteric fraternities in Europe continued some of the ancient

Figure 16.2 Adam. From an altarpiece, Brussels.

traditions and passed on the cultic knowledge which was otherwise generally lost. But even then, confusions about the details of this ancient history crept into the mostly oral accounts. The size of the island outposts was merged with vague memories of the distant American continents. Stories of Atlantean military power were conflated with the civilizations that had originally established the island outposts. Hence the confused legend of Atlantis which is known today.

A tradition concerning future cooperation between the hemispheres had also persisted in Europe or Egypt long enough to be recorded in the Sibylline prophesies. Perhaps the Isis cult transmitted this knowledge into the Alexandrian age via the mystery religions of Greece and Rome, or through the alchemical brotherhoods that flourished in Alexandria around the beginning of our present era. It is conceivable that this knowledge could have come to the attention of the king of Spain, and that the voyages of conquest were intentionally synchronized to the date of Quetzalcoatl's promised return.

In any case, an objective look at history reveals that, by and large, both hemispheres had become morally corrupt by the sixteenth century. Internecine battles were being waged between the various European powers, and a repressive Roman Catholicism dominated cultural life. The cruelties of the Spanish Inquisition exemplify the conditions prevalent at this time. On the western side of the Atlantic, the Aztecs had launched a bloodthirsty reign of terror. During one festival alone, celebrating the inauguration of a new king, eighty thousand human captives were sacrificed to the insatiable gods.[1] It was insanity institutionalized and invincible.

Only one culture that we know of kept itself true to the ancient bond. Despite a prolonged drought that crippled their agriculture, the onslaught of aggressive Navajo invaders from Canada, and cruel depredations by Spanish soldiers and priests, the Hopis had remained a people of peace and simplicity. They had consciously renounced the benefits of an easy life in the fertile river valleys where a tendency towards materialism was unavoidable. They clung to their arid mesas in the inhospitable southwestern desert, knowing that this was the only way to preserve their religious heritage. They recognized the moral corruption of their southern neighbors, and they were determined to avoid the same fate. They waited patiently for the long-lost white brother to arrive and work together with them to establish a new civilization based on peace and brotherhood.

In the present age, the Hopis continue to wait for that same white brother to come to his senses, to begin protecting the environment rather than destroying it, to foster peace and understanding rather than following the blind—and ultimately self-destructive—pursuit of wealth and domination.

II. Fifteen General Attributes of Axis Mundi Mythology

The natural referent for the Tree of Life myth was the Milky Way. Individual components of the myth, as described in the following fifteen attributes, correspond to physical features of the galaxy and the constellations located near it. Together they capture most of the imagery used to represent the Tree of Life in antiquity:

1. An enormous tree, mountain, pillar, or titan is said to extend up to heaven or to support the heavens, separating them from the earth below.

2. The tree (or one of its variant forms) provides prosperity, food, wisdom, or immortality. Often these come through the agency of a female intermediary. These blessings may emanate from an inexhaustible supply such as a cornucopia.

3. The tree is typically located near bodies of water. Often four rivers share a common confluence at the position of the tree, which may act as a conduit or river of water emanating from heaven. The four rivers are often said to flow into the four cardinal directions.

4. The tree is located at the center, axle, or navel of the world. It is typically associated with images of axial motion such as wheels, spindles, potters wheels, whirlpools, or weaving (as an extension of the concept "spinning"). These images reflect an ancient belief that the galaxy functioned as the axis mundi.

5. Descriptions of the Tree of Life frequently include images reflecting the whiteness and nebulosity of the galaxy. These may include the concepts of mist, smoke, clouds, snow, veils, fleece, or milk.

6. The tree is often attended by a god or goddess. These are typically considered divinities of fate, fortune, or destiny. Often this becomes a trio of goddesses who are spinners.

7. The tree is viewed as a bridge, path, or ladder that links the earth with heaven and the underworld. For this reason, mythical imagery of the Tree of Life is often used in ancient funerary contexts.

8. The luminosity of the Milky Way is often referred to when the Tree of Life is described as radiant, flaming, or golden. When the tree is represented anthropomorphically, the brightness of the god is sometimes said to be enveloped in a mantle of dark blue or black. This image refers to the position of the luminous galaxy against the nocturnal sky.

9. The two branches of the Milky Way on each side of the Great Rift give rise to the concept of a tree with a conspicuous branch. Alternatively, the galaxy may be represented as a god or goddess with upraised arms. In older conceptions, this feature was seen as the wings of a great celestial bird, the horns of a cow, or as the open jaws of a cosmic serpent that encircled the earth.

Figure 16.3 Eve. From an altarpiece, Brussels.

Figure 16.4 Christ ascending to heaven, with arms upraised in typical axis mundi position. Detail after Raphael, Vatican, Rome.

10. A bird frequently lives in the upper branches of the Tree of Life. Most often this is a swan or an eagle; in some cases both birds are included. This feature of the myth reflects the position of the two bird constellations, Cygnus (Swan) and Aquila (Eagle), within the Great Rift of the galaxy.

11. A serpent is commonly said to dwell at the base of the tree, or in the underworld beneath the tree's roots. Often this is an Ouroboros-type that bites his own earth-encircling tail. This feature reflects the position of the constellation Hydra (Serpent) situated, for the most part, in the underworld below the celestial equator, but whose head rises into the northern celestial hemisphere and is visible above the horizon when seen from the mid northern latitudes.

12. A hound or two hounds often guard the gates of the underworld in Tree of Life mythology. These reflect the two dog constellations located on each side of the Milky Way near the point where it drops below the horizon and enters the underworld.

13. Stags and/or goats frequently inhabit the top of the Tree of Life. Typically they feed on the upper branches of the tree and produce an inexhaustible supply of water, mead, or ambrosia from their antlers or udders. The goat reflects the constellation Capricornus (Goat) that is located near the top of the branching pattern of the galaxy, and the stags probably do so as well.

14. The tree or mountain may be said to have a cavity in its side. When represented anthropomorphically, the god often suffers a wound in the side, genitals, thigh, or leg. In some cases this may take the form of an irregular birth canal, and the god may bear a child from his side or thigh. This mythical feature reflects the lacuna in the Milky Way that can be seen near the star Capella, not far from the North celestial Pole. In classical quest myths the hero frequently suffers a wound to his side or thigh. The quest of the hero or god—often involving the fruits of the tree—typically includes a visit to the underworld.

Figure 16.5 Birth of Eve from the side of Adam in the Garden of Eden.

In some cases he is said to hang on the tree as an ordeal that he must endure.

15. Because references to the Tree of Life are often symbolic or allegorical, specific mentions of the Milky Way as its natural referent are rare. More often this relationship is indicated by way of cryptic allusions. Occasionally, however, the reference is made explicit in the myth.

The swastika functions as a generalized symbol for the Tree of Life because of the tree's reputed location at the vertex of the four Atlantic rivers. Like the Milky Way, this relationship is occasionally made explicit, either textually or graphically.

III. Applications to Art History, Mythology, and Comparative Religion

The set of symbols on the Trojan spindle whorls is evidence of a religious cult dedicated to the Tree of Life in ancient Troy. These symbols reflect the characteristics of the galaxy as described by the fifteen attributes, appearing, for the most part, as abstract and highly reduced representations of mythological elements. The appearance of these symbols on spindle whorls supports their identification with the axis mundi: The rotating spindle was a miniature replica of the spinning earth. The same mythological matrix can be seen on Greek ceramic ware of the Geometric Period. Their funerary context in Greek art reflects the mythical link—from earth to heaven and the underworld—widely attributed to the Tree of Life.

Recognition of the Milky Way as the natural referent for the Tree of Life leads to coherent interpretations for many otherwise obscure episodes in world mythology. This method can be applied, for example, to extract meaningful content from such puzzling accounts as the birth of Athena from the head of Zeus, the attempted rape of Hera by Ixion, and the hanging of Hera from Olympus. The large number of creator and progenitor gods whose attributes correspond to features of the axis mundi indicates the importance ancient people placed upon this natural phenomenon.

That so many myths relate to this hardly-perceptible natural feature can be understood by considering that ancient people spent much more time outside under the stars than their modern counterparts. More so than any other celestial phenomenon, the Milky Way is ambiguously anthropomorphic. Its upraised arms

Figure 16.6 Christ in the underworld (Hell), rescuing the souls of the dead as devils look on. Fiesole, Saint Mark's, Florence.

evoke images of closer and more familiar living beings, but on a huge scale. Viewed as the celestial dwelling-place of the gods, it offers innumerable opportunities for interactions with other celestial divinities. Its intersection with the ecliptic, for example, creates a locus for encounters with all of the gods who embody the planets, the sun, and the moon. Its proximity to so many of the other constellations—themselves considered as gods in antiquity—allows for multiple divine interrelationships. The very faintness of the galaxy creates ambiguities that stimulate the imagination in a way that even the sun does not. The appearance of the Milky Way in the nocturnal sky engenders a sense of awe and reverence that human beings far less frequently accord to objects appearing in the bright light of day.

Each cultural subgroup must have had its particular name and set of divine attributes for the galaxy god. When these separate notions were fused into a shared religious conception, which must have occurred when early tribes came into prolonged contact with each other, most of the former galaxy gods would be forced to assume a somewhat different function in the new synthesis. So whereas Hera had been the galaxy goddess par excellence for the inhabitants of Argos, after their conquest by Zeus-worshipping invaders, Hera would henceforth assume the role of wife to the now dominant galaxy god. The pantheons of many ancient cultures can be similarly understood.

A heroic quest for the Tree of Life was a predominant mythical theme in antiquity. It recurs in the Jason cycle, the labors of Hercules, and the Gilgamesh epic. That we should find it again as a scarcely recognizable fossil in the Homeric epics thus becomes comprehensible. Granting that his journey up the Nile is vicarious, Odysseus visits the four Atlantic rivers before encountering the goddess of immortality on an island at the navel of the sea. She is the daughter of the old axis mundi titan, Atlas, and she spends her days weaving on her loom. If the story were completely true to type, she would be spinning on her spindle, but then the symbolism becomes just too obvious. The parallelism between the episode where Odysseus cuts down a tree to fashion a bed for Penelope, and where Gilgamesh cuts down the huluppu tree for Inanna's couch is unmistakable; the mythical archetype is clearly operative.

Vestiges of the Tree of Life myth persist in all the major world religions, not only where the tree is referred to directly, but also in the cloak of divine attributes ordinarily ascribed to creator gods and demigods. These can be seen as footsteps in the process whereby religious concepts have developed from animistic beginnings toward a concept of divinity that is less physically oriented. But the limited human mind requires that

its spiritual conceptions be described in familiar terms, and it could be argued that the galaxy is the closest physical approximation to a divinity that could possibly be imagined. It is remote, but always present. It encircles the earth like a mother embracing her child. It is mysterious and elusive, yet immense and dominating. In short, it is an incomprehensible wonder with vaguely anthropomorphic features; a perfect metaphor for God.

Figure 16.7 Christ, in the underworld, rescuing souls of the dead as devils look on. Albrecht Dürer.

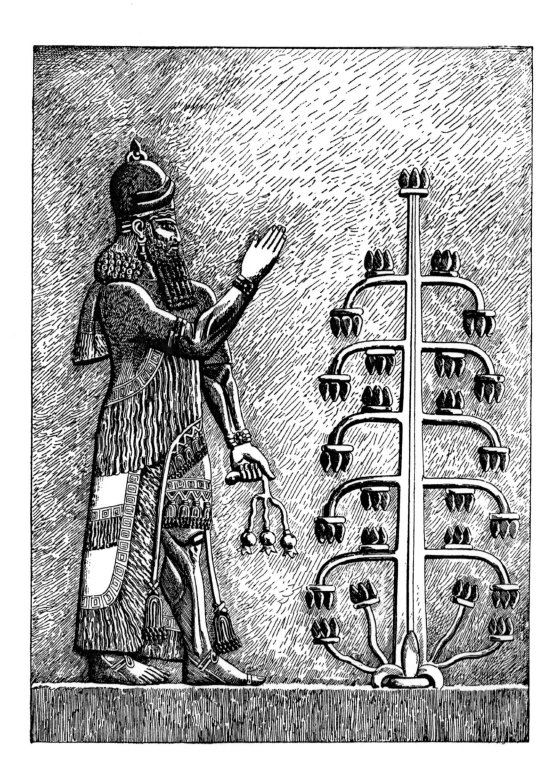

Figure 16.8 Sargon before the sacred tree. Drawing by Saint-Elme Gautier, Louvre, Paris.

Tree of Life, Mythical Archetype

Appendix 1

Plato's Account of Atlantis

Critias. Then listen, Socrates, to a strange tale, which is, however, certainly true, as Solon, who was the wisest of the seven sages, declared. He was a relative and great friend of my great-grandfather, Dropidas, as he himself says in several of his poems, and Dropidas told Critias, my grandfather, who remembered, and told us, that there were of old great and marvellous actions of the Athenians, which have passed into oblivion through time and the destruction of the human race and one in particular, which was the greatest of them all, the recital of which will be a suitable testimony of our gratitude to you, and also a hymn of praise true and worthy of the goddess, which may be sung by us at the festival in her honor.

Socrates. Very good; and what is this ancient famous action of which Critias spoke, not as a mere legend, but as a veritable action of the Athenian State, which Solon recounted?

Critias. I will tell an old-world story which I heard from an aged man for Critias was, as he said, at that time nearly ninety years of age, and I was about ten years of age. Now the day was that day of the Apaturia which is called the registration of youth; at which, according to custom, our parents gave prizes for recitations, and the poems of several poets were recited by us boys, and many of us sung the poems of Solon, which were new at the time. One of our tribe, either because this was his real opinion, or because he thought that he would please Critias, said that, in his judgment, Solon was not only the wisest of men but the noblest of poets. The old man, I well remember, brightened up at this, and said, smiling: "Yes, Amynander, if Solon

had only, like other poets, made poetry the business of his life, and had completed the tale which he brought with him from Egypt, and had not been compelled, by reason of the factions and troubles which he found stirring in this country when he came home, to attend to other matters, in my opinion he would have been as famous as Homer, or Hesiod, or any poet."

"And what was that poem about, Critias?" said the person who addressed him.

"About the greatest action which the Athenians ever did, and which ought to have been most fabulous, but which, through the lapse of time and the destruction of the actors, has not come down to us."

"Tell us," said the other, "the whole story, and how and from whom Solon heard this veritable tradition."

[Here the elder Critias begins his tale of Atlantis.]

At the head of the Egyptian Delta, where the river Nile divides, there is a certain district which is called the district of Sais, and the great city of the district is also called Sais; and is the city from which Amasis the king was sprung. And the citizens have a deity who is their foundress: she is called in the Egyptian tongue Neith, which is asserted by them to be the same whom the Hellenes called Athene. Now, the citizens of this city are great lovers of the Athenians, and say that they are in some way related to them. Thither came Solon, who was received by them with great honor; and he asked the priests, who were most skilful in such matters, about

antiquity, and made the discovery that neither he nor any other Hellene knew anything worth mentioning about the times of old. On one occasion, when he was drawing them on to speak of antiquity, he began to tell about the most ancient things in our part of the world—about Phoroneus, who is called "the first," and about Niobe; and, after the Deluge, to tell of the lives of Deucalion and Pyrrha; and he traced the genealogy of their descendants, and attempted to reckon how many years old were the events of which he was speaking, and to give the dates. Thereupon, one of the priests, who was of very great age, said, "O Solon, Solon, you Hellenes are but children, and there is never an old man who is an Hellene."

Solon, hearing this, said, "What do you mean?" "I mean to say," he replied, "that in mind you are all young; there is no old opinion handed down among you by ancient tradition, nor any science which is hoary with age. And I will tell you the reason of this: there have been, and there will be again, many destructions of mankind arising out of many causes. There is a story which even you have preserved, that once upon a time Phaëthon, the son of Helios, having yoked the steeds in his father's chariot, because he was not able to drive them in the path of his father, burnt up all that was upon the earth, and was himself destroyed by a thunder-bolt. Now, this has the form of a myth, but really signifies a declination of the bodies moving around the earth and in the heavens, and a great conflagration of things upon the earth recurring at long intervals of time: when this happens, those who live upon the mountains and in dry and lofty places are more liable to destruction than those who dwell by rivers or on the sea-shore; and from this calamity the Nile, who is our never-failing savior, saves and delivers us. When, on the other hand, the gods purge the earth with a deluge of water, among you, herdsmen and shepherds on the mountains are the survivors, whereas those of you who live in cities are carried by the rivers into the sea; but in this country neither at that time nor at any other does the water come from above on the fields, having always a tendency to come up from below, for which reason the things preserved here are said to be the oldest. The fact is, that wherever the extremity of winter frost or of summer sun does not prevent, the human race is always increasing at times, and at other times diminishing in

numbers. And whatever happened either in your country or in ours, or in any other region of which we are informed—if any action which is noble or great, or in any other way remarkable has taken place, all that has been written down of old, and is preserved in our temples; whereas you and other nations are just being provided with letters and the other things which States require; and then, at the usual period, the stream from heaven descends like a pestilence, and leaves only those of you who are destitute of letters and education; and thus you have to begin all over again as children, and know nothing of what happened in ancient times, either among us or among yourselves. As for those genealogies of yours which you have recounted to us, Solon, they are no better than the tales of children; for, in the first place, you remember one deluge only, whereas there were many of them …"

"You do not know that there dwelt in your land the fairest and noblest race of men which ever lived, of whom you and your whole city are but a seed or remnant. And this was unknown to you, because for many generations the survivors of that destruction died and made no sign. For there was a time, Solon, before that great deluge of all, when the city which now is Athens was first in war, and was preeminent for the excellence of her laws, and is said to have performed the noblest deeds, and to have had the fairest constitution of any of which tradition tells, under the face of heaven." Solon marvelled at this, and earnestly requested the priest to inform him exactly and in order about these former citizens. "You are welcome to hear about them, Solon," said the priest, "both for your own sake and for that of the city; and, above all, for the sake of the goddess who is the common patron and protector and educator of both our cities. She founded your city a thousand years before ours, receiving from the Earth and Hephaestus the seed of your race, and then she founded ours, the constitution of which is set down in our sacred registers as 8000 years old. As touching the citizens of 9000 years ago, I will briefly inform you of their laws and of the noblest of their actions; and the exact particulars of the whole we will hereafter go through at our leisure in the sacred registers themselves. If you compare these very laws with your own, you will find that many of ours are the counterpart of yours, as they were in the olden time. In the first place, there is the

caste of priests, which is separated from all the others; next there are the artificers, who exercise their several crafts by themselves, and without admixture of any other; and also there is the class of shepherds and that of hunters, as well as that of husbandmen; and you will observe, too, that the warriors in Egypt are separated from all the other classes, and are commanded by the law only to engage in war; moreover, the weapons with which they are equipped are shields and spears, and this the goddess taught first among you, and then in Asiatic countries, and we among the Asiatics first adopted.

"Then, as to wisdom, do you observe what care the law took from the very first, searching out and comprehending the whole order of things down to prophecy and medicine (the latter with a view to health); and out of these divine elements drawing what was needful for human life, and adding every sort of knowledge which was connected with them.

"All this order and arrangement the goddess first imparted to you when establishing your city; and she chose the spot of earth in which you were born, because she saw that the happy temperament of the seasons in that land would produce the wisest of men. Wherefore the goddess, who was a lover both of war and of wisdom, selected, and first of all settled that spot which was the most likely to produce men likest herself. And there you dwelt, having such laws as these and still better ones, and excelled all mankind in all virtue, as became the children and disciples of the gods. Many great and wonderful deeds are recorded of your State in our histories; but one of them exceeds all the rest in greatness and valor; for these histories tell of a mighty power which was aggressing wantonly against the whole of Europe and Asia, and to which your city put an end. This power came forth out of the Atlantic Ocean, for in those days the Atlantic was navigable; and there was an island situated in front of the straits which you call the Columns of Heracles: the island was larger than Libya and Asia put together, and was the way to other islands, and from the islands you might pass through the whole of the opposite continent which surrounded the true ocean; for this sea which is within the Straits of Heracles is only a harbor, having a narrow entrance, but that other is a real sea, and the surrounding land may be most truly called a continent.

"Now, in the island of Atlantis there was a great and wonderful empire, which had rule over the whole island and several others, as well as over parts of the continent; and, besides these, they subjected the parts of Libya within the Columns of Heracles as far as Egypt, and of Europe as far as Tyrrhenia. The vast power thus gathered into one, endeavored to subdue at one blow our country and yours, and the whole of the land which was within the straits; and then, Solon, your country shone forth, in the excellence of her virtue and strength, among all mankind, for she was the first in courage arid military skill, and was the leader of the Hellenes. And when the rest fell off from her, being compelled to stand alone, after having undergone the very extremity of danger, she defeated and triumphed over the invaders, and preserved from slavery those who were not yet subjected, and freely liberated all the others who dwelt within the limits of Heracles. But afterward there occurred violent earthquakes and floods, and in a single day and night of rain all your warlike men in a body sunk into the earth, and the island of Atlantis in like manner disappeared, and was sunk beneath the sea. And that is the reason why the sea in those parts is impassable and impenetrable, because there is such a quantity of shallow mud in the way; and this was caused by the subsidence of the island."[1]

". . . Let me begin by observing, first of all, that nine thousand was the sum of years which had elapsed since the war which was said to have taken place between all those who dwelt outside the Pillars of Heracles and those who dwelt within them: this war I am now to describe. Of the combatants on the one side the city of Athens was reported to have been the ruler, and to have directed the contest; the combatants on the other side were led by the kings of the islands of Atlantis, which, as I was saying, once had an extent greater than that of Libya and Asia and, when afterward sank by an earthquake, became an impassable barrier of mud to voyagers sailing from hence to the ocean. The progress of the history will unfold the various tribes of barbarians and Hellenes which then existed, as they successively appear on the scene but I must begin by describing, first of all, the Athenians as they were in that day, and their enemies who fought with them, and I shall have to tell of the power and form of government of both of them. Let us give the precedence to Athens . . .

Many great deluges have taken place during the nine thousand years, for that is the number of years which have elapsed since the time of which I am speaking, and in all the ages and changes of things there has never been any settlement of the earth flowing down from the mountains, as in other places, which is worth speaking of, it has always been carried round in a circle, and disappeared in the depths below. The consequence is that, in comparison of what then was, there are remaining in small islets only the bones of the wasted body, as they may be called, all the richer and softer parts of the soil having fallen away, and the mere skeleton of the country being left..."

[The younger Critias now continues the story of Atlantis]

And next, if I have not forgotten what I heard when I was a child, I will impart to you the character and origin of their adversaries, for friends should not keep their stories to themselves, but have them in common. Yet, before proceeding farther in the narrative, I ought to warn you that you must not be surprised if you should hear Hellenic names given to foreigners. I will tell you the reason of this: Solon, who was intending to use the tale for his poem, made an investigation into the meaning of the names, and found that the early Egyptians, in writing them down, had translated them into their own language, and he recovered the meaning of the several names and retranslated them, and copied them out again in our language. My great-grandfather, Dropidas, had the original writing, which is still in my possession; and was carefully studied by me when I was a child. Therefore, if you hear names such as are used in this country, you must not be surprised, for I have told you the reason of them.

The tale, which was of great length, began as follows: I have before remarked, in speaking of the allotments of the gods, that they distributed the whole earth into portions differing in extent, and made themselves temples and sacrifices. And Poseidon, receiving for his lot the island of Atlantis, begat children by a mortal woman, and settled them in a part of the island which I will proceed to describe. On the side toward the sea, and in the centre of the whole island, there is a plain which is said to have been the fairest of all plains, and very fertile. Near the plain again,

and also in the centre of the island, at a distance of about fifty stadia, there was a mountain, not very high on any side. In this mountain there dwelt one of the earth-born primeval men of that country, whose name was Evenor, and he had a wife named Leucippe, and they had an only daughter, who was named Cleito. The maiden was growing up to womanhood when her father and mother died; Poseidon fell in love with her, and had intercourse with her; and, breaking the ground, enclosed the hill in which she dwelt all round, making alternate zones of sea and land, larger and smaller, encircling one another; there were two of land and three of water, which he turned as with a lathe out of the centre of the island, equidistant every way, so that no man could get to the island, for ships and voyages were not yet heard of. He himself, as he was a god, found no difficulty in making special arrangements for the centre island, bringing two streams of water under the earth, which he caused to ascend as springs, one of warm water and the other of cold, and making every variety of food to spring up abundantly in the earth. He also begat and brought up five pairs of male children, dividing the island of Atlantis into ten portions: he gave to the first-born of the eldest pair his mother's dwelling and the surrounding allotment, which was the largest and best, and made him king over the rest; the others he made princes, and gave them rule over many men and a large territory. And he named them all: the eldest, who was king, he named Atlas, and from him the whole island and the ocean received the name of Atlantic. To his twin-brother, who was born after him, and obtained as his lot the extremity of the island toward the Pillars of Heracles, as far as the country which is still called the region of Gades in that part of the world, he gave the name which in the Hellenic language is Eumelus, in the language of the country which is named after him, Gadeirus. Of the second pair of twins, he called one Ampheres and the other Evaemon. To the third pair of twins he gave the name Mneseus to the elder, and Autochthon to the one who followed him. Of the fourth pair of twins he called the elder Elasippus and the younger Mestor. And of the fifth pair he gave to the elder the name of Azaes, and to the younger Diaprepes. All these and their descendants were the inhabitants and rulers of divers islands in the open sea; and also, as has been already said, they held sway in the other direction over the

country within the Pillars as far as Egypt and Tyrrhenia.

Now Atlas had a numerous and honorable family, and his eldest branch always retained the kingdom, which the eldest son handed on to his eldest for many generations; and they had such an amount of wealth as was never before possessed by kings and potentates, and is not likely ever to be again, and they were furnished with everything which they could have, both in city and country. For, because of the greatness of their empire, many things were brought to them from foreign countries, and the island itself provided much of what was required by them for the uses of life. In the first place, they dug out of the earth whatever was to be found there, mineral as well as metal, and that which is now only a name, and was then something more than a name—orichalcum—was dug out of the earth in many parts of the island, and, with the exception of gold, was esteemed the most precious of metals among the men of those days. There was an abundance of wood for carpenters' work, and sufficient maintenance for tame and wild animals. Moreover, there were a great number of elephants in the island, and there was provision for animals of every kind, both for those which live in lakes and marshes and rivers, and also for those which live in mountains and on plains, and therefore for the animal which is the largest and most voracious of them. Also, whatever fragrant things there are in the earth, whether roots, or herbage, or woods, or distilling drops of flowers or fruits, grew and thrived in that land; and again, the cultivated fruit of the earth, both the dry edible fruit and other species of food, which we call by the general name of legumes, and the fruits having a hard rind, affording drinks, and meats, and ointments, and good store of chestnuts and the like, which may be used to play with, and are fruits which spoil with keeping—and the pleasant kinds of dessert which console us after dinner, when we are full and tired of eating—all these that sacred island lying beneath the sun brought forth fair and wondrous in infinite abundance.

All these things they received from the earth, and they employed themselves in constructing their temples, and palaces, and harbors, and docks; and they arranged the whole country in the following manner: First of all they bridged over the zones of sea which surrounded the ancient metropolis, and made a passage into

and out of the royal palace; and then they began to build the palace in the habitation of the god and of their ancestors. This they continued to ornament in successive generations, every king surpassing the one who came before him to the utmost of his power, until they made the building a marvel to behold for size and for beauty. And, beginning from the sea, they dug a canal three hundred feet in width and one hundred feet in depth, and fifty stadia in length, which they carried through to the outermost zone, making a passage from the sea up to this, which became a harbor, and leaving an opening sufficient to enable the largest vessels to find ingress. Moreover, they divided the zones of land which parted the zones of sea, constructing bridges of such a width as would leave passage for a single trireme to pass out of one into another, and roofed them over; and there was a way underneath for the ships, for the banks of the zones were raised considerably above the water. Now the largest of the zones into which a passage was cut from the sea was three stadia in breadth, and the zone of land which came next of equal breadth; but the next two, as well the zone of water as of land, were two stadia, and the one which surrounded the central island was a stadium only in width. The island in which the palace was situated had a diameter of five stadia. This, and the zones and the bridge, which was the sixth part of a stadium in width, they surrounded by a stone wall, on either side placing towers, and gates on the bridges where the sea passed in. The stone which was used in the work they quarried from underneath the centre island and from underneath the zones, on the outer as well as the inner side. One kind of stone was white, another black, and a third red; and, as they quarried, they at the same time hollowed out docks double within, having roofs formed out of the native rock. Some of their buildings were simple, but in others they put together different stones, which they intermingled for the sake of ornament, to be a natural source of delight. The entire circuit of the wall which went round the outermost one they covered with a coating of brass, and the circuit of the next wall they coated with tin, and the third, which encompassed the citadel, flashed with the red light of orichalcum.

The palaces in the interior of the citadel were constructed in this wise: In the centre was a holy temple dedicated to Cleito and Poseidon, which

remained inaccessible, and was surrounded by all enclosure of gold; this was the spot in which they originally begat the race of the ten princes, and thither they annually brought the fruits of the earth in their season from all the ten portions, and performed sacrifices to each of them. Here, too, was Poseidon's own temple, of a stadium in length and half a stadium in width, and of a proportionate height, having a sort of barbaric splendor. All the outside of the temple, with the exception of the pinnacles, they covered with silver, and the pinnacles with gold. In the interior of the temple the roof was of ivory, adorned everywhere, with gold and silver and orichalcum; All the other parts of the walls and pillars and floor they lined with orichalcum. In the temple they placed statues of gold: there was the god himself standing in a chariot—the charioteer of six winged horses—and of such a size that he touched the roof of the building with his head; around him there were a hundred Nereids riding on dolphins, for such was thought to be the number of them in that day. There were also in the interior of the temple other images which had been dedicated by private individuals. And around the temple on the outside were placed statues of gold of all the ten kings and of their wives; and there were many other great offerings, both of kings and of private individuals, coming both from the city itself and the foreign cities over which they held sway. There was an altar, too, which in size and workmanship corresponded to the rest of the work, and there were palaces in like manner which answered to the greatness of the kingdom and the glory of the temple. In the next place, they used fountains both of cold and hot springs; these were very abundant, and both kinds wonderfully adapted to use by reason of the sweetness and excellence of their waters. They constructed buildings about them, and planted suitable trees; also cisterns, some open to the heaven, others which they roofed over, to be used in winter as warm baths: there were the king's baths, and the baths of private persons, which were kept apart; also separate baths for women, and others again for horses and cattle, and to them they gave as much adornment as was suitable for them. The water which ran off they carried, some to the grove of Poseidon where were growing all manner of trees of wonderful height and beauty, owing to the excellence of the soil; the remainder was conveyed by aqueducts which passed over the bridges to the outer circles: and there were many temples built and dedicated to many gods; also gardens and places of exercise, some for men, and some set apart for horses, in both of the two islands formed by the zones; and in the centre of the larger of the two there was a race-course of a stadium in width, and in length allowed to extend all round the island, for horses to race in. Also there were guard-houses at intervals for the body-guard, the more trusted of whom had their duties appointed to them in the lesser zone, which was nearer the Acropolis; while the most trusted of all had houses given them within the citadel, and about the persons of the kings. The docks were full of triremes and naval stores, and all things were quite ready for use. Enough of the plan of the royal palace. Crossing the outer harbors, which were three in number, you would come to a wall which began at the sea and went all round: this was everywhere distant fifty stadia from the largest zone and harbor, and enclosed the whole, meeting at the mouth of the channel toward the sea. The entire area was densely crowded with habitations; and the canal and the largest of the harbors were full of vessels and merchants coming from all parts, who, from their numbers, kept up a multitudinous sound of human voices and din of all sorts night and day.

I have repeated his descriptions of the city and the parts about the ancient palace nearly as he gave them, and now I must endeavor to describe the nature and arrangement of the rest of the country. The whole country was described as being very lofty and precipitous on the side of the sea, but the country immediately about and surrounding the city was a level plain, itself surrounded by mountains which descended toward the sea; it was smooth and even, but of an oblong shape, extending in one direction three thousand stadia, and going up the country from the sea through the centre of the island two thousand stadia; the whole region of the island lies toward the south, and is sheltered from the north. The surrounding mountains he celebrated for their number and size and beauty, in which they exceeded all that are now to be seen anywhere; having in them also many wealthy inhabited villages, and rivers and lakes, and meadows supplying food enough for every animal, wild or tame, and wood of various sorts, abundant for every kind of work. I will now describe the plain, which had been cultivated

during many ages by many generations of kings. It was rectangular, and for the most part straight and oblong; and what it wanted of the straight line followed the line of the circular ditch. The depth and width and length of this ditch were incredible, and gave the impression that such a work, in addition to the many other works, could hardly have been wrought by the hand of man. But I must say what I have heard. It was excavated to the depth of a hundred feet, and its breadth was a stadium everywhere; it was carried round the whole of the plain, and was ten thousand stadia in length. It received the streams which came down from the mountains, and winding round the plain, and touching the city at various points, was there let off into the sea. From above, likewise, straight canals of a hundred feet in width were cut in the plain, and again let off into the ditch, toward the sea; these canals were at intervals of a hundred stadia, and by them they brought down the wood from the mountains to the city, and conveyed the fruits of the earth in ships, cutting transverse passages from one canal into another, and to the city. Twice in the year they gathered the fruits of the earth—in winter having the benefit of the rains, and in summer introducing the water of the canals. As to the population, each of the lots in the plain had an appointed chief of men who were fit for military service, and the size of the lot was to be a square of ten stadia each way, and the total number of all the lots was sixty thousand. And of the inhabitants of the mountains and of the rest of the country there was also a vast multitude having leaders, to whom they were assigned according to their dwellings and villages. The leader was required to furnish for the war the sixth portion of a war-chariot, so as to make up a total of ten thousand chariots; also two horses and riders upon them, and a light chariot without a seat, accompanied by a fighting man on foot carrying a small shield, and having a charioteer mounted to guide the horses; also, he was bound to furnish two heavy-armed men, two archers, two slingers, three stone-shooters, and three javelin men, who were skirmishers, and four sailors to make up its complement of twelve hundred ships.

Such was the order of war in the royal city—that of the other nine governments was different in each of them, and would be wearisome to narrate. As to offices and honors, the following was the arrangement from the first: each of the ten kings, in his own division and in his own city, had the absolute control of the citizens, and in many cases of the laws, punishing and slaying whomsoever he would. Now the relations of their governments to one another were regulated by the injunctions of Poseidon as the law had handed them down. These were inscribed by the first men on a column of orichalcum, which was situated in the middle of the island, at the temple of Poseidon, whither the people were gathered together every fifth and sixth years alternately, thus giving equal honor to the odd and to the even number. And when they were gathered together they consulted about public affairs, and inquired if anyone had transgressed in anything, and passed judgment on him accordingly—and before they passed judgment they gave their pledges to one another in this wise: There were bulls who had the range of the temple of Poseidon; and the ten who were left alone in the temple, after they had offered prayers to the gods that they might make the sacrifices which were acceptable to them, hunted the bulls without weapons, but with staves and nooses; and the bull which they caught they led up to the column; the victim was then struck on the head by them, and slain over the sacred inscription. Now on the column, besides the law, there was inscribed an oath invoking mighty curses on the disobedient. When, therefore, after offering sacrifice according to their customs, they had burnt the limbs of the bull, they mingled a cup and cast in a clot of blood for each of them; the rest of the victim they took to the fire, after having made a purification of the column all round. Then they drew from the cup in golden vessels, and, pouring a libation on the fire, they swore that they would judge according to the laws on the column, and would punish anyone who had previously transgressed, and that for the future they would not, if they could help, transgress any of the inscriptions, and would not command or obey any ruler who commanded them to act otherwise than according to the laws of their father Poseidon. This was the prayer which each of them offered up for himself and for his family, at the same time drinking, and dedicating the vessel in the temple of the god and, after spending some necessary time at supper, when darkness came on and the fire about the sacrifice was cool, all of them put on most beautiful azure robes, and, sitting on the ground at night near the embers of the sacrifices on which they

had sworn, and extinguishing all the fire about the temple, they received and gave judgment, if any of them had any accusation to bring against any one; and, when they had given judgment, at daybreak they wrote down their sentences on a golden tablet, and deposited them as memorials with their robes. There were many special laws which the several kings had inscribed about the temples, but the most important was the following: That they were not to take up arms against one another, and they were all to come to the rescue if anyone in any city attempted to overthrow the royal house. Like their ancestors, they were to deliberate in common about war and other matters, giving the supremacy to the family of Atlas; and the king was not to have the power of life and death over any of his kinsmen, unless he had the assent of the majority of the ten kings.

Such was the vast power which the god settled in the lost island of Atlantis; and this he afterward directed against our land on the following pretext, as traditions tell: For many generations, as long as the divine nature lasted in them, they were obedient to the laws, and well-affectioned toward the gods, who were their kinsmen; for they possessed true and in every way great spirits, practicing gentleness and wisdom in the various chances of life, and in their intercourse with one another. They despised everything but virtue, not caring for their present state of life, and thinking lightly on the possession of gold and other property, which seemed only a burden to them; neither were they intoxicated by luxury; nor did wealth deprive them of their self-control; but they were sober, and saw clearly that all these goods are increased by virtuous friendship with one another, and that by excessive zeal for them, and honor of them, the good of them is lost, and friendship perishes with them. By such reflections, and by the continuance in them of a divine nature, all that which we have described waxed and increased in them; but when this divine portion began to fade away in them, and became diluted too often, and with too much of the mortal admixture, and the human nature got the upper-hand, then, they being unable to bear their fortune, became unseemly, and to him who had an eye to see, they began to appear base, and had lost the fairest of their precious gifts; but to those who had no eye to see the true happiness, they still appeared glorious and blessed at the very time when they were filled with unrighteous avarice and power. Zeus, the god of gods, who rules with law, and is able to see into such things, perceiving that an honorable race was in a most wretched state, and wanting to inflict punishment on them, that they might be chastened and improved, collected all the gods into his most holy habitation, which, being placed in the centre of the world, sees all things that partake of generation. And when he had called them together he spake as follows . . .[2]

[Here Plato's account abruptly ends.]

Appendix II

The Trojan Spindle Whorls

The following plates reproduce the illustrations of Trojan spindle whorls appearing in Schliemann's report of his excavations at Troy, published under the title, *Troy and Its Remains*, in 1875.

Tree of Life, Mythical Archetype

Tree of Life, Mythical Archetype

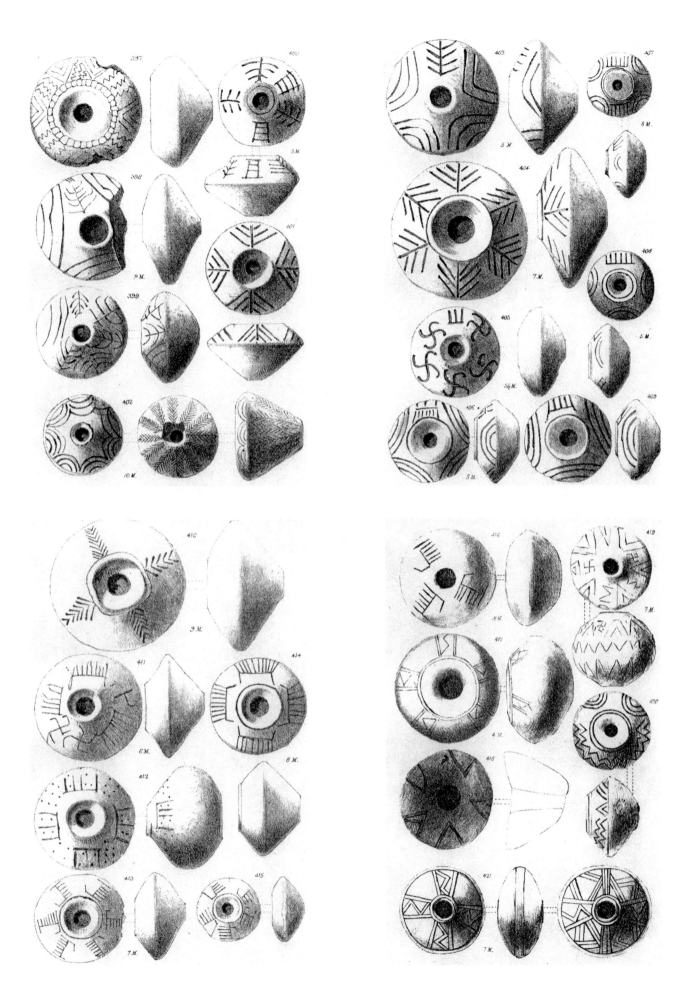

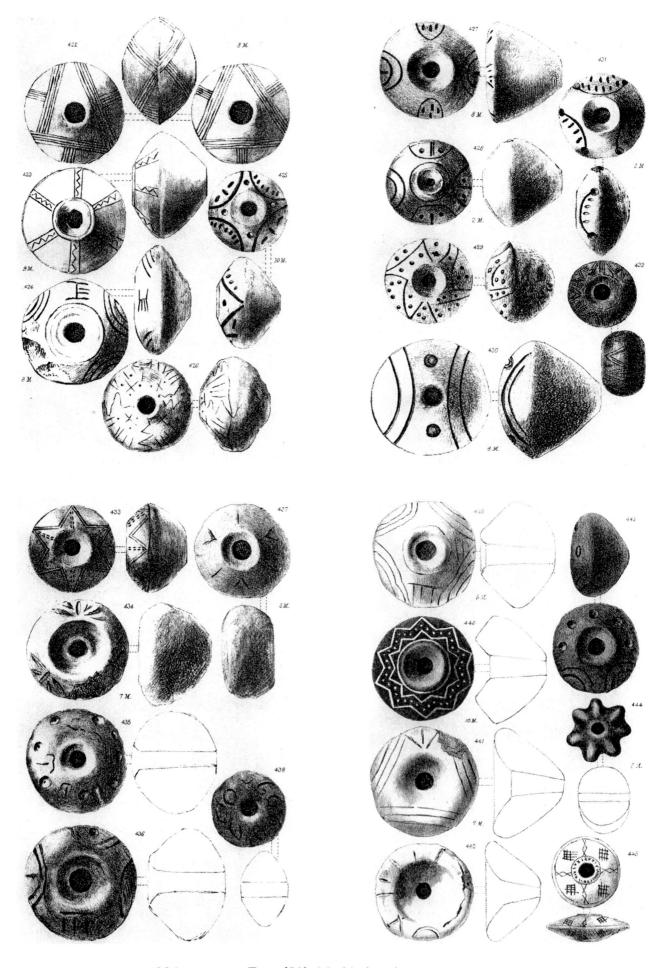

Tree of Life, Mythical Archetype

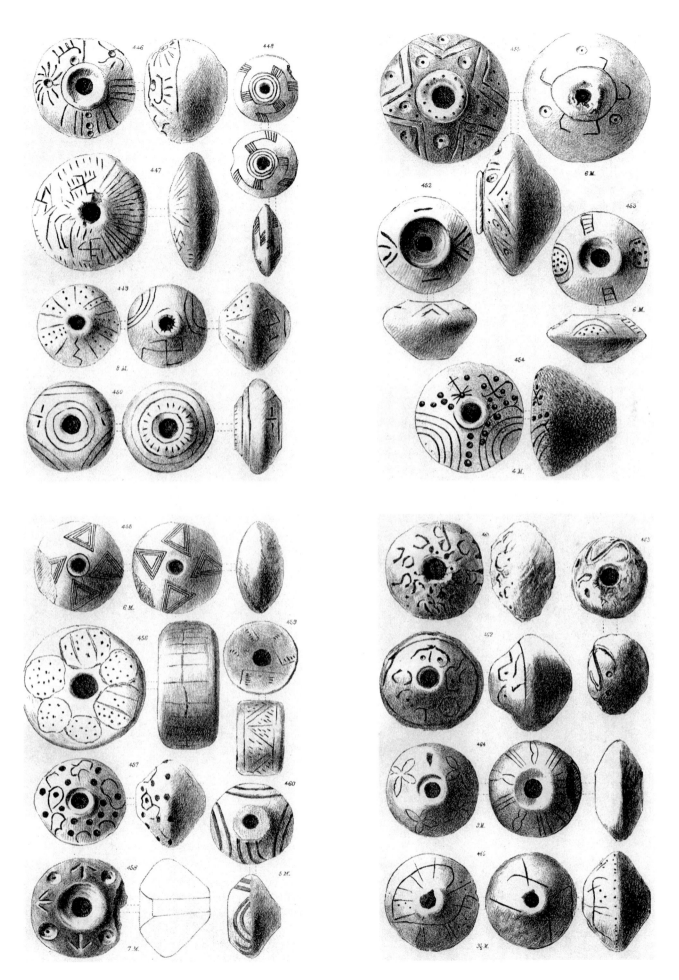

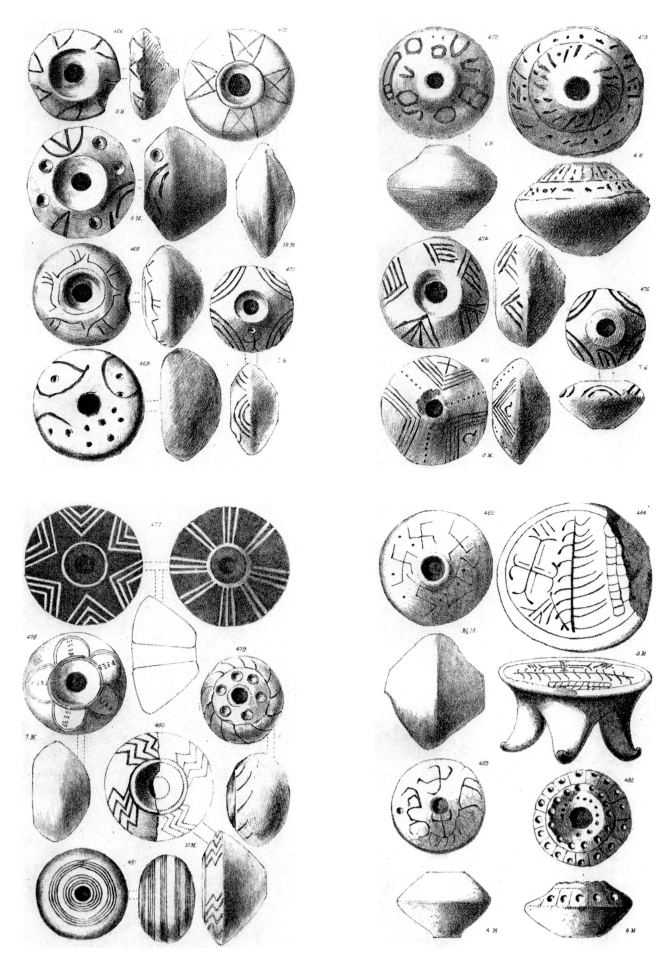

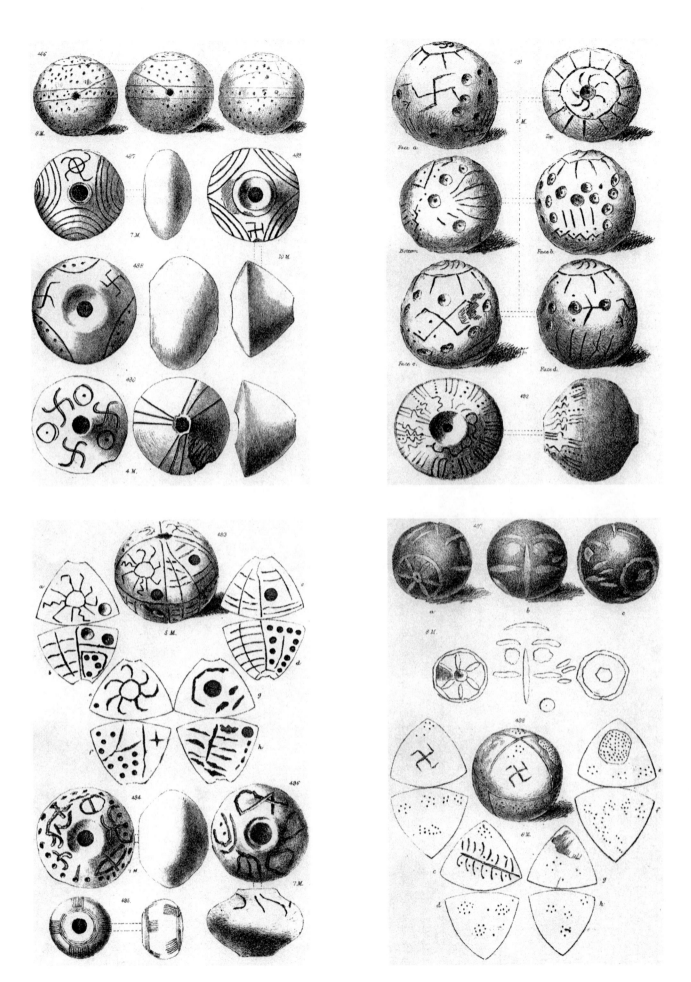

Notes

Notes to Chapter 1

1. For Schliemann's account of his discoveries, see *Troy and Its Remains*. Modern (and more critical) accounts can be found in Wood, *In Search of the Trojan War*, and in Allen, *Finding the Walls of Troy*.

2. Gimbutas, *Goddesses and Gods*, 79–90, and *Language of the Goddess*, 172–177.

3. See Schweitzer, *Greek Geometric Art*.

4. See Schliemann, *Troy and Its Remains*.

5. Balfanz, "Bronzezeitliche Spinwirtel aus Troia," 131. In her bibliography, Balfanz provides an excellent overview of scholarly literature covering the Trojan spindle whorls up to 1995. See also, Crew, *Spindle Whorls*.

6. For the oldest archeological occurrences of the swastika see: Gimbutas, *Goddesses and Gods*, 90; Settegast, *Plato Prehistorian*, 246; and Fairservis, *Roots of Ancient India*. For proposed interpretations, see: Wilson, *The Swastika*, 829; Crewe, *Spindle Whorls*; Balfanz, "Bronzezeitliche Spinwirtel aus Troia," 117–143; Blegen, *Troy and the Trojans*; and Loewenstein, "Swastika: Its History and Meaning," 49–55.

7. *Encyclopedia Britannica*, s.v. "swastika"; Danielou, *Myths and Gods*, 353; Leach, ed., *Dictionary of Folklore, Mythology, and Legend*, s.v. "swastika"; Baden-Powell, *What Scouts Can Do*. All other citations are from Wilson, "The Swastika": 771, 773 (quoting Müller), 777 (quoting Burnouf), 780 (quoting Waring), and 781 (paraphrasing March).

8. Schliemann, *Troy and Its Remains*, 118.

9. Jung and Kerényi, *Essays on a Science of Mythology*, 16, 71, 74, 162. For an argument against this psychological explanation, see Witzel, *Comparison and Reconstruction*.

10. While it is sometimes claimed that inventions are often made independently, this is disputable. See Sorenson and Raish, s.v. "Chandler, Tertius, *Duplicate Inventions?*"

Notes to Chapter 2

1. Waters, *Book of the Hopi*, 35. For confirmation of Waters' research, the respect shown him by Hopi elders, and of the taped transcripts of his interviews with his Hopi informants, see Deloria, *Frank Waters: Man and Mystic*, 103–104, 233. The Tzutujil Maya every year ritually enact a sacred journey to the four quarters of the universe ending in a return to the center; see Carrasco, *Religions of Mesoamerica*, 126.

2. Genesis 2:6–14, (Authorized Version).

3. van der Toorn, *DDD*, s.v. "One."

4. For the River Ocean in antiquity, see *Oxford Classical Dictionary*, s.v. "Oceanus."

5. James, *Tree of Life*, 73–74.

6. Clarkson, Chase, and Harley, Phylogenetic Relationships in Burseraceae."

7. Exodus 28:9–20; and 1 Chronicles 29:2 (Authorized Version).

8. *Encyclopedia Britannica*, s.v. "Onyx."

9. *Encyclopedia Britannica*, s.v. "Brazil: Mining." In 1925, biologist Charles H. T. Townsend published an article suggesting that the city of "Ophir," an abundant source of gold mentioned repeatedly in the Bible (Ge 10:29; 1 Ki 9:28, 10:11, 22:48; 1 Ch 1:23, 29:4; 2 Ch 8:18, 9:10; Job 22:24, 28:16; Ps 45:9; Isa 13:12), was located on the Amazon River. This city, which has never been located by scholars, is described as being familiar to the Phoenicians, lying across the sea, and requiring a three-year journey to reach it and return. The parallels to Havilah are striking. In Biblical genealogy, Ophir and Havilah are brothers (Ge 10:29; 1 Ch 1:23). For the benefit of King Solomon, the Phoenician navy brought back from Ophir: gold, almug trees, and precious stones (1 Ki 10:11, 2 Ch 9:10). This trio of goods parallels the description of Havilah, which is the source of gold, a valuable tree, and a precious stone ("gold, bdellium and the onyx stone"). The route to Ophir is said to pass through the Red Sea, which Townsend speculates was the route to Brazil, around the Cape of Good Hope. See Sorenson and Raish, *Pre-Columbian Contacts*, s.v. "Townsend, *Ancient Voyages to America*." For the original article by Townsend, see: *Brazilian American*, vol. 12, no. 297 (July 4, 1925): unnumbered pages.

11. Strong, *Concordance of the Bible*, s.v. entry number 2342.

12. Hesiod, *Theogony* 133, trans. Wender.

13. Nonnos, *Dionysiaca* 38.108, trans. Rouse.

14. Hesiod, *Theogony* 337, trans. Wender.

15. Graves, *Greek Myths*, art. 42.d. The Eridanus in the legend of Phaethon has a long history of identification with the Milky Way: see Cook, *Zeus*, vol. 2, 476.

16. Ovid, *Metamorphoses* 2.319, trans. Melville.

17. Hesiod, *Catalogues of Women* Fragment 40a.

18. Homer, *Odyssey* 10.86, trans. Fitzgerald.

19. Tacitus, *Germania* 3, trans. Church and Bodribb, 710.

20. Pausanias, *Description of Greece* 1.4.1, trans. Jones.

21. Herodotus, *Histories*, trans. Rawlinson, 279–80; Strabo, *Geography* 5.1.9, trans. Jones; *Oxford Classical Dictionary*, s.v. "Eridanus."

22. Herodotus, *Histories*, trans. Rawlinson, 279n2; Heubeck, West, and Hainsworth, *Commentary on Homer's Odyssey*, vol. 1, 197.

23. *Encyclopedia Britannica*, s.v. "Amber"; Tacitus *Germania* 45, trans. Church and Bodribb, 731. For a discussion of the ancient amber routes, see Cook, *Zeus*, vol. 2, 493–501 and Plate 26.

24. See Apollonius Rhodius, *Argonautica* 4.595, trans. Seaton, for a reference to the River Eridanus as a "deep lake." The passage noted is quoted in chapter 3.

25. *Oxford Classical Dictionary*, s.v. "Alpheus"; Pausanias, *Guide to Greece* 8.54.3, trans. Levi, vol. 2, 499.

26. Pausanias, *Guide to Greece* 5.7.2–3, trans. Levi, (see also 214n55).

27. Homer, *Odyssey* 11.104, trans. Murray.

28. Apollodorus, *The Library* 2.5.10, trans. Frazer.

29. Hesiod, *Theogony*, trans. Evelyn-White, 287.

Notes to Chapter 3

1. Apollodorus, *The Library* 2.5.5, trans. Frazer (emphasis in text added by author).

2. Apollodorus, *The Library* 2.5.10–12, trans. Frazer (emphasis in text added by author).

3. Ovid, *Metamorphoses* 4.624, trans. Mandelbaum.

4. Hesiod, *Theogony,* trans. Evelyn-White, 215.

5. Homer, *Odyssey* 11.104, 12.374, trans. Lattimore.

6. *Oxford Classical Dictionary,* s.v. "Erytheia."

7. Apollodorus, *The Library* 2.5.10–12, trans. Frazer.

8. A fleece suspended from a tree associated with the Tree of Life was also a feature of Hittite religion. Compare also the ancient legend in which Zeus lays a nuptial veil upon the branches of an oak. This cloth later becomes the world's foundation; see James, *Tree of Life,* 142, 159.

9. Apollonius Rhodius, *Argonautica* 3.219, trans. Seaton, 209. Note that the hot and cold springs described here find parallels in both Plato's description of Atlantis (Appendix 1) and in Homer's description of Troy; see Homer, *Iliad* 22.145, trans. Murray. In Hebrew rabbinical literature, the rivers of Eden flowed with wine, balsam, milk and honey. In Islamic literature, rivers of milk and honey, water and wine, flow from the central Tuba tree; see James, *Tree of Life,* 77, 83.

10. Apollonius Rhodius, *Argonautica* 4.123–165, trans. Seaton.

11. Apollodorus, *The Library* 1.9.24, trans. Frazer.

12. For the Cronian Sea, see, e.g., Apollonius Rhodius, *Argonautica* 4.504, trans. Seaton; Liddell & Scott, *Greek-English Lexicon,* s.v. "Κρόνιας"; and Graves, *Greek Myths,* art. 153.d., vol. 2, 242. For Colchis and the Caucasus, see Hansen, *Prometheus and Loki,* 84.

13. Apollonius Rhodius, *Argonautica* 4.574, trans. Seaton.

14. Homer, *Odyssey* 1.50, trans. Murray. The close resemblance and similar location of the island of "Calypso Atlantis" to the island of Atlantis as described by Plato was also observed by Eustathius; see Taylor, *Essays on the Odyssey,* 79–80, 128n4. For a discussion of Atlas as representation of the axis mundi, see Butterworth, *Tree at the Navel,* 10.

15. Apollonius Rhodius, *Argonautica* 4, trans. Seaton, 579.

16. Apollonius Rhodius, *Argonautica* 4, trans. Seaton, 595.

17. Apollonius Rhodius, *Argonautica* 4, trans. Seaton, 559.

18. Apollonius Rhodius, *Argonautica* 4.960, trans. Seaton, (emphasis in text added by author).

19. Apollonius Rhodius, *Argonautica* 4.1231, 4.1384, trans. Seaton,

20. Apollonius Rhodius, *Argonautica* 4. 268, trans. Seaton,

21. Apollonius Rhodius, *Argonautica* 4.1396, trans. Seaton,

22. Hesiod, *Theogony,* trans. Evelyn-White, 215; and Apollodorus, *The Library,* trans. Frazer, vol. 1, 221n2.

23. Homer, *Odyssey* 4.465–586, trans. Palmer.

24. Homer, *Odyssey* 10.350, trans. Murray.

25. Homer, *Odyssey* 10.490, trans. Lattimore.

26. Homer, *Odyssey* 11.11, trans. Murry.

27. For a discussion of this possible interpolation, see Page, *The Homeric Odyssey,* 35.

28. Homer, *Odyssey* 11.617, trans. Murray.

29. Homer, *Odyssey* 12.375, trans. Murray. Mertz (*Wine Dark Sea,* 118) also makes this observation.

30. Hesiod, *Theogony,* trans. Evelyn-White, 969.

31. Saxo Grammaticus, *Danish History,* quoted in: Page, *Folktales in Homer's Odyssey,* 82–83. For full text see Elton, *Danish History.* For a discussion on the unlikelihood of Homeric influences on Saxo, see Page, *Folktales in Homer's Odyssey,* 126n24. For the tradition of secrecy in the ancient world concerning the locations of mineral and other resources, and the sea routes to obtain them, see Jett, "Diffusion Versus Independent Development", in *Man across the Sea,* Riley, ed., 12, 50; and Kehoe, "Small Boats upon the North Atlantic" in *Man across the Sea,* Riley, ed., 284. For a general discussion of the ability of early civilizations to make transatlantic voyages, and botanical evidence to prove that they did so, see Sorenson and Johannessen, "Biological Evidence."

32. Homer, *Odyssey* 1.85, trans. Murray.

33. *Oxford Classical Dictionary*, s.v. "Ogygus"; Nonnos, *Dionysiaca* 3.205, trans. Rouse.

34. Liddell & Scott, *Greek-English Lexicon*, s.v. "ὀμφαλός." See also Butterworth, *Tree at the Navel*, 33–37.

35. Homer, *Odyssey* 1.48, trans. Murray, revised by Dimock.

36. Homer, *Odyssey* 5.61, trans. Murray. Compare Apollonius Rhodius, *Argonautica* 3.219, trans. Seaton. That the mythical image of a goddess weaving on a loom corresponds to the spinning of the axis mundi, see Butterworth, *Tree at the Navel*, 9.

37. Apollonius Rhodius, *Argonautica* 3.219, trans. Seaton.

38. *Oxford Classical Dictionary*, s.vv. "Calypso," "Circe."

39. Apollonius Rhodius, *Argonautica* 4.662, 4.574, trans. Seaton.

40. Homer, *Odyssey* 10.150, 10.197, 10.210, trans. Murray.

41. Homer, *Odyssey* 1.52, trans. Murray; Apollonius Rhodius, *Argonautica* 4.575, trans. Seaton.

42. Zangger, *The Flood from Heaven*, 114.

43. Plato, *The Works of Plato*, trans. Jowett, 370, 381, 388.

44. Heirtzler, "Floor of the Mid-Atlantic Rift," 158–170.

45. Carthaginian coins were found in the foundations of an ancient structure on Corvo, an island in the Azores group, in 1749. Carthage was a Phoenician colony founded in 814 BC and destroyed by the Romans in 146 BC. See Sorenson and Raish, s.vv. "Genovés Tarazaga, Santiago, *Algunos datos y problemática de posibles contactos transatlánticos precolombinos*," "Hennig, Richard, *Ein münzkundliches Schlusswort zur Frage der Karthager auf den Azoren.*"

Notes to Chapter 4

1. Fairservis, *Roots of Ancient India*, 8, 89, 99, 216, etc.

2. James, *Tree of Life*, 24.

3. Kovacs, trans., *Gilgamesh* 1.1.33, 4.

4. Sturluson, *Prose Edda*, trans. Young, 33–34.

5. van der Toorn, *DDD,* s.v. "Isis."

6. Müller, *Egyptian Mythology*, 37–38.

7. Müller, *Egyptian Mythology*, 367.

8. Müller, *Egyptian Mythology*, 38–39.

9. Sandars, trans., *Gilgamesh* 6.4.150.

10. Sandars, trans., *Gilgamesh* 10.5.24.

11. Gardner and Maier, trans., *Gilgamesh* 9.2.1.

12. Langdon, *Semitic Mythology*, 282.

13. Sandars, trans., *Gilgamesh* 10.2.15.

14. Langdon, *Semitic Mythology*, 210.

15. Gardner and Maier, trans., *Gilgamesh* 9.5.45–9.6.24.

16. Ferry, trans., *Gilgamesh* 11.4.189.

17. Sturluson, *Prose Edda*, trans. Brodeur, 39. Compare Young, trans., 54.

18. Genesis 3:22–24 (Authorized Version).

19. Gardner and Maier, trans., *Gilgamesh* 11.6.258.

20. Ferry, trans., *Gilgamesh* 12.3.75.

21. Compare Sorenson and Raish, s.vv. "Van Buren, E., *The Flowing Vase and the God with Streams*," "Ackerman, Phyllis, *The Dawn of Religions*," where the image of the overflowing vase is explicitly associated with the Milky Way.

22. Widengren, *King and the Tree of Life*, 5–6, 19. Compare Langdon, *Semitic Mythology*, 140.

23. Guirand, *New Larousse Encyclopedia*, 56.

24. Widengren, *The King and the Tree of Life*, 26, 45.

25. James, *Tree of Life*, 13.

26. Kramer, trans., *Sumerian Mythology*, 33–34.

27. van der Toorn, *DDD*, s.v. "Lilith."

Notes to Chapter 5

1. Aristotle, *On the Heavens* 296a. See also references cited in Mertz, *Wine Dark Sea*, 161. Jett also describes the advanced state of geographical knowledge attained by the Greeks as early as 550 BC (spherical shape of the earth), 200 BC (its diameter calculated to a reasonable degree of accuracy), and 150 BC (use of spherical coordinates employing latitude and longitude). See Jett, "Diffusion Versus Independent Development," in *Man across the Sea*, Riley, ed., 8.

2. *Oxford Classical Dictionary*, s.v. "Astronomy."

3. Sauvé, "The Divine Victim," in *Myth and Law*, 181–83; see also Butterworth, *Tree at the Navel*, 24.

4. James, *Tree of Life*, 66.

5. Eliade, *Images and Symbols*, trans. Mairet, 45, 48, 50.

6. Eliade, *Images and Symbols*, trans. Mariet, 40, 47.

7. James, *Tree of Life*, 69. For a discussion of the omphalos, pillar, and axis mundi, see Cook, *Zeus*, vol. 2, 166–193. In 1913, Alfred Jeremias, a Lutheran preacher in Germany, suggested that the kiskanu tree of Mesopotamia was an image of the Milky Way as world-tree (Jeremias, *Handbuch*, 60). For this he was roundly ridiculed by Cook: "But A. Jeremias … adds, with confident dogmatism, that the Milky Way is here conceived as a world-tree. I am, however, assured by my learned friend the late Dr. C. H. W. Johns and by Mr. Sidney Smith of the British Museum that there is not the slightest ground for supposing any allusion to the galaxy" (Cook, *Zeus*, vol. 2, 483). See also Jeremias, *Handbuch*, 2nd ed., 154, 222, 232, 236, 237, 357.

8. Eliade, *Images and Symbols*, trans. Mairet, 41.

9. James, *Tree of Life*, 140.

10. Eliade, *Images and Symbols*, trans. Mairet, 42. For the traditional connection of the omphalos to the Tree of Life, see Butterworth, *Tree at the Navel*, 32.

11. Eliade, *Images and Symbols*, trans. Mairet, 43.

12. James, *Tree of Life*, 143. The Tree of Life appears also in the book of Daniel (4:10–12) as the vision of Nebuchadnessar, associated with the king himself. It is common for the king to be identified with the axis mundi in many traditions. For Mesopotamia, see Widengren, *The King and the Tree of Life in Ancient Near Eastern Religion*. For Mesoamerica, see Schele, *The Blood of Kings*, 72, 77, 109, 179. Another biblical reference to the Tree of Life is the burning bush, as seen by Moses. It burned but was not consumed by the flames (Ex. 3:1).

13. James, *Tree of Life*, 18–19, 33.

14. James, *Tree of Life*, 162. Compare Eliade, *Images and Symbols*, trans. Mairet, 163.

15. Schliemann, *Troy and its Remains*, 102; Wilson, *Swastika*, 776, 950, 952. For a discussion of the ancient use of the fleur-de-lys as an axis mundi symbol, see Butterworth, *Tree at the Navel*, 21.

16. Wensinck, *Navel of the Earth*, 15. Compare Eliade, *Images and Symbols*, trans. Mairet, 42.

17. Eliade, *Images and Symbols*, trans. Mairet, 44.

18. James, *Tree of Life*, 160; Eliade, *Sacred and the Profane*, trans. Trask, 35; For an identification of the Irminsul with the axis mundi and the Milky Way, see Cook, *Zeus*, vol. 2, 50–57, 100. For the pillars of Zeus (or Roman Jupiter) and their typical proximity to water and sacred wells, see Cook, *Zeus*, vol. 2, 88–93.

19. Eliade, *Sacred and the Profane*, trans. Trask, 36.

20. Eliade, *Sacred and the Profane*, trans. Trask, 53.

21. James, *Tree of Life*, 48–49. For the Milky Way as a pillar of light and a soul ladder leading

from earth to heaven, see Cook, *Zeus,* vol. 2, 114–140; and Sorenson and Raish, s.vv. "Gibbon, William, *Asiatic Parallels in North American Star Lore,*" "Holland, William, *Contemporary Tzotzil Cosmological Concepts.*"

22. James, *Tree of Life,* 88.

23. Danielou, *Myths and Gods of India,* 134.

24. Hunt, *Transformation of the Hummingbird,* 80. See also Sorenson and Raish, s.v. "Dretschmar, Freda, *Hundestammvater und Kerberos.*"

25. Eliade, *Images and Symbols,* 164.

26. de Santillana, *Hamlet's Mill,* 319.

27. de Santillana, *Hamlet's Mill,* 247. For the stags that typically figure on the pillars of Diana, see Cook, *Zeus,* vol. 2, 146. Note also that in the Germanic languages, the word for *deer* is cognate to the Indo-European word for *tree* (Pok. *deru- 214).

28. See also the fiery olive tree of Tyre which, according to Nonnos, gave forth a friendly glow from its eternally burning trunk, but was never consumed by the fire. This tree was said to grow in the navel of the rock which is radiant; see Butterworth, *Tree at the Navel,* 45, 86.

29. Eliade, *The Quest,* 69.

30. Danielou, *Myths and Gods of India,* 353–55.

31. Kuiper, "The Bliss of Aša," 117.

32. Diodorus of Sicily, *Bibliotheca Historica* 1.27.6, trans. Oldfather.

33. Pausanias, *Guide to Greece* 1.14.3, trans. Levi.

34. Apollonius Rhodius, *Argonautica* 1.915, trans. Seaton.

35. Herakleitos *Fragment,* trans. Davenport, 14.

Notes to Chapter 6

1. Holmberg, *Finno-Ugric Mythology, Siberian,* 349–359. For more on the serpent-eagle symbolism of the Tree of Life, see Butterworth, *Tree at the Navel,* 83–88.

2. Markman, *The Flayed God,* 394, 408, 411.

3. Leach, ed., *Standard Dictionary of Folklore,* s.v. "Churning of the Ocean."

4. Holmberg, *Finno-Ugric Mythology, Siberian,* 333.

5. Holmberg, *Finno-Ugric Mythology, Siberian,* 335.

6. Holmberg, *Finno-Ugric Mythology, Siberian,* 413. An obvious indicator that this lake of milk represents the Milky Way can be seen from the episode when the White Youth asks what lies beyond the sky. He is told that the Lake of Milk can be found there. But when he inquires about the dark patch in the middle, he is told that there lies the wood where the bird dwells (Butterworth, *Tree at the Navel,* 7), a clear reference to the darkness of the Great Rift and to the bird constellations lying with it. See chapters 5 and 7.

7. Kirby, trans., *Kalevala* 2.49.

8. Kirby, trans., *Kalevala* 2.77.

9. Kirby, trans., *Kalevala* 2.179–196.

10. Kirby, trans., *Kalevala* 2.271.

11. Kirby, trans., *Kalevala* 1.37.

12. de Santillana and von Dechend, *Hamlet's Mill,* 111–112. The book cited here notes many instances of axis mundi images in world myth. The thesis of its authors is that these mythical references primarily reflect the so called "precession of the equinox," a phenomenon caused by a wobble in the earth's axis. As a result of this wobble, the position of the celestial poles describes a large circle in the sky requiring nearly 26,000 years to complete. Another result is that the vernal equinox moves from one zodiac sign to another over this period of time, defining the various "world ages," such as the age of Pisces or the age of Aquarius. While the theory of these authors is quite ingenious, the mythological imagination of ancient people is unlikely to have been stimulated by such an abstract concept. The precession is imperceptible within a human lifetime, and is too far removed from direct experience to have become a central focus

of ancient religion.

13. Sauvé, "The Divine Victim," in *Myth and Law*, Puhvel, ed., 182.

14. Kirby, trans., *Kalevala* 7.311.

15. Kirby, trans., *Kalevala* 8.1–26.

16. Kirby, trans., *Kalevala* 8.123.

17. Kirby, trans., *Kalevala* 8.151.

18. Kirby, trans., *Kalevala* 9.43, 9.281.

19. Kirby, trans., *Kalevala* 10.129.

20. Kirby, trans., *Kalevala* 10.413.

21. Kirby, trans., *Kalevala* 16.44.

22. Kirby, trans., *Kalevala* 16.63.

23. Kirby, trans., *Kalevala* 16.335.

24. Kirby, trans., *Kalevala* 42.141.

25. Kirby, trans., *Kalevala* 42.179.

26. Kirby, trans., *Kalevala:* 43.423.

27. Irish monks had occasionally taken up residence on Iceland at least by 795 AD, calling it by the name Thule; see Kehoe, "Small Boats upon the North Atlantic," in *Man across the Sea*, Riley, ed., 282.

28. Turville-Petre, *Myth and Religion of the North*, 12.

29. Sturluson, *Gylfaginning*, in *Prose Edda*, trans. Brodeur, 27; compare trans. Young, 42. In the case of the *Prose Edda*, cross-references in this chapter are made to the translation by Jean Young. For the *Poetic Edda*, cross-references are to the translation by Lee M. Hollander.

30. "He cast the serpent into the deep sea, where he lies about all the land; and this serpent grew so greatly that he lies in the midst of the ocean encompassing all the land, and bites upon his own tail." Quoted from Sturluson, *Gylfaginning*, in *Prose Edda*, trans. Brodeur, 42; compare trans. Young, 56.

31. "Just as cold arose out of Niflheim, and all terrible things, so also all that looked toward Múspellheim became hot and glowing; but Ginnungagap [Yawning Void] was as mild as windless air, and when the breath of heat met the rime [ice], so that it melted and dripped, life was quickened from the yeast-drops, by the power of that which sent the heat, and became a man's form. And that man is named Ymir." Quoted from Sturluson, *Gylfaginning*, in *Prose Edda*, trans. Brodeur, 17; compare trans. Young, 33. Note also that Ymir gives birth from his side (under his left arm); see Sturluson, *Gylfaginning*, in *Prose Edda*, trans. Young, 34.

32. Hollander, trans., *Grímnismál* 26, in *Poetic Edda*, 58.

33. "The third root of the ash stands in heaven; and under that root is the well which is very holy, that is called the Well of Urd; where the gods hold their tribunal." Quoted from Sturluson, *Gylfaginning*, in *Prose Edda*, trans. Brodeur, 27; compare trans. Young, 43. Note that I have regularized the spelling of Urd's name throughout.

34. Hollander, trans., *Voluspá*, in *Poetic Edda*, 4n17. Compare the three goddesses of fate, Lacheses, Clotho, and Atropos, located together at the axis mundi. See Plato, *Collected Dialogues*, eds. Hamilton and Cairns, 840–841.

35. Bellows, trans., *Voluspá* 19–20, in *Poetic Edda*, 9 (I have reversed the order of the clauses in line four of stanza 20 for greater clarity.) Compare trans. Hollander, 4.

36. Sturluson, *Gylfaginning*, in *Prose Edda*, trans. Brodeur, 30; compare trans. Young, 45–6.

37. "An eagle sits in the limbs of the Ash, and he has understanding of many a thing; and between his eyes sits the hawk that is called Vedrfölnir." Sturluson, *Gylfaginning*, in *Prose Edda*, trans. Brodeur, 29; compare trans. Young, 45.

38. "Straightway after the [ice melted], there sprang from it the cow called Audumla; four streams of milk ran from her udders." Quoted from Sturluson, *Gylfaginning*, in *Prose Edda*, trans. Brodeur, 18; compare trans. Young, 34.

39. "The Aesir ride up to that place every day over the bridge Bifröst ... and Thór walks to the court wading through the rivers that have these names: Körmt and Örmt and both the

Kerlaugar these must Thór wade through every day, when he goes to give judgment at Yggdrasil's ash, since the Bridge of the Aesir is flaming with fire the sacred waters glow." Quoted from Sturluson, *Gylfaginning*, in *Prose Edda*, trans. Young, 44. Also see *Grímnismál* 29, in *Poetic Edda*, trans. Hollander, 59. Snorri identifies the bridge with the rainbow, but it is not uncommon in myth for the axis mundi/galaxy to be confused or deliberately misidentified with the rainbow. See Butterworth, *Tree at the Navel*, 11, for a comparison to Plato's account (*Rebublic* 616b) of the death and resurrection of Er.

40. Hollander, trans., *Grímnismál* 26, in *Poetic Edda*, 58. A reference to this stag occurs also in the *Prose Edda*: "Even more notable is the stag Eikthyrnir [Oak Antlers], who stands on top of Valhalla and chews on the branches of that tree. So much moisture drips from his horns that it finds its way down into Hvergelmir. From there flow the rivers ..." Quoted from Sturluson, *Gylfaginning*, in *Prose Edda*, trans. Byock; compare trans. Young, 64.

41. Snorri Sturluson, *Gylfaginning*, in *Prose Edda*, trans. Young, 45. The presence of these four stags in the branches of Yggdrasill is also attested in the Poetic Edda: "Harts there are also four, which from its summits, arch-necked, gnaw. Dâin and Dvalin, Duneyr and Durath-rôr." Quoted from Thorpe, trans., *Grímnismál* 33 in *Poetic Edda*, 23; compare trans. Hollander, 60 (reflects the standard numbering as *Grímnismál* 34).

42. Snorri Sturluson, *Gylfaginning*, in *Prose Edda*, trans. Byock, 48; compare trans. Young, 64.

43. "Heidrûn the goat is called, that stands o'er Odin's hall, and bites from Laerâd's branches. He a bowl shall fill with the bright mead; that drink shall never fail." Quoted from Thorpe, trans., *Grímnismál* 25, in *Poetic Edda*, 22; compare trans. Hollander, 58.

44. "Garm bays loudly before Gnipa-cave, he rope will break and the ravener run free, much wisdom she knows, I see further ahead to the terrible doom of the fighting gods." Quoted from Larrington, trans., *Voluspá* 44, in *Poetic Edda*, 10; compare trans. Hollander, 9, 9n61.

45. Thorpe, trans., *Baldr's Dreams* 6, in *Poetic Edda*, 27. Compare *Baldrs Draumar* 2, in Hollander, trans., *Poetic Edda*, 117, 117n6.

46. Hollander, trans., *Lay of Svipdag* 1, 5, in *Poetic Edda*, 143, 144, 144n3.

47. Hollander, trans., *Lay of Svipdag* 2, in *Poetic Edda*, 144.

48. Bellows, trans., *Svipdagsmol* 35–36, in *Poetic Edda*, 244. Compare trans. Hollander 147, 147n23.

49. Hollander, trans., *Lay of Svipdag* 35–40, in *Poetic Edda*, 144.

50. Hollander, trans., *Lay of Grotti*, in *Poetic Edda*, 153–58.

51. Turville-Petre, *Myth and Religion of the North*.

52. Bellows, trans., *Havamol* 139–140, *Poetic Edda*, 60–61. Compare trans. Hollander, 36.

53. Turville-Petre, *Myth and Religion of the North*, 42–51. Not all scholars accept this view. Several attempts have been made to demonstrate borrowings from Christianity; see Hollander, *Poetic Edda*, 36n67. The occurrence of this cosmic side wound in so many other pre-Christian mythological contexts, however, suggests that its appearance at the Christian crucifixion is a later instance of this ancient motif, rather than its prototype.

54. Sturluson, *Prose Edda*, trans. Jean Young, 45. See also Hollander, trans., *Grímnismál* 36, in *Poetic Edda*, 60.

55. Hollander, trans. *Poetic Edda*, 2. Note that Jaan Puhvel also suggests an identification of Heimdall with the axis mundi, deriving his name from linguistic roots denoting *World Tree*. See his *Comparative Mythology*, 212.

56. Sturluson, *Prose Edda*, trans. Brodeur, 40.

57. Sturluson, *Prose Edda*, trans. Brodeur, 40.

58. The mythical link between the cornucopia and the goat Amalthea in Greek myth, who later became the constellation Capricorn, may help explain the Gjallarhorn of Heimdall. The Great Rift in the galaxy forms a horn-like structure with its open end located at the position of Capricorn (Figure 7.1). See also Butterworth, *Tree at the Navel*, 42–43.

59. Thorpe, trans., *The Lay of Rig* 6, 30, in *Poetic Edda*, 78, 81

60. Sturluson, *Skáldskaparmál* 8, in *Prose Edda*, trans. Brodeur, 113.

61. Rydberg, *Teutonic Mythology*, art. 82. Rydberg argues for an identification of Heimdall with the Indo-Aryan fire-god Agni. This link is plausible, since both gods exhibit axis mundi characteristics.

62. In support of this identification of Heimdal with the axis mundi, see de Santillana and von Dechend, *Hamlet's Mill*, 157–9.

63. Jones, *Discourse, On the Hindus*. The concept of "four vast rocks" adjoining the central axis of the world is common. In some cases they are considered islands, in others they are the four regions of the earth. In the Indian tradition, they lie in the salt sea, they are four special parts of the earth, and they are large islands. See Butterworth, *Tree at the Navel*, 2.

64. Baumer, *Bon: Tibet's Ancient Religion*, 86.

65. Karmay, *Treasury of Good Sayings*, "Introduction," p. xxxiv.

66. Baumer, *Bon: Tibet's Ancient Religion*, 158.

67. Baumer, *Bon: Tibet's Ancient Religion*, 89.

68. Karmay, *Treasury of Good Sayings*, 23.

69. Karmay, *Treasury of Good Sayings*, xvii, 20, and 26.

70. Karmay, *Treasury of Good Sayings*, xxviii.

71. Baumer, *Bon: Tibet's Ancient Religion*, 78.

72. Baumer, *Bon: Tibet's Ancient Religion*, 29.

73. Baumer, *Bon: Tibet's Ancient Religion*, 29, 37.

74. Baumer, *Bon: Tibet's Ancient Religion*, 32.

75. Danielou, trans., *Mahanirvana Tantra* 5.172–76, in *The Myths and Gods of India*, 353–55.

76. Danielou, *The Myths and Gods of India*, 353–55.

77. Baumer, *Bon: Tibet's Ancient Religion*, 51.

78. Baumer, *Bon: Tibet's Ancient Religion*, 21.

79. Baumer, *Bon: Tibet's Ancient Religion*, 111.

80. Gimbutas, *Goddesses and Gods of Old Europe*, 78–80. See also James, *Tree of Life*, 29–33, 43, 49, 226, 229.

Notes to Chapter 7

1. Jung and Kerényi, *Essays on a Science of Mythology*, 16–17, 92. Contrast Jung's view with a diffusionist perspective of the world directions in: Sorenson and Raish, s.v. "Brogue, Patricia, *The World Directions in Greece, India, and Meso-America.*"

2. Gardner and Maier, trans., *Gilgamesh* 9.2.1.

3. Plato (*Republic*, eds. Hamilton and Cairns, 616) describes "extended from above throughout the heaven and the earth, a straight light like a pillar, most nearly resembling the rainbow, but brighter and purer." This, he says, is the spindle of Necessity, the center of all the planetary revolutions, the dwelling of the three goddesses of fate.

4. See Cook, *Zeus*, vol. 2, 840, for associations of the axis mundi and the Milky Way. Cook, however, cannot recognize the axis mundi as the Tree of Life; see notes to chapter 5.

5. James, *Tree of Life*, 162. See also: Eliade, *Images and Symbols*, trans. Mairet, 163.

6. James, *Tree of Life*, 148.

7. Rey, *The Stars*, 129; see also Jeremias, *Handbuch*, 2nd ed., 234.

8. Hollander, trans., *Voluspá* 28, in *Poetic Edda*, 5.

9. Apuleius, *The Golden Asse*, 259, 261, 269.

10. Griffiths, *Plutarch's De Iside et Osiride*, 350; Budge, *Gods of the Egyptians*, vol. 2, 212.

11. Ford, trans., *Mabinogi*, 70.

12. For the sometimes hermaphroditic character of the omphalos and Tree of Life, see Butterworth, *Tree at the Navel*, 37. For a particularly revealing (but also recondite) association of the Hermaphrodite with images of the galaxy and the Tree of Life, see Maier's discourse on

Emblem 38 in de Jong, *Michael Maier's Atalanta Fugiens*, 253–254. Hermes is said to inhabit one peak of the "two-topped [mountain] Parnassus," and Venus (Aphrodite) the other. Hence, the name Hermaphrodite is composed of the names for Hermes and Aphrodite, each of which occupies one of the branches of the galaxy at the Great Rift.

13. Griffiths, *Plutarch's De Iside et Osiride*, 137; for a long list of irregular births from the side of gods and goddesses in mythology, see Cook, *Zeus*, vol. 3, 95n3. For Meso-American parallels, see Sorenson and Raish, s.v. "Furst, Jill, *The Tree Birth Tradition*."

14. Apollonius Rhodius, *Argonautica* 1.503, trans. Seaton. See also Liddell & Scott, *Greek-English Lexicon*, s.v. "ὄφις," and Graves, *The Greek Myths*, art. 1.

15. van der Toorn, *DDD*, s.v. "Typhon."

16. Apollodorus, *The Library* 1.6.3, trans. Frazer.

17. Griffiths, *Plutarch's De Iside et Osiride*, 259, 59, 86; van der Toorn, *DDD*, s.v. "Typhon." The huge jets of fire from Typhon's mouth may be an allusion to the great bulge in the galaxy located in the constellation Sagittarius, just beyond the limits of the great rift (which represents the serpent's mouth). This astronomic feature results from the location of the true galactic center in Sagittarius. See also chapter 12, note 9 below.

18. van der Toorn, *DDD*, s.v. "Typhon." See also Liddell & Scott, *Greek-English Lexicon*, s.v. "Τυφώς."

19. Hesiod *Theogony* 333, trans. Evelyn-White.

20. Isaiah 27:1 (Authorized Version). For his identity as serpent, see van der Toorn, *DDD*, s.v. "Leviathan."

21. Job 41:12–23, 31–34 (Authorized Version).

22. Leach, ed., *Dictionary of Folklore, Mythology and Legend*, s.v. "Milky Way"; Cook, *Zeus*, vol. 2, 479, 482.

23. van der Toorn, *DDD*, s.v. "God."

24. Genesis 2:10 (Authorized Version).

25. Kuperjanov, "Names in Estonian Folk Astronomy." Cook identifies the "Road of the Birds" upon which Apollo and Artemis travel to the land of the Hyperborians as the Milky Way. See Cook, *Zeus*, vol. 2, 462–464.

26. Pausanias, *Guide to Greece*, 2.17.4, trans. Levi.

27. Ovid, *Metamorphoses* 6.110, trans. Mandelbaum.

28. Apollodorus, *The Library* 3.10.7, 23.

29. *Encyclopedia Britannica*, s.v. "Cygnus," *Oxford Classical Dictionary*, s.v. "Constellations."

30. Euripides *Helen*, trans. Vellacott, 136. For references to Helen as a tree goddess, see *Oxford Classical Dictionary*, s.v. "Helen." See also: Puhvel, *Comparative Mythology*, 141.

31. Pausanias, *Guide to Greece*, 3.19.10–11, trans. Levi.

32. Apollodorus, *The Library* 2.4.1, trans. Frazer.

33. Guirand ed., *Encyclopedia of Mythology*, 106–7.

34. Graves, *The Greek Myths*, art. 58b. For a lengthy discussion of Europa as a tree goddess, see Cook, *Zeus*, vol. 1, 527–541. For a general treatment of Zeus in the form of an ox, see Cook, *Zeus*, vol. 3, 605–655.

35. Ovid, *Metamorphoses* 2.855, trans. Mandelbaum.

36. Theseus kills the Minotaur at the center of the Labyrinth. For a persuasive argument that the original form of the labyrinth was a swastika, see Cook, *Zeus*, vol. 1, 472–490. This association of the axis mundi god, Theseus, with the swastika-shaped labyrinth, corresponds with the same pairing in the Bon Po religion of Tibet, where the axis mundi is called the Nine-story Swastika Mountain.

37. van der Toorn, *DDD*, s.v. "Behemoth."

38. Müller, *Egyptian Mythology*, 367.

Notes to Chapter 8

1. Wilson, *Swastika*, 888–9. For a modern commentary on the Hopewell finds, and yet another interpretation of the swastika symbol, see Sorenson and Raish, s.v. "Freed, Stanley and Ruth, *Swastika: A New Symbolic Interpretation*."

2. Wilson, *Swastika*, 764.

3. Accounts left by members of the De Soto expedition describe a red-haired, blue-eyed, fair-skinned tribe of Indians in the mountains of Tennessee; see Sorenson and Raish, s.vv. "Hudson, Charles, *The Juan Pardo Expedition: Exploration of the Carolinas and Tennessee, 1556–1568*," "Knobloch, Francis J., *The Aharaibu Indians: A 'White' Tribe in the Amazon*."

4. Mercatante, *Who's Who in Egyptian Mythology*, s.v. "Geb"; Griffiths, *Plutarch's De Iside et Osiride*, 85.

5. Campbell, *Mythologies of the Great Hunt*, 217–18.

6. Eliade, *The Sacred and the Profane*, trans. Trask, 35. Among the Olmecs, the Tree of Life was conceived as a tree that excreted a white juice. See Briggs, *Tree of Life*, 50. See also Sorenson and Raish, s.v. "Krickeberg, Walter et al., eds., *Die Religionen des alten America*."

7. Aveni, *Stairways to the Stars*, 49.

8. Milbrath, *Star Gods of the Maya*, 264, compare 39, 249. See also Sorenson and Raish, s.v. "King, Mary E., *Tree Worship in Mesoamerica and Some Asiatic Comparisons*." For a depiction of the Tree of Life in the vase painting described here, see D. Tedlock, trans., *Popol Vuh*, 90–91.

9. Hunt, *Transformation of the Hummingbird*, 80, 141.

10. Tedlock, B., *Time and the Highland Maya*, 188.

11. Milbrath, *Star Gods of the Maya*, 291. See also folio 3 in *Los Códices de Dresde, París y Grolier* (The Dresden Codex), 53, 78, 34, 42. See also Schele, *Blood of Kings*, 42, 55, 72, 77, 109, 179, 182, 268, 269.

12. Milbrath, *Star Gods of the Maya*, 39.

13. Waters, *Book of the Hopi*, 35.

14. Waters, *Book of the Hopi*, 166.

15. Powell, ed., *Bureau of Ethnology Report 1886–1887*, Plate 121.

16. See Campbell, *Mythologies of the Great Hunt*, 241.

Figure Notes.1 Lycian coin with owl (representing Athena?) peering from within an ogee swastika, comparable to the representation of Jun Raqan in the Maya swastika (see Chapter 8, note 17).

17. Tedlock, D., trans., *Popol Vuh*, 203–4. See also Carmack and Mondloch, trans., *Titulo de Totonicapán*, 174–176, 181–185, and Raynaud, et al., trans., *Anales de los Xahil*, 3, 14, 15, 19, 24, 170n40, 174n84. D. Tedlock, reversing his earlier opinion, claims the text should read "from beside the sea" instead of "from across the sea," suggesting that the Maya place of origin was Yucatan (16, 219). All of the ancient texts, however, are emphatic that the Maya place of origin was in the East where the sun rises, whereas Yucatan is north from the Maya territory in Guatemala. Furthermore, a later passage in the *Popol Wuj* recounts how the K'iche' Maya lords made a journey to the East "where our fathers came from," and in so doing they "passed over the sea" (chuwi palo). This implies a journey across the sea rather than a mere visit to the seashore of Yucatan. In yet another description of how the ancestors originally came from the east, the words in the text indicate again that they "crossed over the sea" (ki ik'owik uloq pa palo). (See Colop, ed., *Popol Wuj: Versión Poética K'iche'*, 140, 174, and compare D. Tedlock, 158, 179.) The king of the land to the east is named Nacxit, who is identified with Quetzalcoatl. Curiously, in the Nahuatl language of Mexico, the word *Nacxit* means "Four Foot" (D. Tedlock, 315). Could this be an oblique reference to the (four-legged) swastika whose center lay to the east? This possibility is strengthened by the illustration reproduced in D. Tedlock (68), in which Jun Raqan (One-Leg, Heart of Sky) peers out from within a stylized ogee swastika (the lower right arm of which is missing or stunted).

18. Tedlock, D., trans., *Popol Vuh*, 174.

19. Wilson, *Swastika*, 897–900.

20. Campbell, *The Sacrifice*, 36; Carrasco, *Religions of Mesoamerica*, 51, 52, 100–103.

21. Markman, *Flayed God*, 167.

22. Markman, *Flayed God*, 91. See also folios 75–76, *El Códice de Madrid* (*The Madrid Codex*) 70, 155–156.

23. de Olmos, *Historia de los Mexicanos*, trans. Mahler, quoted in Markman, *Flayed God*, 129.

24. Nicholson, *Art of Aztec Mexico*, 79.

25. *Codex Chimalpopoca*, in Markman, *Flayed God*, 137. Quetzalcoatl is also conceived as a god who can be found, like many axis mundi deities, in heaven, on earth, and in the underworld. See also Briggs, *Tree of Life*, 25–26.

26. Campbell, *Mythic Image*, 150. In the *Popol Wuj*, the god Tohil makes fire by pivoting inside his sandal (an example of axis mundi vortex-motion). Tohil is equivalent to the Mexican god Quetzalcoatl, as the *Popol Wuj* makes explicit: "Xawi xere Tojil ub'i' ukab'awil Yaki winaq. Yolkwat Kitzalkwat, ub'i'" (Colop, ed., *Popol Wuj: Versión Poética K'iche'*, 148). Compare D. Tedlock, *Popol Wuj*, rev. ed., 162. D. Tedlock argues (305) that the text is mistaken, and that the Mexican identification of Tohil is instead Tezcatlipoca. But as Eva Hunt points out (*Transformation of the Hummingbird*, 153, 165) Quetzalcoatl was but one aspect of Tezcatlipoca. Other axis mundi aspects of Tezcatlipoca include the following (page numbers following are to Hunt, *Transformation*): He is the axis or North Pole; ruler of all directions; he is the Northern Wheel, the celestial pole; he is the heart of heaven, heart of earth (148); he is one-legged (240, 242); he is god of tornadoes, waterspouts, and whirlwinds (all vortex motions) (241, 242); and like Prometheus, he created fire (218). Also see note 31, below.

27. Markman, *Flayed God*, 349.

28. Durán, *Histories of the Indies of New Spain*, trans. Heyden, 213. Compare Markman, *Flayed God*, 416, and Tezozómoc, *Crónica Mexicayotl*, in Markman, *Flayed God*, 395.

29. Durán, *Historia de las Indias*, in Markman, *Flayed God*, 418–23.

30. Hunt, *Transformation of the Hummingbird*, 153, 165

31. Hunt, *Transformation of the Hummingbird*, 148, 218, 240–242. Eva Hunt, in her analysis of a Zinacantecan mythical poem, identifies the mythical one-legged hummingbird with Huitzilopochtli, the hummingbird god that was yet another form of Tezcatlipoca. She does not, however, recognize the identity of both the hummingbird and Tezcatlipoca with the Milky Way galaxy, instead identifying the hummingbird with the sun. The characteristics of the mythical hummingbird as described in the Zinacantecan poem are revealing. Its size is enormous. It is white. It descends to the earth from the sky through a fire that is highly visible since this fire is so tall. It flies in the evening. And it is called One Leg … These rather transparent galaxy attributes, combined with the axis mundi characteristics of Tezcatlipoca, serve to mark the mythical hummingbird with a large number of the fifteen attributes of the Tree of Life. See her *Transformation of the Hummingbird*, 28–30, 65, 122–123, 164. On the other hand, her recognition of the identity between the galaxy and the Mesoamerican axis mundi is remarkable for its clarity. "I believe that the snake was not the sky as a whole, but rather the Milky Way. The image was double-headed because the Milky Way forks into two branches" (75). She also recognizes the mythical navel or omphalos in Mesoamerican legend as representing the celestial axis (114), and equates the Milky Way with a double trunk tree and as a road linking heaven, earth and the underworld (151, 205). Further evidence that Tezcatlipoca was an axis mundi god can be seen from descriptions of him as a giant who wanders at night with his head in his hands wearing an ash-colored veil (Guirand, ed., Aldington and Ames, trans., *LEM*, 436), and by his identification with Quetzalcoatl dwelling in the Milky Way. The Aztec Tezcatlipoca's epithet, One-Leg, is reflected in Mayan literature as the god Jun Raqan (Huricane), also meaning "one leg" in the K'iche' Maya language. Jun Raqan is called "Uk'ux kaj," meaning heart (or center) of sky. This designation links Jun Raqan with the axis mundi, at the omphalos (center) of heaven (see Colop, ed., *Popol Wuj: Versión Poética K'iche'*, 25, and compare D. Tedlock's note, *Popol Wuj*, rev. ed., 223). For a comparison of Tezcatlipoca with the Vedic god Rudra-Siva, see Sorenson and Raish, s.v. "Giesing, Kornelia, *Rudra-Siva und Tezcatlipoca*." For additional discussion of the double-headed serpent as a Milky Way image,

see Sorenson and Raish, s.v. "Carlson, John B., *The Double-Headed Dragon and the Sky.*" For a reference to American Indian belief in the Milky Way as a place where human spirits go after death, see Sorenson and Raish, s.v. "DuBois, Constance, *The Religion of the Luiseño Indians.*"

32. Hunt, *Transformation of the Hummingbird*, 140–141.

33. de Sahagún, *General History of the Things of New Spain, Book 3: The Origin of the Gods*, 13, trans. Anderson and Dibble. Compare Markman, *Flayed God*, 353, 365.

34. Bierhorst, *Annals of Cuauhtitlan*, in *History and Mythology of the Aztecs*, 31.

35. von Hagen, *Ancient Sun Kingdoms*, 217–18.

36. von Hagen, *Ancient Sun Kingdoms*, 37–38; Waters, *Book of the Hopi*, 251; Carrasco, *Religions of Mesoamerica*, 45, 59.

37. Waters, *Book of the Hopi*, 112, 31, 252–53, 252n.

38. Waters, *Book of the Hopi*, 252.

39. Liddell & Scott, *Greek-English Lexicon*, s.v. "σύμβολον."

40. Maier, *Atalanta Fugiens*, 166–167, 175. [Note: Unless otherwise noted, all translations of Maier given in the text are my own. In these endnotes, however, for purposes of comparison, I have reproduced the original Latin, followed by a page reference to the translation of H. M. E. de Jong in *Michael Maier's Atalanta Fugiens*]: "Talia esse Philos. Dogmata, q. faltem in illis versatus est, facile intelliget. Ubi n.unum dicitur, & alterum intelligitur, ibi aequocatio errorem parit, q. Solis Philos. Non solùm concessum, sed & imperatum est. ... Nam quae vera sunt, etiamsi sub velo allegoriae tecta, miro inter se suffragio consentiunt." [Compare de Jong, 257, 265.]

41. Maier, *Atalanta Fugiens*, 2: "Auribus ista tuis, oculísque Emblemata prostent, / At ratio arcanas expetat inde notas: / Sensibus haec objecta tuli, intellectus ut illis / Illicibus caperet, quae preciosa latent." [Compare de Jong, 316.]

42. Maier, *Atalanta Fugiens*, Emblema 46, 193: "Jupiter è DELPHIS aquilas misisse gemellas / Fertur ad Eôas Occiduasque plagas: / Dum medium explorare locum desiderat Orbis, / (Fama ut habet) Delphos hae rediêre simul. / Ast illae lapides bini sunt, unus ab ortu, / Alter ab occasu, qui bene convenient." [Compare de Jong, 282. For my translation of *Orbis* as "earth disk," see Andrews, *Latin-English Lexicon*, s.v. "orbis."]

43. Maier, *Atalanta Fugiens*, Emblema 47, 197: "Hinc, ubi Sol oritur, Lupus advenit, ast ubi Ponto / Mergitur, inde canis, qui duo bile tument: / Hunc is, et hic illum, stimulante furore momordit, / Et rabidus rictu visus uterque fuit. / Sunt gemini hi lapides, gratis qui dantur ubique / Omnibus atque omni tempore, quos teneas." [Compare de Jong, 285–286.]

44. Maier, *Atalanta Fugiens*, Discourse to Emblem 47, 198: "Hi lapides sunt verissimum Bezoar ex quibus praestantissimum mittit India Orientalis ex ferarum ventre depromptum, aliud sed minoris efficaciae dat India Occidentalis, Peruana, ex cicuribus animalibus acceptum; Sic oriens dat lupum atrocissimum, occidens canem hominibus familiarem ... Qui duo quàm primum se invicem offendunt, in mutuos morsus incidunt: Canis verò magnitudine insignis primam victoriam obtinet prostrando lupum & semianimem reddendo: At lupus vires recolligens post canem dejicit eíque dejecto instat usque ad internecionem; Interim non minora vulnera nec minus lethalia, quam intulerat cani, ab eo recipiens, donec se mutuis consiciant & interimant morsibus." [Compare de Jong, 286–287.]

45. Lambsprinck, *The Book of Lambspring*, Figure 5; The translation given is mine. The original Latin is quoted by de Jong, 456: "Lupus & Canis sunt in una domo / Postremo tamen ex his unum sit." [Compare de Jong, 376.]

46. Lambsprinck, *The Book of Lambspring*, Figure 5, http://www.levity.com/alchemy/lamb-text.html: "Alexander writes from Persia / That a wolf and a dog are in this field, / Which, as the Sages say, / Are descended from the same stock, / But the wolf comes from the east, / And the dog from the west. / They are full of jealousy, / Fury, rage, and madness; / One kills the other, / And from them comes a great poison. / But when they are restored to life, / They are clearly shewn to be / The Great and Precious Medicine, / The most glorious Remedy upon earth, / Which refreshes and restores the Sages, / Who render thanks to God, and do praise Him."

47. de Jong, *Michael Maier's Atalanta Fugiens,* 351.

48. See *New Advent Catholic Encyclopedia* for an introduction to Terry's translation. See also the following note.

49. Terry, trans., *Sibylline Oracles* 14.448.

50. *Sibylline Books* 14.349 (original Greek text).

51. Compare Sorenson and Raish, s.v. "Thompson, J., *Rise and Fall*" (especially the commentary to pages 42–43).

Notes to Chapter 9

1. Wood, *In Search of the Trojan War,* 16.

2. Wilson, *Swastika,* 829.

3. Wilson, *Swastika,* 903–4.

4. Campbell, *The Sacrifice,* 30; and Plato *Critias* and *Timaeus,* in *The Works of Plato,* trans. Jowett.

5. Puhvel, *Comparative Mythology,* 108. See also Witzel, *Vala and Iwato,* 40; and Euripides, *Helen,* trans. Vellacott, 145.

6. Homer, *Odyssey* 6.41, trans. Fitzgerald. For another voice arguing against the traditional view of an underworld inside the earth, see de Santillana and von Dechend, *Hamlet's Mill,* 73, where the authors identify the underworld as a portion of the heavens. This is accurate to a point, since the ancients appear to have considered all regions near or below the equator, both terrestrial and celestial, as parts of the underworld. Probably the original concept encompassed all areas below the immediate horizon, but as civilization became more familiar with earthly geography, this was later expanded to the general area beyond which the pole star was not visible.

7. Puhvel, *Comparative Mythology,* 139.

8. Puhvel, *Comparative Mythology,* 180.

9. Rydberg, *Teutonic Mythology,* section 27.

10. Rydberg, *Teutonic Mythology,* section 28b.

11. Rydberg, *Teutonic Mythology,* section 55.

12. But compare Sorenson and Raish, s.v. "Townsend, C., *Ancient Voyages.*"

13. Mann, *1491,* 291.

14. Puhvel, *Comparative Mythology,* 145.

15. Hencken, *Tarquinia and Etruscan Origins,* 33–37.

16. The most unequivocal example of early pre-Columbian contact between Europe and the Americas is the discovery of a Roman terra cotta head three floor levels beneath an Aztec pyramid near Mexico City. See Hristov and Genovés, "Viajes transatlánticos antes de Colón," in *Arqueología Mexicana* 33, no. 6 (1998): 48–53; Kelley, "Diffusion: Evidence and Process," in *Man across the Sea,* Riley, ed., 60; and Jett, "Diffusion Versus Independent Development," in *Man across the Sea,* Riley, ed., 30. For more about the discovery of this terra cotta head and its eventual publication, see Sorenson and Raish, s.vv. "García-Peyón, José, *Una cabecita de barro de extraño fisonomía,*" "Hristov, Romeo, *The Little 'Roman' Head of Tecaxic-Calixtlahuaca, Mexico.*" That sea voyages, both intentional and unintentional (castaways, storms, etc.), could and did occur in ancient times, with at least reasonable survival rates, see *Man across the Sea,* Riley, ed., 14, 279, etc. A vast literature on the subject of ancient contact between the hemispheres can be consulted, with topics ranging from early transmission of plants and animals to mysterious similarities in ceramics, tools, myths, and much more. For a general survey of this literature in bibliographic format, see Sorenson and Raish, *Pre-Columbian Contacts with the Americas across the Oceans,* 2 vols, 2nd ed. rev. (1996).

17. Eliade, *The Quest,* 101–103.

18. Eliade, *The Quest,* 106–107.

19. Cuningham, *Cosmographical Glasse*, 47.

20. Maier, *Subtilis Allegoria*, (emphasis added).

21. Homer, *Odyssey* 10.490, trans. Latimore.

22. Wensinck, *Ocean in the Literature of the Western Semites*, 31–33.

23. Wensinck, *Ocean in the Literature of the Western Semites*, 33.

24. The initial consonant is also sometimes transliterated "Kh" or "Ch". It is given here as "H" to be consistent with the modern spelling given to Havilah. See the Hebrew and Chaldee Dictionary (entry 2341–2344) in *Strong's Concordance*.

Notes to Chapter 10

1. Seidlmayer, "Egypt's Path to Advanced Civilization," 9–23.

2. Westendorf, *Painting, Sculpture, and Architecture*, 13.

3. Budge, *Gods of the Egyptians*, vol. 2, 124–25. The search for Osiris by the goddess Isis reappears in Greece as Demeter's search for her abducted daughter Persephone. Like Isis, Demeter becomes the nurse to a nobleman's child. Every night she places him in the fire in order to make him immortal, but is likewise interrupted by a spying mother who breaks the spell (see, *Homeric Hymns*, "To Demeter," 307). Persephone was the goddess of the underworld just as Osiris was Lord of the Underworld in Egypt. This parallelism suggests that Persephone was a galaxy goddess, and that her mother's search for her was a variant on the archaic quest for the Tree of Life. This story was the basis of the secret Eleusinian Mysteries, the content of which is still unknown (see Jung and Kerényi, *Essays on a Science of Mythology*, 113–129). Because Persephone is so identified with Osiris, however, we can conclude that these mysteries, like the Isis cult, concerned themselves with a search for the midnight sun, which is to say, for the galaxy as the axis mundi.

4. Budge, *Gods of the Egyptians*, vol. 2, 125. Egyptian traditions indicating that the father of Isis was either Hermes or Prometheus further associate her with axis mundi gods (see chapters 13 and 15).

5. Budge, *Gods of the Egyptians*, vol. 1, 488–89.

6. Compare this episode to the beheading of Dadhyañc (whitish) by the Indian god Indra. In this case, his severed head is replaced by that of a horse. See Witzel, *Vala and Iwato*, 33n130. Indra exhibits a number of axis mundi characteristics, indicating a probable origin as a galaxy god. See chapter 11, note 28.

7. Guirand ed., *Encyclopedia of Mythology*, 9. Compare Griffiths, *Plutarch's De Iside et Osiride*, 1, 74, and 86, which provides a reference to the "fiery" appearance of Typhon.

8. Guirand ed., *Encyclopedia of Mythology*, 17; compare James, *Tree of Life*, 38–40.

9. Budge, *Gods of the Egyptians*, vol. 2, 203–204.

10. Müller, *Egyptian Mythology*, 99.

11. Budge, *Gods of the Egyptians*, vol 2, 108.

12. Müller, *Egyptian Mythology*, 53.

13. Müller, *Egyptian Mythology*, 35–37.

14. James, *The Tree of Life*, 45.

15. Müller, *Egyptian Mythology*, 31.

16. Budge, *Gods of the Egyptians*, vol. 1, 58, 165.

17. Müller, *Egyptian Mythology*, 178.

18. Budge, *Gods of the Egyptians*, vol. 2, 371.

19. Müller, *Egyptian Mythology*, 390n38.

20. Müller, *Egyptian Mythology*, 106.

21. Budge, *Gods of the Egyptians*, vol. 1, 325.

22. Budge, *Gods of the Egyptians*, vol. 1, 335–39. Typhon, like so many other axis mundi deities, also suffers the cosmic wound. Plutarch tells how Horus holds the genitals of Typhon,

and also relates the legend in which Hermes rips out Typhon's sinews (Griffiths, *Plutarch's De Iside et Osiride*, 207).

23. Müller, *Egyptian Mythology*, 104; compare Griffiths, *Plutarch's De Iside et Osiride*, 59, 217.

24. Müller, *Egyptian Mythology*, 34–35.

25. Müller, *Egyptian Mythology*, 370n35.

26. Müller, *Egyptian Mythology*, 105.

27. James, *The Tree of Life*, 41.

28. Müller, *Egyptian Mythology*, 46.

29. Müller, *Egyptian Mythology*, 112.

30. Budge, *Gods of the Egyptians*, vol. 2, 42.

31. Müller, *Egyptian Mythology*, 389n29.

32. Budge, *Gods of the Egyptians*, vol. 1, 481.

33. Müller, *Egyptian Mythology*, 72.

34. Budge, *Gods of the Egyptians*, vol. 1, 475.

35. Müller, *Egyptian Mythology*, 390.

36. Budge, *Gods of the Egyptians*, vol. 1, 167.

37. Budge, *Gods of the Egyptians*, vol. 2, 241.

38. Budge, *Gods of the Egyptians*, vol. 1, 266.

39. Budge, *Gods of the Egyptians*, vol. 2, 366.

40. Budge, *Gods of the Egyptians*, vol. 2, 264.

41. Müller, *Egyptian Mythology*, 110–111.

42. Budge, *Gods of the Egyptians*, vol. 2, 100.

43. Budge, *Gods of the Egyptians*, vol. 2, 102.

44. Mercatante, *Who's Who in Egyptian Mythology*, s.v. "Geb"; compare Griffiths, *Plutarch's De Iside et Osiride*, 85.

45. Budge, *Gods of the Egyptians*, vol. 2, 14. The god Ptah, residing at the omphalos, was also said to have created the cosmic egg on a potter's wheel, which, hatching, gave birth to the earth. This was said also of the god Khnum. See James, *The Tree of Life*, 132, 135. The Djed pillar was originally an emblem of Ptah, further linking that god with Osiris and the axis mundi (compare Griffiths, *Plutarch's De Iside et Osiride*, 37).

46. Budge, *Gods of the Egyptians*, vol 2, 103.

47. Budge, *Gods of the Egyptians*, vol. 2, 106.

48. Budge, *Gods of the Egyptians*, vol. 2, 106.

49. Budge, *Gods of the Egyptians*, vol. 2, 104.

50. Budge, *Gods of the Egyptians*, vol. 2, 121.

51. Budge, *Gods of the Egyptians*, vol. 2, 108–109.

52. Müller, *Egyptian Mythology*, 390; compare Griffiths, *Plutarch's De Iside et Osiride*, 137.

53. Müller, *Egyptian Mythology*, 41.

54. Guirand ed., *Encyclopedia of Mythology*, 25.

55. Budge, *Gods of the Egyptians*, vol. 1, 428.

56. Budge, *Gods of the Egyptians*, vol. 1, 429–31.

57. Budge, *Gods of the Egyptians*, vol. 1, 437

58. Müller, *Egyptian Mythology*, 410n1; compare James, *The Tree of Life*, 41.

59. Budge, *Gods of the Egyptians*, vol. 1, 435.

60. Budge, *Gods of the Egyptians*, vol. 1, 438.

61. Müller, *Egyptian Mythology*, 40.

62. Budge, *Gods of the Egyptians*, vol. 2, 158.

63. Müller, *Egyptian Mythology*, 115.

64. Budge, *Gods of the Egyptians*, vol. 1, 203.

65. Budge, *Gods of the Egyptians*, vol. 1, 420.

66. Budge, *Gods of the Egyptians*, vol. 2, 131.

67. Budge, *Gods of the Egyptians*, vol. 2, 100.

68. Plutarch, *Isis and Osiris*, trans. Squire, quoted in Budge, *Gods of the Egyptians*, vol. 2, 192; compare Müller, *Egyptian Mythology*, 395.

69. Müller, *Egyptian Mythology*, 398.

70. Budge, *Gods of the Egyptians*, vol. 2, 89.

71. Budge, *Gods of the Egyptians*, vol. 1, 466.

72. Budge, *Gods of the Egyptians*, vol. 2, 90–92.

73. Müller, *Egyptian Mythology*, 90.

74. James, *The Tree of Life*, 66; compare de Santillana and von Dechend, *Hamlet's Mill*, 262.

Notes to Chapter 11

1. Sauvé, "The Divine Victim," in *Myth and Law*, Puhvel, ed., 182. The sacred tree is also referred to as the Aśvattha. See van Buitenen, trans., *Bhagavadgītā* 10.26, 15.1, and O'Flaherty, trans., *Hindu Myths*, 103.

2. O'Flaherty trans., *Hindu Myths*, 274; Leach, *Dictionary of Folklore, Mythology and Legend*, s.v. "Meru."

3. Griffith, trans., *Rig Veda* 1:62:6. The Griffith translation is quoted here because it is the most recent English translation available of the complete *Rig Veda*, despite its early date (1896). The scholarly translations of Renou (French) and Geldner (German) are more reliable. A new translation by Michael Witzel was not available to the author at the time of this writing. For purposes of comparison, the Geldner translation is given here in the notes for each of the Rig Veda passages quoted in the text.

4. Vijñanananda, trans., *S'rîmad Devî Bhâgawatam* 8:7:1–37.

5. James, *The Tree of Life*, 28.

6. Danielou, *Myths and Gods of India*, 221. The Milky Way has also been identified with the Indian Sarasvati, who is at the same time a river and a goddess. See Witzel, "Sur le chemin du ciel," 213–279.

7. Griffith, trans., *Rig Veda* 1.164.20; *Mundaka Upanishad* 3.1.1 and *Svetusvatara Upanishad* 4.6 [63] quoted in Danielou, *Myths and Gods of India*, 43.

8. O'Flaherty trans., *Hindu Myths*, 111.

9. Sturluson, *Gylfaginning*, in *The Prose Edda*, trans. Jean Young, 45–46.

10. The association between the Milky Way galaxy and the Eagle constellation was made by Witzel in note 30 of "Sur le chemin du ciel." He also notes the image of a celestial ladder in Indian mythology and compares it to other traditions, as, for example, Jacob's ladder in the Bible (Gen. 28.12). See his note 83. For the four rivers which flow toward the cardinal directions, see his note 101. For the association between the Tree of Life and the axis of stellar motion, see his note 103. For the Greek story of Leda's impregnation by the swan, and its pursuit by an eagle, see Euripides *Helen*, trans. Villacott, 136.

11. Danielou, *Myths and Gods of India*, 144–5, 163. Compare also Sorenson and Raish, s.v. "Needham and Gwei-Djen (commentary to page 41)."

12. O'Flaherty trans., *Hindu Myths*, 276; and Leach, *Dictionary of Folklore, Mythology and Legend*, s.v. "Churning of the Ocean."

13. Danielou, *Myths and Gods of India*, 262, 163.

14. James, *Tree of Life*, 23.

15. Kuiper, "The Bliss of Aša," 113.

16. Sturluson, *The Prose Edda*, trans. Jean Young, 42–46; compare *Lokasenna* (Prose Introduction) *Poetic Edda*, trans. Lee M. Hollander, 91.

17. Griffith, trans., *Rig Veda* 7.86; Macdonell, *A Vedic Reader for Students*, 135–41.

18. Macdonell, *A Vedic Reader for Students*, 134. See Witzel, "Looking for the Heavenly Cas-

ket," for another interpretation of this image.

19. Danielou, *Myths and Gods of India*, 115–118; see also: Eliade, *Images and Symbols*, trans. Mariet, 98.

20. Danielou, *Myths and Gods of India*, 119–120.

21. Witzel, "Sur le chemin du ciel." See note 106.

22. Griffith, trans., *Rig Veda* 1.25.12–13. Compare the Geldner translation: "Dieser umsichtige Sohn der Adita möge uns jederzeit gute Wege bereiten; er möge unsere Lebenstage verlängern. Ein goldenes Gewand trägt Varuna und legt ein Prachtkleid an. Rings herum sitzen seine Späher."

23. Kuiper, "The Bliss of Aša," 106.

24. Kuiper, "The Bliss of Aša," 114–117.

25. Eliade, *Images and Symbols*, trans. Mariet, 97.

26. Kuiper, "The Bliss of Aša," 108.

27. James, *The Tree of Life*, 150.

28. The god Indra also shows strong axis mundi attributes, indicating that he may originally have been a galaxy god. He gives birth to his son, Kutsa, from his thigh. He owns a pole representing the world tree. See Witzel, *Vala and Iwato*, 27, 29.

29. O'Flaherty, trans., *The Rig Veda* 10.14, p. 44.

30. Mesoamerican mythology also knew of a dog, Xolotl, that guarded the entrance to the underworld. See Hunt, *Transformation of the Hummingbird*, 80, 141. For the association of Sarama with the Milky Way, see Witzel, *Vala and Iwato*, 17.

31. *Encyclopedia Britannica*, s.v. "Constellations."

32. O'Flaherty, trans., *The Rig Veda* 9.74, pp. 122–23. See also James, *The Tree of Life*, 82.

33. Griffith, trans., *Rig Veda* 9.12.4–7. Compare the Geldner translation: "Im Nabel des Himmels fühlt sich der Hellsehende groß in der Schafwolle, der Soma, welcher der weise Seher ist … Der eigene Loblieder hat, der Baum, der unter Liedern immer melkende …" A striking parallel can be found in Mesoamerica. The K'iche' Maya word "Kaqulja" is defined as both *thunderbolt*, and as a name for the fungus *Amanita Muscaria*. In the *Popol Wuj*, "Kaqulja" occurs as an epithet for Jun Raqan (one-leg) who is widely identified as the god Hurricane/Tezcatlipoca. It is interesting that here we have the axis mundi galaxy god, One-Leg (Tezcatlipoca), linked to the Amanita, while in India the axis mundi galaxy god, Soma Pavamana, is linked to the Amanita as well (if Wasson is right about its identification). See the following: Wasson, *Soma*; Tum, et al., *Diccionario K'iche'*, 128; D. Tedlock, *Popol Vuh* (rev. ed.), 223–225, 294 (as well as 1985 ed., 249–251, 343); and Colop, *Popol Vuh*, 25. See also chapter 8, note 31 above.

34. Griffith, trans., *Rig Veda* 9.86.8, 13–14, 27, 33–34, 40. Compare the Geldner translation: "Sich läuternd hat er den Rücken der Schafwolle erstiegen, im Nabel der Erde, der Träger des großen Himmels … Zwischen beiden Welten … der reine Soma für dich geläutert. Einen Mantel umlegend, der zum Himmel reicht, den Luftraum erfüllend, über die Welten gesetzt … Diese hundertstrahligen, bevorrechteten, wassergebenden Ströme rauschen auf den Falben herab. Die Finger putzen den rings in Kuh (milch) eingehüllten auf dem dritten Rücken, dem Lichtraum des Himmels … In tausend Güssen wird der Goldgelbe ausgegossen; die Rede bringt er hervor, während er geläutert wird, zu Reichtum kommend. O Pavamana, als große Flut rinnst du farbenprächtig wie die Sonne durch die Filter aus Schafwolle … Die Welle der Süßigkeit hat (unser) Begehren erregt, in Wasser sich kleidend taucht der Büffel hinein. Als ein König, dessen Wagen die Seihe ist, hat er den Siegerpries erklommen, als der Tausendzackige gewinnt er hohen Ruhm." Where Griffith has used the obsolete English "meath," I have consistently changed these to the modern spelling "mead."

35. Sauvé, "The Divine Victim," in *Myth and Law*, Puhvel, ed., 183.

36. Griffith, trans., *Rig Veda* 9.5.1–3, 10. Compare the Geldner translation: "Entflammt prangt nach allen Seiten, sich läuternd, der Herr, sich beliebt machend, der brüllend Stier. Als Tanunapat sich läuternd, die Hörner wetzend, fließt er prangend durch die Luft. Anzurufen

sich läuternd prangt er (wie) glänzender Reichtum nach Kräften mit den Strömen der Süßigkeit … Den Baum salbe du Geläuterter mit deinem süßen Strome, den tausendzweigigen, grünen, strahlenden, goldenen!"

37. Griffith, trans., *Rig Veda* 9.107.5, 14, 16. Compare Geldner translation: "Aus dem himmlischen Euter die liebe Süßigkeit herausmelkend hat er sich an seinen altgewohnten Platz gesetzt … Die lebenverlängernden Somasäfte klären sich zum berauschenden Rauschtrank auf der Höhe des Meeres, die Gedankenreichen, Berauschenden, die das Himmelslicht finden … Von den Männern gelenkt, der Begehrenswerte, Weitschauende, der König, der Meeresgott."

38. Campbell, *Mythic Image*, 260. The story is told in Cook, *Zeus*, vol. 3, 97n3–4. In the succeeding note (5), Cook describes the Old French legend whereby the mother of the Virgin Mary was born from the side of her father.

39. Campbell, *Mythic Image*, 140, 162; Danielou, *Myths and Gods of India*, 235, 355, 356; and James, *Tree of Life*, 257.

40. d'Alviella, *Migration of Symbols*, 31.

41. Müller, *Egyptian Mythology*, 50; D'Alviella, *Migration of Symbols*, 30.

42. O'Flaherty, trans., *Hindu Myths*, 115, 143–45.

43. See O'Flaherty, trans., *Hindu Myths*, 104–115; Leach, ed., *Dictionary of Folklore, Myth, and Legend*, s.v. "Skanda."

Notes to Chapter 12

1. Hesiod, *Theogony*, trans. Wender, 27. "Sometimes Olympus was considered to send up fire—not like volcanic fire—but 'peaceful and mild'" (Cook, *Zeus*, vol. 3, 228).

2. Homer, *Odyssey* 6.41, trans. Murray.

3. Hesiod, *Theogony*, trans. Wender, 26.

4. Apollodorus, *The Library* 1.1.6, trans. Frazer. See also Frazer's note, vol. 1, 7n3.

5. Homer, *Iliad* 14.329, trans. Rieu, 265–6.

6. Homer, *Iliad* 14.286, trans. Murray, 87.

7. Ovid, *Metamorphoses* 1.176, trans. Innes.

8. Pausanias, *Guide to Greece* 3.19.7, 8.53.9, trans. Levi, vol. 2, 69, 498.

9. For the club of Hercules, see Graves, *Greek Myths*, art. 122.f. Compare Pausanias, *Guide to Greece* 2.31.13, trans. Levi, vol. 1, 207, and Cook, *Zeus*, vol. 2, 466. For the underworld duration of the galactic center, see Rey, *The Stars*, 73–97. For the dying and reborn god see the following: Evelyn-White, trans., *Homeric Hymn to Demeter II*, 317; Apollodorus, *The Library*, 1.5.3, 3.14.4, trans. Frazer, 39–41, 87; van der Toorn, ed., *DDD*, s.vv. "Adonis," "Melqart"; Cary, ed., *OCD*, s.v. "Adonis"; Ovid, *Metamorphoses* 10.501, trans. Mandelbaum, 346–355; Graves, *Greek Myths*, art. 18 h–j; and, finally, Butterworth, *Tree at the Navel*, 96. For the winnowing fan see Graves, *Greek Myths*, arts. 171.k, 17a, and *Odyssey* 23.267.

10. Graves, *Greek Myths*, arts. 135, 136.

11. Apollodorus, *The Library* 2.4.9, trans. Frazer.

12. Ovid, *Metamorphoses* 9.273, trans. Mandelbaum, 299.

13. Graves, *Greek Myths*, arts. 119.i, 145.j.

14. Apollodorus, *The Library* 2.7.5, trans. Frazer. Compare van der Toorn, *DDD*, 45–46.

15. van der Toorn, *DDD*, s.v. "Melqart."

16. Pausanias, *Guide to Greece* 5.11.6, trans. Levi, vol. 2, 228.

17. Apollodorus, *The Library* 2.5.11, trans. Frazer.

18. Wensinck, *The Ocean*, 26–33.

19. Hesiod, *Theogony* 517, trans. Evelyn-White.

20. Hesiod, *Theogony* 565, trans. Evelyn-White.

21. Exodus 3:1–6, (Oxford Study Bible). See also the notes to Exodus 3:1–3:2 therein.

22. Apollodorus, *The Library* 1.7.1, trans. Frazer.

23. Sauvé, "The Divine Victim," in *Myth and Law*, Puhvel, ed., 180–190.

24. *Svetasvatara Upanishad* 3.3, *Mahanarayana Upanishad* 1.14, quoted in Danielou, *Myths and Gods of India*, 57.

25. "Karapatri, Sri Visnu tattva," *Siddhanta*, V, quoted in Danielou, *Myths and Gods*, 57.

26. Kirby, trans., *Kalevala* 31.160–190.

27. de Santillana, *Hamlet's Mill*, 27.

28. For Christ as creator of the world, see John 1:1–3 (Oxford Study Bible).

29. Apollodorus, *The Library* 1.7.1, trans. Frazer.

30. Graves, *Greek Myths*, art. 39.c.

31. Homer, *Iliad* 15.18–22, trans. Murry, 107–9.

32. Apollodorus, *The Library* 1.3.6, trans. Frazer.

33. Puhvel, *Comparative Mythology*, 127.

34. Hesiod, *Theogony* 314, trans. Evelyn-White.

35. Pausanias, *Guide to Greece* 9.25.2, trans. Levi, vol. 1, 360; Homer, *Iliad* 5.390, trans. Murry.

36. Compare to other veiled goddesses with axis mundi characteristics: James, *Tree of Life*, 169; Griffiths, *Plutarch's De Iside Et Osiride*, 241.

37. Homer, *Iliad* 14.183, trans. Murry, rev. Wyatt.

38. Apollodorus *The Library* 2.5.11, 220n1, trans. Frazer.

39. James, *Tree of Life*, 196–97; Pausanias, *Guide to Greece* 8.23.5, trans. Levi, vol. 2, 425.

40. Eliade, *Images and Symbols*, trans. Mairet, 48; the story is told in Cook, *Zeus*, vol. 2, 130.

41. James, *Tree of Life*, 196. The fleur-de-lis was a white iris germanica (lily family).

42. Apollodorus, *Epitome* 1.20, trans. Frazer.

43. Apollodorus, *Epitome* 1.20, 148n1, trans. Frazer.

44. Liddell & Scott, *Greek-English Lexicon*, s.v. "ἄξων."

45. James, *Tree of Life*, 28. But that Zeus was a sky god (particularly a night-sky god), see Cook, *Zeus*, vol. 1, p. 6: "Look up, not down. There! We are staring up towards Zeus himself: I see the stars; I see Orion too" (quoted from *Eur. Cycl.* 211 ff). That Zeus was a god of light, see vol. 1, p. 7.

46. James, *Tree of Life*, 264. For a discussion of the relation of the Minoan double-axe in relation to trees, columns, pillars, and the labyrinth, see Cook, *Zeus*, vol. 2, 516–704, 845.

47. *Oxford Classical Dictionary*, s.v. "Stones, Sacred." Plato also describes the home of Zeus at the omphalos: "[Zeus] collected all the gods into his most holy habitation, which being placed at the center of the world, sees all things ..." (*Critias*, trans., Jowett, 121). For a lengthy discussion of the pillar of Zeus and its identification with the omphalos and the Milky Way, see Cook, *Zeus*, vol. 2, 45–50, 841. The thunderbolts of Zeus (and the fork or trident of Poseidon) show a marked resemblance to the branching pattern of the galaxy at the Great Rift; see Cook, *Zeus*, vol. 2, 764–806, 848. The three sons of Cronos: Zeus, Poseidon, and Hades form a triad that may reflect three aspects of one original god. These would then correspond to the three aspects of the axis mundi/galaxy in its three positions: heaven, earth, and the underworld, which are the respective realms of these gods. Cook derives an etymology for Poseidon (Poteidon) as Lord (poti) Zan (an alternative Greek form of *Zeus*). This would perhaps explain the confused etymology of the word *Neptune* (the Latin name of Poseidon) which derives ultimately from Indo-European *enebh (Pok. 314–315). As with "1. dei" and "2. dei" (see below), Pokorny separates this lemma into two distinct roots because he cannot reconcile the two semantic concepts "navel" and "cloud" as belonging to the same root. As we have seen, these are two aspects of the galaxy as axis mundi. See Cook, *Zeus*, vol. 2, 583, 850.

48. Apollodorus, *The Library* 3.4.3, trans. Frazer. Compare Ovid, *Metamorphoses* 3.315–318, trans. Mandelbaum, 89.

49. Graves, *Greek Myths*, art. 39.8, and Cook, *Zeus*, vol. 1, 330. Zeus, and his Germanic counterpart, Ziu, were also associated with whirlwinds (Cook, *Zeus*, vol. 3, 162–165).

50. de Santillana, *Hamlet's Mill*, 318. For an extensive treatment of the fleece of Zeus, see

Cook, *Zeus*, vol. 1, 420–428. For an identification of the "Elysian Way," (the road traversed by gods and men also called the "road of Zeus") with the Milky Way, see Cook, *Zeus*, vol. 2, 36–44.

51. *American Heritage Dictionary*, s.v. "dyeu," in Appendix 1; *Oxford Classical Dictionary*, s.v. "Zeus"; Kerényi, *Zeus and Hera*, 3–11; Beekes, *Comparative Indo-European*, 39; Szemerényi, *Introduction to Indo-European*, 181; Cook, *Zeus*, vol. 2, 840.

52. Pokorny, *Indogermanisches Etymologisches Woerterbuch*, s.vv. "1. dei," vol. 1, 183–187, "2. dei-," vol. 1, 187. Compare the name of the Tracian god, "Zbelsourdos, or Zeus Zbelsourdos." Cook recounts an etymology that combines Lithuanian *ziburys*, "light, torch, brilliance," with *sver-d*, "to twist, to bore." See Cook, *Zeus*, vol. 2, 822.

53. Pokorny, *Indogermanisches Etymologisches Woerterbuch*, s.v. "1. dei," 183–187.

54. Tacitus, *Germania* 11, trans. Church and Bodribb, 714; Leach, ed., *Dictionary of Folklore, Mythology and Legend*, s.v. "Night."

55. It is also possible that the axis mundi characteristics of Demeter (see chapter 10, note 3) can shed light on the disputed etymology of her name, e.g., the attempt to relate it to Γημήτηρ, δημομήτηρ, or δηαί = κριθαί; compare Liddell and Scott, s.v. "Δημήτηρ." The name (also occurring as Δηώ) may be parallel to the many Indo-European masculine forms with "–pater." For example: the Greek Ζεύς πατήρ, the Latin *Iuppiter* and *Diēspiter*, the Umbrian *Jupater*, the Sanskrit *dyāuš pitā*, and the Illyrian Δει-πατυρος. Hence, Demeter may be "Zeus Mother" in contrast to "Zeus Father."

56. Homer, *Iliad* 2:303, trans. Fitzgerald, 45.

57. *Oxford Classical Dictionary*, s.v. "Helen." Saint Elmo's fire is an electrical discharge on the masts of ships visible during storms when lightning is present. It creates a glow something like the aurora borealis around the vertical wooden mast; as such, it would appear similar to the glowing Milky Way in the nocturnal sky.

58. *Oxford Classical Dictionary*, s.v. "Helen"; Heubeck, *Commentary on Homer's Odyssey*, vol. 1, 200–201. See also, Butterworth, *Tree at the Navel*, 25.

59. Pausanias, *Guide to Greece* 3.19.10, trans. Levi, 2:70.

60. Apollodorus *Epitome* 3.5, trans. Frazer.

61. Homer, *Odyssey* 4.120–25, 4.569, trans. Murray; Heubeck, *Commentary on Homer's Odyssey*, vol. 1, 201.

62. Schliemann, "Chapter III: The History of Troy," in *Ilios*, 1st and 2nd pages.

63. Heubeck, *Commentary on Homer's Odyssey*, vol. 2, 124.

64. Homer, *Odyssey* 12.430, trans Murray.

65. Homer, *Odyssey* 12.77, trans. Murray.

66. Homer, *Odyssey* 23.192, trans. Murray.

67. Homer, *Odyssey* 5.345, trans. Murray.

68. Leucothea seems to be a type of goddess known in the later Hellenistic period as Tyche (fate, fortune, luck). Each large Greek city of this period had a temple to Tyche, and later this was also true of smaller towns. The literature of the times describes her as more powerful and more noble than the traditional gods, and she ultimately became associated with Isis, emphasizing the benign aspect of fortune which that goddess exemplified. Like Leucothea, Tyche was typically pictured holding a cornucopia, and this symbol was clearly associated with Amalthea. She is frequently found depicted in proximity to a wheel or a globe. Although the reasons for this were no longer understood in later times, it is reasonable to regard them as representations of axial motion as has been so frequently seen in association with such goddesses of fortune. See van der Toorn, *Dictionary of Deities and Demons*, s.v. "Tyche."

69. Another occurrence of axial motion in the *Odyssey* is the story of the red-hot olive tree that was thrust and twirled in the eye of Cyclops (9.318–328, 9.375–397), which suggests the flaming world tree/axis mundi twirling in the north celestial pole. The Trojan war itself was started by the abduction of Helen (whom we have already seen in her aspect as tree goddess) by Paris, but this abduction was the result of his entanglement in the rivalry between Hera,

Athena, and Aphrodite. Paris gave the golden apple to Aphrodite, acknowledging her as the most beautiful of the three goddesses, and in return Aphrodite gave Helen to him. Hence the galactic golden apple, if this hypothesis is correct (see the note on Hercules' club above), serves as the origin of the Trojan war and all of Odysseus' adventures.

70. Schweitzer, *Greek Geometric Art*, 11, 25, 32, 37, 38–40.

71. Goblet d'Alviella, *Migration of Symbols*, 36, 42–43, 60; compare Davidson, *Pagan Scandinavia*, plate 45.

Notes to Chapter 13

1. Gimbutas, *Goddesses and Gods,* 37–38; Hencken, *Tarquinia*, 34.

2. Schliemann, *Troy and its Remains*, 120–21, 136. Schliemann often refers to the naturalistically depicted stags as "antelopes" or, when shown without antlers, "hares." See page 136 in this reference.

3. Gimbutas, *Language of the Goddess*, 298–300.

4. Schliemann, *Troy and its Remains*, 119–20.

5. Schliemann, *Troy and its Remains*, 118.

6. On the quincunx, see Hunt, *Transformation of the Hummingbird*, 177, 180–183, 197. Compare Markman, *Flayed God*, 167.

7. Schliemann, *Troy and Its Remains*, 135.

8. Schliemann, *Troy and Its Remains*, 135.

9. For the preferable translation of this phrase as "owl-faced" rather than "grey-eyed," see Schliemann, *Troy and its Remains*, 113; Pausanias, *Guide to Greece*, trans. Levi, vol. 1, 44n84. For Athena as a bird, see Homer, *Iliad* 7.58, trans., Murry, rev. Wyatt, vol. 1, 319; Pausanias, *Guide to Greece* 1.5.3, 1.14.5, 1.41.6, trans. Levi, vol. 1, 22, 115n49, 115n44, 115n84; Homer, *Odyssey* 22.236, trans. Murray; Gimbutas, *Goddesses and Gods*, 147–50.

10. *Oxford Classical Dictionary*, s.v. "Athena." For a discussion of Athena Ergane at Troy, see Wallrodt, *Ritual Activity in Late Classical Ilion*.

11. See Gimbutas, *Language of the Goddess*, 121, 132–137; *Oxford Classical Dictionary*, s.v. "Athena." The birth of Athena provides additional evidence of her galaxy associations. She was born from the opening, created when Prometheus split the head of Zeus with an axe. Her form as a bird emerging from the head of Zeus conforms to the axis mundi pattern where a bird is placed on the shoulders of the galaxy-god.

12. Wilson, *Swastika*, 767.

13. See Bagrow, *History of Cartography* (1985), for a map now in the British Museum (catalogued as Egerton MS 73).

Notes to Chapter 14

1. MacBain, *Celtic Mythology and Religion*, 135–37; MacCulloch, *Religion of the Ancient Celts*, 363, 371–72.

2. MacCulloch, *Religion of the Ancient Celts*, 372.

3. Dillon, *Early Irish Literature*, 101–102, 106.

4. Loomis, *The Grail*, 193.

5. Eschenbach, *Parzival*, trans. Mustard and Passage, as quoted in Loomis, *The Grail*, 201.

6. Eschenbach, *Parzival*, trans. Mustard and Passage, 130–33.

7. Loomis, *The Grail*, 35, 93.

8. Eschenbach, *Parzival*, trans. Mustard and Passage, 142–43.

9. Eschenbach, *Parzival*, trans. Mustard and Passage, 255–62.

10. Eschenbach, *Parzival*, trans. Lefevere, 124–125.

11. Eschenbach, *Parzival*, trans. Mustard and Passage, 251n11.

12. Eschenbach, *Parzival*, trans. Mustard and Passage, 244.

13. Loomis, *The Grail*, 117.

14. Klüge, *Etymologisches Wörterbuch*, s.v. "Wunsch."

15. MacCulloch, *Religion of the Ancient Celts*, 368, 370; Loomis, *The Grail*, 22, 154, 127, 122.

16. Loomis, *The Grail*, 55–56, 60.

17. Loomis, *The Grail*, 101.

18. Loomis, *The Grail*, 72.

19. Loomis, *The Grail*, 102–103.

20. MacCulloch, *Religion of the Ancient Celts*, 377.

21. Rhŷs, *Celtic Folklore, Welsh and Manx*, 678.

22. Loomis, *The Grail*, 122–26, 138, 114, 108, 104, 93.

23. Loomis, *The Grail*, 48.

24. Ford, trans., *Mabinogi*, 77, 81. Compare the axis mundi characteristics ascribed to "the Word" (Wisdom personified), said in Ecclesiastes 24:3 (Oxford Study Bible) to cover the earth like a mist: "I am the word spoken by the Most High; it was I who covered the earth like a mist. My dwelling-place was in high heaven; my throne was in a pillar of cloud. Alone I made a circuit of the sky and traversed the depths of the abyss." Similar imagery describing Wisdom personified can be found in Proverbs 8:21–35 (Oxford Study Bible): "I endow with riches those who love me; I shall fill their treasuries. The Lord created me the first of his works long ago, before all else that he made. I was formed in earliest times, at the beginning, before earth itself. I was born when there was yet no ocean, when there were no springs brimming with water … whoever finds me finds life and wins favor with the Lord." In John 1:1–14, "the Word" is also described as existing from the beginning, and as the source of (eternal) life.

25. *Mabinogi*, trans. Ford, 67.

26. Ford, trans., *Mabinogi*, 60, 67–68.

27. Ford, trans., *Mabinogi*, 65.

28. Ford, trans., *Mabinogi*, 133.

29. The motif, whereby a pursuer cannot overtake a continually receding goal, occurs again in the echtra, "Pwyll, Prince of Dyfed," from the *Mabinogi*. There, Pwyll cannot catch up with Rhiannon, even though she merely ambles slowly along on her "great, majestic, pale-white horse." This alludes to the slow, steady motion of the Milky Way across the sky, and to the inability of any mortal to catch it. The description of the horse further suggests its galaxy identification. Rhiannon's possession of a magic bag of plenty identifies her as the Celtic goddess Epona, who is frequently depicted on an ambling horse holding a bag or cornucopia. These traits lead to the inescapable conclusion that Epona was also a galaxy goddess (see Ford, trans., *Mabinogi*, 36). In this connection it is appropriate to point out that the Norse word *Yggdrasill* is derived from the roots *Ygg*, an alternate name for the god Odin, and *drasill*, an ancient word meaning "horse." This may indicate that both Odin and Epona are two instances of gods who ride the galaxy envisioned as a celestial horse. The Greek goddess, Demeter, is also portrayed with the head of a horse (see chapter 12, note 55).

30. Loomis, *The Grail*, 128; Skelton, et al., *Vinland Map*, 137–38, 154. This map (ca. 1440) shows Europe, Africa, Iceland, Greenland, and the northeastern coast of the North American continent (labeled "Vinlanda" after the name given to it by tenth-century Vikings). Its pre-Columbian date has been used to argue for a longer tradition of knowledge about the Americas among Mediterranean sea captains and map makers. Doubt was cast on the authenticity of the Vinland Map by the discovery of titanium in the ink, in belief that this is a strictly modern substance. But subsequent tests have revealed that many other medieval documents also contain titanium. Although some scholars continue to dissent, Yale University Press issued a new edition (1996) that strongly defends its authenticity. See Sorenson and Raish, s.v. "Associated Press, *Forged Map declared the Real Thing*." The subject of lost islands in the Atlantic, e.g., "Bra-

sil," is a large one, with a voluminous literature unto itself. For a recommended introduction to the subject, see Sorenson and Raish, s.v. "Crone, Gerald, *The Mystical Islands of the Atlantic Ocean.*"

31. For the history of this development, see Loomis, *The Grail*, 25.

Notes to Chapter 15

1. Kuiper, *The Bliss of Aša*, 115.

2. Kuiper, *The Bliss of Aša*, 107. This concept is also consistent with the doctrine of the Greek mystery schools. The Pythagoreans, for example, held that the center of the cosmos was fire (see Plutarch 5.11, quoted in J. G. Griffiths, trans., *Plutarch's De Iside et Osiride*, 288). The technical name employed by the Pythagoreans for the central, cosmic fire was "the Monad." This designation appears again in the writings of later alchemists such as John Dee, whose sign for the Monad was a modification of the traditional symbol for Mercury. The same sign was incorporated into the summons received by Christian Rosenkreutz in "Day One" of the *Chymical Wedding of Christian Rosenkreutz*, the first manifesto of the Rosicrucian Fraternity.

3. Müller, *Egyptian Mythology*, 35–37.

4. Kuiper, *The Bliss of Aša*, 108, 111, 116.

5. Apuleius, *Golden Asse*, 273.

6. Kuiper, *The Bliss of Aša*, 109, 111, 119, 123–124.

7. Mallory, *In Search of the Indo-Europeans*, 39.

8. Kuiper, *The Bliss of Aša*, 118–121. Zoroaster himself possessed ample axis mundi characteristics. He emerged, for example, from a fire that descended upon a mountain from the sky. See Cook, *Zeus*, vol. 2, 33.

9. Lindsay, *Origins of Alchemy*, 135.

10. Quoted in Lindsay, *Origins of Alchemy*, 140–41.

11. Lindsay, *Origins of Alchemy*, 142–45.

12. Lindsay, *Origins of Alchemy*, 251–52.

13. Lindsay, *Origins of Alchemy*, 135, 156, 158.

14. Vaughan, *Lumen de Lumine, or a New Magical Light.*

15. Vaughan, *Coelum Terrae.*

16. From "The Glory of the World," in *Hermetic Museum I*, quoted in Poncé, *Alchemical Death*, 51.

17. Maier, *Symbola Aureae Mensae*, 5: "Sol est eius coniugii Pater et alba Luna Mater, tertius succedit, ut gubernator, Ignis." (Compare de Jong, *Maier's Atalanta Fugiens*, 376.)

18. Maier, *Atalanta Fugiens*, Emblema 25, 109: "Draco non moritur, nisi cum fratre & sorore sua interficiatur, qui sunt Sol & Luna." (Compare de Jong, *Maier's Atalanta Fugiens*, 191.)

19. de Jong, *Maier's Atalanta Fugiens*, 192–93. In Greek myth, Mercury (Hermes) is a grandson of Atlas (see below, and the discussion of Prometheus in chapter 12).

20. Maier, *Atalanta Fugiens*, Emblema 14, 65: "Hic est Draco caudam suam devorans." (Compare de Jong, *Maier's Atalanta Fugiens*, 129.)

21. de Jong, *Maier's Atalanta Fugiens*, 130–31. The god Hermes has many associations with axis mundi symbolism in Greek myth, as well as in the alchemical literature. He is the grandson of Atlas. He is the first to invent the fire drill for making fire by friction and axial motion (*Homeric Hymn* 4, trans. Evelyn-White, 110). He is unique among the Greek gods in that he moves freely between the heights of Olympus and the underworld to which he conducts the souls of the dead (M. Cary, ed., *OCD*, s.v. "Hermes"). He is associated with good luck, good fortune (M. Cary, ed., *OCD*, s.v. "Hermes," and Liddell & Scott, *Greek-English Lexicon*, s.v. "ἕρμαιον"). He is also worshipped as a pillar (Liddell & Scott, *Greek-English Lexicon*, s.v. "Ἑρμῆς"). And, finally, he is the grandfather of Odysseus. See also Butterworth, *Tree at the Navel*, 28.

22. Maier, *Atalanta Fugiens*, Emblema 36, 153: "Lapis projectus ist in terras, & in montibus

exaltatus, & in aëre habitat, & in flumine pascitur, id ist, Mercurius." (Compare de Jong, *Maier's Atalanta Fugiens*, 243.)

23. Villanova, *Speculum Alchymiae*, in *Theatrum Chemicum* 4, 517. The original is quoted in de Jong, *Maier's Atalanta Fugiens*, 255: "Tu quaeris, in quo loco inveniri possit: et libenter dicam. In duobus montibus invenitur: et si perfectissime invenire desideras, ascende in montem alteriorem hujus mundi: quia ibi lapis noster absconditur: et scias, quod in alio loco non invenitur." (Translation in the text is by the author, but compare de Jong, *Maier's Atalanta Fugiens*, 255.)

24. de Jong, *Maier's Atalanta Fugiens*, 243.

25. de Jong, *Maier's Atalanta Fugiens*, 317.

26. Jodocus Greverus, *Secretum Nobilissimum et Verissimum*, in *Theatrum Chemicum* 3, 717–721. The original is quoted in de Jong, *Maier's Atalanta Fugiens*, 322n10: "In hoc ipso monte, fili me, vidisse te opinor regales Hesperidum hortos … Videbis autem in summo montis custodem hori turrim altissimam, cum duobus propugnaculis, quae omnia in ardentissimo igne sita sunt." (Translation in the text is by the author, but compare de Jong, *Maier's Atalanta Fugiens*, 325.)

27. Maier, *Atalanta Fugiens*, Emblema 2, 17: "Nutrix ejus terra est." (Compare de Jong, *Maier's Atalanta Fugiens*, 63.)

Notes to Chapter 16

1. *Encyclopedia Britannica*, s.v. "Aztec."

Notes to Appendix 1

1. Plato, *Dialogues: Timaeus*, trans., Jowett, 20–25. The relevant portions of these dialogues have been combined in Appendix 1.

2. Plato, *Dialogues: Critias*, trans., Jowett, 108–109, 113–121.

Bibliography

Al-A'dami, Khalid Ahmad. "Excavations At Tell es-Sawwan (Second Season)." *Sumer* 24 (1968): 54–94.

Annals of Cuauhtitlan. See, Bierhorst.

Andrés de Olmos. *Historia de los Mexicanos por sus Pinturas*. Manuscript ca. 1540. Translated by Scot Mahler. See Markman.

Angus, S. *The Mystery Religions*. New York: Dover, 1975. First published 1925 as *The Mystery-Religions and Christianity*.

Apollodorus. *The Library and Epitome*. Translated by Sir James George Frazer. Loeb Classical Library 121 and 122. Cambridge: Harvard University Press, 2001. First published 1921.

Apollonius Rhodius. *Argonautica*. Translated by R. C. Seaton. Loeb Classical Library 1. Cambridge, MA: Harvard University Press, 2003. First published 1912.

Apuleius. *The Golden Asse (or Metamorphosis)*. Translated by William Adlington. London: Grant Richards, 1913.

Archäologischen Instituts. *Jahrbuch, Band IX, 1894*. Berlin: Georg Reimer, 1895.

Aristotle. *On the Heavens (De caelo)*. Translated by J. L. Stocks. *The Works of Aristotle: Vol. 1. Great Books 8*. Chicago: Encyclopedia Britannica, 1952.

Aveni, Anthony. *Stairways to the Stars*. New York: J. Wiley, 1997.

Bagrow, Leo. Revised R. A. Skelton. *History of Cartography*. Chicago: Precedent, 1985.

Balfanz, Kathrin. "Bronzezeitliche Spinwirtel aus Troia." In *Studia Troica* 5 (1995): 117–143.

Bartholomew, John C., ed. *Times Atlas of the World: Comprehensive Edition*. New York: Times Books, 1983.

Baumer, Christoph. *Bon: Tibet's Ancient Religion*. Trumbull, Connecticut: Weatherhill, 2002.

Baumgarten, Fritz, Franz Poland, and Richard Wagner. *Die Hellenische Kultur*. Leipzig and Berlin: B. G. Teubner, 1905.

Becatti, Giovanni. *The Art of Ancient Greece and Rome: From the Rise of Greece to the Fall of Rome*. New York: Harry N. Abrams, nd.

Beekes, Robert S. P. *Comparative Indo-European Linguistics*. Philadelphia: John Benjamins, 1995.

Bellows, Henry Adams, trans. *Poetic Edda*. Mineola, New York: Dover, 2004. First published 1923.

Bennett, Wendell. *Ancient Art of the Andes*. New York: New York Museum of Modern Art/Arno Press, 1966.

Bierhorst, John. *History and Mythology of the Aztecs: The Codex Chimalpopoca*. Tucson, Arizona: University of Arizona Press, 1992.

Blegen, Carl. *Troy and the Trojans*. New York: Frederick A. Praeger, 1963.

Bok, Bart J., and Priscilla F. Bok. *The Milky Way*. 4th ed. Cambridge, Massachusetts, 1974.

Bonfante, Larissa. *Etruscan*. Berkeley and Los Angeles: University of California Press, 1990.

Brashear, Ronald, Daniel Lewis, and Owen Gingerich. *Star Struck: One Thousand Years of the Art and Science of Astronomy*. San Marino, California: Huntington Library, 2001.

Briggs, Irene M. "The tree of life symbol: its significance in ancient American religion." Master's thesis, Brigham Young University, 1950. http://patriot.lib.byu.edu/cdm4/document.php?CISOROOT=/MTAF&CISOPTR=16784&REC=1.

Brown, Arthur C. L. *The Origin of the Grail Legend*. New York: Russell and Russell, 1966. First published 1943.

Budge, E. A. Wallis. *The Gods of the Egyptians*. 2 vols. New York: Dover, 1904.

Buschor, Ernst. *Griechische Vasen*. Munich: R. Piper & Co. Verlag, 1969.

Butterworth, E. A. S. *The Tree at the Navel of the Earth*. Berlin: Walter de Gruyter, 1970.

Campbell, Joseph. *The Hero with a Thousand Faces*. Princeton, New Jersey: Princeton University Press, 1949.

———. *Historical Atlas of World Mythology: Volume I, The Way of the Animal Powers, Part II, Mythologies of the Great Hunt*. New York: Harper and Row, 1988.

———. *Historical Atlas of World Mythology: Volume II, The Way of the Seeded Earth, Part I, The Sacrifice*. New York: Harper and Row, 1988.

———. *The Mythic Image*. Princeton: Princeton University Press, 1974.

Campbell, Tony. *The Earliest Printed Maps: 1472–1500*. Berkeley and Los Angeles: University of California Press, 1987.

Carmack, Robert M., and James L. Mondloch. *El título de Totonicapán: texto, traducción y comentario*. Centro de Estudios Mayas, Fuentes para el Estudio de la Cultura Maya 3. México: Universidad Nacional Autónoma de México, 1983.

Carrasco, Davíd. *Religions of Mesoamerica*. New York: Harper San Francisco, 1990.

Chadwick, John. *The Mycenaean World*. New York: Cambridge University Press, 1976.

Clarkson, James J., Mark W. Chase, and Madeline M. Harley. "Phylogenetic relationships in Burseraceae based on plastid rps16 intron sequences." *Kew Bulletin* (2002). http://www.findarticles.com/p/articles/mi_qa3974/is_200201/ai_n9070183.

Codex Chimalpopoca. Also titled: *Leyenda do los Soles, or Legends of the Suns, or Manuscript of 1558*. See, Bierhorst.

Códice de Madrid (Codex Tro-Cortesianus). Guatemala City, Guatemala: Amanuense Editorial, 2007.

Códices de Dresde, París y Grolier. Guatemala City, Guatemala: Amanuense Editorial, 2007.

Colop, Sam, ed. *Popol Wuj, Versión Poética K'iche'*. Guatemala City, Guatemala: Cholsamaj, 1999.

Cook, Arthur Bernard. *Zeus a Study in Ancient Religion, Volume I, Zeus God of*

the Bright Sky. Cambridge: Cambridge University Press, 1914.

———. *Zeus a Study in Ancient Religion, Volume II, Zeus God of the Dark Sky (Thunder and Lightning) Part I Text and Notes*. Cambridge: Cambridge University Press, 1925.

———. *Zeus a Study in Ancient Religion, Volume III, Zeus God of the Dark Sky (Earthquakes, Clouds, Wind, Dew, Rain, Meteorites), Part I Text and Notes*. Cambridge: Cambridge University Press, 1940.

Courlander, Harold. *The Fourth World of the Hopis*. Albuquerque, New Mexico: University of New Mexico Press, 1971.

Cox, Kenyon. *Old Masters and New: Essays in Art Criticism*. New York: Fox, Duffield, 1905.

Craven, J. B. *Count Michael Maier: Life and Writings*. Berwick, Maine: Nicolas-Hays, 2003. First published 1914.

Crewe, Lindy. *Spindle Whorls: A Study of Form, Function and Decoration in Pre-historic Bronze Age Cyprus*. Jonsered: Paul Åströms Förlag, 1998.

Crossley-Holland, Kevin. *The Norse Myths*. New York: Pantheon Books, 1980.

Cuningham, William. *The Cosmographical Glasse, conteinyng the pleasant Principles of Cosmographie, Geographie, Hydrographie, or Navigation*. London: John Day Typographi, 1559.

Curtin, Jeremiah. *Myths and Folk Tales of Ireland*. New York: Dover, 1975. First published 1890.

Danielou, Alain. *The Myths and Gods of India*. Rochester, Vermont: Inner Traditions International, 1985. First published under the title: *Hindu Polytheism*. New York: Bollingen Foundation, 1964.

Davidson, H.R. Ellis. *Pagan Scandinavia*. London: Thames and Hudson, 1967.

de Jong, H. M. E. *Michael Maier's Atlanta Fugiens: Sources of an Alchemical Book of Emblems*. York Beach, Maine: Nicolas-Hays, 2002 first published 1969 (Leiden: E. J. Brill).

Deloria, Vine, Jr. *Frank Waters: Man and Mystic*. Athens, Ohio: Ohio University Press, 1993.

Delumeau, Jean. *History of Paradise: The Garden of Eden in Myth and Tradition*. Translated by Matthew O'Connell. New York: Continuum, 1995. Originally published as *Une Historie du Paradis: Le Jardin des délices* (1992).

de Sahagún, Bernardino. *General History of the Things of New Spain, Book 3: The Origin of the Gods*. Translated by Arthur J. O. Anderson and Charles E. Dibble. Santa Fe, New Mexico: The School of American Research and The University of Utah, 1952.

de Santillana, Giorgio, and Hertha von Dechend. *Hamlet's Mill*. Boston: Godine, 1969.

Detzel, Heinrich. *Christliche Ikonographie: Ein Handbuch zum Verständniss der Christlichen Kunst*. Freiburg im Breisgan: Herder'sche Verlagshandlung, 1894.

Díaz, Gisele, and Alan Rodgers. *Codex Borgia: A Full-Color Restoration of the Ancient Mexican Manuscript*. New York: Dover Publications, 1993.

Didron, Adolphe. *Christian Iconography: The History of Christian Art in the Middle Ages*. Vol. 1. Translated by E. J. Millington. New York: Fredrick Ungar, 1965 (reprinted from the 1st ed., 1851).

Dillon, Myles. *Early Irish Literature*. Chicago: University of Chicago Press, 1948.

Diodorus of Sicily. *Bibliotheca Historica*. Translated by C. H. Oldfather. Loeb Classical Library. Cambridge, MA: Harvard University Press, 1936.

Donnelly, Ignatius. *Atlantis: The Antediluvian World*. New York: Harper, 1882.

Ducati, Pericle. *L'Arte Classica*. Torino: Unione Tipografico / Editrice Torinese, 1920.

Durán, Fray Diego. *The History of the Indes of New Spain*. Translated by Doris

Heyden. Norman, Oklahoma: University of Oklahoma Press, 1994.

Du Chaillu, Paul. *The Land of the Midnight Sun.* New York: Harper and Brothers, 1882.

———. *The Viking Age: The Early History, Manners, and Customs of the Ancestors of the English-Speaking Nations.* 2 vols. New York: Charles Scribner's, 1889.

Edmonson, Munro S. *Quiche-English Dictionary.* Middle American Research Institute, Publication no. 30. New Orleans: Tulane University, 1965.

Eliade, Mircea. *Images and Symbols: Studies in Religious Symbolism.* Translated by Philip Mairet. New York: Sheed and Ward, 1952.

———. *The Quest: History and Meaning in Religion.* Chicago: University of Chicago Press, 1969.

———. *The Sacred and the Profane.* Translated by Willard R. Trask. New York: Harcourt Brace, 1957.

Ellis, Richard. *Imagining Atlantis.* New York: Vintage, 1999.

Encyclopedia Britannica. 1966 edition.

Eschenbach, Wolfram von. *Parzival.* Translated by André Lefevere. New York: Continuum, 1991.

———. *Parzival: A Romance of the Middle Ages.* Translated by Helen M. Mustard and Charles E. Passage. New York: Vintage, 1961.

Euripides. *Helen.* In *Euripides: The Bacchae and Other Plays.* Translated by Philip Vellacott. New York: Penguin, 1973. First published 1954.

Evans, James. *The History and Practice of Ancient Astronomy.* Oxford: Oxford University Press, 1998.

Fairservis, Walter Jr. *The Roots of Ancient India: The Archeology of Early Indian Civilization.* New York: Macmillan, 1971.

Farrar, Frederic. *The Life of Christ as Represented in Art.* London: Black, 1901.

Frazier, James George. *The Golden Bough.* New York: Macmillan, 1963. First published 1922.

Ferry, David, trans. *Gilgamesh: A New Rendering in English Verse.* New York: Farrar, Straus and Giroux, 1992.

Ford, Patrick K., *Mabinogi and other Medieval Welsh Tales.* Berkeley and Los Angeles: University of California Press, 1977.

Furtwängler, Adolf. *Die Antiken Gemmen: Geschichte der Steinschneidekunst im Klassischen Altertum.* Vol. 3. Leipzig und Berlin: Geisecke und Devrient, 1900.

Furtwängler, Adolf, and K. Reichhold. *Griechische Vasenmalerei.* München: F. Bruckmann, 1909.

Gardner, John, and John Maier, trans. *Gilgamesh: Translated from the Sin-Leqi-Unninni Version.* New York: Vintage Books, 1985.

Geldner, Karl Friedrich, trans. *Rig Veda.* Harvard Oriental Series. Cambridge, Massachusetts: Harvard University Press, 1951.

George, Andrew, trans. *The Epic of Gilgamesh: A New Translation.* New York: Penguin, 1999.

Gerhard, Eduard. *Auserlesene Griechische Vasenbilder, Hauptsächlich Etruskischen Fundorts.* 3 vols. Berlin: G. Reimer, 1843.

Gimbutas, Marija. *The Goddesses and Gods of Old Europe: 6500–3500 B.C. Myths and Cult Images.* Berkeley and Los Angeles: University of California Press, 1982.

———. *The Language of the Goddess.* San Francisco: Harper, 1989.

Goblet D'Alviella, Eugène, Count. *La Migration Des Symboles.* Paris: Leroux, 1891.

———. *The Migration of Symbols.* New York: University Books, 1956. First published 1894.

Goodyear, W. H. *Roman and Medieval Art.* New York: Macmillan, 1910.

Gordon, E. V. *An Introduction to Old Norse.* Oxford: Clarendon Press, 1957.

Graves, Robert. *The Greek Myths.* Wakefield, Rhode Island: Moyer Bell, 1988.

Griffith, Ralph T. H. *Rig Veda* (1896). Reprinted in *Sacred Writings: Hinduism: The Rig Veda.* New York: Quality Paperback Book Club, 1992.

Griffiths, J. Gwyn. *Plutarch's De Iside Et Osiride.* Swansea, Wales: University of Wales Press, 1970.

Grimm, Herman. *Life of Michaelangelo.* Vol. 1. Translated by Fanny Bunètt. Boston: Little Brown, 1900.

Gregory, Lady Augusta. *Irish Myths and Legends.* Philadelphia: Running Press, 1998. First published 1910 (John Murray, London).

Grosse, Johannes. *Die Schönheit des Menschen: Ihr Schaun, Bilden, und Bekleiden.* Dresden: Gerhard Kühtmann, 1912.

Grünwedel, Albert. *Buddhist Art in India.* Translated by Agnes Gibson, and revised by James Burgess. London: Bernard Quaritch, 1901. Originally published as *Handbuch.*

Guirand, Felix, ed. *New Larousse Encyclopedia of Mythology.* Revised Edition. Translated by Richard Aldington and Delano Ames. London: Hamlyn Publishing Group Limited, 1959.

Hansen, William. "Prometheus and Loki." *Classica et Mediaevalia: Danish Journal of Philology and History* 58. (2007).

Heirtzler, J. R., and W. B. Bryan. "The Floor of the Mid-Atlantic Rift." In *Continents Adrift and Continents Aground,* 158–170. San Francisco: W. H. Freeman, 1975.

Heller, Steven. *The Swastika: Symbol Beyond Redemption?* New York: Allworth Press, 2000.

Hencken, Hugh. *Tarquinia and Etruscan Origins.* New York: Frederick A. Praeger Publishers, 1968.

Herakleitos. *Fragment.* Translated by Guy Davenport. *Herakleitos and Diogenes.* San Francisco: Grey Fox Press, 1976.

Herodotus. *The Histories.* Translated by George Rawlinson. New York: Knopf, 1997.

Hesiod. *Hesiod, Homeric Hymns, and Homerica.* Translated by Hugh G. Evelyn-White. Loeb Classical Library 57. Cambridge: Harvard University Press, 2002. First published 1914.

———. *Theogony.* Translated by Dorothea Wender. London: Penguin Books, 1973.

Heubeck, Alfred, Stephanie West, and J. B. Hainsworth. *A Commentary on Homer's Odyssey.* Oxford: Clarendon Press, 1988.

Hodge, Frederick Webb, ed. *Handbook of American Indians North of Mexico.* Smithsonian Institution, Bureau of Ethnology, Bulletin 30, Part 1. Washington DC: Government Printing Office, 1907.

Hollander, Lee M. *Poetic Edda.* Austin: University of Texas Press, 1962.

Holmberg, Uno. *Finno-Ugric Mythology, Siberian.* In *The Mythology of All Races.* New York: Cooper Square, 1964. First published by Archaeological Institute of America, Marshal Jones, 1927.

Holy Bible. Authorized (King James) Version.

Homer. *Iliad.* Translated by Robert Fitzgerald. New York: Doubleday, 1974.

———. *Iliad.* Translated by A. T. Murray. Revised by William F. Wyatt. Loeb Classical Library 170 and 171. Cambridge, MA: Harvard University Press, 1999. First published 1924.

———. *Iliad.* Translated by E. V. Rieu. New York: Penguin, 1950.

———. *Odyssey.* Translated by A. T. Murray. Loeb Classical Library 104 and 105. Cambridge, MA: Harvard University Press, 1919.

———. *Odyssey*. Translated by A. T. Murray. Revised by George Dimock. Loeb Classical Library 104 and 105. Cambridge, MA: Harvard University Press, 2002.

———. *Odyssey*. Translated by George Herbert Palmer. New York: Houghton-Mifflin, 1912.

———. *Odyssey*. Translated by Richmond Lattimore. New York: Harper Perennial, 1965.

———. *Odyssey*. Translated by Robert Fitzgerald. New York: Farrar, Straus and Giroux, 1998.

Homeric Hymns. Translated by Hugh G. Evelyn-White. Loeb Classical Library 57. Cambridge, MA: Harvard University Press, 1936.

Hopper, R.J. *The Early Greeks*. New York: Harper and Row, 1977.

Hoskin, Michael. *The Cambridge Illustrated History of Astronomy*. New York: Cambridge University Press, 1997.

Hristov, Romeo H., and Santiago Genovés T. "Viajes transatlánticos antes de Colón." *Arqueología Mexicana* 33, no. 6, (1998): 48–53.

Hunt, Eva. *The Transformation of the Hummingbird: Cultural Roots of a Zinacantecan Mythical Poem*. Ithaca: Cornell University Press, 1977.

Hurll, Estelle. *Michelangelo*. Boston: Houghton, Mifflin, 1901.

James, E. O. *The Tree of Life: An Archeological Study*. Leiden: Brill, 1966.

Jeremias, Alfred. *Handbuch der altorientalischen Geisteskultur*. Leipzig: J. C. Hinrichs'sche Buchhandlung, 1913.

———. *Handbuch der altorientalischen Geisteskultur*. 2nd ed., rev. Berlin and Leipzig: de Gruyter, 1929.

Jones, Gwyn. *A History of the Vikings*. 2nd ed. Oxford: Oxford University Press, 1984. First published 1968.

Jones, Sir William. "Third Anniversary Discourse, On the Hindus." Lecture delivered February 2, 1786. In *Works I*, 19–34. Quoted in: W. P. Lehmann. *A Reader in Nineteenth Century Historical Indo-European Linguistics*. Bloomington: Indiana University Press, 1967. http://www.utexas.edu/cola/depts/lrc/iedocctr/ie-docs/lehmann/reader/chapterone.html.

Jung, C. G., and C. Kerényi. *Essays on a Science of Mythology: The Myth of the Divine Child and the Mysteries of Eleusis*. Translated by F. C. Hull. Princeton, New Jersey: Princeton University Press, 1969.

Jung, E. *Germanische Götter und Seldon in christlicher Zeit*. Munich: Lehmanns Verlag, 1922.

Karmay, Samten, trans. and ed. *The Treasury of Good Sayings: A Tibetan History of Bon*. Delhi: Motilal Banarsidass Publishers, 1972.

Keith, Arthur Berriedale. *Indian Mythology*. Vol. 6, *Mythology of All Races*. Boston: Marshall Jones, 1917.

Kenoyer, Jonathan. *Ancient Cities of the Indus Valley Civilization*. Karachi: Oxford University Press, American Institute of Pakistan Studies, 1998.

Kerényi, Carl. *Zeus and Hera: Archetypal Image of Father, Husband, and Wife*. Princeton, New Jersey: Princeton University Press, 1975.

Kirby, W. F., trans. *Kalevala: The Land of the Heroes*. Everyman's Library 259. New York: E. P. Dutton, 1907.

Kirk, G. S. *Myth: Its Meaning and Functions in Ancient and Other Cultures*. Berkeley and Los Angeles: University of California Press, 1970.

Klein, Wilhelm. *Euphronios: Eine Studie zur Geschichte der Griechischen Malerei*. Vienna: Carl Gerold's Sohn, 1886.

Klüge, Friedrich. *Etymologisches Wörterbuch der Deutschen Sprache*. 19th ed. Berlin: Walter De Gruyter, 1960.

Kovacs, Maureen Gallery, trans. *The Epic of Gilgamesh*. Stanford, California: Stanford University Press, 1989.

Kramer, Samuel Noah. *Sumerian Mythology: a Study of Spiritual and Literary Achievement in the Third Millennium B.C.* Revised ed. Philadelphia: University of Pennsylvania Press, 1944. Revised 1961.

Kuhn, P. Albert. *Allgemeine Kunst-Geschichte.* 3 vols. Einsiedeln: Benziger Bros., 1909.

Kuiper, F. B. J. "The Bliss of Aša." *Indo-Iranian Journal* 8 (1964): 96–129.

Lambsprinck. *The Book of Lambspring.* http://www.levity.com/alchemy/lamb-text.html. Originally published as *De Lapide Philosophico Libellus* (Leiden, 1599).

Langdon, Stephen Herbert. "Semitic Mythology." Vol. 5, *The Mythology of All Races.* John A. MacCulloch, ed. New York: Cooper Square, 1964.

Larrington, Carolyne, trans. *The Poetic Edda.* Oxford: Oxford University Press, 1996.

Lasseur, Denyse Le. *Les Déesses Armées dans L'Art Classique Grec leurs Origines Orientales.* Paris: Librairie Hachette, 1919.

Leach, Maria, ed. *Funk and Wagnall's Standard Dictionary of Folklore, Mythology and Legend.* New York: Harper and Row, 1984.

Liddell & Scott. *Greek-English Lexicon.* 9th ed. Oxford: Oxford University Press, 1940.

Lindsay, Jack. *The Origins of Alchemy in Graeco-Roman Egypt.* New York: Frederick Muller, 1970.

Lloyd, Seton, and Fuad Safar. "Tell Hassuna, Excavations by the Iraq Government Directorate General of Antiquities in 1943 and 1944." *Journal of Near Eastern Studies* 4 (1945): 255–89.

Loewenstein, John. "The Swastika: Its History and Meaning." *Man* 41 (1941): 49–55.

Loomis, Roger Sherman. *The Grail: From Celtic Legend to Christian Symbol.* Princeton, New Jersey: Princeton University Press, 1991. First published 1963.

MacCulloch, J. A. *The Religion of the Ancient Celts.* Mineola, New York: Dover, 2003. First published 1911.

Macdonell, Arthur A. *A Vedic Reader for Students.* Madras: Oxford University Press, 1917.

MacBain, Alexander. *Celtic Mythology and Religion.* Royston, Hertfordshire, England: Oracle, 1996. First published 1917.

McLean, Adam. *The Alchemical Mandala: A Survey of the Mandala in the Western Esoteric Traditions.* Grand Rapids, Michigan: Phanes, 2002.

Maier, Michael. *Subtilis Allegoria super Secreta Chymiae Perspicuae Utilitatis et Iucundae meditationis Michaelis Maeieri.* In *Musaeum Hermeticum.* Frankfurt, 1678. http://www.alchemywebsite.com/maier.html.

———. *Atalanta Fugiens, hoc est, Emblemata Nova De Secretis Naturae Chymica.* Oppenheim: de Bry, 1618. Facsimile edition, Kassel: Bärenreiter-Verlag, 1964. Illustrations and emblems also partially reproduced and translated (by de Jong) in *Maitreya Three.* Berkeley: Shambala Publications, 1972.

———. *Symbola Aureae Mensae Duodecim Nationum.* Graz, Austria: Akademische Druck- und Verlagsanstalt, 1972. First published 1617 (Frankfurt).

Malek, Jaromir. *Egypt: 4000 Years of Art.* London: Phaidon, 2003.

Mallory, J.P. *In Search of the Indo-Europeans: Language, Archaeology and Myth.* New York: Thames and Hudson, 1989.

Mallowan, M. E. L. and J. Cruikshank Rose. "Excavations at Tall Arpachiyah, 1933." *Iraq* 2 (1935): 1–178.

Mani, B. R. and Alok Tripathi, eds. *Expressions in Indian Art: (Essays in Memory of Shri M.C. Joshi).* Vol. 1. Delhi: Agam Kala Prakashan, 2008.

Mann, Charles C. *1491: New Revelations of the Americas Before Columbus.* New York: Alfred A. Knopf, 2005.

March, H. Colley. "The Fylfot and the Futhorc *Tir.*" *Transactions of the Lancashire and Cheshire County Antiquarian Society*, (1886): 1–12.

Marchant, E. C. *Homer's Odyssey, edited with introduction and notes.* London: George Bell, 1901.

Mariette-Bey, August. *Dendérah: Description Générale du Grand Temple de Cette Ville.* Paris: Librairie A. Franck, 1874.

Markman, Roberta H., and Peter T. Markman. *The Flayed God: Mesoamerican Mythological Tradition.* New York: HarperCollins, 1992.

Mayer, August. *Meisterwerke der Gemäldesammlung des Prado in Madrid.* München: Franz Hanfstaengl, 1922.

Mellaart, James. *The Neolithic of the Near East.* New York: Scribner's, 1975.

Ménard, René. *Histoire des Beaux-Arts.* Paris: Librairie de L'imprimerie Générale, 1875.

Mercatante, Anthony S. *Who's Who in Egyptian Mythology.* New York: Clarkson N. Potter, 1978.

Mertz, Henriette. *The Wine Dark Sea.* Chicago: Henriette Mertz, 1964.

Milbrath, Susan. *Star Gods of the Maya: Astronomy in Art, Folklore, and Calendars.* Austin: University of Texas Press, 1999.

Monier-Williams, Monier. *A Sanskrit-English Dictionary.* Delhi: Motilal Banarsidass, 1981.

Monuments of Egypt: The Napoleonic Edition. Old Saybrook, Connecticut: Princeton Architectural Press, 1987. Orininally published as *La Description de L'Egypte* (1809).

Müller, Max. *Egyptian Mythology.* In *The Mythology of All Races.* Boston: Marshall Jones Company, 1918.

New Advent Catholic Encyclopedia. http://www.newadvent.org/cathen/13770a.htm.

Nicholson, H. B., with Eloise Quiñones Keber. *Art of Aztec Mexico: Treasures of Tenochtitlan.* Washington, DC: National Gallery of Art, 1983.

Nonnos. *Dionysiaca.* Vol. 3. Translated by W. H. D. Rouse. Loeb Classical Library. Cambridge, Mass: Harvard University Press, 1940.

Nowotny, Karl, ed. and commentator. *Codex Borgia.* Graz: Akademische Druck und Verlags Anstelt, 1976.

Oats, Joan. "Choga Mami, 1967–68: A Preliminary Report." *Iraq* 31 (1969): 115–52.

O'Flaherty, Wendy Doniger, trans. *Hindu Myths.* New York: Penguin, 1975.

———. *Rig Veda.* New York: Penguin, 1981.

Ovid. *Metamorphoses.* Translated by Mary Innes. New York: Penguin, 1955.

———. *Metamorphoses.* Translated by Allen Mandelbaum. New York: Harcourt, 1993.

———. *Metamorphoses.* Translated by A. D. Melville. Oxford: Oxford University Press, 1986.

Oxford Classical Dictionary. Edited by M. Cary, et al. Oxford: Clarendon Press, 1949.

Oxford Study Bible: Revised English Bible with the Apocrypha. New York: Oxford University Press, 1992.

Pachinger, A. M. *Die Mutterschaft in der Malerei und Graphik.* Leipzig: Georg Müller, 1906.

Page, Denys. *The Homeric Odyssey: The Mary Flexner Lectures delivered at Bryn Mawr College Pennsylvania.* Oxford: Clarendon Press, 1955.

———. *History and the Homeric Iliad.* Berkeley and Los Angeles: University of California Press, 1959.

———. *Folktales in Homer's Odyssey.* Cambridge, Massachusetts: Harvard University Press, 1973.

Pausanias. *Description of Greece*. Translated by W. H. S. Jones. Cambridge, Mass: Harvard University Press, 1918.

———. *Guide to Greece*. Translated by Peter Levi. London: Penguin Books, 1971.

Perrot, Georges and Charles Chipiez. *A History of Art in Chaldaea and Assyria*. 2 vols. Translated and edited by W. Armstrong. London: Chapman and Hall, 1884.

———. *History of Art in Primitive Greece: Mycenian Art*. London: Chapman and Hall, 1894.

Perrot, Georges, and Robert de Lasteyrie. *Monuments et Mémoires*. 20 vols. Paris: 'Académie des Inscriptions et Belles-Lettres, 1897.

Petrie, Flinders. *The Arts and Crafts of Ancient Egypt*. London: T. N. Foulis, 1910.

Pietzner, Carlo, and Paul Marshall Allen. *A Christian Rosenkreutz Anthology*. Blauvelt, New York: Rudolf Steiner Publications, 1981.

Plato. *The Collected Dialogues*. Edited by Hamilton, Edith, and Huntington Cairns. Princeton, New Jersey: Princeton University Press, 1961.

———. *The Works of Plato*. Translated by B. Jowett. New York: Tudor Publishing, nd. First published 1871.

Plutarch. *Isis and Osiris*. Translated by S. Squire. Cambridge, 1744. Quoted in: Budge, E. A. Wallis. *The Gods of the Egyptians*. New York: Dover, 1904.

Pokorny, Julius. *Indogermanisches Etymologisches Woerterbuch*. Bern: Franke Verlag, 1959.

Poncé, Charles. "The Alchemical Death: Notes from a Journal." In *Maitreya Three*. Berkeley: Shambhala Publications, 1972.

Possehl, Gregory. *Harappan Civilization: A Recent Perspective*. 2nd rev. ed. New Delhi: American Institute of Indian Studies, and Oxford & IBH Publishing, 1993.

Powell, J. W., ed. *Third Annual Report of the Bureau of Ethnology 1881–82*. Washington, DC: Government Printing Office, 1884.

———. *Eighth Annual Report of the Bureau of Ethnology 1886–87*. Washington, DC: Government Printing Office, 1891.

Puhvel, Jaan. *Comparative Mythology*. Baltimore: Johns Hopkins University Press, 1987.

Ramos, Guadalupe, and Ángel Sanz Tapia. *Grandes Civilizaciones: Maya – Azteca*. Madrid: Gr. U. P. O., 1998.

Rayet, Olivier, and Maxime Collignon. *Histoire de La Céramique Grecque*. Paris: Georges Decaux, 1888.

Recinos, Adrián, trans. *Popol-Vuh*. Guatemala City, Guatemala: Editorial Piedra Santa, 2006.

Redford, Donald B. *Egypt, Canaan, and Israel in Ancient Times*. Princeton, New Jersey: Princeton University Press, 1992.

Reichen, Charles-Albert. *A History of Astronomy*. New York: Hawthorn, 1968.

Raynaud, Georges, Miguel Angel Asturias, and J.M. Gonzalez de Mendoza, trans., *Anales de los Xahil*. Biblioteca del Estudiante Universitario 61. Mexico City, Mexico: Ediciones de la Universidad Nacional Autonoma, 1946.

Rey, H. A. *The Stars: A New Way to See Them*. Boston: Houghton Mifflin, 1952.

Rhŷs, John. *Celtic Folklore, Welsh and Manx*. Oxford: Oxford University Press, 1901. http://www.sacred-texts.com/neu/cfwm/cf206.htm.

Riley, Carroll L., et al., eds. *Man across the Sea: Problems of Pre-Columbian Contacts*. Austin, Texas: University of Texas Press, 1971.

Roob, Alexander. *Alchemy and Mysticism: the Hermetic Cabinet*. Bonn: Taschen, 2005.

Rydberg, Victor. *Teutonic Mythology: Gods and Goddesses of the Northland.* Translated by Rasmus Anderson. Text from http://www.northvegr.org/lore/rydberg/index.php.

Sandars, N. K., trans. *Gilgamesh.* rev. ed. New York: Penguin, 1972.

Sauvé, James L. "The Divine Victim." In *Myth and Law among the Indo-Europeans: Studies in Indo-European Comparative Mythology.* Jaan Puhvel, ed. Berkeley and Los Angeles: University of California Press, 1970.

Saxo Grammaticus. *The Nine Books of the Danish History of Saxo Grammaticus.* Translated by Oliver Elton. New York: Norroena Society, 1905. http://omacl.org/DanishHistory/book511.html.

Schliemann, Heinrich. *Troy and its Remains: A Narrative of Researches and Discoveries Made on the Site of Ilium, and in the Trojan Plain.* New York: Scribner, Welford, and Armstrong, 1875.

———. *Ilios.* New York: Harper and Bros., 1881.

Schuchhardt, C. *Schliemann's Excavations.* Chicago: Ares, 1965.

Schweitzer, Bernhard. *Greek Geometric Art.* Translated by Peter and Cornelia Usborne. New York: Phaidon Publishers, 1971.

Seidlmayer, Stephan. "Egypt's Path to Advanced Civilization." In *Egypt: The World of the Pharaohs.* Regine Schulz and Matthias Seidel, eds. np. Könemann, nd.

Settegast, Mary. *Plato Prehistorian: 10,000 to 5,000 B.C. Myth, Religion, Archeology.* Hudson, New York: Lindisfarne Press, 1990.

Schele, Linda, and Mary Ellen Miller. *The Blood of Kings: Dynasty and Ritual in Maya Art.* New York: George Braziller, 1986.

Seler, Eduard, et al. *Mexican and Central American Antiquities, Calendar Systems, and History.* Translated by Charles Bowditch. Bureau of American Ethnology, Bulletin 28. Washington D.C.: Government Printing Office, 1904.

Seler, Eduard, ed., trans., *Codex Borgia, Eine altmexikanische Bilderschrift der Bibliotek der Congregatio de Propaganda Fide.* 3 vols. Berlin: 1904–1909.

Sibylline Books. (Greek text) http://www.uwo.ca/kings/ocp/SibOr.xml.

Skelton, R. A. *Explorers' Maps: Chapters in the Cartographic Record of Geographical Discovery.* New York: Praeger, 1958.

Skelton, R. A., Thomas E. Marston, and George D. Painter. *The Vinland Map and the Tartar Relation.* New Haven: Yale University Press, 1965.

Smithsonian Institution, Bureau of American Ethnology. *Bulletin 157, Anthropological Papers Numbers 43–48.* Washington DC: Government Printing Office, 1955.

Sorenson, John L., and Martin H. Raish. *Pre-Columbian Contact with the Americas across the Oceans: An Annotated Bibliography.* 2nd ed., revised. 2 vols. Provo, Utah: Research Press, 1996.

Sorenson, John L. and Carl L. Johannessen. "Biological Evidence for Pre-Columbian Transoceanic Voyages." In *Contact and Exchange in the Ancient World*, Mair, Victor H., ed. Honolulu: University of Hawai'i Press, 2006.

Spearing, H. G. *The Childhood of Art or The Ascent of Man.* New York: Putnam's Sons, 1913.

Sprague de Camp, L. *Lost Continents: The Atlantis Theme in History, Science, and Literature.* New York: Dover, 1970. First published 1954.

Springer, Anton. *Handbuch der Kunstgeschichte.* 4 vols. Leipzig: Seemann, 1911.

Stolcius de Stolcenberg. *Viridarium Chymicum.* Translated by Vinci Verginelli. Firenze: Nardini, 1983. First published 1624.

Strabo. *The Geography.* Translated by H. L. Jones. Loeb Classical Library, 8 vols. Cambridge, MA: Harvard University Press, 1917–1932. http://pe-

nelope.uchicago.edu/Thayer/E/Roman/Texts/Strabo/5A*.html.

Strong, Donald. *The Early Etruscans.* New York: G. P. Putnam's Sons, 1968.

Strong, James. *The New Strong's Expanded Exhaustive Concordance of the Bible: Hebrew and Aramaic Dictionary.* Nashville, Tennessee: Thomas Nelson Publishers, 2001.

Sturluson, Snorri. *The Prose Edda.* Translated by Arthur Gilchrist Brodeur. New York: The American-Scandinavian Foundation, 1929. First published 1916.

———. *The Prose Edda.* Translated by Jesse L. Byock. New York: Penguin, 2005.

———. *The Prose Edda.* Translated by Jean Young. Berkeley and Los Angeles: University of California Press, 1964.

———. *Heimskringla, Part One: The Olaf Sagas.* Vol. 1. Translated by Samuel Laing. New York: Dutton, 1964.

Szemerényi, Oswald J. L. *Introduction to Indo-European Linguistics.* Oxford: Oxford University Press, 1990.

Tacitus. *Germania.* Translated by Church and Bodribb. *The Complete Works of Tacitus* New York: The Modern Library, 1942.

Taylor, Charles H., ed. *Essays on the Odyssey.* Bloomington, Indiana: Indiana University Press, 1963.

Tedlock, Barbara. *Time and the Highland Maya.* Revised ed. Albuquerque: University of New Mexico Press, 1992.

Tedlock, Dennis. *Popol Vuh.* New York: Simon & Schuster, 1985. Also revised ed., 1996.

Terry, Milton S., trans. *Sibylline Oracles.* New York: Eaton & Mains, 1899; http://www.sacred-texts.com/cla/sib/sib14.htm.

Tezozómoc, Hernando Alvarado. *Crónica Mexicayotl* (1609). Translated by Thelma D. Sullivan. See Markman.

Thorpe, Benjamin, trans. *The Elder Eddas of Saemund Sigfusson.* New York: Norrœna Society, 1906.

Thorsson, Örnólfur, Editor. *The Sagas of Icelanders: A Selection.* New York: Viking, 2000.

Times Atlas of the World. Comprehensive Edition. Bartholomew, John C., ed. New York: Times Books, 1983.

Tum, Pedro Florentino Ajpacajá, et al. *Diccionario K'iche'.* Guatemala City: Proyecto Lingüístico Francisco Marroquín/Cholsamaj, 1996.

Turville-Petre, E. O. G. *Myth and Religion of the North: The Religion of Ancient Scandinavia.* New York: Holt, Rinehart & Wilson, 1964.

van Buitenen, J. A. B., trans. *Bhagavadgītā.* Chicago: University of Chicago Press, 1981.

van der Toorn, Karel, Bob Becking, and Pieter W. van der Horst, eds. *Dictionary of Deities and Demons in the Bible (DDD).* New York: E. J. Brill, 1995.

Vaughn, Thomas. *Lumen de Lumine, or a New Magical Light.* London, 1651. http://www.alchemywebsite.com/lumen2.html.

———. *Coellum Terrae or the Magician's Heavenly Chaos.* First published as *Magia Adamica,* under the pseudonym Eugenius Philalethes. London, 1650. http://www.levity.com/alchemy/vaughan1.html.

Venkatesananda, Swami, trans. *The Concise Ramayana of Valmiki.* Albany, New York: State University of New York Press, 1988.

Ventris, Michael, and John Chadwick. *Documents in Mycenaean Greek: Three Hundred Selected Tablets From Knossos, Pylos and Mycenae with Commentary and Vocabulary.* Cambridge: Cambridge University Press, 1959.

Venturi, A. *Storia Dell'Arte Italiana.* 11 vols. Milan: Ulrico Hoepli, 1901–1940.

Vergil. *The Aeneid.* Translated by Patric Dickinson. New York: New American

Library, 1961.

Vijñanananda, Swami, trans. *S'rîmad Devî Bhâgawatam* (1921). Text from http://www.sacred-texts.com/hin/db/bk08ch07.htm.

Volkstein, Diane, and Samuel Noah Kramer. *Inanna: Queen of Heaven and Earth*. New York: Harper and Row, 1983.

von Hagen, Victor Wolfgang. *The Ancient Sun Kingdoms of the Americas*. New York: World Publishing, 1957.

Waite, Arthur Edward. *The Brotherhood of the Rosy Cross*. New Hyde Park, New York: University Press, nd. First published 1924.

Wallis, Henry. *Egyptian Ceramic Art*. London: Taylor and Francis, 1918.

Wallrodt, Susan. "Ritual Activity in Late Classical Ilion: The Evidence from a Fourth Century B.C. Deposit of Loomweights and Spindle Whorls." *Studia Troica* 12 (2002): 179–196.

Walters, H. B. *The Art of the Greeks*. New York: Macmillan, 1906.

———. *Catalogue of the Bronzes, Greek, Roman, and Etruscan, of the British Museum*. London: Trustees of the British Museum, 1899.

———. *History of Ancient Pottery; Greek, Etruscan, and Roman*. 2 vols. London: John Murray, 1905.

Wasson, R. Gordon. *Soma: Divine Mushroom of Immortality*. New York: Harcourt Brace Jovanovich, nd.

Waters, Frank. *Book of the Hopi*. New York: Viking Press, 1963.

Wensinck, A. J. *The Ideas of the Western Semites Concerning the Navel of the Earth*. Amsterdam: Johannes Müller, 1916. Reprinted in *Studies of A. J. Wensinck* (New York: Arno Press, 1978).

———. *The Ocean in the Literature of the Western Semites* (1918). Reprinted in *Studies of A. J. Wensinck.* New York: Arno Press: 1978.

Westendorf, Wolfhart. *Painting, Sculpture, and Architecture of Ancient Egypt*. New York: Harry N. Abrams, 1968.

Widengren, Geo. *The King and the Tree of Life in Ancient Near Eastern Religion*. In *Uppsala Universitets Årsskrift* 4 (1951). Uppsala: A-B Lundequistska Bokhandeln.

Wilson, Thomas. "The Swastika, the Earliest Known Symbol, and Its Migrations; with Observations on the Migration of Certain Industries in Prehistoric Times." In *Report of the United States National Museum for the Year Ending June 30, 1894*, Part 2, no. 6: 757–1011. Washington, DC: Government Printing Office, 1896.

Witzel, Michael. "Sur le chemin du ciel." *Bulletin des Etudes Indiennes* 2 (1984): 213–279. http://www.people.fas.harvard.edu/~witzel/CheminDuCiel.pdf.

———. "Looking for the Heavenly Casket." *Electronic Journal of Vedic Studies* 1.2 (1995). http://users.primushost.com/~india/ejvs/issue2/art1.html.

———. "Comparison and Reconstruction: Language and Mythology." Mother Tongue 6 (2001). http://www.people.fas.harvard.edu/~witzel/Comp_Myth.pdf.

———. "Vala and Iwato: The Myth of the Hidden Sun in India, Japan, and Beyond." *Electronic Journal of Vedic Studies* 12-1 (March 2005): 1–69. http://users.primushost.com/~india/ejvs/ejvs1201/ejvs1201article.pdf.

Wood, Michael. *In Search of the Trojan War*. Berkeley and Los Angeles: University of California Press, 1985.

Yates, Francis. *The Rosicrucian Enlightenment*. Boston: Routledge, 1972.

Zangger, Eberhard. *The Flood from Heaven: Deciphering the Atlantis Legend*. New York: William Morrow and Company, 1992.

Zoëga, Geir T. *A Concise Dictionary of Old Icelandic*. Oxford: Clarendon Press, 1972. First published 1910.

Index to the Chapters

Atlas 1, 2, 7, 9, 11, 22, 29, 30–32, 35, 36, 40, 42, 43, 51, 69, 71, 72, 76, 77, 108, 114, 115, 119, 124, 132, 135, 141, 143, 144, 154, 165, 166, 170, 173, 187, 188, 192, 201, 204–206, 208, 257, 258, 280, 286, 290, 303, 325
Audumla 49, 95, 182, 307
Augeas 28
Aurora Consurgens 272
Avalon 250, 255
axe 87, 89, 169, 321, 323
axle 11, 61, 62, 66, 67, 112, 189, 277
Azores 19, 44, 165, 255, 304
Aztec 67, 75, 76, 84, 111, 134, 138, 141, 142, 144–147, 154–156, 163, 164, 168, 275, 276, 312, 313, 315, 326
Aztlan 138, 144

B

Baal 202
Babylonian 6, 7, 52, 57, 58, 59, 63, 72, 158
Badarian 169
Baden-Powell 2, 6, 301
Bai-Ylgön 82
Balkans 4
Baltic 11, 13, 19–23, 34, 35, 42, 49, 122, 159, 162, 165, 166
barley 87, 88
Bashkirs 85
Batu-Ribn 63
Bavaria 23, 24
bdellium 16, 17, 39, 160, 302
Behemoth 125, 126, 310
bennu 251, 175
Bering Straits 159
Bethlehem 17
Bezoar 151, 313
Bhagavad Gita 112
Bible 6, 8, 16–18, 275, 302, 318, 320, 323
birch 74, 87
bird 24, 35, 58, 59, 65, 72, 75, 76, 85, 87, 90, 95, 100, 103, 112, 113, 114, 115, 122, 124, 134–137, 140–142, 146, 170–172, 175, 190, 195, 198, 200, 204, 213, 215–222, 225, 235, 251, 252, 254, 264, 265, 272, 274, 277, 278, 306, 310, 323
bison 32
black pine 58
Black Sea 2, 21, 35, 205
boat 89–91, 170, 171, 178, 180, 185, 187, 188, 243
Bon Po 101, 102, 103, 105, 106, 309, 310

Book of Henoch 167
Book of the Dead 177, 181, 185, 186, 188
Books of Overthrowing Apep 175
Boreas 20
bow 7, 24, 25, 28, 67, 191, 201, 212
bracteate 97–99, 103
Brahma 190, 191, 195
Brân 113, 246, 247, 251, 252, 254
Branwen, Daughter. of Llr 251, 252
Brazil 17, 18, 24, 158–166, 302
breasts 83, 84, 89, 110, 265
bridge 8, 52, 63, 71, 84, 94, 96, 100, 101, 117, 135, 159, 190, 211, 218, 235, 251, 254, 277, 287, 308
Bronze Age 3, 9, 157, 160, 163
Buch der Heiligen Dreifaltigkeit 65
Buddha 75, 117, 197, 198
Buddhism 102
bull 50, 91, 124–127, 196, 197, 289
Bull of Heaven 50
Bundahisn 159
Buriat 83
Buriats 85
Burnouf, Emile 5, 6, 301
Bursera. *See* Commiphora
Busiris 29, 30
Byblos 32, 170, 186

C

Cadiz 30
caduceus 118, 177, 265, 266
Caer Siddi 246, 250
Cahokia 135
Callirrhoe 28
Calvary 64, 65
Calypso 33, 35, 40–43, 61, 69, 76, 77, 91, 153, 205, 214, 303–4
cameo 18
Campbell, Joseph 135, 137, 144
Canaan 64
Canary Islands 44, 165
Canis Major 116, 179, 195
Canis Minor 116, 119, 179
Capricorn 74, 115, 119, 204, 217, 238, 278, 308, 309
Carbon 109
cardinal directions 1, 3, 7, 15, 17, 49, 50, 62, 71–73, 84, 103–106, 109, 121, 126, 131, 138, 140–143, 168, 170, 171, 176, 177, 181, 182, 184, 187, 188, 192, 235, 277, 318
carob 54, 63, 72
castle 92, 97, 98, 101, 244, 245, 246–255
cat 175, 176, 182
catacombs 66

Catalogues of Women 20, 302
cattle 22, 23, 28, 30–32, 35, 37, 39, 40, 288
Caucasus 24, 30, 205, 303
cauldron of plenty 68, 97, 243, 255
cedar 54, 57, 72, 125, 126, 174
Celts 21, 22, 113, 160, 323
centaurs 229
Centaurus 209
Cerberus 30, 31, 73, 74, 97, 136, 179, 195, 204, 253
Ceryneian Hind 33
Ceto 120
Chaldaea 11, 12
Charlemagne 68
Charybdis 35, 74, 214, 216
Cheremiss 85
Cherubims 55, 56
Chichén Itzá 144–146
China 8, 73
Choga Mami 46
Christ 64–66, 74, 75, 77, 206, 243, 256, 260, 278, 279, 281, 320
Christianity 64, 66, 93, 173, 243, 308
Christoforo Simone dei Crocefissi 65
Chrysaor 28
churning of the ocean of milk 190, 191, 196
Cimmerians 38
Cinyras 203
Circe 33, 35, 37–39, 41, 42, 55, 61, 91, 166, 205, 214, 216, 304
City of Is 160
clouds 87, 89, 196, 198, 208, 214, 277
club 28, 201–204, 320, 322
Coatlicue 67, 144
Codex Borgia 70, 76, 140, 141, 144, 145, 155, 156
Codex Chimalpopoca 144, 312
Codex Cortesianus 141, 143
Codex Fejervary 75, 141, 142
Colchis 35, 41, 303
collective unconscious. *See* Jung, C. G.
comb 3, 7, 88, 97, 228
combat myths 120
Commiphora 17, 18
Conn of the Hundred Battles 250
copper 71, 90, 91, 103, 133, 135, 148, 169
Coptic 173, 178
cornucopia 68, 74, 97, 101, 202, 204, 215, 217, 254, 277, 308, 322, 324
Coronado, Francisco de 147, 148
Cortéz, Hernán 146, 148
Cosmographia 67
Cosmographical Glasse 69, 165, 315
couch 58, 59, 280

spindle and spindle whorls 3–7, 9, 11–13, 62, 66, 67, 69, 87, 89, 99, 111, 112, 132, 157, 158, 181, 203, 214, 217, 222, 227–238, 240, 273, 275, 279, 280, 301, 309
Sri 84, 191, 192, 320
stag 2, 4, 7, 9, 33, 45–47, 73, 74, 76, 77, 84, 96,107, 115, 122, 141, 170, 171, 204, 207, 210, 216, 218, 219, 221, 222, 227–231, 233, 235, 240, 247, 254, 278, 306, 308, 322
St. Elmo's fire 213, 214
Michelspacher, Stephan 266
Stolcius 115
Stonehenge 135
Strabo 21, 302
Strymon 18, 23, 29–31
Stymphalian Birds 35
Suidas 270
Sumerians 6, 45, 57, 58, 60, 121, 305
sun 2, 4, 5, 11, 19, 20–23, 28–32, 34, 38, 39, 50, 52, 54, 59, 83, 86, 110, 119, 137, 142, 147, 150, 167, 173, 174, 186–188, 192, 200, 208, 210, 212, 229, 231, 244, 252, 257, 258–260, 263, 266–270, 280, 284, 287, 311–313, 315
Svipdag 97, 308
swan 72, 76, 88, 95, 114, 115, 122, 123, 190, 193, 206, 213, 278, 318
Swanefelt 76
swastika 2–6, 9, 10, 11, 13, 15–19, 23, 24, 25, 27, 28, 31–34, 36, 39, 40, 42, 44–47, 49, 66, 67, 72, 73, 76, 77, 80, 94, 96, 97, 98, 99, 100–107, 109, 116, 128, 131, 133–135, 137–141, 144, 145, 147, 154–156, 158–160, 162–168, 190, 192, 204, 207, 208, 210, 216, 218–222, 228, 229, 231–235, 237–240, 255, 274, 279, 301, 305, 310, 311, 313, 314, 323
Sweden 98, 100, 162
swine 37
sword 9, 55, 56, 74, 93, 121, 203, 261, 264
sycamore 173, 174, 181, 182, 184, 213
Symbola Aureae Mensae 115, 266, 268, 270, 325
symbolon 148
Syracuse 22

T

Tacitus 20, 21, 37, 302, 321
Taittirīya Ārantyaka 78
Talmud 59
tamarisk 172, 174, 186
Tammuz 202
tantric 77, 104, 109
Tartessus 28, 29
Tatars 85
Taurus 126, 127
teal 86
Tefnut 184
Teiresias 37, 39
Teleuts 85
Tell Arpachiyayh 46
Tell Hassuna 46
Teneriffe 165, 166
Tethys 18, 19, 23
Teutons 159, 161
Tezcatlipoca 143, 144, 146, 312, 319
Themis 29
Thermydrae 30
Theseus 27, 28, 43, 125, 126, 128, 213, 214, 310
Thisbe 24, 25
Thor 96, 159
Thorkill 40
Thorsbjerg 94
Thoth 171, 182, 185
Thrace 16, 29, 201, 209
Three Fates, The 95
Thrinakia 22, 32, 33, 35–37, 39, 42
thrinax 22
Thutmose III 51
Tibet 11, 67, 72, 81, 101–103, 105, 107, 139, 190, 197, 218, 274, 275, 309, 310
Tigris 16, 17, 22, 138
Tir na n-Og 160
Tiryns 23
titan 7, 11, 12, 71, 76, 110, 132, 143, 154, 173, 187, 192, 205, 207, 257, 258, 277, 280
Tithonus 30
Titian 14, 125
titmouse 87
Tiw 211
Tlalteutli 141
Toltecs 146
Tree of the Middle Place 140, 141
trident 22, 32, 321
triskelion 101
Triton 33, 36
Trojan War 2, 36, 301, 314
Troy 2–4, 6, 9, 11, 13, 74, 122, 131, 157–160, 213, 214, 216, 222, 228, 231, 235–238, 242, 275, 279, 301, 303, 305, 322, 323
Tuat 185, 186

Tula, Tulan 138, 139, 144, 145, 146
Tungus 73
Tungus-Orotshons 85
Tuonela 91
Turkey 3, 16
Turville-Petre 96, 99, 100, 307, 308
Twelve Chapters by Ostanes the Philosopher on the Philosopher's Stone 261
Typhon 29, 30, 118, 121, 176, 183, 310, 316

U

udder 49, 68, 84, 96, 97, 197, 200
Uigurs 85
Ulysses *See* Odysseus
underworld 7, 8, 31, 38, 39, 42, 45, 50, 52, 56, 57, 61, 63, 68, 71–74, 84, 91, 94, 102, 103, 107, 110, 111, 116, 119, 125, 131, 135–137, 144, 157, 159, 160, 165–167, 179, 184–188, 190, 192, 193, 195, 198, 202–204, 207, 210, 213–218, 235, 240, 241, 251, 254, 262, 273, 277–279, 281, 312, 314, 315, 318, 320, 321, 325
Uppsala 99, 100
Uranus 186
Urd 94, 95, 99, 115, 307
urn 93, 96, 162, 163, 218, 227
Urshanabi 56
Uruk 50, 56
Utnapishtim 45, 50, 54, 61, 68
Utu 59

V

Väinämöinen 72, 86–92, 111
Valhalla 97, 308
Vanaspati 197
vara 159
Varuna 104, 112, 192–195, 258–260, 318
Vasuki 191
Vatican Mythographer 210
Vaughan, Thomas 263, 264
Veda 2, 229, 259, 317, 318, 319. See also *Rig Veda, Atharva-Veda*
veil 148, 149, 191, 200, 203, 208, 210, 215–217, 261, 303, 312
Venus 267, 310
Verthandi 95
Videvdat 159
Viking 93, 94, 97–100, 102, 103
Vindler 101. *See also* Heimdall
vine 41, 42, 54, 174, 175
vipers 118
Virgil 69

Sources for illustrations not otherwise attributed in the text

Abreviations: A = the present author; B = Budge 1904; BE = Bureau of Ethnology; C = Cook 1914; DuC = Du Chaillu; G = Goblet D'Alviella 1891; M = Müller 1918; RC = Rayet and Collignon 1888; S = Schliemann 1875; W = Wilson 1894;
Full citations are given in the Bibliography. Decimal numbers refer to Figures in the text.

Cover: Elements from a scene painted on the tomb of Inherkha at Deir el Medinah, Thebes: A; Opp. p.1 A; 1.1 W; 1.2–1.6 S; 1.7–1.8 G; 1.9 S; 1.10–1.12 G; 1.14 G; 1.15 G; 1.17 G; 1.19 W; 1.20 Perrot 1884; 2.3 A (base map adapted from Donnelly, 1882); 2.4 DuC 1882; 2.5 W; 2.6 A; 2.7 W; 3.2 Klein 1886; 3.3 adapted by A from http://commons.wikimedia.org/wiki/File:Herakles_Kerberos_Louvre_F204.jpg; 3.5 Gerhard 1843; 3.7 C; 3.8 Seemann; 3.9 Furtwängler and Reichold 1909; 4.2a A (after Mallowan and Rose 1935); 4.2b A (after Oats 1969); 4.2c A (after Lloyd and Sefar 1945); 4.2d A (after Mellaart following Maleki 1968); 4.3 A (after Fairservis 1971); 4.4 A (after Kenoyer, 1998); 4.5a A (after Possehl 1982); 4.5b A (after Mani 2008); 4.6 A; 4.7 A; 4.8 M; 4.9 A; 4.12, and 4.14 Perrot and Chipiez 1884; 4.16 A; 5.1 Didron 1851; 5.2 A; 5.6 M; 5.7 Seler 1904; 5.8 Wensink 1978; 5.9 Budge; 5.10–5.11 A; 5.12 Mon. of Egypt 1987; 5.13 Kuhn 1909; 5.14 Venturi vol 2 1902; 5.15 Detzel 1894; 5.17 Seler 1904; 5.18 Pachinger 1906; 5.19 Didron 1851; 5.20 Pachinger 1906; 5.21 Didron 1851; 5.23 Pachinger 1906; 5.24 A; 6.2 DuC 1889; 6.3 DuC 1889; 6.4 Lindsey 1970; 6.6 A; 6.7–6.11 DuC 1889; 6.12 W; 6.13 DuC 1889; 6.14 W; 6.15–6.16 DuC 1889; 6.17 E. Jung 1922; 6.18 A; 6.19 A (after Danielou 1953); 6.20 A; 7.1–7.2 Spearing 1913; 7.3 Perrot and Chipiez 1894; 7.4 Mariette-Bey 1874; 7.7 Pietzer and Allen 1981; 7.8 W; 7.10 adapted from B; 7.12 Gerhard 1847; 7.13 A (using traditional animal representations); 7.15 http://commons.wikimedia.org/wiki/File:Leda_and_Zeus_(Swan).jpg. Photo by Alejandro Bárcenas. Used under the Creative Commons Atribution ShareAlike 2.5 license (use is free, but requires attribution and identical license); 7.16 C; 7.18 Gerhard 1847; 7.19–7.21 C; 8.1 A; 8.2 and 8.3b BE 1884; 8.3a A (after a piece in the Stoval Museum of Science and History); 8.4–8.5 W; 8.6 BE 1891; 8.7 W; 8.8 A; 8.11 BE 1955; 8.12 A; 8.13 A; 8.21 BE 1884; 9.1 Perrot and Chipiez 1894; 9.2 W; 9.3 A; 9.4 W; 9.5a Walters 1905; 9.5b and 9.6c W; 9.6a,b A; 9.7 A; 10.1 Spearing 1913; 10.2 Wallis 1898; 10.3 Spearing 1913; 10.4 B; 10.5 and 10.7–10.11 M; 10.12 A; 10.13 B; 10.14 Kuhn 1909; 10.15 M; 10.16 B; 10.17 M; 10.18 B; 10.19 M; 11.1 Keith 1917; 11.3 adapted by A from Grünwedel 1901; 12.1 C; 12.2 Gerhard 1843; 12.4–12.6 C; 12.7 RC; 12.9 Spearing 1913; 12.10 Baumgarten 1905; 12.11 W; 12.12–12.14 RC; 12.15 W; 12.16 Walters 1905; 12.17–12.18 W; 12.19 RC; 13.1 S; 13.3a,b Spearing 1913; 13.4–13.8 S; 13.9 A; 13.10 A (after Gimbutas 1982 following Makkay 1969); 13.11–13.14 S; 13.15 A (after Fairservis 1971); 13.16 S; 13.17 W; 13.18–13.22 S; 13.23 W; 13.24 S; 13.25 A (after Putman 1983); 13.26 A; 14.1 Kuhn 1909; 16.2 and 16.3 Springer 1896; 16.5 Pietzner and Allen 1981; 16.6 Detzel 1894; 16.7 Farrar 1901; Notes1 C.

Printed in the United States
149033LV00002B/2/P

9 780982 403457